HOUSES OF
CIVIL WAR AMERICA

OTHER BOOKS BY HUGH HOWARD

Houses of the Presidents

Mr. and Mrs. Madison's War

Houses of the Founding Fathers

The Painter's Chair

Dr. Kimball and Mr. Jefferson

Writers of the American South

Natchez

Colonial Houses

Thomas Jefferson, Architect

House-Dreams

Wright for Wright

The Preservationist's Progress

How Old Is This House?

OTHER BOOKS BY ROGER STRAUS III

Houses of the Presidents

Houses of the Founding Fathers

America's Great Railroad Stations
(with Hugh Van Dusen and Ed Breslin)

Writers of the American South

Natchez

Thomas Jefferson, Architect

Wright for Wright

Modernism Reborn: Mid-Century American Houses
(with Michael Webb)

U.S. 1: America's Original Main Street
(with Andrew H. Malcolm)

Mississippi Currents
(with Andrew H. Malcolm)

HOUSES OF CIVIL WAR AMERICA

THE HOMES OF ROBERT E. LEE, FREDERICK DOUGLASS, ABRAHAM LINCOLN, CLARA BARTON, AND OTHERS WHO SHAPED THE ERA

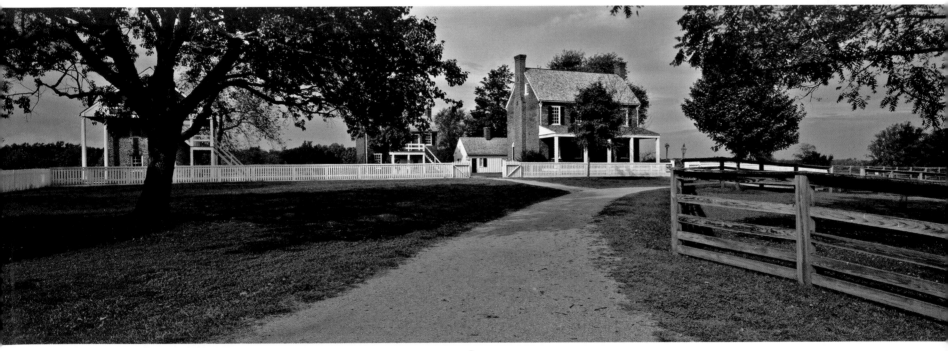

by

HUGH HOWARD

Original Photography by

ROGER STRAUS III

Little, Brown and Company
New York | Boston | London

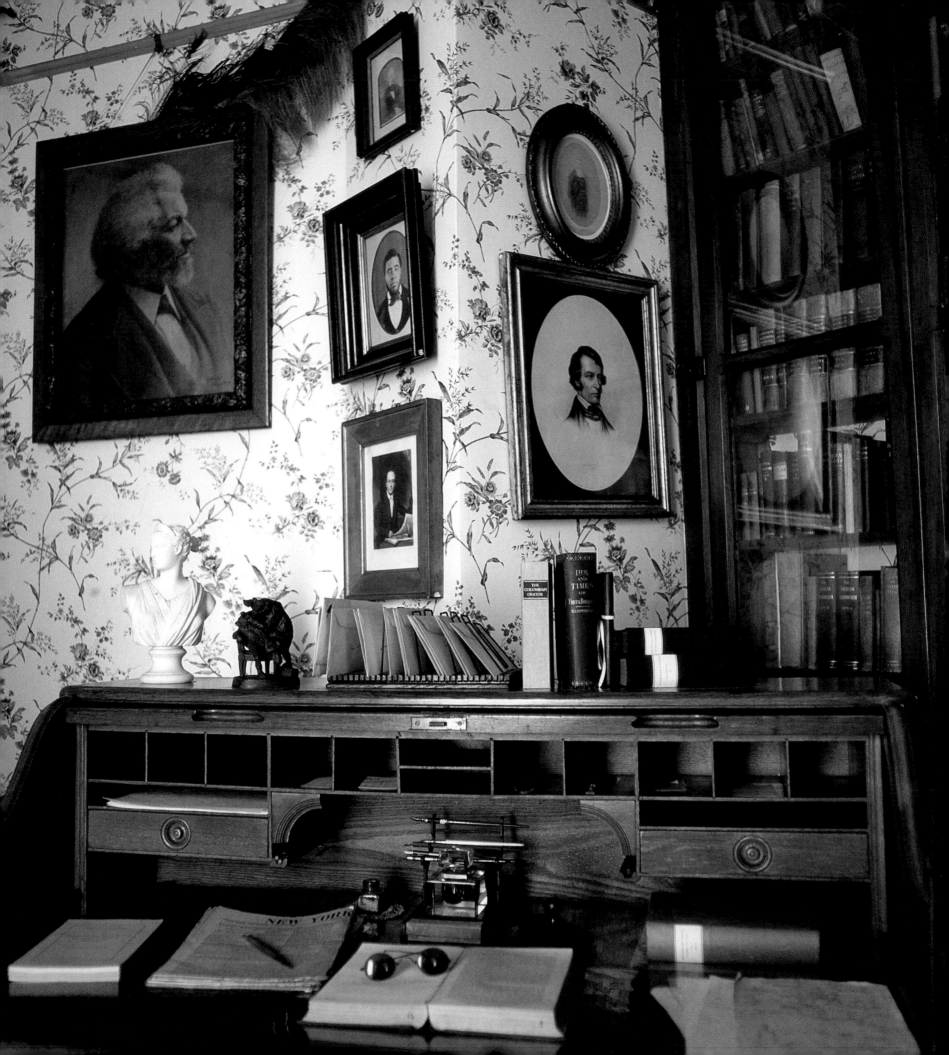

To the men and women who lived

the War between the States—

and to the students, scholars, and partisans

who seek to understand it today

CONTENTS

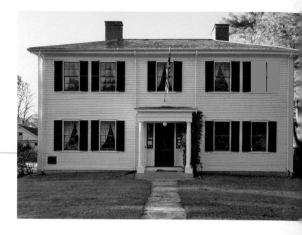

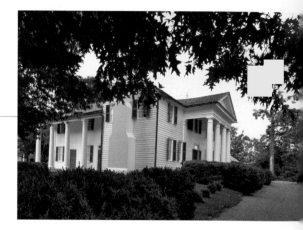
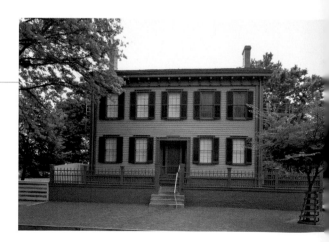

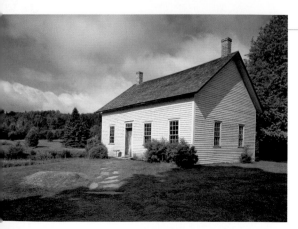

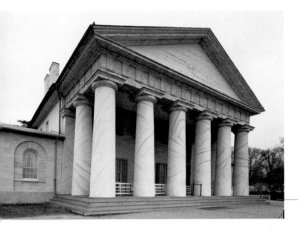

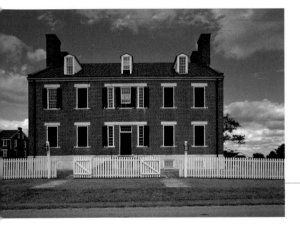

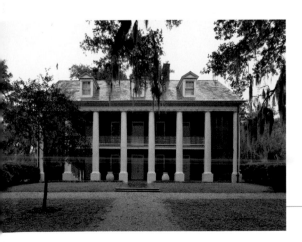

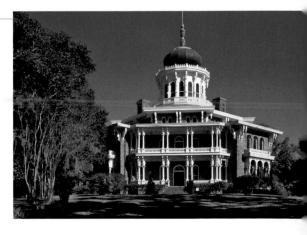

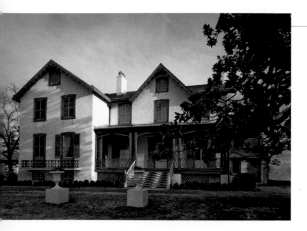

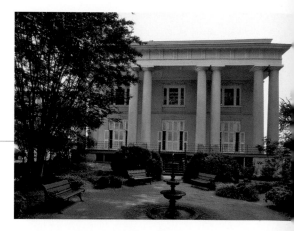

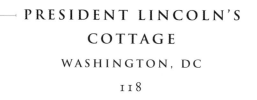
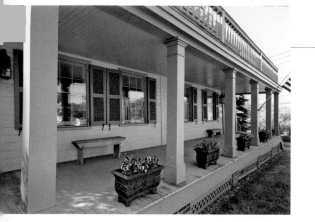

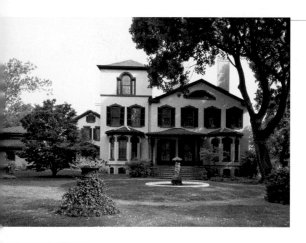

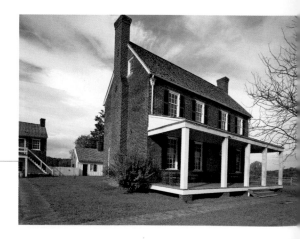

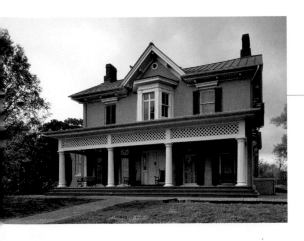

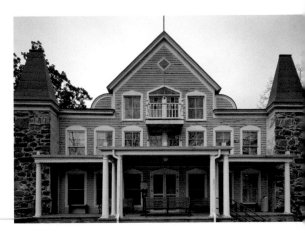

PART III
RECONSTRUCTION AND AFTER

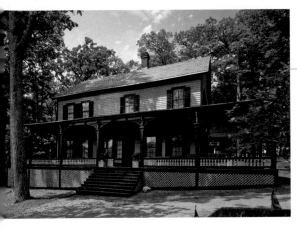

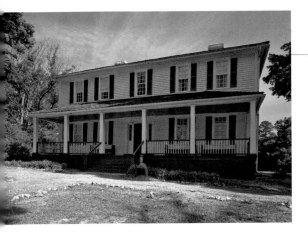

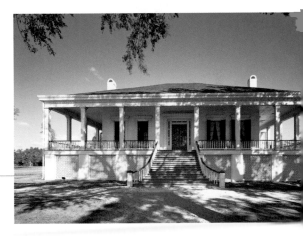

"The fall of Sumter has finished the work begun by South Carolina. . . .

To doubt that we will be victorious [is] to doubt that

justice is one of the attributes of the Almighty."

Charleston Daily Courier, April 20, 1861

"The seven thousand conspirators who assaulted Fort Sumter have

sown the dragon's teeth, which have instantly sprung up

armed men. . . . The people are one and indivisible."

Boston Evening Transcript, April 20, 1861

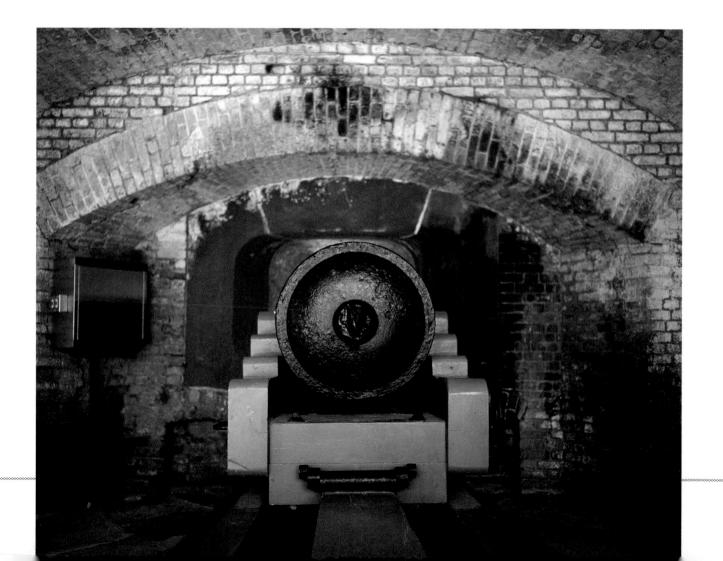

AUTHOR'S NOTE

Words and images constitute the tools that most historians employ to revisit the past. For some of us, however, the research instrument of choice is the house; namely, historic dwellings where people famous, infamous, and obscure lived. Documents, biographies, portraits, memoirs, photos, and other source materials will later add texture and detail, but I prefer to begin with a sense of place.

To borrow the coinage of the late Oxbridge don Richard Cobb, another nontraditional historian, the *archive of the feet* offers a three-dimensional orientation to earlier eras. A well-restored house of a certain age conveys much about its inhabitants, as well as their culture, rituals, and tastes. The concrete reality of walking into a period room full of personal artifacts offers an immersion that can be illuminating, surprising, and disorienting. At one level, the furniture may look uncomfortable, the lighting inadequate, the works of art quaint. But to inhabit a place, even as visitors, can deliver us back in time. I take the historian Gordon Wood at his word: "The essence of historical explanation," he observed, is "giving a sense of surrounding circumstances."

Though it is convenient to think of the Civil War as beginning in Charleston, South Carolina, in April 1861 and ending with the silence that fell at Appomattox forty-eight months later when Robert E. Lee surrendered to Ulysses S. Grant, *Houses of Civil War America* offers a more encompassing view of the time. In the chapters to come, you will indeed visit the Edmondston-Alston House in Charleston, where General P. G. T. Beauregard watched the shelling of Fort Sumter, as well as the parlor at the Wilmer McLean House at Appomattox Court House, where the major hostilities of the war came to a close, but I believe the Civil War can be better understood with a wider frame of reference. Thus, included in these pages are Rokeby, a Vermont farm that was home to a conductor on the Underground Railroad, and the Connecticut residence of Harriet Beecher Stowe, author of *Uncle Tom's Cabin* (the "little woman," according to Abraham Lincoln, "who wrote the book that made this great war"). Other stops include the upland South Carolina plantation of John Calhoun (from the floor of Congress he proclaimed slavery "a good—a positive good"); Shadows-on-the-Teche, a Louisiana mansion occupied by the lady of the house after her menfolk went to war; and South Union Shaker Village, in the border state of Kentucky, where utopian pacifists found themselves in the path of both Union and Confederate armies.

Key battlefields, including Shiloh, Antietam, and Gettysburg, appear in these pages, but the narrative of the war also unfolded at such essential sites as Arlington House, where, in 1861, Robert E. Lee deliberated for whom he would fight; at an Adirondack cottage, where, very much later, Ulysses S. Grant completed his *Personal Memoirs*; and at Cedar Hill, home of the Sage of Anacostia, former slave Frederick Douglass, who looked back on a time he helped reconfigure.

Moving from the particular to the general, this book presents a panoramic view of the Civil War era. Although *Houses of Civil War America* cannot offer a comprehensive examination of the war—no single book can—my hope is that, upon closing this volume, the reader will regard the Civil War with a richer sense of the principal actors and their mise-en-scènes. Even today, the way we remember the people, the events, and the scenes of our bloodiest conflict colors our vision of our nation's destiny.

Hugh Howard
Hayes Hill, New York

Opposite: Fort Sumter delivered cannon fire but no doubt sustained even more. After bombardment by more than three thousand tons of shells during the Union siege of Charleston between 1863 and 1865, the fort had just one wall that remained standing, the others having been reduced to little more than rubble.

HOUSES of
CIVIL WAR AMERICA

★ ★ ★ ★ ★ ★ ★ ★ ★ ★ ★ ★ ★ ★ ★ ★ ★

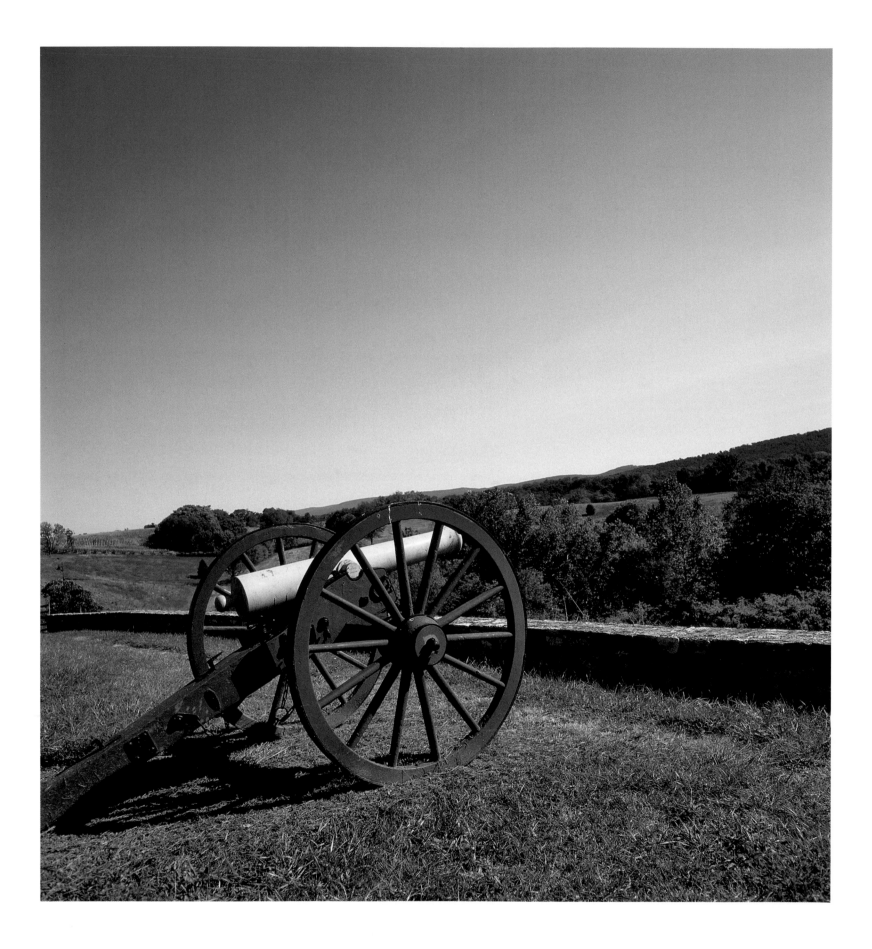

INTRODUCTION

"O time! Thou must untangle this, not I;
It is too hard a knot for me to untie."

William Shakespeare,
Twelfth Night

O n an overcast day in July 2012, Patrick Schroeder held me spellbound at Appomattox Court House. We made our way along the streetscapes of the restored village, which consists of a handful of houses, two law offices, a store, a tavern, a jail, and a courthouse set amid rolling fields, rail fences, and tall trees. As we walked, Schroeder recounted the events of April 9, 1865, gesturing to indicate the movements of Confederate and Federal troops in the vicinity. I knew where the tale ended, of course, but that made his telling no less bittersweet.

A historian on the payroll of the National Park Service, Schroeder wore the unmistakable uniform of a park ranger. The sight of his wide-brimmed straw hat and forest-green trousers led other visitors to join the tour and listen to his running account of the battle. One of them, without so much as raising her hand, interrupted his narration.

A woman of middle years, she demanded, "Where was Colonel Custard?"

I had to suppress a smile at what I assumed was her conflation of the man who later died at Little Big Horn with the board-game character from Clue (maybe Custer was in the conservatory?). But Schroeder never broke stride. Having explicated Appomattox to all comers for many of the past twenty-five years, he turned and pointed over his shoulder, explaining that the fair-haired, publicity-seeking Major General George Armstrong Custer and his Cavalry

Corps would have been found a few miles away on the morning of Robert E. Lee's surrender. Her curiosity satisfied, the questioner wandered away as Schroeder led us toward the two-story wood-frame McLean dwelling, the locale for that key vignette, which I describe in the pages of this book (see "Generals Grant and Lee at the Wilmer McLean House," page 172).

In my subsequent musings, that woman became Ms. Mustard. She obviously knew more than a little about Appomattox (how many of us recall that Custer was on Grant's staff?), and her presence at the battlefield suggests a curiosity about the Civil War. While I suspect her malapropism was atypical, I understand it is symptomatic of how the memory of that disastrous war both engages our attention and eludes our understanding.

The Civil War has its own very substantial constituency. In bookstores, the shelf space devoted to the 1861 to 1865 conflict dwarfs that of any other war. Perhaps thirty thousand costumed Civil War reenactors annually don uniforms to re-create various battles; hundreds of local groups, many called Civil War Round-tables, meet monthly for lectures, discussions, and other events related to Civil War topics. Millions of people visit Civil War battlefields each year; millions more visit the sites described in the chapters that follow. In 1990, forty million Americans tuned in to Ken Burns's *The Civil War*, making it the most watched show ever on PBS. In more recent years, with the commemoration of the war's 150th anniversary, untold bloggers remind us daily of the events of the war.

In spite of both this passionate interest and the ongoing work of countless scholars, no view of the war satisfactory to all parties

Opposite: The scene today at Antietam National Battlefield, near Sharpsburg, Maryland, belies the bloody realities of September 17, 1862, when some 3,500 soldiers died and almost five times that number were wounded.

The life of freedmen improved after the Civil War, yet, for many, much remained the same. At Middleton Place outside Charleston, South Carolina, a plantation established in the early eighteenth century, the humble lives of two former slaves, Ned and Chloe, are remembered. They remained in the employ of the Middleton family after the war, working as butler and cook. They occupied quarters like these, with a workroom (*right*) and a plain bedstead like this one (*left*), which was made on the plantation.

has emerged. The differences of opinion are wide and varied, beginning with the answers to such simple questions as *When did the Civil War become inevitable?* A case can be made not only for the bombardment of Fort Sumter on April 12, 1861 but also for such fulcrum events as Lincoln's election (November 1860); the Dred Scott decision (1856); the Kansas-Nebraska Act (1854); the emergence of the "Slavocracy" as a bloc in Congress; and the birth of abolitionism in the North. There were other moments too, as far back as the Constitutional Convention of 1787 in Philadelphia, where many of the same Founding Fathers who had proclaimed that "all men are created equal" integrated a paradoxical compromise into the U.S. Constitution permitting slavery to survive in their new country.

Another oft-asked—but as yet unresolved—question is, *Whom do we blame for the terrible war?* Again, the responses range widely, from Southern fire-eaters to radical Northern abolitionists; from South Carolina secessionists to black Republicans.

Or: *What was the crux of the matter?* Most insist that slavery was incontrovertibly the essential cause of the conflict; others argue that the paramount issue was states' rights. Surely the South's fear of its waning political power in Washington factored in; later, the North's adamant insistence upon union added to the momentum of events.

Perhaps the closest we can come to a statement that meets with general agreement is this: No single flame ignited the conflagration that took the lives of an estimated seven hundred and twenty thousand men. Rather, a dense weave of cultural, social, and economic factors led to a national tragedy of unprecedented proportions.

Teasing the tapestry apart has been the work of historians ever since, but the goal of this book is not to settle on one compact explanation. Instead, we will consider varied perspectives, ranging from Patrick Schroeder's and Ms. Mustard's to those of Lincoln, Lee, Douglass, and Davis. It is, after all, illusory to think that our remote vantage offers us omniscience. To understand the Civil War one must triangulate, as the coordinates left by historians of past eras are rarely without their margins of error.

PLACES AND PLAYERS

In the years spent researching and writing this book, I attempted to master the dramatis personae of the Civil War era. The players

(and their places) are many, but I quickly learned how remarkable was their interconnectedness. Brethren—political, military, and genetic—would face one another across battle lines, as both armies were commanded by West Point–trained officers (often friends, sometimes classmates), among them Generals Robert E. Lee and Ulysses S. Grant, William Tecumseh Sherman and Joseph E. Johnston, and Thomas "Stonewall" Jackson and Philip Sheridan. But the crisscrossing of personal destinies predates the war itself.

In 1848, a freshman congressman named Lincoln felt tears come to his eyes after a speech by Georgia's Alexander Stephens, the man who later became vice president of the Confederacy (and who argued that slavery was "the negro['s] . . . natural and normal condition"). In the 1850s, Jefferson Davis masterminded the raising of the Capitol dome; for some two decades, the Mississippian diligently served his first nation as a soldier, U.S. senator, and secretary of war.

Cassius Clay and Horace Greeley, Kentuckian and New Yorker, respectively, became fast friends. In turn, both men interacted with Lincoln. Having listened to Clay's emancipationist pleadings, Lincoln found roles for him in his wartime administration, while Greeley both pleaded Lincoln's case to the public and periodically pricked him from his chair as editor of the widely read *New York Tribune.*

The places presented in his book, which were inhabited by dozens of these memorable men and such women as Clara Barton, range from the other great presidential white house (Jefferson Davis's executive mansion, in Richmond, Virginia, which came to be known as the White House of the Confederacy) down to a simple farmhouse in Auburn, New York, gifted by William Henry Seward to Harriet Tubman, the diminutive former slave dubbed "General Tubman" by John Brown. Brown's own home in upstate New York in the interracial community known as Timbuctoo could hardly have been more rudimentary. In contrast, Seward lived in high style in an in-town mansion as he contributed mightily to Lincoln's presidency in multiple ways (he was secretary of state, the president's confidant, and even editor of some of Lincoln's

greatest speeches). To visit Stonewall Jackson's home in Lexington, Virginia; Ralph Waldo Emerson's Bush in Concord, Massachusetts; and the Green-Meldrim House, General Sherman's temporary home in Savannah, Georgia, is to encounter those men in their contexts.

THE SLAVE QUARTERS

The enslaved occupy a central place in the Civil War story, but relatively little original slave housing exists. Part of the explanation lies in a preservation truism: the best houses attract restorers, while lesser dwellings tend to disappear over time. Since the people whose destinies were most altered by the war inhabited the plainest places, neither freedmen nor masters in the postbellum South sought to preserve a record of life in cramped, windowless hovels with dirt floors.

Slave conditions varied greatly. House servants typically lived in better accommodations than did field hands. In the years before the war, a new appreciation of cleanliness led to improved conditions for some bondsmen. Surfaces were sometimes refreshed with a coat of whitewash, and many slaves were granted their own garden plots and allowed to keep pigs and poultry. On some properties, a limit was set of a single family per "negro house," which was, as one slave owner observed, "conduc[ive] to peace & good morals." While these and other improvements no doubt added to the slaves' quality of life, there could be an upside for the master too. Healthier slaves, as one planter explained, were more "prolific," and their "*annual increase* may be estimated as *adding as much to my income* as arises from all other sources." Like other "species of property," slaves had value in the marketplace.

In 1861, four million men, women, and children were in bondage. Nearly two hundred thousand former slaves would serve in Union armies; many more fled toward Union lines, becoming "contraband" on their way to freedom. Yet that road led to an uncertain fate. With the end of the war, former slaves faced a fundamentally altered world: officially, they had been emancipated, but African Americans, we now know, would wait another century

Left: This 1930s photograph records the row of slave cabins that still stand at Boone Hall in Mount Pleasant, South Carolina. The nine brick structures are thought to have housed skilled slaves (cook, carpenter, blacksmith) in relative comfort, with multiple windows per structure, a center chimney, and a raised wooden floor. Lower-caste slaves who worked in the fields of the Boone brickyard occupied humbler wood-frame huts out of view of the mansion house. *Frances Benjamin Johnston/Library of Congress, Prints and Photographs*

Right: A surviving freedman's dwelling, dating from just after the Civil War, known as Eliza's House. The two-family residence gets it name from Eliza Leach, the last person to live there. For more than forty years, she worked in the great landscape garden at Middleton Place and as a costumed interpreter in the stable yard.

and more for full racial equality and social justice. Perhaps it is not surprising, then, to find many slaves remained on the land they knew, still linked to the plantations of their former masters. Though they were no longer enslaved, their day-to-day lives as servants or sharecroppers often resembled what had come before.

Over the course of the recent decades, new attention has been paid to slave dwellings, and a growing body of scholarship is emerging concerning the circumstances of slave life. More and more historic sites are interpreting for a curious public what life may have been like in the typical slave quarters. Researchers have also identified ways in which slaves were agents of change rather than mere pawns in a larger game. In future, expect to encounter richer and more complete portrayals of life at the bottom layer of the plantation strata.

MYSTIC CHORDS OF MEMORY

At his inauguration on March 4, 1861, Abraham Lincoln appealed to the "better angels of our nature." Although his petition for peace fell on deaf ears—barely a month later, the cannonade echoed in Charleston Harbor—another memorable turn of phrase from the same sentence in his speech describes the real subject of *Houses of Civil War America*. Indeed, this book is a manifestation of a poetic metaphor, the "mystic chords of memory," that Lincoln, with an able assist from his soon-to-be secretary of state Henry Seward, offered his inaugural audience.

Today the Civil War remains a destination, particularly in the Southern imagination. Consider William Faulkner's view: he wrote of the Battle of Gettysburg in *Intruder in the Dusk* (1948), "For every Southern boy fourteen years old, not once but whenever he wants it, there is the instant when it's still not yet two o'clock on that July afternoon in 1863." Faulkner plants a mnemonic flag at a historic moment, the hour when Pickett issued his order to charge, which had disastrous consequences for both his men and his country (the Union victory at Gettysburg proved a turning point in the war). Faulkner's back-to-the-future moment

still has a surreal appeal in a region where some remain haunted by the outcome of what Henry Adams would call Lincoln's "great war."

You will encounter many tableaux and vignettes in the pages to follow; I hope such shards of memory will help you reconsider the past as you meet its inhabitants. To visit Fort Hill in South Carolina, for example, and to survey the rugged upland farmhouse near North Elba, New York, is to gain acquaintance with two men whose visages haunt the conflict. Though both died before the Civil War, the biblical beard of John Brown and the penetrating glare of John Calhoun establish a defining opposition.

A chorus of voices beyond Brown's and Calhoun's informs our travels. Seward's memorable insistence upon "higher law," Greeley's coinage "Bleeding Kansas," Lincoln's characterization of the nation as a "House Divided," and other rhetorical flourishes distinguish key moments in what Herman Melville called the "conflict of convictions."

My deeper hope is that, by visiting the places, by hearing the voices, you will be able to avoid the most fundamental error made by many students of the Civil War era, namely, *presentism*. When we impose our twenty-first-century ideas, perspectives, and values on the past, our understanding of history is tainted. Red flags should start waving before your eyes when a seemingly Solomonic soul tells you the war wasn't about slavery (for the South, it most certainly was; just read the explicit words of the secessionist conventions) or when someone else advises you that Lincoln prosecuted the war to end bondage (he didn't; it wasn't until well into the second year of the war that he realized that emancipation was an essential war strategy). As in the pinball machines of the arcades of old, the Tilt sign should light up in your brain the moment that the prejudices of the present-minded bring a twenty-first-century perspective to bear on the decisions, inclinations, and attitudes of the men and women of the mid-nineteenth century. Their paradigm differed from ours.

One essential distinction regarding black Americans in the Civil War era offers a case in point. Even among the many who recognized that human bondage must end, few thought the black man the equal of the white man. In the South, where 95 percent of the nation's African Americans resided, slavery had been a fact of life for generations, fixing the black man's inferiority in the minds of most whites. In the North, where less than 1 percent of the population was black, relatively few whites interacted with men or women of color; the African remained very much *other*. In the second year of the war, during the very months he contemplated the Emancipation Proclamation, Abraham Lincoln consulted African American leaders to advocate colonization—the return of dark-skinned peoples to Africa. "Even when you cease to be slaves," he warned them, "you are yet far removed being placed on an equality with the white race." If Lincoln spoke for the liberal-minded few, then Mary Chesnut, wife of a South Carolina senator and Confederate general, spoke for most people when she admitted to being confounded by the blacks she saw. The war's invaluable diarist, Chesnut confided in her journals as the first shots of the war were fired, "Not by one word or look can we detect any change in the demeanor of these negro servants. . . . You could not tell that they hear the awful row that is going on in the bay. . . . And people talk before them as if they were chairs and tables. And they make no sign. Are they stolidly stupid or wiser than we are, silent and strong, biding their time?" To presume that any form of post-racial thinking was commonplace in the North (or South) is to interpret the past in today's terms.

The Civil War must not be regarded as some kind of national fairy tale to serve either the self-satisfied rectitude of one region or the romantic mythologizing of another. It is the author's and the photographer's hope that the blending of words and images in the pages that follow offer glimpses of the Civil War era in a manner that, should any of the players magically come back to life they might recognize their place in time.

PART
I

A HOUSE DIVIDED
AGAINST ITSELF

TIMELINE

1808
The prohibition of slave importation goes into effect in the United States; it slows, but does not halt, the trafficking of slaves.

1820
Henry Clay brokers the Missouri Compromise, under the terms of which one slave state and one free state are admitted to the Union (Missouri and Maine, respectively). The legislation also establishes that the remaining lands in the Louisiana Purchase will be divided at the line of 36°30' latitude, with slavery permitted below but banned above.

1831
Abolitionist William Lloyd Garrison publishes the first issues of his antislavery newspaper the *Liberator*. It will appear weekly until 1866.

Some sixty whites are killed in a slave insurrection in Southampton County, Virginia. In retaliation, fifty-six slaves are executed and many other blacks killed by militias. The corpse of Nat Turner, leader of the rebellion, is beheaded and quartered.

1836
The gag rule goes into effect in the House of Representatives, automatically tabling all antislavery petitions without discussion. John Quincy Adams begins what will be a nine-year fight to lift the restriction.

1837
South Carolina senator John Calhoun rises on the floor of the Senate to speak and makes his famous statement that slavery is, "instead of an evil, a good—a positive good."

1850
The Fugitive Slave Act, part of the Compromise of 1850, becomes law, requiring law enforcement officials in all states to arrest any suspected runaway slave without permitting the individual recourse to due process.

1851
Uncle Tom's Cabin is serialized in the antislavery weekly *National Era;* publication in book form will follow in 1852. The book is a runaway success in both the United States and Great Britain.

1854
The Kansas-Nebraska Act permits citizens of these territories to determine by popular sovereignty whether to permit slavery in their regions. The act galvanizes Lincoln to rejoin the political fray.

1856
On the floor of Congress, Massachusetts senator Charles Sumner is beaten about the head to near unconsciousness by South Carolina congressman Preston Brooks. On hearing the news, John Brown in Bleeding Kansas, along with four of his sons and his son-in-law, slash five proslavery men to death using broadswords.

1857
In an opinion delivered by Chief Justice Roger Taney, the Supreme Court rules in *Dred Scott v. Sanford* that Scott, though he had lived most recently in the free state of Illinois and the territory of Minnesota, is to be returned to his owner. The basis of the ruling is that neither Scott nor any other person of African ancestry can claim citizenship.

1859
Attempting to launch a slave revolt, John Brown and twenty men capture the engine house in Harper's Ferry, Virginia, on October 17. Soon after, Brown is captured by a U.S. Army unit commanded by Lieutenant Colonel Robert E. Lee, tried, and executed by hanging; Herman Melville calls him "the Meteor of war."

1860
In November, Illinois lawyer Abraham Lincoln is elected president; in December, South Carolina secedes from the Union.

Opposite: This smokehouse is one of eight surviving agricultural outbuildings on the ninety-acre Rokeby in Ferrisburgh, Vermont, a stop on the Underground Railroad. To see the structures arrayed beyond the house's dooryard is to get a sense of the clutter of a New England farm, which this homestead was, first and foremost. Over time, the operation's emphasis shifted from merino sheep to orchards to dairy farming.

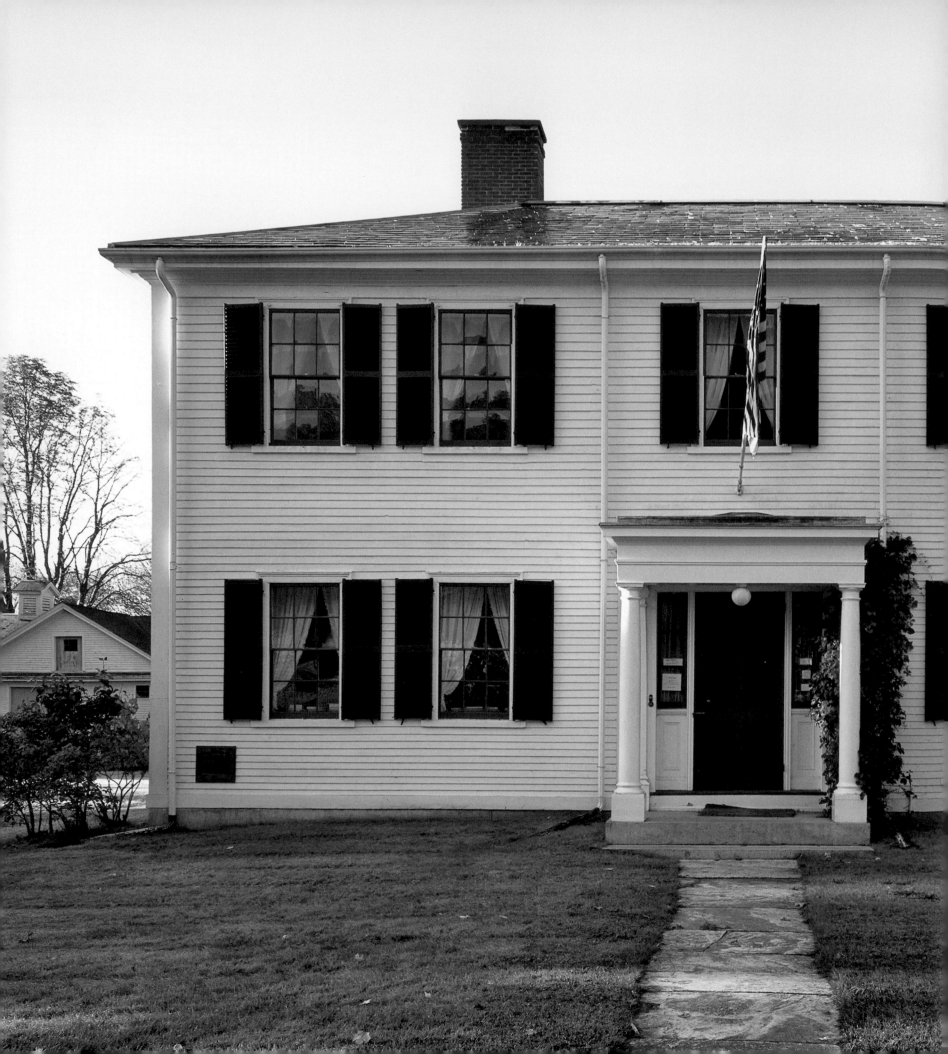

RALPH WALDO EMERSON MEMORIAL HOUSE

CONCORD, MASSACHUSETTS

"We shall crowd so many books and papers, and, if possible, wise friends into it, that it shall have as much wit as it can carry."

RALPH WALDO EMERSON TO WILLIAM EMERSON

July 27, 1835

The word — in both the North and South — made people angry. The very idea of *abolitionism* rang radical even in Massachusetts, where many regarded those who espoused such views as dangerous zealots. Then, on August 1, 1844, Ralph Waldo Emerson (1803–1882) broke his philosophical silence on the subject.

At age forty-one, he held a formidable place in the intellectual life of his country. American literary celebrities such as Edgar Allan Poe and William Cullen Bryant had taken notice of the self-described transcendentalist poet and essayist. In England, Charles Dickens discussed his work, while a French critic hailed him as "the most original man produced by the United States up to this day." A speech Emerson had given at Harvard, titled "The American Scholar," amounted to something of an "intellectual Declaration of Independence," as Oliver Wendell Holmes later characterized Emerson's 1837 manifesto, but Emerson continued to aspire to think national thoughts. "There are stairs below us, which we seem to have ascended," he wrote, adding that he anticipated "stairs above us . . . which go upward and out of sight."

By 1844, Emerson had come to realize that if his country was to climb those stairs, he could no longer keep his opinions on slavery to himself. Slavery disgusted him. In his twenties he witnessed a Florida slave auction, and in 1835, he wrote in his diary, "I do not wish to live in a nation where slavery exists. . . . In the light of Christianity [there] is no such thing as slavery."

Though he expressed a reluctance to be "a mover in politics," Emerson had closely followed the nine-year legislative fight that John Quincy Adams finally won in spring 1844 in the Capitol, bringing to an end the so-called gag rule that forbade congressmen to so much as raise the issue of slavery in the House of Representatives. When invited by the Women's Anti-slavery Association to deliver a lecture — the name of Lidian Emerson, his wife, appeared on the association's membership rolls, as did Cynthia Thoreau's, mother of Emerson's young friend Henry — Emerson determined to use the occasion of the tenth anniversary of the emancipation of the slaves in the British West Indies to take a firm position on slavery.

Despite his fame and reputation, Emerson faced resistance in Concord. Lacking a suitable venue of their own, the sponsoring ladies sought to use the sanctuary of one of the local churches for the

Previous page: Emerson's journal entry for July 24, 1872, wasted no words: "House burned." The blaze was extinguished by neighbors, summoned by Emerson's shouts. Among them was Louisa May Alcott. "We had a topsy turvy day at the fire," she wrote to a friend the following day. "The upper story is all gone & the lawn strewed with wrecks of beds, books & clothes. They all take it very cooling & in a truly Emersonian way." A collection taken up (unbeknownst to Emerson) brought in seventeen thousand dollars, which paid for not only repairs to the hip-roofed house but also a trip Emerson and daughter Ellen took to Europe and Egypt.

Opposite: Although its original furniture and books have gone elsewhere (the former across the street to the Concord Museum, the latter to Harvard University), Emerson's study now closely resembles the space in which he thought and wrote almost every day. Some 1,200 books lined the walls.

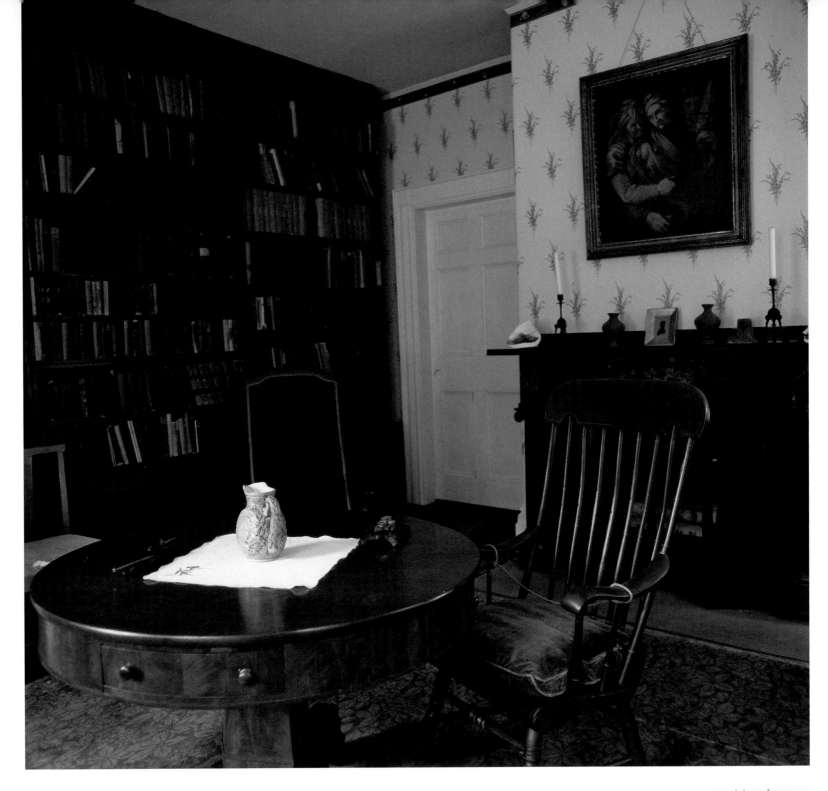

lecture, only to find the controversial nature of the subject cowed the elders at nearby houses of worship. Nathaniel Hawthorne offered his glade, but when rain prevented an outdoor lecture, permission was obtained to use Concord's town hall. Henry David Thoreau went door to door, advising neighbors and townspeople of the upcoming event. When the sexton at the First Parish Church refused to toll the town bell to announce the gathering, Thoreau impulsively pushed past him and did it himself.

From the podium, Emerson offered a long, considered peroration. He recounted England's measured path to banning bondage and the slave trade; he recalled outrages of "the habit of oppression." But he moved on from foreign affairs to the local, collective conscience of his listeners. "Whilst I have read of England," he said pointedly, "I have thought of New England."

He challenged those who sat before him, most of whom remained reluctant to embrace abolitionism. While their elected

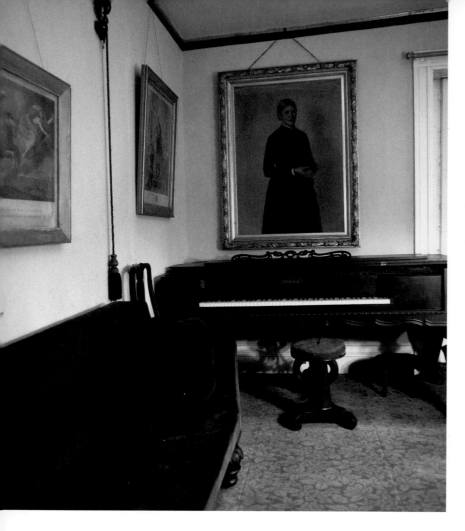

Left: The canvas that hangs over the Chickering piano portrays Ellen Tucker Emerson (1839–1909), Waldo and Lidian's elder daughter, who resided in Concord (and at Bush) throughout her life. Ellen remained unmarried, and in Emerson's later years, she became her father's assistant and traveling companion.

Right: An inveterate walker, Emerson kept his walking sticks in the hall tree in the rear stair hall.

representatives to the seat of government at Washington were "amiable" and "accomplished," Emerson saw "a disastrous want of *men* from New England." The time had arrived, he argued, for "a moral revolution." The time had come for "the civilization of the Negro" on American shores. He saw this as a moment for "the action of the intellect and the conscience of the country."

As one of the nation's leading public intellectuals—a rubric of our time—Emerson brought forward the discussion of slavery, a topic often ignored in mercantile New England, where slave-cultivated cotton meant profit. Abolitionists appeared well out of the mainstream when Emerson announced himself an advocate of the

unpopular idea. Although his position alarmed many—he was called a fanatic, and worse—Emerson helped shift the waters.

"THE EXPRESSION OF INDIVIDUAL OPINION"

Ralph Waldo Emerson's speechifying amounted to a variation on an old family theme, as his willingness to offer guidance was an inheritance from generations of Puritan clergymen. With the death of his pastor father, however, circumstances required that the boy, then eight years of age, plot his own course.

He attended Boston Latin School before moving to Harvard. Just prior to his eighteenth birthday, the scholarship student delivered the class poem at graduation; he had also determined he would henceforth be known as Waldo. After teaching for several years at his brother William's school for young ladies in Boston, he entered Harvard Divinity School in 1825. Ordained a minister four years later, he preached from such notable pulpits as that of the Second Unitarian Church of Boston.

The same year he married Ellen Tucker, but as the young minister watched her lose her battle with consumption, his faith wavered. She died in the winter of 1831, and the following year Emerson resigned his post. "I have sometimes thought," he wrote in his journal, "that, to be a good minister, it [is] necessary to leave the ministry." The Emersons faced other periods of mourning. Two brothers, Edward and Charles, also succumbed to tuberculosis, in 1834 and 1836, respectively; after Waldo remarried in 1835, he and his wife welcomed a namesake son in 1836, only to see him die at age five. "He gave up his little innocent breath like a bird," the elder Waldo reported.

By then, however, Emerson was well launched on a new career as an essayist, editor, poet, and lecturer. His first book, *Nature*, appeared in 1836, and he started a short-lived but influential magazine, the *Dial*, in 1842. His lectures provided him a modest livelihood after 1833 (some years he delivered as many as eighty). No longer a churchman, he found a national audience for his prescriptions, as he traveled to many parts of the country. From the lecture platform, Emerson observed, "People will let you say what you think."

BUSH

In July of 1835, Emerson devoted one sentence to the acquisition of the home to which he would continuously return over the next half century. He noted in his journal, "I bought my house and two acres six rods of land of John T. Coolidge for 3,500 dollars."

The day after they took their vows, Waldo and Lidian Emerson took up residence. (Waldo insisted that the former Lydia Jackson change both her names, concerned that *Lydia* would be distorted into *Lydiar* by the local Yankee dialect.) The bride arrived at a house she had never seen, greeted by two cartloads of familiar furniture brought from her childhood home in Plymouth, Massachusetts. The marriage, as well as the house, proved satisfactory, as the Emersons remained in residence together at the home they called Bush until Waldo's death, in 1882.

The substantial house stood on the Cambridge Turnpike, set well back from the dirt road. Though the townspeople in Concord knew the property as Coolidge Castle, Emerson wrote to his

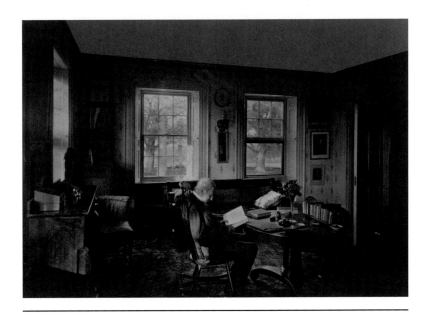

Ralph Waldo Emerson seated in his study in 1879. *A. H. Folsom/Houghton Library, Harvard University*

brother William, "It is in a mean place, and cannot be fine until trees and flowers give it a character of its own." In a town that, like much of nineteenth-century New England, was largely deforested (the true horizon line was visible nearly everywhere in Concord), the Emersons set to work planting shade trees. In addition to the nine horse chestnuts that lined the road, elms and firs went in to the east and more than a dozen balsams soon grew around the house itself.

Lidian gave birth to four children at Bush. Waldo, born in 1836, was followed by Ellen (1839), Edith (1841), and Edward Waldo (1844). During those early years at Bush, Emerson's mother, Ruth Haskins Emerson, also resided in the house. Kitchen girls came and went, while a hired man tended to the livestock (horses and a cow) and did other chores.

Waldo took for his own a room that overlooked the street, immediately to the right of the front door. Tightly packed bookshelves rose to the ceiling on one wall; at the center of the room, he placed a large, round table. He wrote on a pad he held on his lap while seated on his preferred chair, a rocker. Daughter Ellen recalled that it was "the chair in which he really spent his whole

indoor life." The other first-floor rooms included a parlor, dining room, and a bedroom. Above were four more bedchambers.

Concord was convenient to Boston and Cambridge. Stagecoach service rolled past on a regular schedule, enabling the comings and goings of Emerson and his many visitors (after 1845, regular trains served the town). Some guests were local; the Emersons had been in residence only a month when the reformer Bronson Alcott arrived for the weekend; his daughter Louisa May would live nearby and be a frequent visitor in the years to come. Emerson talked art with the sculptor Horatio Greenough, and writers James Russell Lowell, Henry Wadsworth Longfellow, and Nathaniel Hawthorne dined at his table, as did politicians, including then-secretary of state Daniel Webster and Charles Francis Adams, grandson of John.

Emerson confided in the brilliant and independent-minded Margaret Fuller, in whom he found a kindred spirit and a sometime editor for the *Dial*. Emerson admired and endorsed the work of a then-unknown poet, Walt Whitman, though the author of *Leaves of Grass* didn't manage a visit to Concord until 1881; by then Emerson was, in Whitman's words, in "the modest radiant twilight of his old age," his memory and mind fading. Though Emerson invited John Muir to visit on multiple occasions, by the time the great naturalist made the pilgrimage to Bush, Emerson was many years dead. Son Edward Emerson tended to the task of welcoming Emerson's admirer, the man whom we remember as the father of our national parks.

THE CHAMPION OF AMERICAN LETTERS

Emerson raised his voice repeatedly to talk of slavery after the Fugitive Slave Act passed in 1850. He unburdened himself in numerous lectures during which he characterized the legislation as "this filthy law." More lectures followed at Massachusetts, New York, Philadelphia, Rochester, and Syracuse Anti-Slavery Society meetings, and, in 1854, he quietly turned activist. He decided that the configuration of the rambling frame structure and attendant farm buildings at Bush suited themselves to another purpose, and

his house became a stop for fugitive slaves on their way north on the Underground Railroad.

At Bush the visitors included John Brown, who delivered a lecture in Concord in 1857 (see "John Brown Farm and Gravesite," page 56). Brown sought money for his cause; Emerson, struck by the power and intensity of the man, invited him home for the night. Though Brown had recounted the violent events he witnessed in Bleeding Kansas to the audience at the town hall, the next morning he delighted the Emerson children with animal tales ("very pretty stories — not about slavery," Ellen later wrote).

Both Emerson and Thoreau contributed to Brown's coffers. After the Harper's Ferry raid led to Brown's hanging, the younger Brown daughters came to Concord and resided for a time at the Emerson home, where, Ellen reported, the Emerson women "dress[ed] them in Boston fashion, that they should look like the rest of the world" upon enrolling in a local school.

Today, Bush remains in the hands of Emerson descendants (Waldo and Lidian's daughter Ellen resided there until her death in 1909, other descendants until the 1940s). The property, administered by the R. W. Emerson Memorial Association, has been open as a museum since 1930.

The wife of a publisher and a literary figure in her own right, Annie Fields once called Emerson the "champion of American letters." Such Emerson essays as "Nature," "The American Scholar," and "Self-Reliance" remain fixtures in the American canon. In Emerson's own time, his words on slavery had great power too. In an address at the Smithsonian Institution in January 1862, Emerson announced, "This conspiracy of slavery, — they call it an institution, I call it a destitution." He went on to make a detailed case for ending the "stealing of men," concluding that "emancipation is the demand of civilization, everything else is an intrigue."

THE MAN WHO CAME TO DINNER

Henry David Thoreau moved into Bush in the 1840s, earning his keep, Emerson reported, as "an indefatigable and very skillful laborer." Fourteen years Emerson's junior, Thoreau would play the roles of literary protégé, neighbor, and friend to Emerson, as well as confidant to Lidian Emerson.

He came and went over the years. For a time, he lived on Staten Island with Waldo's brother William before returning to Concord. Later he left Bush again, this time to inhabit a hut he constructed on a nearby lake. Emerson had enlarged his holdings in 1844, acquiring roughly eleven acres at Walden Pond (for $8.10 per acre) and a smaller parcel nearby of standing white pine (for which he paid $125), both a mile distant from Bush. As he wrote to his brother on October 4, 1844, "So [I] am landlord & waterlord of 14 acres, more or less, on the shore of Walden."

Emerson would walk there often, but Thoreau made the place famous. He lived there barely two years (when he left, in the fall of 1847, it was to return to Emerson's house, where he assumed the role of "man-of-the-house"—Lidian's term—during a trip that Emerson took to England to lecture). Years later, Thoreau published a book about his two years, two months, and two days in his cabin, compressing them into a calendar year. "I went into the woods because I wished to live deliberately, to front only the essential facts of life, and see if I could not learn what it had to teach, and not, when I came to die, discover that I had not lived." *Walden; or, Life in the Woods* appeared in 1854.

Throughout the rest of his short life, Thoreau periodically came to tea or dinner at the Emersons' and moved in when Waldo traveled to deliver lectures. He made pencils in his father's factory; he kept a journal, as his friend Emerson advised. The two men's relationship grew complicated, to judge from their diaries, but they remained essential friends, though Thoreau was clearly burdened by living in the older man's shadow. Thoreau, like Emerson, became a powerful voice for abolition, famously defending John Brown on the eve of his trial in a widely published speech titled "A Plea for Captain John Brown."

Thoreau died at age forty-four of consumption. At his funeral, according to Thoreau's sister, "Mr. Emerson read such an address no other man could have done." When Emerson turned away from the grave, he was heard to say, "He had a beautiful soul."

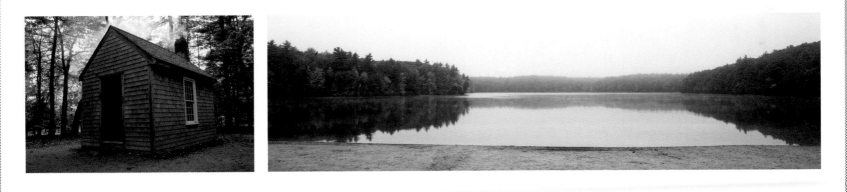

Top: A sometime denizen of Bush and a beneficiary of Emerson's continuing generosity, Henry David Thoreau was also a powerful voice of conscience. At the time of John Brown's execution, Thoreau told the citizens of Concord, "Some eighteen hundred years ago Christ was crucified; this morning, perchance, Captain Brown was hung. These are the two ends of a chain which is not without its links. He is not Old Brown any longer; he is an angel of light." *Library of Congress, Prints and Photographs*

Left: A replica of Thoreau's ten-by-fifteen-foot cottage. When he constructed the original and planted his garden around it, the cost (as recorded in *Walden; or, Life in the Woods*) was $28.12½¢.

Right: Walden Pond today: Although an amusement park stood at the western end of the pond in the late nineteenth century (it burned in 1902), the site that Thoreau knew has changed relatively little. Managed by the Commonwealth of Massachusetts, it is a popular place for swimming during the brief New England summer.

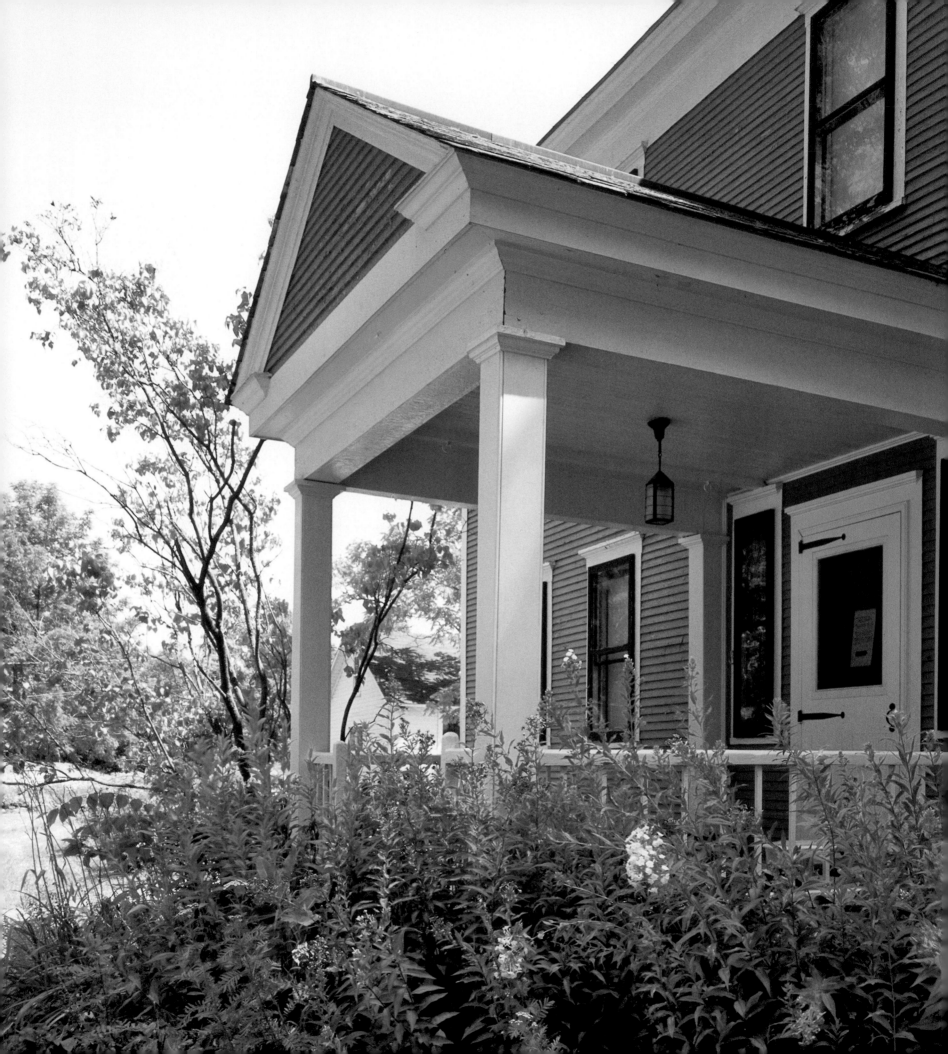

RAIL STOP AT ROKEBY

FERRISBURGH, VERMONT

"I hope [Simon] will arrive in safety and prove to be an honest, faithful laborer. . . . If such should be the result, I shall have occasion to rejoice that . . . the 'laborer' will be considered 'worthy of his hire,' instead of being regarded as a mere *chattel* and compelled to toil without hopes of reward."

OLIVER JOHNSON TO ROWLAND T. ROBINSON

April 3, 1837

"DUSKY FUGITIVES"

Rowland E. Robinson's specialty was local color. In the late nineteenth century, he wrote stories of the region he knew best, telling tales of fishermen, hunters, and farmers in their native woods and waters. Popular magazines, among them *Lippincott's* and *Century*, provided a ready market, and *Frank Leslie's Magazine* bought his drawings.

Late in life, Robinson (1833–1900) shifted his focus to slavery. He published several stories in the *Atlantic Monthly* and elsewhere that, after his death, were collected in a little volume called *Out of Bondage*. Though the rural Vermont milieu remained the same, these tales departed from his usual subject matter, telling of fugitives making their way to Canada on the Underground Railroad.

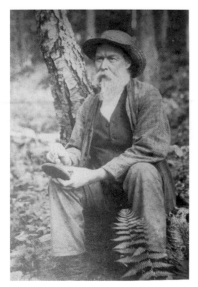

Robinson's shift in subject matter may have been prompted by a letter he received in 1896 from a young Ohio State University history professor. Wilbur H. Siebert had asked, "What in your knowledge was the route of the Underground Road (names and locations of 'stations' and 'Station Keepers')?" In a detailed reply, Robinson recalled that, during his childhood, he saw "four fugitives at a time in my father's house and quite often one or two harboring there." He added that one had "carried the first pistols I ever saw," another "the first bowie knife."

Those little-boy memories, dating from the 1840s, informed the sixty-something Robinson when he turned to write of "runaway negroes," but his slave characters never come to life on the page. Little more than dramatic devices, the fugitives tend to be paralyzed by fear (one confides, "I was dat skeered I's just' shook to pieces"; another is described as a "dark negress with the scared, alert look of a hungry wild animal"). While the plight of the escaping slaves prompts the action in the stories, courageous and principled Quakers play the central roles.

Previous page: At Rokeby, in northern Vermont, far above the 36°30' north parallel — the line beyond which slavery was prohibited by the Missouri Compromise of 1820 — fugitive slaves found a view of New York's Adirondack Mountains as well as what some called "unshackled space."

Left: An amateur ethnographer, Rowland Evans Robinson wrote carefully observed accounts of local wildlife, of the people of the Green Mountains practicing their trades, of the farms and farmhouses they inhabited. He also added to the mythic character of the Underground Railroad in his *Out of Bondage and Other Stories* (1904). *Rokeby Museum*

Opposite: A twentieth-century descendant of Rowland T. Robinson remembered that a bedchamber at the rear of the house "was often called the 'slave room.'" Also called the east chamber, the room was hardly hidden, though its doorway was at the far end of another bedroom.

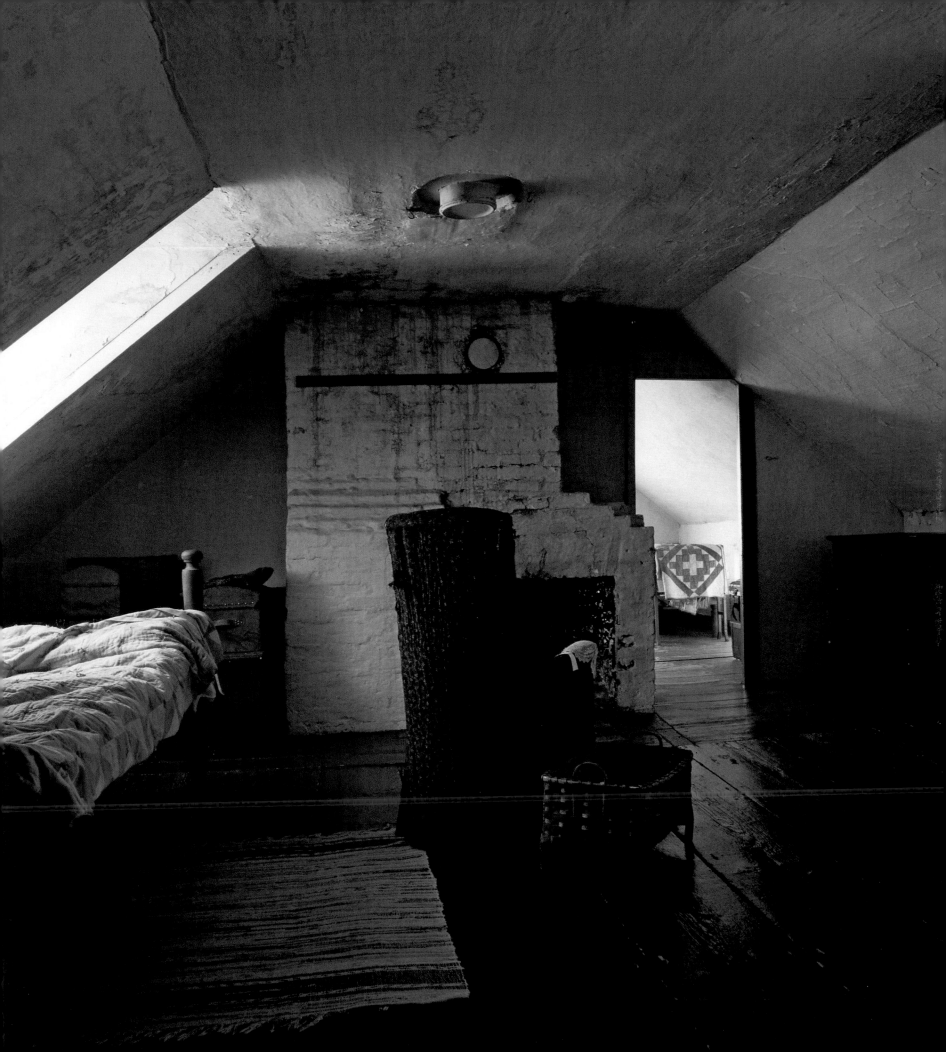

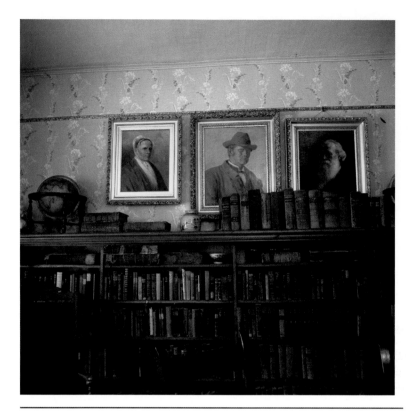

Above, left: The Robinson family library includes Quaker titles, abolitionist works, Bibles, fiction, and schoolbooks. The portrait at right is of Rowland Evans Robinson.

Above, right: The piano, an Austrian-made Bösendorfer, dates to circa 1850. It belonged to a Robinson descendant, Agatha Minturn, pictured with her daughter in this portrait.

For Rowland Evans Robinson and other writers of his era, the Underground Railroad provided the backdrop for melodrama; they excited the imaginations of several generations of readers with such details as hidden stairways, secret attic rooms, and underground tunnels—few or perhaps none of which ever existed. But a visit to Rokeby, the Robinson family home in Ferrisburgh, Vermont, suggests that the true story of R.E. Robinson's parents, Rowland Thomas Robinson (1796–1879) and Rachel Gilpin Robinson (1799–1862), better represents the means by which thousands of slaves escaped bondage. There are fewer villainous slave catchers, and the abolitionists are a magnitude less heroic than in *Out of Bondage.* But Rokeby's true history offers a central piece of the Civil War story: slaves marching away from bondage, seeking freedom.

THE U.G.R.R.

The Underground Railroad was a metaphor come to life. In the absence of any physical infrastructure—there were neither rails nor locomotives—so-called stationmasters and conductors aided passengers over a period of six decades along lines that led northward across a dozen states. The U.G.R.R. was a racially integrated experiment in civil rights, largely secret, with one common goal: Despite numerous federal and state prohibitions, the threat of physical violence, and in opposition to widely held public opinion, activists helped fugitive slaves escape to freedom. The origin of the name Underground Railroad has been variously explained, but one 1831 story has it that a Kentucky slave owner said of his missing slave Tice Davids, "The nigger must have gone off on an underground railroad."

The slavery schism had begun in the nation's earliest days. Vermont banished slavery in its 1777 constitution, and in 1780, Pennsylvania passed the country's first emancipation law, which would gradually free bondsmen. Other Northern states followed their lead in the next two decades, but in the same span, slavery

flourished anew in the South, particularly in the Cotton Kingdom, which stretched from Georgia to Texas, as cotton exports boomed at the turn of the nineteenth century.

This regional tension was manifest in the ongoing congressional debates about permitting slavery in the territories, disputes that produced the Missouri Compromise of 1820, among other legislative acts. But on a much smaller scale, an abolitionist underground began taking shape in Philadelphia, in large measure thanks to the Society of Friends. Quakers in other parts of the country, including in the Piedmont area in North Carolina, near today's Greensboro, and in Ohio and Indiana, assisted fugitive slaves and freemen wrongly enslaved. Upper Canada became a destination in the years after the War of 1812; there, runaways were accepted on the same terms as other immigrants. Some slaves escaped by sea, not a few to Nantucket, where a large Quaker population welcomed the fugitives.

Evangelical Methodists, Presbyterians, and New England Congregationalists also manned stops along the variable route of the U.G.R.R. Transit was often on foot, sometimes by horse-drawn conveyance, the travel usually at night. The assistance provided along the way typically consisted of meals, places to sleep (haylofts, attic rooms, woodsheds, bedrolls on kitchen floors), and directions, often from free black men and women aiding their brothers and sisters, to the next sympathetic soul on the path away from slavery and toward the North Star. The U.G.R.R. was less a fixed route between slavery and freedom and more a series of safe havens that dotted the map, linked by faith, family, and belief rather than any systematic plan.

The 1830s saw significant shifts in thinking about the enslaved in the country. The year 1831 began with the first issue of abolitionist William Lloyd Garrison's the *Liberator,* in which he advocated the "immediate and complete emancipation of slaves," but most of his countrymen regarded Garrison as a dangerous radical. A few months later, Nat Turner led a violent slave revolt in Virginia in which nearly sixty whites died; the murder of white women and children in Southampton County led to a redoubled

The house's best room, the south parlor, contained the family's library and a range of furniture, including eighteenth-century chairs and a nineteenth-century sofa, which suggest the enduring residence of the Robinsons at Rokeby.

fear of insurrection in the South as well as a violent backlash in which some two hundred slaves died.

Partial solutions like colonization suddenly seemed insufficient (the American Colonization Society, founded in 1816 and supported by such worthies as Henry Clay, Daniel Webster, James Monroe, and Andrew Jackson, proposed the resettlement of freemen to Africa). A new organization, the American Anti-Slavery Society, established in 1833, soon had state and local branches across the North. The society publicly lobbied Congress, printed antislavery tracts, and dispatched agents to win converts to abolitionism.

Unofficially, more than a few members of the society took more direct action, playing clandestine roles on the U.G.R.R.

More than fifteen thousand letters permit many glimpses of life at Rokeby, spanning as they do the decades from 1760 to 1960. Not a few of them were written at this desk and bookcase, which is, appropriately enough, a married piece; the desk portion dates from the turn of the nineteenth century (it's of curly maple, its hardware and finish original, and it may be an early example of Vermont-made furniture), while the bookcase came later. The surviving documents inform the interpretation of the events at Rokeby and offer unique insights into the U.G.R.R.

THE "REAL" RAILROAD

Like his father before him and his son after, Rowland Thomas Robinson (1796–1879) occupied a large but plain house in God's country. Surrounded by grazing merino sheep, the dwelling was situated in a vista that included the expanse of Lake Champlain in the middle distance and, beyond that, the jagged peaks of New York's Adirondack Mountains.

Rowland and his wife, Rachel, adopted Garrison's abolitionist creed. Their Quaker faith led them to seek a sin-free life, and slavery, they believed, was "man stealing." To profit from it was theft; therefore, slavery was a sin against God. They corresponded with Garrison, founded the Ferrisburgh Anti-Slavery Society in 1833, and avoided slave-made goods.

As their son recalled much later, they also welcomed fugitive slaves to their home, called Rokeby. The precise workings of the Robinson rail stop are not known; as its activities were often illegal, the U.G.R.R. kept few records. That said, the Robinson family remained on the farm until 1961, and the generations of family members left some fifteen thousand letters, many of which attest to the presence of escaped slaves. Since names are named in the correspondence, researchers know something of a few of the slaves on the run, such as John and Martha Williams, Jeremiah Snowden, and Simon, all of whom took shelter at Rokeby. Some remained in Ferrisburgh for weeks and even months, often earning wages on the Robinsons' busy farm, which relied on hired hands.

On behalf of a North Carolina runaway named Jesse, Robinson corresponded with the slave's owner, seeking to broker a deal by which Jesse could buy his freedom. At Rokeby, the fugitives learned early lessons in independence; a period of "guardianship," as one correspondent called it, might prove to be of use to an escaped slave seeking to become "a useful man" in a free society.

Vermont was far enough from the Mason-Dixon Line that few professional slave hunters could afford to travel there to collect fees, which rarely amounted to more than a hundred dollars per fugitive; thus, the functioning of the U.G.R.R. in northern New England was not identical to its workings in Ohio, Indiana, or Pennsylvania, closer to southern borders. No exact numbers exist as to how many slaves passed through Rokeby or any other stop on the U.G.R.R., but in the half century of its secret operation, it is believed, roughly ten thousand individuals — whites and free blacks — assisted as many as one hundred thousand fugitives on their northward journeys. Perhaps one in three fugitives reached Canada.

Rowland and Rachel Robinson: devout Quakers, radical abolitionists, Vermont farmers. *Rokeby Museum*

More recent decades have seen a reinterpretation of the U.G.R.R. at Rokeby and elsewhere. The romanticized half-truths of such writings as *Out of Bondage* have been superseded by a more rigorous reading of the facts, which recognizes the primacy not of the conductors but of the fugitives.

The bondsmen who reached Vermont had already traveled at least four hundred miles, and perhaps many more, in escaping the South. Most of them had left loved ones in running for their lives and freedom. Rowland Evans Robinson described fugitives who seemed afraid of their own shadows, but such characterizations seem as unlikely as the hidden stairs that existed, for the most part, only in the pages of fiction.

A more believable characterization was offered by a conductor, himself an escaped slave, in a narrative based on a series of interviews conducted in the 1880s. John Parker recalled that those he helped escape were "usually strong physically, as well as people of character, and were resourceful when confronted with trouble." For him, the meaning was obvious: "Other wise they never would have escaped."

JOHN C. CALHOUN'S FORT HILL

CLEMSON, SOUTH CAROLINA

"I desire above all things to save the whole [Union]; but if that cannot be, to save the portion where Providence has cast my lot."

**JOHN C. CALHOUN TO HIS DAUGHTER
ANNA CALHOUN CLEMSON**

December 27, 1846

THE CAST-IRON MAN

Well into his seventh decade, the famous orator John Caldwell Calhoun (1782–1850) found that a bout of "congestive fever" left his stamina diminished, his voice weak and scratchy. Nearly a half century earlier, while studying legal principles at Tapping Reeve's one-room law school in Litchfield, Connecticut, Calhoun had mastered speaking without notes, a skill he employed to persuade Congress to declare war on Great Britain in 1812; to vote for tariffs and, later, against them; and to promote his notions of states' rights. His had become a powerful Southern voice. For many years, as a wit of the day observed, when Calhoun took snuff, South Carolina sneezed.

By the late 1840s, however, Senator Calhoun's influence among the younger men of his region was fading, along with his insistent manner of oratory, which had once been characterized, according to a contemporary, by "extraordinary fluency and rapidity, at times . . . with the force of a round shot." Weakened by a long battle with consumption, Calhoun had collapsed to the floor of the Senate chamber in January 1849. Though he returned to the Capitol a few days later, he failed to achieve his goal of unifying the men of his region into a Southern party, and a New Orleans newspaper suggested that the aging South Carolinian might have "outlived his time." After a second collapse, he was carried to the vice president's office, quarters he himself had twice occupied, as John Quincy Adams's and then Andrew Jackson's second. A feverish and tearful Calhoun admitted to a friend, "My career is nearly done."

Yet, with the arrival of a summons from his favorite child, he immediately rose to the occasion. Writing from New York, Calhoun's daughter Anna Maria advised him of her imminent departure for Europe, along with her husband, Thomas Green Clemson. Clemson was to resume his duties as U.S. chargé d'affaires to Belgium, but Anna wished to see her father before leaving. Despite his fragile health, Calhoun promptly went to her.

He not only weathered the journey but, compliments of his doting daughter, got his picture taken by the man who, more than any other, would capture the faces and scenes of the Civil War era. Desiring a likeness of her father for her locket, Anna Clemson accompanied him to the gallery of Mathew Brady, on the corner of Broadway and Fulton Street.

The photographer, who resided in the fashionable Astor House across the street, had begun to gain fame, not least by cultivating

Previous page: Bright white amid the trees, a simple manse (its builder had been a preacher) gained a tall portico at the front during the Calhoun years. Even elaborated as it is, Fort Hill is unmistakably an overgrown farmhouse.

Opposite: What had once been a porch at the rear of the house was converted to a combination master chamber and daytime sitting room. Cornelia Calhoun, the handicapped daughter who resided with her parents at Fort Hill, made the coverlet on the bed.

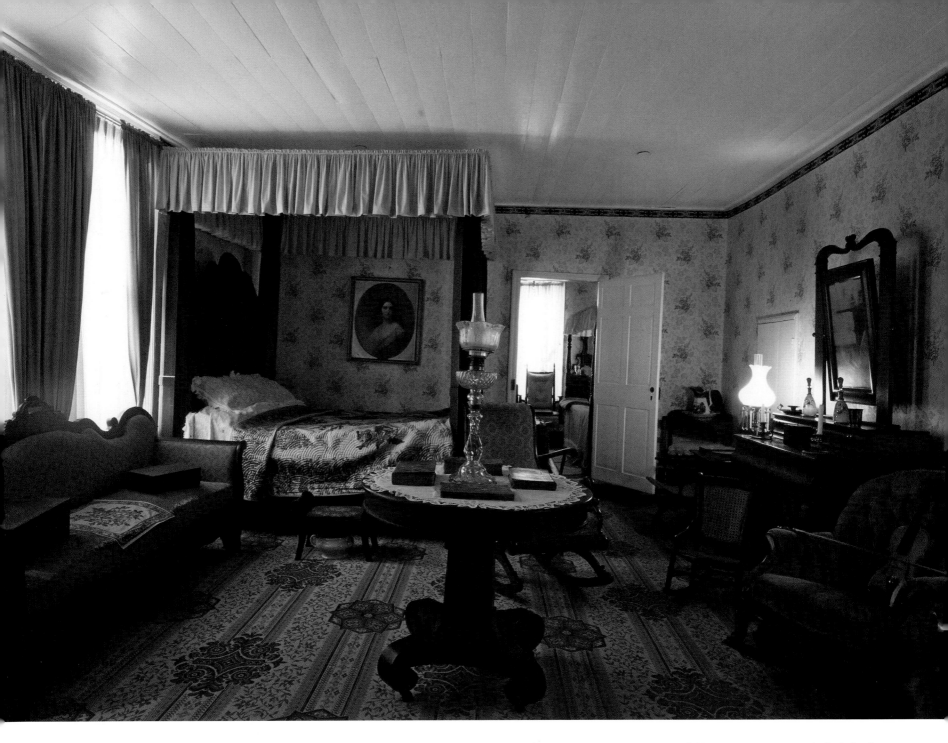

celebrity sitters, pictures of whom he was collecting for his proposed volume *The Gallery of Illustrious Americans*. Calhoun's timely arrival meant his visage would appear in the book's pages, together with those of two other noted senators of the era (the three — Calhoun, Henry Clay of Kentucky, and Daniel Webster of Massachusetts — come down to us as "the Great Triumvirate").

Rain clouds darkened the March sky that afternoon. To the surprise of those in attendance, Calhoun exhibited a detailed knowledge of daguerreotypy. With the smell of iodine salts in the air, he explained the process to Anna. Given the reliance upon natural light (the gallery's sole source of illumination was a skylight), the first exposure required thirty seconds, with the subject held rigid by an immobilizer, a system of clamps that fixed his head and neck. Anna arranged her father's hair and cloak, and the studious-looking Brady struck two more images on his sensitized plates.

The session produced a memorable image. Calhoun looks older than his sixty-seven years, his cheekbones almost visible through his parchment skin. His steel-gray hair, shaggy and swept back, frames his high forehead. Despite having to remain motionless for many seconds, the man in the picture seems engaged, his firmly

set mouth and strong chin conveying what might well be defiance. Most memorable of all, however, is the fixed intensity of Calhoun's gaze. According to Brady, "Calhoun's eye was startling, and almost hypnotized me." Another observer, Albert Brisbane, a social theorist who engaged Calhoun in lengthy discussions of the nation's progress, saw "the eye of a wolf in the intellectual sphere seeking ravenously to devour or destroy every idea opposed to his own."

According to some, Brady's image captured Calhoun as an Old Testament prophet, gaunt but certain, the philosophical father of what would become the Confederacy. Others less disposed to Calhoun's point of view saw the man differently. As one contemporary observed of him, Calhoun seemed to be "the perfect likeness of Milton's Satan."

FORT HILL PLANTATION

South Carolina might have been two states. Settled by Englishmen of means, the Low Country prospered greatly in colonial days. Grandees of coastal Carolina and the port of Charleston established a planter aristocracy based on the cultivation of rice and indigo by many slaves on large estates. Later arrivals, like Patrick

A portrait of John Calhoun hangs above his Holmes chair, a mechanical device that some would term the La-Z-Boy of its era.

A famous English visitor, Harriet Martineau, offered a poetic description of John Calhoun: "Mr. Calhoun, the cast-iron man, who looks as if he had never been born." *Mathew Brady/Library of Congress, Prints and Photographs*

Calhoun, who migrated from Ireland's County Donegal via Pennsylvania, established smaller upcountry farms during and after the French and Indian War.

Although the yeoman farmer's son gained an education in Connecticut and, for much of his life, served the nation in its capital, John Calhoun always regarded upland Carolina as home. His father had fought the Cherokees for his land, surveyed it himself, and become a farmer of more than middling means (at his death, Patrick Calhoun owned thirty-one slaves). Patrick served in the state senate too, and, though he died when his son was thirteen, Patrick imbued John with the hardheaded independence of a man who had refused to support the Constitution.

For five years, the teenage John farmed his widowed mother's acres, until, at the intercession of an older brother, he went off to Yale. A whirlwind rise followed. Calhoun established himself as a lawyer and won a term in the South Carolina legislature before his election to Congress in 1810. That same year, he wed his second cousin Floride Bonneau Colhoun. By marrying the Charleston belle, the frontiersman established invaluable connections in the Low Country, straddling the politics of the state he would lead for decades to come.

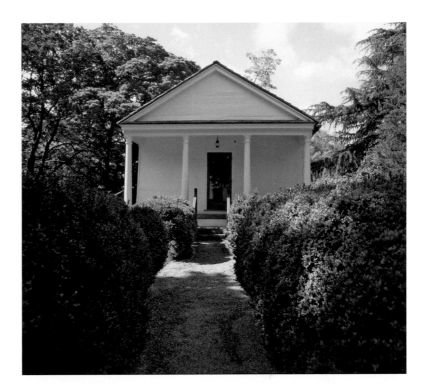

After service as James Monroe's secretary of war, he became Adams's vice president, in 1825, and, his power in Washington ascendant, he and Floride (*"Flow*-reed") acquired Clergy Hall. Purchased with the financial assistance of his in-laws, the plain vernacular house, built some twenty years earlier, lay just a few miles from Calhoun's place of birth near the Georgia border.

In 1827, John and Floride began enlarging the place for their family (she bore him ten children, three of whom died in infancy). The original four rooms were reconfigured, the footprint enlarged, and a Greek Revival portico added to the façade, along with a pair of columned porches on the opposite elevations of a new ell to the rear. The house, renamed Fort Hill in 1830, consisted of more than a dozen rooms.

The enlarged dwelling sat amid some eleven hundred acres, a plantation that made John Calhoun a man of means as his government compensation could not (members of the U.S. Senate at the time were paid eight dollars per diem). With nearly four hundred acres in tillage, the cotton crop produced cash, but, with an eye to self-sufficiency, Calhoun cultivated orchards, vines, and vegetables, along with corn and other grains. Livestock (hogs and cattle) and various fowl, such as pigeons in a dovecote, provided meat for

The Plantation Office, a small yet impressive building located behind the main house (*top*), served Calhoun as both the operations center for his agricultural holdings and a place to think and write. Here he shaped many of his public utterances later expressed in print and on the floor of Congress. The desk (*bottom*) dates from his early days as a country lawyer, the chair from his Senate service.

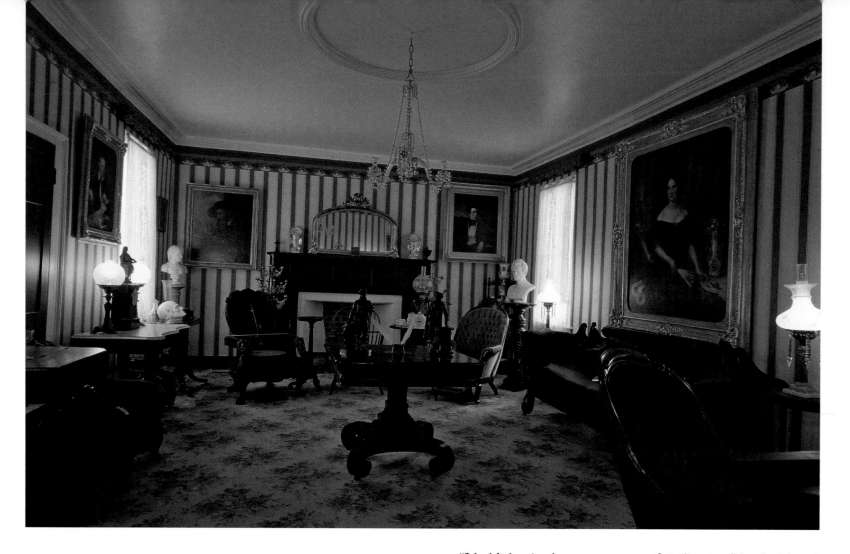

Most of the portraits in the parlor are of family members. The wallpaper border is a design of tobacco and cotton blossoms, a suitable choice for Calhoun, whose life and attitudes were shaped by both crops.

the table. Calhoun's holdings included barns, a carriage house, a cotton gin, a springhouse, a corn mill, an icehouse, and a plantation office, along with more than eighty slaves, mostly field hands who resided in stone slave quarters.

Though Calhoun regarded himself a progressive agriculturalist, his prolonged absences from Fort Hill required him to leave management to an overseer. However, he certainly attended Anna and Thomas's wedding, in the parlor at Fort Hill, in November 1838.

THE SABLE GENIUS OF THE SOUTH

Mathew Brady's unforgettable daguerreotype puts a face to the name John Calhoun. In the same way, the speech the senator from South Carolina delivered in the Capitol on February 6, 1837, gives voice to that countenance.

"I hold that in the present state of civilization," he declaimed, "where two races of different origin, and distinguished by color, and other physical differences, as well as intellectual, are brought together, the relation now existing in the slaveholding States between the two, is, instead of an evil, a good—a positive good."

For Calhoun, the dialectic was clear: The "European race" was superior to the "black race of Central Africa." That meant, by his logic, that slavery "was the most safe and stable basis for free institutions." Therefore, he believed, the challenges posed by abolitionists and even those compromisers who accepted slavery as a "necessary evil" could lead only to disunion. Today we find the principles that underlie the argument repugnant, but history certainly sustained the correctness of his conclusion that the nation would come apart at the seams.

"Mr. Speaker, he is gone," said Henry Clay on rising to eulogize his sometime friend and rival on the floor of the Senate in 1850. "He is now an historical character." Even after his death, however, Calhoun remained a spiritual father of the fire-eaters, the genera-

tion of proslavery men who helped inflame sectional passions in the 1850s and who, after the election of Lincoln, pushed for secession. In a eulogy, Robert Barnwell Rhett had described Calhoun as the first "great Statesman in the country, who denounced the cant—that slavery is an evil—a curse."

Calhoun's political philosophy, outlined in his speeches and writings, amounted to a disciplined distillation of states' rights constitutionalism. Almost two decades before his death, he addressed the readers of a New York newspaper in his "Fort Hill Letter," suggesting that, where the majority governed in such a way as to be "ruinous" to a minority, nullification (the right of the state to veto federal laws it regarded as unconstitutional) could be the "natural, peaceful and proper remedy." It was an article of faith with Calhoun that "wage slaves" in the North were worse off than bondsmen in the South. He promulgated other ideas, such as concurrent majority (a variation on the minority-veto theme), and during the last years of his life, he drafted a two-part treatise, published after his death as *A Disquisition on Government* and *A Discourse on the Constitution*, that further explicated his political thinking.

An impressive consistency reveals itself in these late theoretical writings. His perspective wasn't so distant from that of Founding Fathers like Washington and Madison and Jefferson, all of whom owned slaves even as they shaped a remarkable vision of institutions based on liberty. As Calhoun's life neared its close, however, the nation had embarked on a larger dialogue, and the extraordinarily single-minded Calhoun displayed little willingness to compromise. That said, he did recognize the inevitability of a North-South break long before it occurred and well before he himself died. In 1844, he wrote to a brother-in-law, "A split between us and the northern democracy is inevitable."

—⊷⊶—

Fort Hill eventually became the property of Anna and Thomas Clemson. She predeceased her husband, but Thomas, a mining engineer by training, bequeathed to the State of South Carolina the

The sculptor Clark Mills came to Fort Hill in 1845. Mills was a common plasterer from Charleston who taught himself to make life masks; this marble bust was considered by Calhoun's friends and family to be the best likeness of Calhoun in his later years.

bulk of his estate (appraised at $106,179) for the express purpose of founding at Fort Hill a scientific and agricultural college, with the proviso that the Calhoun home remain a relic of pioneer and antebellum South Carolina. Today, where once there was virgin forest and open fields with a vista to the Blue Ridge mountains, there stands the variegated architecture of a modern research university. In the midst of Clemson University is the Calhoun home, restored as a museum devoted to John Calhoun and to the institution's benefactors, Anna and Thomas Clemson, who resided there as newlyweds and during their retirement years.

In one of history's odder symmetries, a century and a half after the Clemson wedding, a centennial conference devoted to "Women, Family, and Marriage in the Victorian South" took place at Clemson University. On the day the papers were presented, the student newspaper ran a photograph on its front page of the winner of that year's Miss Clemson pageant. Calhoun, the stolid believer in racial inequality, might not have approved, as Miss Clemson 1988 was African American.

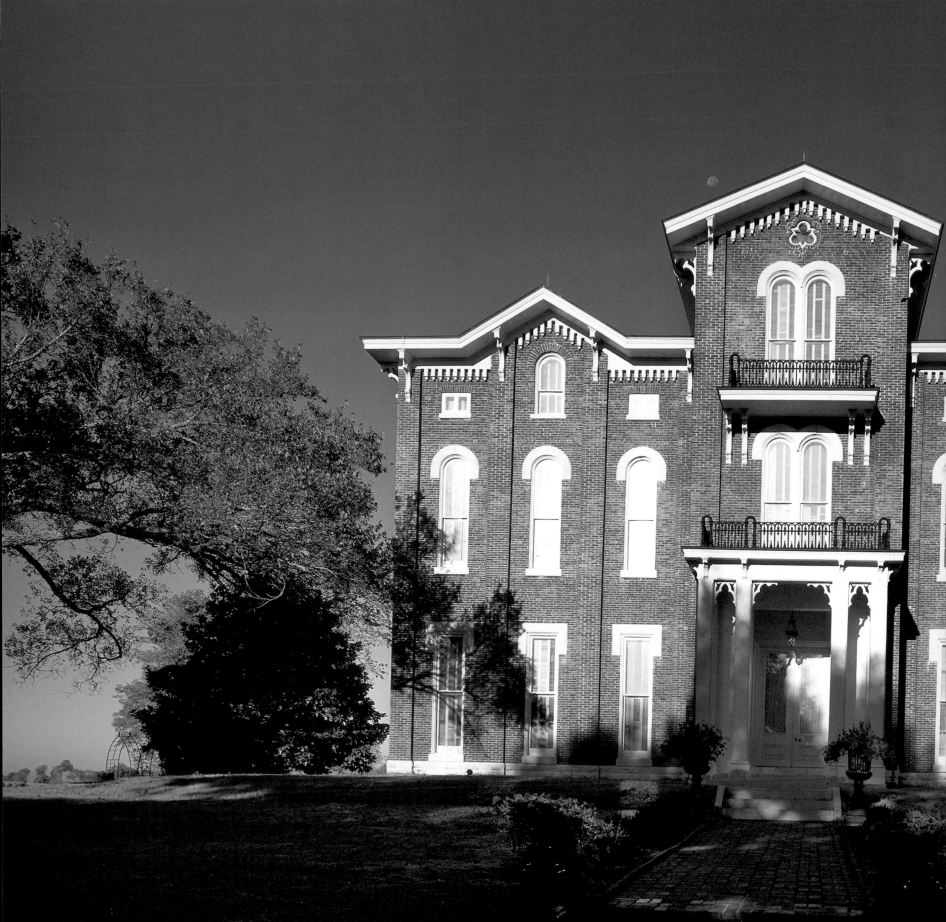

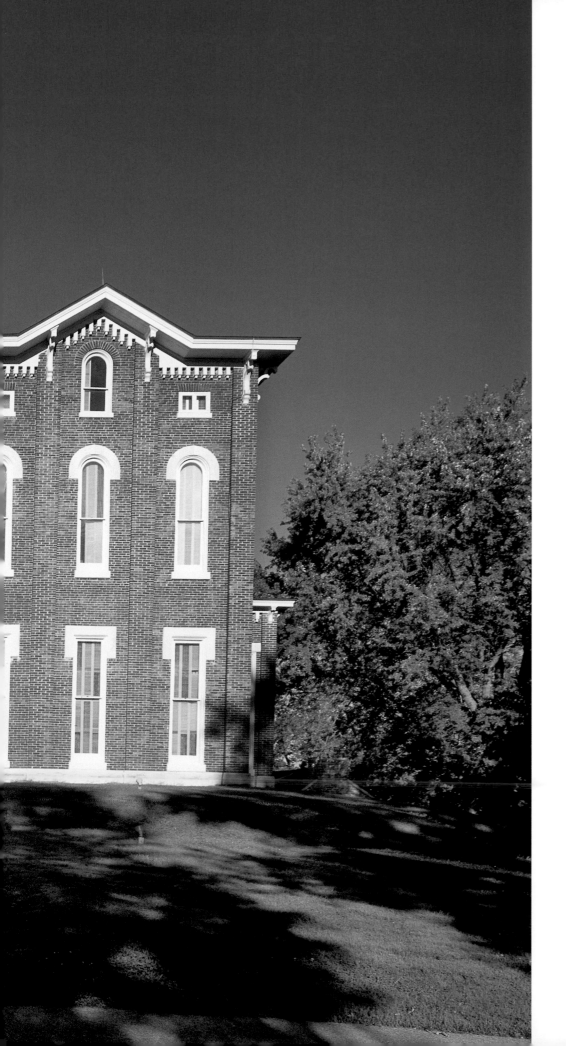

CASSIUS CLAY'S WHITE HALL

RICHMOND, KENTUCKY

"The slave question is now assuming an
importance in the opinions of the enlightened
and human, which prejudice and interest cannot
long withstand. The slaves of Virginia, Kentucky
and in fact all the slave holding states
must soon be free!"

CASSIUS CLAY TO BRUTUS CLAY

December 1831

"I WOULD SPEAK OR DIE"

Cassius Clay's desire to reform the plantation system in Kentucky grew from what he knew. His father, General Green Clay, a veteran of the War of 1812, owned vast tracts of land in the fifteenth state, much of which he had surveyed and claimed for himself as a young man. When his last-born son nursed him during his final illness, the elder Clay decided to bequeath substantial properties to the sixteen-year-old, including his plantation house set on some twenty-two hundred acres.

The younger Clay's 1828 inheritance also included seventeen slaves.

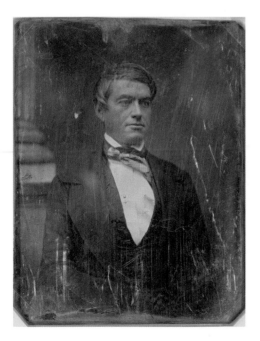

His tranquil childhood permitted Cash Clay to regard the life of the enslaved "as bearable as was consistent with facts," and he remembered his father providing his slaves with "first-class clothing, food, and shelter." But the boy also witnessed disquieting events, among them an episode when a mulatto house slave he knew well was "sold south." He watched as Mary, a pretty girl of eighteen, "tied at the wrists, [was] sent from . . . the home of her infancy and girlish days." Though she faced a harsher life, separated from her family and most likely at work on a cotton plantation in the Deep South, she departed, Clay later wrote, "without a word, as 'a sheep to the slaughter.'"

The property he inherited and later renamed White Hall would be Cassius Marcellus Clay's lifelong home, but at age twenty, he went east to further his education. En route to New Haven, the well-to-do and well-connected lad visited Washington, DC, where he met President Andrew Jackson. He ventured to Boston and encountered Daniel Webster and Charles Sumner, men who would play large roles in the unfolding slavery debate, as would Clay's older cousin Henry Clay. But another man shifted the polarities of Clay's thinking.

At Yale in 1831, Clay experienced what he called a "new revelation" at a lecture given by abolitionist William Lloyd Garrison, founder and editor of the antislavery newspaper the *Liberator*. Though Clay had already decided to emancipate his slaves, he recalled that the words he heard at New Haven's South Church

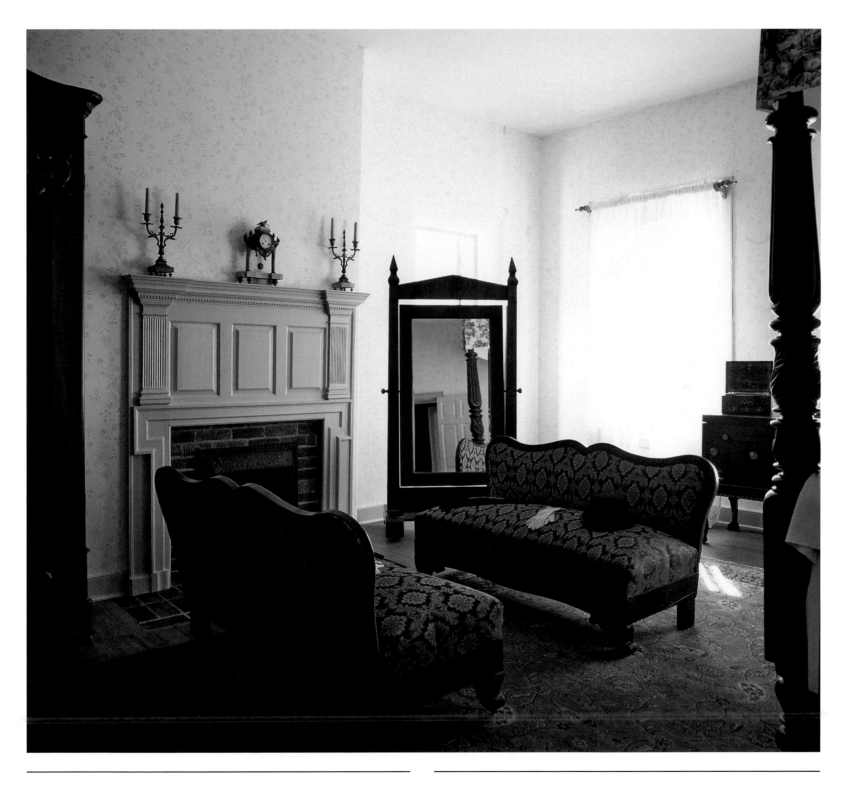

Previous spread: When Cassius and Mary Jane Clay remodeled his father's house, they transformed a solid, two-story Federal-style home of locally made brick and Kentucky gray limestone into a towering mansion. The height of the house (nearly fifty feet from grade to chimney top) is further enhanced by the narrow windows and central tower, as well as by the pilaster-like brickwork accents that stand forth at the corners and between the windows.

Above: The master chamber at White Hall, with its two small Empire-style sofas, functioned as both a sitting room and a bedroom.

Opposite: A battered circa 1850 daguerreotype of Cassius Clay posed before a column. He looks ready to live up to his reputation for belligerence. *Library of Congress, Prints and Photographs*

On entering White Hall, the visitor gets a sense of the expansiveness of the house, which encloses some ten thousand square feet of living space. The painting of the snow scene was a gift from Alexander II of Russia during Clay's time as minister to the czar's court.

"aroused my whole soul." While Garrison's arguments moved him (his "sentiments" were "as water to a thirsty wayfarer"), Clay chose not to embrace Garrison's principles in their entirety, opting instead for a middle course. The Kentuckian believed that slavery would eventually poison his region's prosperity but that its sudden elimination would dangerously rend the economic and social fabric of the South. Rather than pressing for immediate abolition, he hoped to facilitate "a system of gradual prospective emancipation of slaves."

As a young graduate returning to Kentucky, he served in the general assembly until voters came to view him, according to the *Lexington Observer and Reporter*, as too "militant and provocative" (if they deigned to speak it at all, many of his neighbors spat the word *emancipation* as they would a curse). In 1845, he founded the *True American* as an organ of constitutional emancipation, proclaiming his principles in the broadest possible terms. "Morally, economically, physically, intellectually, socially, religiously, politically," he wrote, slavery is "evil in its inception, in its duration and in its catastrophe." When many powerful men in his region took exception to his arguments, local authorities forced the removal of the paper's offices from Lexington, Kentucky, to Ohio.

Still, Cassius Marcellus Clay refused to restrict his words. A large man who stood more than six feet tall, big-boned yet agile, Clay possessed a stubborn and unyielding temperament that suited his well-muscled torso. He took to carrying a brace of pistols in his satchel on the regular junkets he made to promote his cause, recognizing that, as moderate friends advised, talking about

slavery at all was "incendiary." But on June 15, 1849, he made the mistake of relaxing his guard.

That day he rode to nearby Foxtown on the Lexington-Richmond Turnpike. Though he no longer held political office, the well-spoken Clay still commanded an audience. A state constitutional convention, scheduled for that October, had been called to consider the status of slavery in Kentucky, and Clay arrived at a meeting to debate the topic.

Clay followed a speaker whose proslavery rhetoric had roused the crowd, but, trusting to the goodwill of the people of his native Madison County—Foxtown was barely a mile from home—he carried no pistols. When his turn came, Clay climbed atop a table without hesitation. Speaking for himself and other emancipationists, some of whom still owned slaves, he sought to persuade the four out of five Kentuckians who did not own slaves to see a

means, over time, of ending "the curse of slavery" and to elect like-minded men to the convention.

When Clay finished and stepped down, the son of the opposing speaker approached and struck him in face. Clay instinctively drew the bowie knife he carried at his belt, but an angry mob quickly surrounded him, and his attacker disarmed him. Though "struck with sticks, and finally stabbed in the right side," Clay did manage to wrest his weapon from his opponent. With blood gushing from a chest wound, he thrust the bowie knife into his attacker's abdomen. Fearing he himself had been mortally wounded, Clay cried out as he lost consciousness, "I died in the defense of the liberties of the people."

In fact, Cassius Clay survived to live a long life (1810–1903), though his opponent did not, dying of his wounds ten hours later. But the bloody fight harmed Clay's cause more than it helped, and the Kentucky constitution of 1850 embraced even tougher protections for slave property than before.

Yet Clay refused to be silenced by episodes of violence, and he would later claim that he had delivered more speeches than any man alive. He came to be known as the Lion of White Hall, an unusual sobriquet that reflected both the roar of his rhetoric and his willingness to draw blood.*

THE LION'S LAIR

To see White Hall today is to be reminded of a fortress. Set high in a bluegrass meadow, the tall brick façade, with its central tower and exaggeratedly vertical windows, bears a distant resemblance to Tudor battlements. Inside, however, the forbidding aspect is gone, and the interior has a grand and welcoming air.

In the great entry hall, a sweeping staircase beckons; off to the right, the visitor is drawn toward an immense ballroom, thirty-two feet square, with a grand colonnade of Corinthian columns and richly decorated cornices. These spaces reflect not just the financial

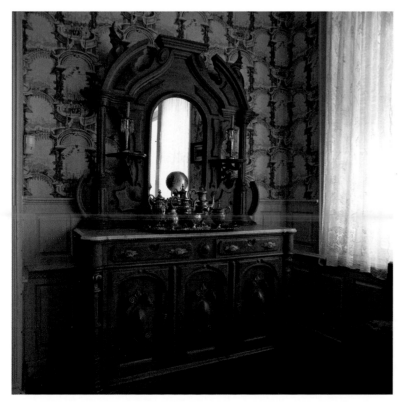

The dining room from Clermont, the 1798/1799 house Green Clay built that was remodeled, expanded, and renamed White Hall, survives largely intact. The Renaissance Revival sideboard arrived later, with the son's generation; it's of American chestnut.

* For the record: The American prizefighter Muhammad Ali was named Cassius Marcellus Clay Jr. at his birth in 1942; his father had been named in honor of emancipationist Cassius Clay of White Hall.

means of the Clay clan during the Civil War era but also Cassius's elevated status, as he served President Lincoln as the nation's minister to Russia.

On a lecture tour in the days after the passage of the Kansas-Nebraska Act of 1854, Cassius Clay spoke for more than two and a half hours at an outside gathering in Springfield, Illinois. When a hostile member of the audience yelled, "Would you help a run-away slave?" Clay's response — "That depends on which way he's running" — provoked the crowd to laughter. But one man there, whom Clay described later as possessing a "long, ungainly form" and an "ever sad and homely face," listened with great seriousness as he lay beneath a tree whittling a stick.

Later, the paths of lanky Lincoln and burly Clay crossed again, this time on a train bound for New York in February 1860.

Both were to deliver addresses at Cooper Union, and Lincoln found their antislavery sentiments coincided. After again listening to Clay's fervent arguments, the soon-to-be candidate observed, "Yes, I always thought, Mr. Clay, the man who made the corn should eat the corn."

An early member of the Republican Party, Clay supported Lincoln that year, and his speech at the Chicago Republican National Convention was regarded as crucial to gaining the votes of the Kansas delegation, essential to Lincoln's nomination. While Clay's hopes of joining Lincoln's cabinet did not come to pass (Lincoln later confided, "I was advised that your appointment as Secretary of War would have been considered a declaration of war upon the South"), as a consolation, Clay was given the post of minister to the Court of Saint Petersburg.

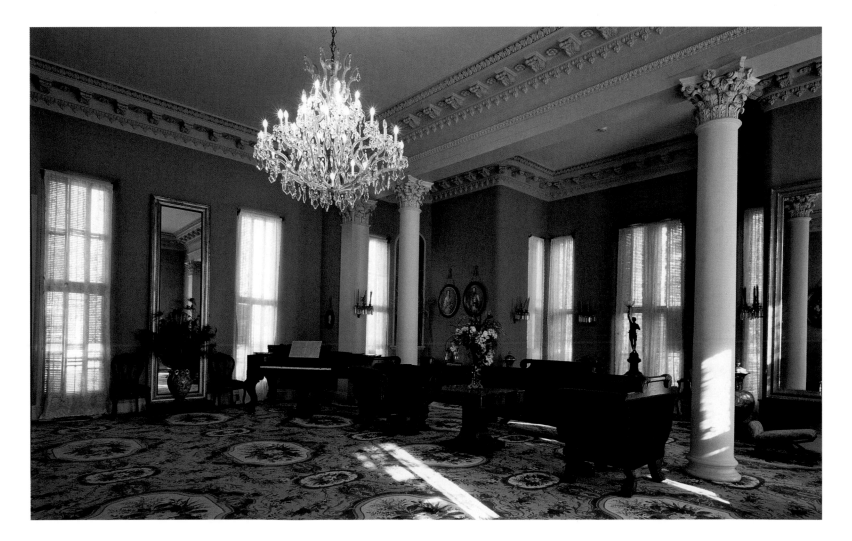

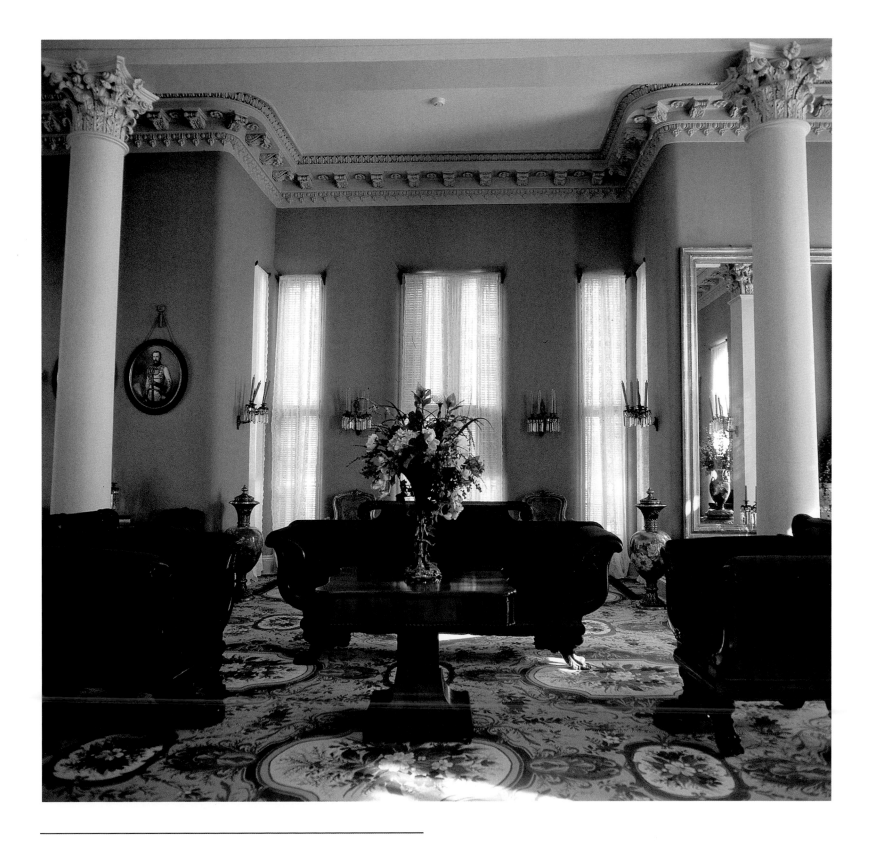

The 1859 piano in the drawing room belonged to the Clays, but the drama in
this room is the great colonnade that divides the main area (it's more than
thirty-one feet square, not including the bay window). The sense of spacious-
ness is enhanced by the tall, gilt pier mirrors.

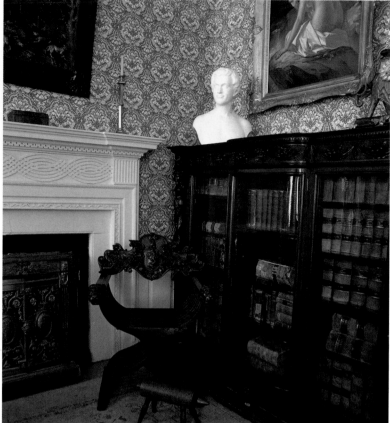

Clay's instinct for self-preservation remained sharp; he is remembered as having fought off three intruders here in his library at age eighty-nine (for decades, he was afraid for his life, as few of his neighbors shared his principles; he long said that he was the object of a "vendetta"). That's his desk (*left*) and a copy of a bust of him (*right*) taken from life by sculptor Joel T. Hart.

He served two stints abroad. During the second (1863–1869), his wife, Mary Jane, remained in Kentucky and supervised a massive remodeling of Green Clay's original 1798/1799 house. The existing structure—a substantial two-story brick home with a footprint thirty feet by forty—was subsumed, becoming, in effect, an ell, as the new façade reoriented the house to the east. At a cost of roughly thirty thousand dollars, the original four-chamber house, some twenty-five hundred square feet, was quadrupled in size, resulting in an eccentric house of more than thirty rooms, including ten bedrooms.

Cassius's architect, Thomas Lewinski, who designed (and redesigned) many Kentucky houses, added a hot-air furnace, to provide central heat, as well as a gravity-fed water system that distributed rainwater, captured by gutters, from a cistern.

Whether the revised version of the house was masterminded by Clay or his soon-to-be estranged wife remains the subject of debate, but White Hall's fusion of Kentucky Federal architecture and Victorian excess certainly mirrors the complicated and vigorous personality of Cash Clay. The intersection of the early and later construction programs is evident in varying levels, especially on the upper floors, the inevitable result of the decision to meld White Hall's new sixteen-foot-high rooms with the existing twelve-foot ceilings.

Young or old, Cassius Clay possessed no capacity to be uninteresting. He gave John G. Fee, an abolitionist colleague, the land upon which Fee founded what became Berea College, the nation's first interracial college. After Clay's return from Russia, he sent

for and raised a Russian boy he named Launey Clay; Launey may or may not have been Cassius's biological child. Having divorced Mary Jane, Clay—at eighty-four—married a fifteen-year-old servant girl. Although the marriage to Dora lasted fewer than three years, in the divorce proceedings that ensued, he swore in a deposition that he had "fully met and discharged all the covenants" of his marriage contract.

Late in life he appears to have descended into paranoia (although perhaps his fears were not all imaginary, as decades after his death, he was still remembered by many as a traitor to his region). For self-protection, Clay wore a bowie knife at his belt until his last days. Shortly before his death, the bedridden Clay is said to have ordered a servant to bring him his rifle, with which he dispatched—at the cost of some plaster in his chamber—a fly that had been irritating him.

In this view of White Hall's rear, the higgledy-piggledy aspect that resulted from the several building campaigns is apparent. The original 1798 house is sandwiched between the tall 1860s addition at front and the 1810 ell at rear.

Born to great wealth, he could afford to emancipate his slaves and did so. As a man of great physical courage, he faced violence in preaching his antislavery creed to hostile crowds and returned from the Mexican War with a reputation for heroism on the battlefield. He would never gain the political fame he desired, although his name briefly surfaced in 1860 and 1876 as a candidate for the vice presidency.

As one of his biographers has said of him, Clay regarded himself as a "freedom hunter." During the Civil War, Lincoln dispatched him to Kentucky—the year was 1862, between Clay's ministries in Russia—and asked him to report back about where his fellow Kentuckians stood on emancipation. Just weeks after Clay briefed Lincoln on his journey, Lincoln issued the Emancipation Proclamation.

Cassius Clay once said of Benjamin Butler, the controversial Union general and proponent of slaves' rights, "like the German carp, [he] is likely to live a hundred years, and keep the waters muddy and turbulent all the time." The long-lived and short-fused Cassius Clay might well have been speaking of himself.

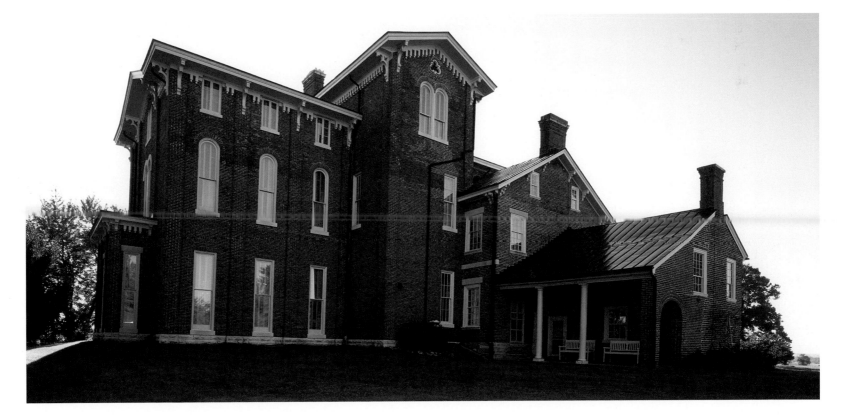

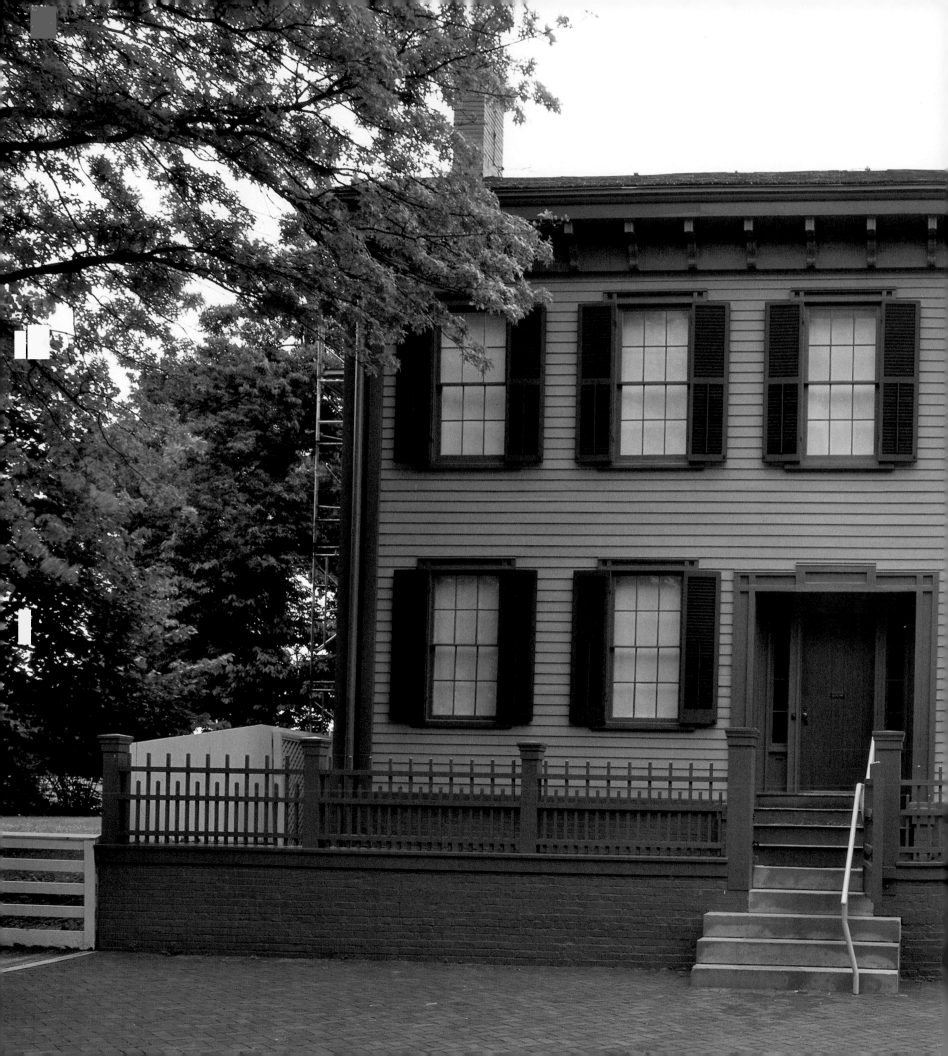

ABRAHAM LINCOLN HOME

SPRINGFIELD, ILLINOIS

"I was losing interest in politics, when the repeal of the Missouri Compromise aroused me again. What I have done since then is pretty well known."

ABRAHAM LINCOLN

Autobiography, 1859

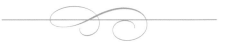

THE CAPITOL AT SPRINGFIELD

Despite his wit and an evident gift for storytelling, Abraham Lincoln avoided extemporaneous speeches. Thus, as he contemplated an address to be delivered in his adopted home of Springfield, Illinois, on June 16, 1858, the elements emerged piecemeal. When phrases came to mind, he jotted them down on scraps of paper or on used envelopes. Over a period of several weeks, the sheets of paper accumulated in his tall hat, his storage place of choice. They would be Lincoln's rhetorical building blocks.

He shared a downtown law office with his junior partner, William H. Herndon, on the west side of Springfield's public square. Though the building's façade overlooked the handsome capitol building with its domed cupola and great stone porticos, Lincoln occupied a second-floor office to the rear, a dim room illuminated by what one visitor remembered as "two stingy windows." There, seated at a well-worn table, he organized his preliminary scribblings.

He would be among friends when he spoke to the thousand-odd delegates at the Illinois Republican convention. Four years earlier, he had emerged from a self-imposed political exile and won friends and influence for his articulate opposition to the Kansas-Nebraska Act and the spread of slavery. At the new Republican Party's convention in 1856, he had been floated as a possible vice presidential candidate, and now, though his name would not appear on any ballot (the state legislature would, ultimately, choose the man to send to Washington), Illinois Republican Party bosses made the unusual decision to endorse Lincoln at their convention as the "first and only choice" for the senate seat held by Democrat Stephen A. Douglas.

Unlike most of his twentieth-century successors, Lincoln wrote his own speeches. He approached the task as a wordsmith, shaping his thoughts, hewing his jottings, articulating his evolving ideas as he crafted sentences. He was an autodidact (his formal education totaled perhaps one year of schooling), and his prose amounted to a self-willed artistry. Ordered and considered, worked and reworked, his acceptance speech became an essay rendered onto large sheets of paper in his clear, unadorned hand. His listeners would soon find he offered them no mere thank-you for his selection.

The draft completed, he locked the office door and read the pages to Herndon, who occupied the opposite end of a T-shaped table in their unpretentious office. The boldness of Lincoln's words surprised his listener.

Previous page: The much-visited Lincoln Home, its colors restored to those that lawyer Lincoln knew.

Opposite: The Lincolns relaxed together in their informal sitting room. Note the two-drawer sewing table (*right*) at which Mary worked. The open flames of the multiple candles were the principal source of nighttime illumination in the Lincoln home.

Above: Like many couples of their time, the Lincolns slept in separate bedrooms. Mary rose early, and Abraham, a notoriously poor sleeper, sometimes worked at the small desk in his bedchamber.

Opposite: The 1856 renovation left the front parlor intact but opened the partition *(center)*, updating the house with the more stylish double-parlor configuration. Note the étagère *(left)* for the display of Victorian bric-a-brac.

"I think it is all true," Herndon told the older man. "But is it entirely politic to read or speak as it is written?" When Lincoln recited the speech to a group of his political advisers in private, they, too, expressed concerns, but after considering their objections—was the speech too far in advance of the times?—the candidate resolved to leave the pages as written.

At eight o'clock that Wednesday evening, he walked to the lectern, accompanied by "shouts and hurrahs, and prolonged cheers." A life-size portrait of George Washington hung behind Lincoln as he looked out upon the Hall of Representatives, its floor and galleries packed with people. Just five sentences into his speech, he delivered the phrase that concerned Herndon and the others. His utterance would define one of history's great before-and-after moments.

The words were simple, the reference biblical: "'A house divided against itself cannot stand,'" Lincoln intoned. "I believe this government cannot endure, permanently half *slave* and half *free*."

He followed with a disclaimer: "I do not expect the Union to be *dissolved*—I do not expect the house to *fall*."

And he offered a prediction. "I *do* expect it will cease to be divided. It will become *all* one thing or *all* the other."

He went on at length, expanding the basic premise for a mesmerized audience. "As he advanced in this argument," one observer remembered, "he towered to his full height. . . . Men and women who heard that speech well remember the wonderful transformation wrought in Lincoln's appearance. The plain, homely man towered up majestically; his face lit as with angelic light; the long, bent, angular figure, like the strong oak of the forest, stood erect, and his eyes flashed with the fire of inspiration."

Lincoln explained not only why slavery and freedom were incompatible but how his opponent, sitting senator Stephen Douglas, was part of a dangerous conspiracy to nationalize slavery, and not merely in the South. Lincoln's radical words were the prologue to one of the most famous senate races in history, with the two men meeting seven times to debate. The widely reported campaign and the republication of his speeches made Lincoln a politician of national stature.

In presenting the idea that his nation was a house divided, Lincoln spoke his mind as he delineated the differences between Douglas, an advocate for majority rule (exemplified by his favored doctrine of popular sovereignty, in which the majority in a state or territory could choose to sustain slavery), and himself, a defender of minority

rights who believed that no majority should have the power to limit anyone's right to life, liberty, and the pursuit of happiness.

However, by articulating what Herndon called the "eternal truth" of the "house divided," the forty-nine-year-old Lincoln probably doomed his chances of gaining a Senate seat, as the Illinois legislature eventually chose to return Douglas to Washington. Ironically, the house-divided dichotomy also set the terms for the national debate that resulted in Lincoln's election to the presidency two years later and the civil war that followed.

THE HOUSE ON EIGHTH STREET

"If any personal description of me is thought desirable," Lincoln wrote, "it may be said, I am, in height, six feet, four inches, nearly; lean in flesh, weighing, on an average, one hundred and eighty

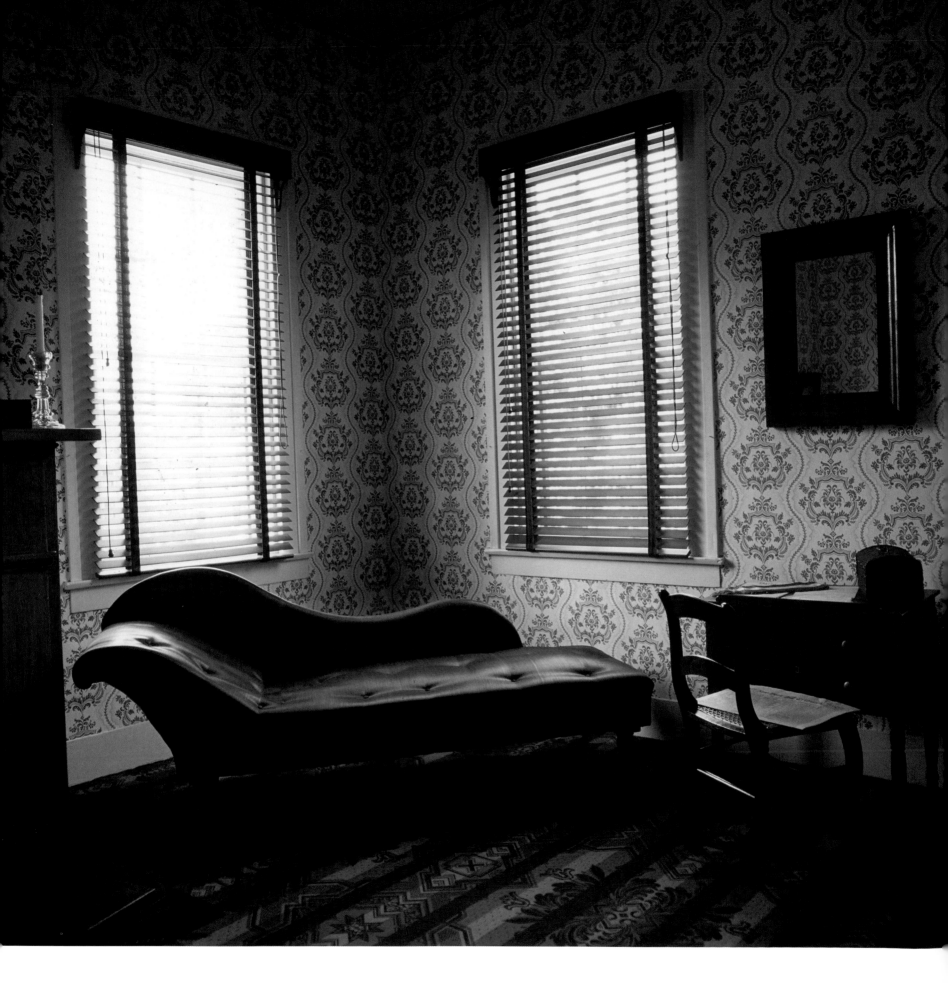

pounds; dark complexion, with coarse black hair, and grey eyes—no other marks or brands recollected." The vigor and unusual length of the tall man's stride meant he could walk from the Illinois state capitol to his home in five minutes.

Heading southeast, he would find his proud house at the corner of Jackson and Eighth Streets, painted Quaker brown with green shutters, per his specifications. For a man who had arrived in town barely twenty years before astride a borrowed horse with everything he owned in two saddlebags, lawyer Lincoln had done well. His Grecian-style home reflected his rising status.

Lincoln lived with his wife, Mary Todd Lincoln, whom he wed in 1842. Their first son, Robert Todd, was born in 1843. The man who married Abraham and Mary, the Reverend Charles Dresser, had built this very house a few years earlier, and the Lincolns purchased the property in 1844 for fifteen hundred dollars. In the years that followed, Mary gave birth to three more sons: Edward (Eddie) Baker in 1846, William (Willie) Wallace in 1850, and Thomas (Tad) in 1853. Though Eddie died before his fourth birthday, probably of consumption, a household of growing boys, two parents, and a resident servant girl made for cramped quarters in the simple structure, with its three rooms on the main floor.

Using monies from his growing law practice and the proceeds from the sale of eighty acres of nearby farmland inherited from her father, the Lincolns hired local builders Hannon and Ragsdale to enlarge the house. Though Abraham's log-cabin origins on the frontier had been mean, Mary's father's house in Lexington, Kentucky, contained French mahogany furniture, Brussels carpets, damask curtains, and the latest lighting invention, astral lamps. Mary set out to raise the Lincolns' status and managed much of the construction while her husband was traveling the mid-Illinois court circuit. Certainly their renovated home, completed in 1856, better suited the rising fortunes of a man with political ambitions.

The thirteen-hundred-dollar renovation doubled the living space. On the ground floor, the main entrance gave access to a central stairway and, to the right, an informal sitting room, where the family—the Lincolns were caring and, some said, indulgent parents—relaxed together. Visitors to the home would be welcomed into the double parlors to the left (the rear parlor had been the old master bedroom). Beyond the stairs were a modest dining room and the kitchen.

Hannon and Ragsdale had literally raised the roof, making what had been a sleeping attic into bedchambers with eleven-foot-high ceilings. There were adjoining bedrooms for the lady and the gentleman of the house (a standard social convention of the time), plus one for the eldest son. When Robert departed to continue his education in the East, Willie and Tad took over his room, moving from a trundle bed in Mary's bedroom. A comfortable bedchamber at the front of the house welcomed relatives and

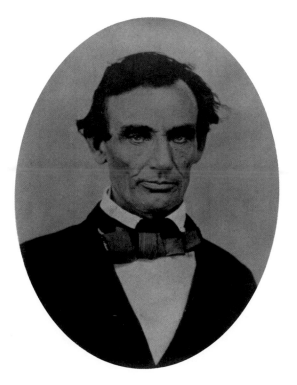

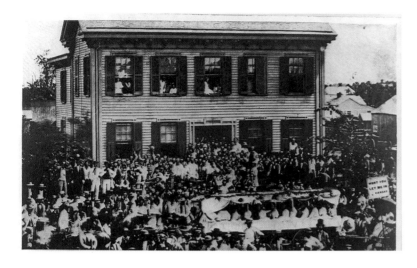

Above: A Republican rally in Springfield, photographed during the 1860 campaign, with the figure of Lincoln standing in his dooryard, surrounded by admirers. *William Shaw/Library of Congress, Prints and Photographs*

Opposite: The Lincolns' kitchen, complete with cookstove *(foreground)* and dry sink *(right).* Mary Todd Lincoln herself prepared meals here, with the assistance of her hired girl and, in later years, a cook.

guests, some of whom stayed for extended periods. A maid's room at the back offered convenient access to the kitchen stairs.

The changes at the Lincoln house reflected larger changes in the state capital. In the years before the war, Springfield's boundaries expanded and the city gained hundreds of new homes. The fanciest house in town belonged to Governor Joel Aldrich Matteson; his Italianate mansion, with its four-and-a-half-story tower, cost ninety-three thousand dollars. But Abraham and Mary Lincoln both nurtured long-held hopes of occupying another mansion, one even larger than Matteson's, a house with white Aquia stone walls that stood on Washington's Pennsylvania Avenue.

A CROOKED ROAD

Abraham Lincoln (1809–1865) traveled no ordinary route to national prominence. On his arrival in Springfield in 1837, he possessed a scattershot résumé, having worked as a shopkeeper, postmaster, county surveyor, soldier (during the 1832 war against the Black Hawk Indians), and politician (he first won a seat in the Illinois General Assembly in 1834). His highly irregular education

(he himself called it "defective") hadn't stopped him from reading law—as was his habit, he "studied with nobody"—and he gained admission to the bar in 1836.

As a general practitioner, he had a legal portfolio that included criminal, divorce, and property cases, although, as his visibility rose, a richer mix of corporate and transportation clients (railroad and steamboat) entered his purview. While he grew his practice, he also served five terms in the Illinois legislature and one in the U.S. House of Representatives (1847–1849), though after returning from Washington, he chose to focus not on holding public office but on making a living and on family matters.

Until, that is, he felt compelled to join the national conversation; this was prompted by the passage of the Kansas-Nebraska Act, which erased the decades-old prohibition on owning slaves north of the 36°30' parallel, Missouri's southern boundary extended. He still chose not to run for office, despite his party's talk of drafting him in 1854 as a state representative; he had his eye on higher things. In retrospect, refusing to run for office (in 1854) and even losing the Senate election (in 1858) served Lincoln's political prospects in the longer term.

To examine Lincoln's remarkable appeal is to reveal elemental strains based in his time and place. His self-deprecating humor, a fondness for country parables, and his easy manner suited the rural courts of the Eighth Judicial District, around which he traveled, sometimes for months at a time. As his audience gradually expanded beyond Illinois, he conveyed both a down-to-earth character and a sense that he was a man who thought deeply about important matters. Adding to his gravitas was his predilection for bedrock principles (he regularly referenced the Declaration of Independence, the Constitution, and the Founding Fathers). To an America that seemed to be walking a precarious fault line, he offered thoughtful guidance, blending his lawyer's skill for reading essential texts (including the Bible) with a faultless honesty, an inspiring idealism, and a folksy pragmatism.

Perhaps the hardest months of his three decades in Springfield were those that followed his first moment of annunciation, May 19,

1860, when a delegation of Republicans came to town to notify him of his nomination at the just-completed Chicago convention. In the presidential campaign that followed, he made no speeches; it was the consensus among his advisers that others, among them his soon-to-be secretary of state William Henry Seward, should be his political surrogates (see "William Henry Seward House," page 162). So Lincoln posed for photographers, painters, and sculptors who wished to make his likeness. He read reports of his several opponents, their travels and many speeches, but remained in Springfield. The press of office seekers and campaigners led him to avoid even his workplace; when Herndon called on him, he found his law partner "bored—*bored badly.*"

All that changed at two a.m. on November 7 with the arrival of a telegram carrying the news that New York's voters had put him over the top. "I then felt as I never had before," Lincoln remembered, "the responsibility was upon me."

———◆———

Before Lincoln left for the nation's capital, on February 11, 1861, he rented his home on Eighth Street and sold most of the furnishings to the new occupants. He would return, in a coffin, four years later (the sixteenth president's body lay in state in the Illinois capitol in May 1865). Though Mary could not bring herself to return to their

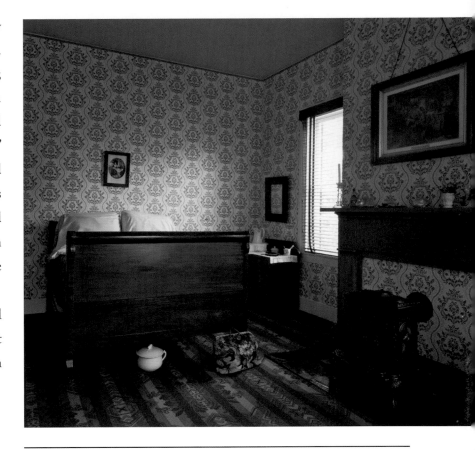

The Lincoln's guest chamber, pictured here with its mahogany bedstead.

Springfield home after Abraham's death, the house remained in the Lincoln family as a rental property, and one tenant established a museum of Lincolniana there, charging two bits for admission. Five years after Mary's death, in 1882, Robert Todd Lincoln deeded the house to the State of Illinois for one dollar, stipulating that the home be well maintained and open to the public. In 1972, the nation assumed ownership, and today the National Park Service administers the Lincoln precinct, which includes other neighboring structures, and welcomes countless visitors to the only home that Lincoln ever owned. (See also "President Lincoln's Cottage," page 118.)

Opposite, top: In this engraving, made during his last year in office, a haggard-looking Buchanan appears more than ready to return to Wheatland, which one newspaper called "the Mecca of Lancaster County." *Library of Congress, Prints and Photographs*

Opposite, left to right: Although images of Wheatland were widely distributed during the election of 1856 in an attempt to suggest to voters in the South that he understood something of their landed comforts, James Buchanan's Pennsylvania home was most certainly located in the snowy North.

The rear stair hall at the former president's home suggests its comfortable scale and handsome fittings.

A veteran diplomat, Buchanan played the gracious host in Lancaster; his portrait looks down on his dining table to this day.

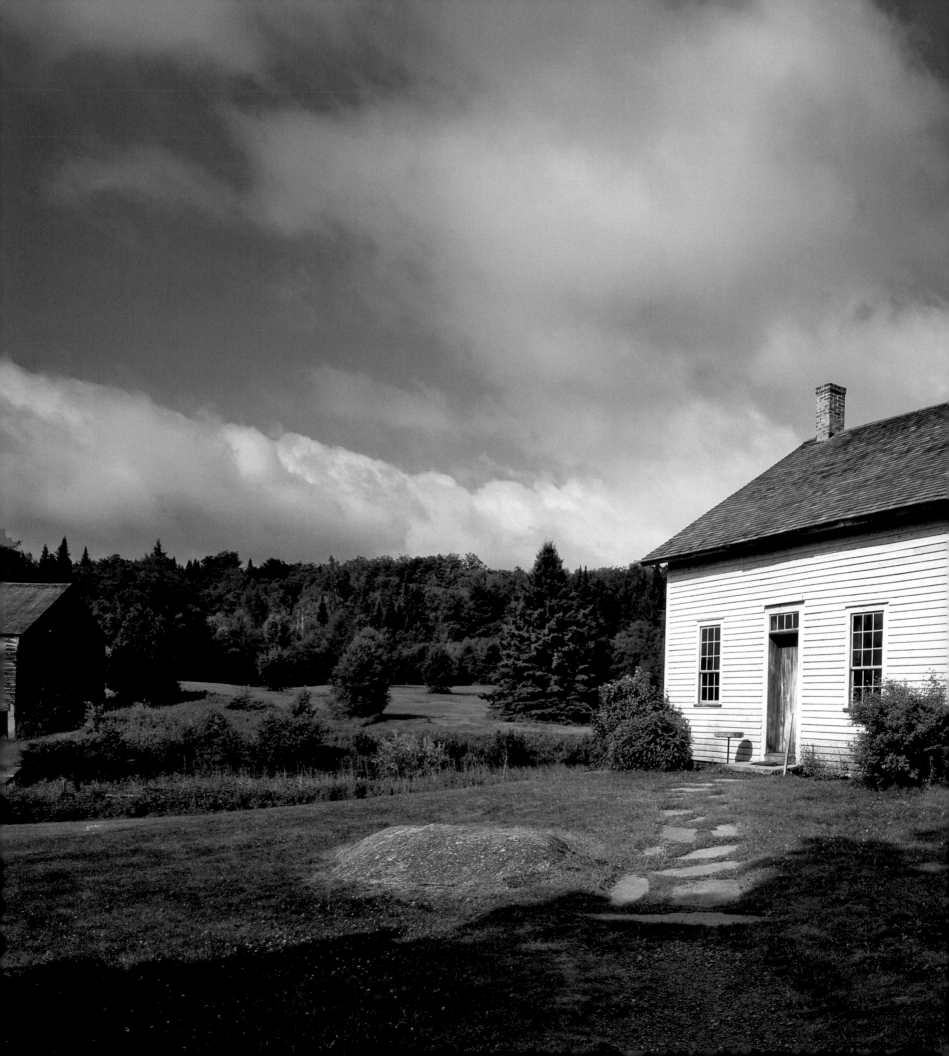

JOHN BROWN FARM AND GRAVESITE

LAKE PLACID, NEW YORK

"Though a white gentleman, [he] is in sympathy a black man, and is as deeply interested in our cause, as though his own soul had been pierced with the iron of slavery."

FREDERICK DOUGLASS TO WILLIAM C. NELL

February 5, 1848

DECEMBER 1859

John Brown's body was already moldering when McGraw and Taylor took delivery of the rosewood casket on New York's Lower Broadway. Barely eighteen hours earlier, on the morning of December 2, 1859, the infamous Brown had been hung by the neck until dead, the sentence meted out in Harper's Ferry, Virginia, for his triple conviction of conspiring to incite a slave insurrection, treason against the State of Virginia, and murder in the first degree (see "The Invasion at Harper's Ferry," page 63).

"He was black in the face," reported one observer at the undertakers, "for they slung him in the coffin with all his clothes on . . .

and the rope he was hung with." The noose was removed, and his corpse iced and dressed in a pleated white shroud with white cravat (chemical embalming procedures would not come into wide use until the Civil War years). As a product of slaveholding Virginia, the casket in which the dead man began his journey was deemed unsuitable, and the many men who filed by that evening for a final glimpse of the bearded Brown saw him in a new coffin of black walnut. It was reported that, despite the evident bruise on Brown's neck, his "countenance was as serene as if asleep."

His expression belied the strong feelings the very mention of his name evoked. Some in the South thought him the devil incarnate or, at least, their worst nightmare come to life. In contrast, Henry David Thoreau had spoken for many abolitionists when, the day before, in an address given at Concord, Massachusetts, he had equated the dead man with Jesus Christ, calling them the "two ends of a chain."

To most, Brown's burial would be a relief and a release. The morning after the funeral entourage arrived in New York City, it resumed the journey toward North Elba, New York, and Brown's final resting place.

AN INSTRUMENT OF PROVIDENCE

John Brown (1800–1859) was an unlikely lightning rod. Born in Connecticut to a devout Calvinist family, he remembered having been "taught from earliest childhood to 'fear God and Keep his commandments.'" He was just five when his family moved west, their worldly goods loaded into a wagon pulled by an "ox Team." Growing up in Hudson, Ohio, he lost his mother and a stillborn sibling when he was nine, but his father soon remarried. Owen Brown prospered, establishing a tannery, speculating in land and merchant goods (he helped provision the U.S. Army during the

JAMES BUCHANAN'S
WHEATLAND

The man who took the oath of office on March 4, 1857, a truly momentous time in the nation's history, brought decades of public service to the role of chief magistrate. Since first winning elected office in his native Pennsylvania in 1820, James Buchanan (1791–1868) had served five terms in the House and portions of three in the Senate. His impressive foreign-policy portfolio included postings abroad as Andrew Jackson's minister to Russia and a tour of duty as minister to Great Britain, as well as four years as James Polk's secretary of state.

Whatever his legislative and international savvy, however, the imposing, white-haired fifteenth president proved peculiarly unable to negotiate the nation's differences over slavery.

"Old Buck," as many called him, sought to permit the machinery of government to repair the rift. In his early days in office, Buchanan stood aside as the Supreme Court ruled that, in the eyes of the Constitution, the sometime slave Dred Scott and all other blacks "were beings of an inferior order" and, further, that they "had no rights which the white man was bound to respect." In his last months of office four years later, Buchanan again watched helplessly as, one by one, Southern states seceded; he chose to do nothing to stop them beyond appealing for a day of prayer. His was a lawyerly but sadly ineffectual approach, one that failed to anticipate how dramatically deeds would drown out mere words.

When Abraham Lincoln took office, Buchanan retired to his Pennsylvania home, which he'd owned since 1848. "I come to lay my bones among

you," he told the large crowd that gathered to welcome him. At what he himself called his "agreeable country residence," set on twenty-two acres in bucolic Lancaster County, he lived amid objects collected in his travels and stylish Victorian furniture.

During the war years he would write a book in which he attempted to justify his actions—some would say his inaction—as president. Titled *Mr. Buchanan's Administration on the Eve of Rebellion*, it appeared to no great acclaim in the year the war ended. Some historians then and since have insulted his memory, calling the War between the States "Mr. Buchanan's War." While the Pennsylvanian could surely have taken a more interventionist stance during his term in office, even in retrospect no easy scenario offers itself by which he might have avoided the cataclysm.

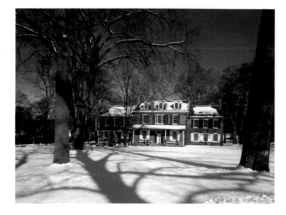

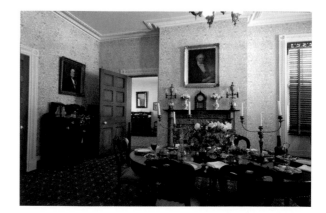

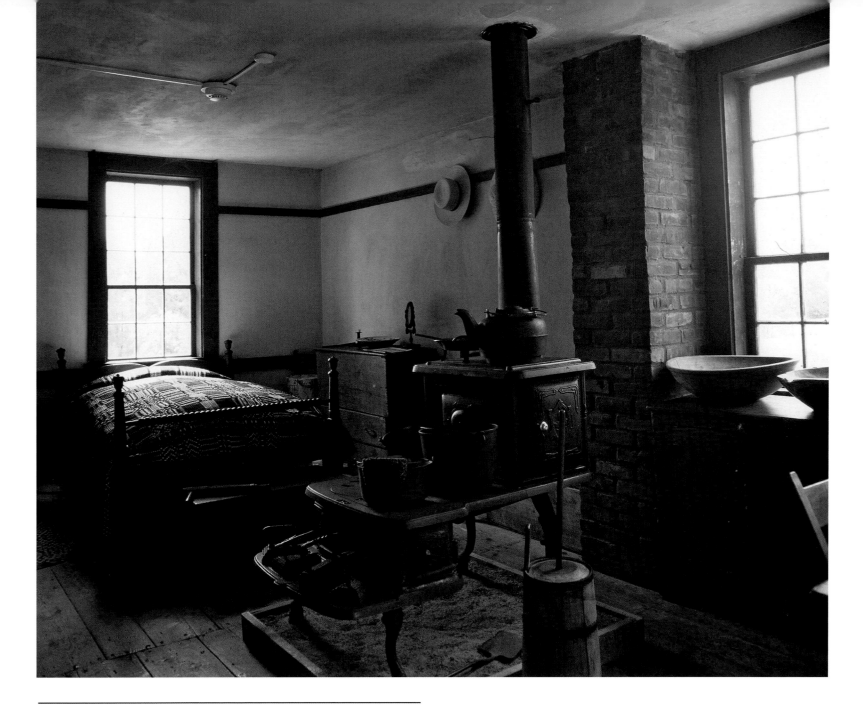

Previous spread: The Brown abode was humble, its unpainted exterior unadorned. The two chimneys served not fireplaces but woodstoves, a welcome and efficient source of heat in the winter cold at its site in the Adirondack Mountains.

Opposite: The bearded John Brown—he grew the facial hair to disguise himself—holding a copy of the *New York Tribune* in a circa 1859 lithograph. The paper's influential editor Horace Greeley wrote after the raid at Harper's Ferry, "[Brown] seems to have infected the citizens of Virginia with a delusion as great as his own . . . that a grand army of abolitionists were about to invade them from the North." *Library of Congress, Prints and Photographs*

Above: A woodstove divides what was once two partitioned spaces, a kitchen and the bedchamber where John Brown slept when in residence at North Elba, near the town known today as Lake Placid.

War of 1812), and becoming Hudson's justice of the peace.

Influenced by his father's antislavery beliefs, young John later in life recalled an experience that he said made him "a most *determined Abolitionist.*" While away from home on a cattle drive at age twelve, he was treated with kindness and consideration by a slave owner but was shocked when the same man mistreated his "*negro boy . . . who was fully if not more than [my] equal.*" The slave was poorly clothed and fed and was "beaten before [my] eyes with Iron Shovels or any other thing that came first to hand." The sight, Brown remembered, led him to "*swear: Eternal war* with slavery."

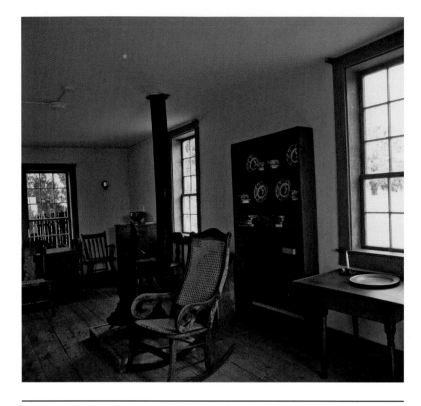

The simple parlor at John and Mary Ann Brown's dwelling was the site of his funeral rites.

Henry Thompson, who married one of Brown's twenty children, built not only the house but the desk in the sitting room at North Elba.

Hoping his son would attend college, his prosperous father sent John back east, but the sixteen-year-old proved less than attentive during two stints at academies in Connecticut. After returning to Ohio, he married at age twenty and, like his father, worked at being a tanner and farmer. Over the next two decades, Brown prospered for a time and, after striking out on his own, became postmaster of Randolph township. But his wife died in 1832, and a series of business setbacks left him besieged by lawsuits and debts.

He remarried and worked to rebuild his fortune. As he gained a reputation as a sheep breeder, he began to consider playing a more active role in opposing slavery. He was a student of scripture and a sometime Bible teacher, and his belief in "biblical egalitarianism" fueled his righteous indignation at white supremacy. For years he aided escaping slaves; Hudson was a station on the Underground Railroad, the secret network that helped black fugitives flee northward. The 1830s saw a number of violent antiaboli-

tion incidents, in one of which the Presbyterian minister Elijah Lovejoy was killed by a mob in Alton, Illinois, while protecting the press on which he printed his abolitionist paper. As one of John Brown's sons remembered, his father, influenced by such events, assembled his family one day. Dropping to his knees in prayer, he asked his wife and sons to share his avowal to oppose slavery, by violent means if necessary.

"It might be years before opportunity offered to strike the blow," John Brown Jr. said many decades later of the family conclave, "but he meant to prepare for it." Brown's subsequent efforts—in Kansas, at Harper's Ferry—would indeed be a family affair, as sons Frederick, Oliver, and Watson would die, along with their father, in the war that he declared on slavery.

TIMBUCTOO, NEW YORK

In 1846, abolitionist Gerrit Smith hatched a "scheme of justice and benevolence." The son of New York's largest landowner, Smith

hoped to parcel out one hundred and twenty thousand acres to three thousand black New Yorkers, both freemen and escaped slaves. The homesteaders could establish self-sufficient farms and also gain access to the ballot box, since New York State allowed a black citizen who owned at least forty acres of land to vote.

Just as his casket would make its inexorable way to the Adirondacks in December 1859, a decade earlier John Brown had been drawn to the aborning African American community at North Elba. In 1848, Brown joined his "colored brethren," purchasing 244 acres from Smith at a dollar an acre. As an experienced farmer and a man wise in the ways of surveying and deed registration, he expected his skills would be of use to his neighbors, most of whom were inexperienced in farming matters, freshly arrived as they were from the cities of Brooklyn, Troy, Newburgh, and Manhattan. "I can think of no place where I think I would sooner go," he wrote to Owen Brown in 1849, " . . . than to live with these poor despised Africans . . . & encourage them; & show them a little so far as I am capable how to manage."

At first, the Browns rented a log cabin with a view of Whiteface Mountain. John's wife, Mary, and much of the family remained there for a time, though Brown's real estate schemes and wool business took him far afield, even to Europe, where he hoped to sell his wool. When away from the community that came to be known as Timbuctoo, he sent his fellow settlers money and barrels of salt pork and flour. When present, he shared his expertise.

In the summer of 1855, the family moved into what would be John Brown's last home, a simple farmhouse in North Elba. Constructed by Brown's son-in-law Henry Thompson, the plain, wood-frame dwelling survives today. When the Browns moved in, the walls were unplastered, and the gable-roofed structure enclosed four rooms down, a sleeping attic above, and a root cellar below. Thompson had fashioned a desk and some shelves, and wood-stoves provided heat.

Fifty feet from the front door rested a huge boulder, a stone left by an antediluvian glacier, on top of which Brown was known to sit "reading his Bible and looking at the mountains." The farm was sur-

rounded by snowcapped peaks, dense forests, and scattered clearings dotted with burned-out tree stumps. But Brown saw more than a panoramic mountain view. As he told his family, "I like to live in a country where everything you see reminds one of Omnipotence."

The peaceful months on his upland farm would prove to be few, as he soon departed for what *New York Tribune* editor Horace Greeley called "Bleeding Kansas" (see "Horace Greeley House," page 144). The previous year, Congress had nullified the 1820 Missouri Compromise, establishing with the Kansas-Nebraska Act the concept of popular sovereignty, which enabled the inhabitants of each territory to determine whether they would allow slavery. The result was a proxy war: The nation watched as proslavery forces and abolitionists engaged in violent confrontations. Five of Brown's sons had already traveled to Kansas in support of the antislavery cause when Brown followed, in the fall of 1855, "with a view," as he put it, "to help defeat *Satan* and his legions."

Moral suasion had been the preferred weapon of abolitionists, including Brown. But on May 22, 1856, South Carolina congressman Preston Brooks assaulted Massachusetts senator Charles Sumner on the floor of Congress. Infuriated at a Sumner speech concerning Kansas, Brooks had matter-of-factly walked up to the seated Sumner and beat him about the head with his gold-topped cane. Sumner was left senseless in a pool of blood. News of the attack reached John Brown the following day, pushing him to his flashpoint; within hours, he led a small band of men, including four of his sons and his son-in-law Henry Thompson, into the night. By daybreak, they had kidnapped five men, each of whom was associated with local proslavery violence. Brown's men slashed them to death with broadswords near Pottawatomie in the Kansas Territory.

While brutal murders were committed on both sides, the action of Brown's band represented a new and different strain of abolitionism. The antislavery contingent had begun, as Brown put it, to "fight fire with fire." They were suddenly dangerous, and, as one newspaperman on the scene in Kansas saw it, the proslavery forces gained a "wholesome dread" of "Captain Brown. They hate him as they would a snake, but their hatred is composed nine

tenths of fear." Thereafter the conflict would be peopled by aggressors on both sides, many of whom became victims. Brown's son Frederick would be murdered in the months that followed, but the larger story was the way in which Brown and his men had recast the character of one wing of the abolitionist movement. Brown accomplished his stated goal, to "strike terror in the hearts of the proslavery people."

The raw natural beauty of his Adirondack farm had moved Brown, but the experience at the farmstead at North Elba had a second and perhaps more profound effect on him. At a time when few white men, even the most committed of abolitionists, regarded blacks as equals, Brown helped create an interracial community (though one that barely outlived its most famous inhabitant).

His huge family at North Elba consisted of his own progeny (he would father twenty children, eleven of whom lived to maturity), several of their spouses, his second wife, and other whites, but also blacks. All dined as equals at his table. Brown called all of his neighbors, even the African Americans, by their surnames: Mr. Jefferson; Mrs. Wait. One black neighbor child remembered, "He'd walk up to our house . . . and come in and play with us children and talk to father. Many's the time I've sat on John Brown's knee."

As a stop on the Underground Railroad, North Elba saw numerous fugitives passing through on their way to freedom in Canada; when Brown traveled, he often found accommodations — and friendship — at the homes of such men as Frederick Douglass (see "Frederick Douglass's Cedar Hill," page 182). In Brown's time, his acceptance of and respect for his "black brethren" was regarded as no less radical than his embrace of violence on their behalf.

COMING HOME

Accompanying her husband's remains, Mrs. Brown traveled by rail to Troy, New York, then on to Rutland and Vergennes, Vermont. A boat carried the entourage across Lake Champlain to Westport, New York, as sleet fell from the sky and a skim of ice was visible on the dark waters. Two more days were required for the rugged fifty-mile journey to the Browns' hillside farm, a climb of almost two thousand feet in altitude.

On the morning after the body's return to North Elba, a crowd of two hundred persons attended the funeral service. About half were black; many in attendance, reported daughter Anne, had come "from long distances." Brown's casket rested atop a table before the simple house; in it, said son Salmon, his father "look[ed] as though sleeping, the features being natural as could be." At hand were five women widowed by the events in Harper's Ferry: Mrs. Brown, two Brown daughters, and the wives of Brown's sons Watson and Oliver.

Together with three of his children, Lyman Eppes, one of the black farmers who settled at North Elba, performed Brown's favorite hymn, "Blow Ye the Trumpets, Blow." Upon finding he was the only clergyman present, the Reverend Joshua Young of Burlington, Vermont, said prayers for Brown, his family, and the cause he had died for. The casket was lowered into a freshly dug grave near the great stone atop which Brown had contemplated his place, his times, and his Creator.

Many speeches were given that day, but one was especially memorable. Standing in the cold at North Elba, abolitionist Wendell Phillips delivered a long discourse in which he offered a metaphor suitable to the pine forests of the Adirondacks. "History will date Virginia Emancipation from Harper's Ferry," he intoned. "When the tempest uproots a pine on our hills, it looks green for months — a year or two. Still, it is timber, not a tree. John Brown has loosened the roots of the slave system; it only breathes — it does not live — hereafter."

Opposite, top: During the Civil War, the engine house was used as a guardhouse and a prison; after the war, it came to be known as "John Brown's Fort" and drew curious tourists. In ensuing decades it was moved four times, once traveling all the way to Chicago for the 1893 World Columbian Exposition. The structure spent much of the twentieth century on the campus of Storer College (a historically black college, now defunct), where it was used as a museum commemorating John Brown and Harper's Ferry.

Opposite, bottom: The building John Brown occupied has doors topped by Diocletian windows and a roof capped with an open belfry. After Storer College's closing, in 1955, ownership of the engine house was transferred to the National Park Service, which relocated the engine house in 1968 to a site some two hundred feet from its original location.

THE INVASION AT HARPER'S FERRY

The moon was shrouded by clouds on October 16, 1859, as a small band of armed men marched on the federal arsenal at Harper's Ferry, Virginia. The leader was known to his neighbors as Isaac Smith, a farmer recently arrived from New York. His "provisional army" that night consisted of eighteen soldiers, three of them African Americans. They cut telegraph wires and posted guards at the bridges across the Potomac and Shenandoah Rivers. They pried open a padlocked gate with a crowbar, then took command of two sprawling gun factories and perhaps a hundred thousand guns. Not a shot was fired.

Addressing the two watchmen taken hostage, the leader, whom history remembers by his real name, John Brown, confided his intentions: "I want to free all the Negroes in this state."

What he didn't say was that he planned to create a "Subterranean Pass-Way," an escape route north that would run along the Appalachian and Allegheny Mountains. At intervals, he planned to establish forts manned by abolitionists and freed blacks from which small bands would raid plantations, freeing slaves and enabling their exodus to Canada. He understood that no secret avenue could secure the freedom of all four million men, women, and children enslaved in the South, but he hoped to undermine an economic system in which slaves were the most essential commodity.

He had tried to enlist his friend Douglass (see "Frederick Douglass's Cedar Hill," page 182), hoping his presence would encourage slaves to flock to him, but the former slave refused. Instead of local slaves flying to Brown's aid as word spread of the raid at Harper's Ferry, militiamen appeared from nearby Charles Town, cutting off his escape route. Military units soon filled the town, and, taking refuge in the fire-engine house, Brown and his men realized that, as Douglass had warned, they had walked "into a perfect steel trap."

His little fortress wasn't steel, but brick, its roof slate. Thick oak doors lined the façade of the thirty-five-by-twenty-four-foot structure. Brown and his men held eleven white hostages; as a symbolic gesture, Brown had ordered the capture of local plantation owner Lewis Washington, George Washington's great-grand-nephew, and had put him under the guard of several of his own just-liberated slaves, a shocking reversal of the usual white-black power roles. But exchanges of fire had left most of Brown's men wounded or dead, among them two of his sons. Watson Brown lay dying of a gunshot wound, the corpse of his brother Oliver nearby.

In the predawn hours of October 18, the man dispatched by President Buchanan to command the U.S. Army forces at the scene, Lieutenant Colonel Robert E. Lee, sent a young cavalry lieutenant to parley with the invaders. Brown offered to free the hostages if he and his men were given safe passage across the river to Maryland. But Lieutenant J.E.B. Stuart's terms were tougher. He could offer only to protect the raiders from the mob that now filled Harper's Ferry; his

orders were to arrest the invaders and hold them for trial.

When Brown refused his offer, Stuart signaled the attack. Within three minutes, the U.S. Marines had battered down the doors of the engine house. Several of Brown's men escaped, but ten were killed or mortally wounded, and five were placed under arrest. Brown himself was unconscious and bleeding from blows to the head.

Though the siege was over, the nation's attention would remain focused on Harper's Ferry for another six weeks, as Brown played to perfection the role of martyr to the antislavery cause. In a long and widely published interview conducted the day after his capture and in other subsequent press coverage, he provided detailed explanations of his motives. In his closing statement at his trial, he denied the commission of any crimes "but what I have all along admitted,—the design on my part to free the slaves."

In military terms, the events at Harper's Ferry amounted to nothing more than a minor skirmish, and the slave revolt that Brown prophesied did not come to pass. Yet Brown, who was no giant—not quite six feet tall, a lean and sinewy hundred and fifty pounds—cast an immense new shadow over the slavery debate. In the eyes of some historians, he above all others made the Civil War inevitable.

In a way that would stretch the reader's credulity if a novelist concocted the story, the events drew a stellar cast of supporting players. In addition to Robert E. Lee and J.E.B. Stuart, Edmund Ruffin (the man who would fire one of the first shots at Fort Sumter), Thomas J. Jackson (later known as the stalwart Confederate general "Stonewall" Jackson), and Lincoln's future assassin, John Wilkes Booth, also played cameo roles in the drama.

THE WAR YEARS

TIMELINE

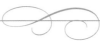

1861

On January 9, following the lead of South Carolina, Mississippi withdraws from the Union. Florida, Alabama, Georgia, Louisiana, and Texas do the same on succeeding days.

Jefferson Davis is inaugurated provisional president of the Confederacy on February 18; Lincoln is sworn in as the sixteenth president of the United States on March 4.

Confederate bombardment at Fort Sumter begins on April 12, and the Union force surrenders the following day. Virginia, North Carolina, Arkansas, and Tennessee soon secede, bringing the total to eleven. Richmond becomes capital of the Confederate States of America.

After initial reports of Union success, Confederate forces rout Union troops at the First Battle of Bull Run (or Manassas) on July 21. For his stalwart efforts at Henry House Hill, Brigadier General Thomas Jackson gains the nickname "Stonewall."

1862

Following victories at Fort Henry and Fort Donelson in February, the bloody Battle of Shiloh is fought on April 6 and 7. Union forces eventually prevail, but only after combined casualties of 23,746, losses greater than those in all previous American wars combined.

The Union navy, commanded by Admiral David Farragut, takes New Orleans on April 25.

On August 30, after a two-day battle, Confederate forces once again prevail at Manassas. Richmond seems secure, while Washington appears vulnerable to attack.

After the Battle of Antietam at Sharpsburg, Maryland, where, in the bloodiest single day of the war, Federal troops claim victory, Lincoln announces the Emancipation Proclamation.

In December, Union troops are routed by Robert E. Lee's men at Fredericksburg, Virginia.

1863

On New Year's Day, the Emancipation Proclamation goes into effect.

Thomas "Stonewall" Jackson dies on May 10 after the Battle of Chancellorsville.

Union forces turn back invading Confederate troops at the Battle of Gettysburg in a three-day battle waged on July 1–3. The day after the battle ends, the city of Vicksburg, Mississippi, surrenders.

Manhattan implodes in the so-called Draft Riots, July 13–16, as a racist mob terrorizes the city's African American citizens.

On November 19, Lincoln delivers a brief but resonant address at the dedication of the new Federal cemetery in Gettysburg.

1864

On March 9, after his successes in the war's western theater, General Ulysses S. Grant is appointed commander of all Federal armies.

In June, in one of his last great victories, Lee and his Army of Northern Virginia defeat Union forces at the Battle of Cold Harbor, Virginia.

On July 30, at the Battle of the Crater, an immense explosion detonated beneath the Confederate line near Petersburg results in a chaotic loss of Union lives.

On September 2, Atlanta falls to Union general William Tecumseh Sherman; the news helps propel Lincoln to reelection on November 8.

The city of Savannah, Georgia, surrenders to General Sherman, who occupies Charles Green's mansion, on December 22.

1865

On January 31, the House of Representatives, following the lead of the Senate, passes the Thirteenth Amendment, which abolishes slavery.

Lincoln and Seward meet C.S.A. vice president Alexander Stephens and other "peace Commissioners" at Hampton Roads, Virginia. Neither side can agree to the other's demands.

On April 2, Lee orders the evacuation of Petersburg, Virginia; the following day, Union soldiers occupy Richmond.

On the afternoon of April 9, Lee and Grant meet at Appomattox, where Lee surrenders. On returning to his men, Grant tells them, "The war is over; the rebels are our countrymen again."

At Ford's Theatre, on the evening of April 14, John Wilkes Booth shoots Lincoln. The sixteenth president dies of his wounds the next morning.

The last of the Confederate forces surrender: Mosby's raiders in Virginia on April 21; Joseph E. Johnston's army in North Carolina on April 26; Richard Taylor's in Alabama and Edmund Kirby Smith's in Texas on May 4 and May 26, respectively.

Although President Andrew Johnson formally declares the war over in August, the warship CSS *Shenandoah* doesn't officially surrender until November 6.

Opposite: At the First Battle of Bull Run, the strategy of Thomas J. Jackson belied the words of Abraham Lincoln. Seeking to reassure his commanding general, Irvin McDowell, Lincoln had quipped, "You are green, it is true, but they are green also; you are all green alike."

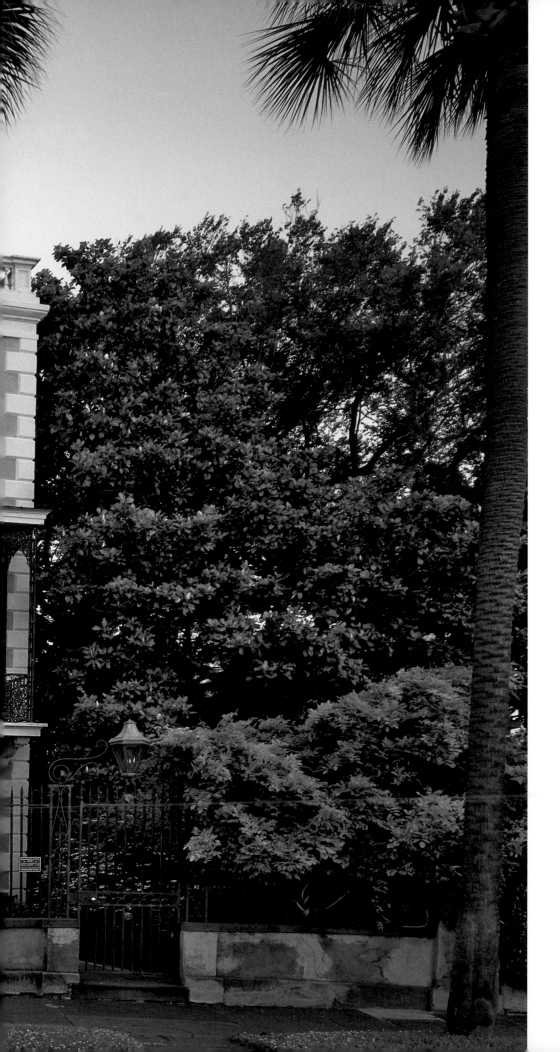

GENERAL BEAUREGARD VISITS THE EDMONDSTON-ALSTON HOUSE

CHARLESTON, SOUTH CAROLINA

"We, the People of the State of South Carolina, in Convention assembled, do declare and ordain . . . that the union now subsisting under the name of 'The United States of America,' is hereby dissolved."

ORDINANCE OF SECESSION

December 20, 1860

THE GUNS AT SUMTER

Pierre Gustave Toutant Beauregard, a handsome man with an outsize talent for stepping onto the stage at dramatic moments, would win the first major land battle at Manassas in July 1861 (see page 90). He nearly prevailed at Shiloh in 1862 (page 108), and his men held off Grant's at Petersburg in 1864. Yet his most memorable star turn occurred in the spring of 1861, when, in Charleston, South Carolina, his order to fire truly launched the Civil War.

On December 20, 1860, South Carolinians signed the Ordinance of Secession. While the people celebrated in the city's streets, in the harbor the U.S. Army's Major Robert Anderson pondered his orders to "hold possession of the forts." Within a week, he responded with a defensive but provocative military move.

He kept his plans to himself until just minutes before issuing the order to evacuate his headquarters at the nearly indefensible Fort Moultrie, moving his sixty-man garrison under the cover of night on December 26. Despite the presence of patrol steamers, Anderson and his men, together with the company's women and children, managed to reach Fort Sumter, bringing with them four months' worth of supplies as well as ammunition and basic hospital equipment. The city of Charleston awoke to smoke rising from the abandoned fort, where Anderson had left a small force to spike the cannons and burn the gun carriages.

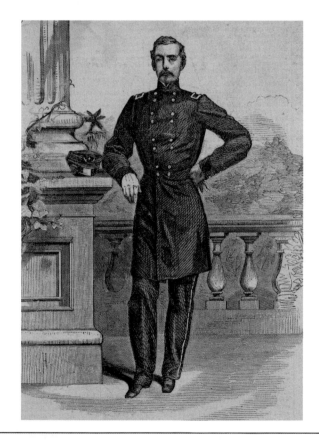

Previous page: Seen from the street, the Alston coat of arms is visible, set into the panel at the center of the house's surmounting parapet.

Above: Born to a French-speaking family of sugarcane planters, the handsome Beauregard retained a slight accent into adulthood. A West Point graduate, Beauregard remembered one teacher as his particular favorite: professor of artillery Robert Anderson. *Library of Congress, Prints and Photographs*

Opposite: The seascape on view took in not only Sumter but the military installations at Castle Pinckney and Forts Johnson and Moultrie.

Several months of stalemate ensued, as six other Southern states seceded and their representatives met in Montgomery, Alabama, to form a new government. Former secretary of war and Mississippi senator Jefferson Davis, who assumed the presidency (see "Jefferson Davis and the White House of the Confederacy," page 130), summoned P.G.T. Beauregard. After appointing him the first brigadier general in the Confederate army, Davis ordered the Louisiana native to travel to Charleston, where the Union presence at Fort Sumter, overlooking the shipping channel into the important port, stuck in the Confederacy's craw. On Beauregard's arrival on March 3, 1861, he reorganized the Confederate cannons sighted on Fort Sumter, then awaited further orders.

To those within the fort's walls, the danger was well known. As one private in Anderson's command wrote to his father, the Carolinians "of course [are] boiling over to attack Sumter, and tear down the cursed Stars and Stripes."

In Washington, the other new president took the oath of office on March 4. Abraham Lincoln worried about the status of Virginia, which had yet to secede. Within hours, however, he read a report from Major Anderson: unless resupplied soon, the Union garrison would be forced to surrender. Lincoln, regarding the fort as an important symbol, wished to hold it, even in the face of opposing advice from some in his cabinet, including Secretary of State William Henry Seward (see "William Henry Seward House," page 162). Lincoln decided something had to be done.

The moves and the motives of the men on both sides over the course of the next five weeks lend themselves to dispute—more than a century and a half later, tempers still warm at the topic. In the most straightforward telling of the tale, Lincoln resolved to reprovision the men at Sumter, not with military materiel but with food and supplies. The subsequent approach of Union ships to Charleston Harbor precipitated a demand by Beauregard that Anderson evacuate Fort Sumter, and when the major refused (his instructions were to hold the fort unless, "to save yourself and your command, capitulation becomes a necessity"), Beauregard ordered that shelling commence. The first cannon echoed in the darkness

Above: The well-appointed dining room at the Edmondston-Alston House, surveyed by the thoughtful countenance of a churchman, Episcopal bishop Robert Smith, the first president of the College of Charleston.

Opposite: A substantial collection of some two thousand volumes accumulated by three generations of the Alston family lines the library shelves.

at four thirty on Friday morning, April 12, 1861, though Anderson and his men would not return fire until after daybreak.

Forty-three pieces fired on the fort from multiple artillery positions, one of them the Floating Battery, an iron-faced gun barge, moored at Moultrieville, that presaged more mobile ironclads later in the war. The Union artillerists returned fire at intervals, husbanding Sumter's finite supply of powder and cartridges. Confederate hotshots—cannonballs heated in a furnace before they were fired—ignited conflagrations in Fort Sumter's wooden barracks. The men on both sides of the artillery exchange watched as the projectiles fired at them traced great arcs in the sky, moving as if in slow motion and remaining aloft for thirty seconds and more. Spotters shouted warnings at the approach of well-aimed

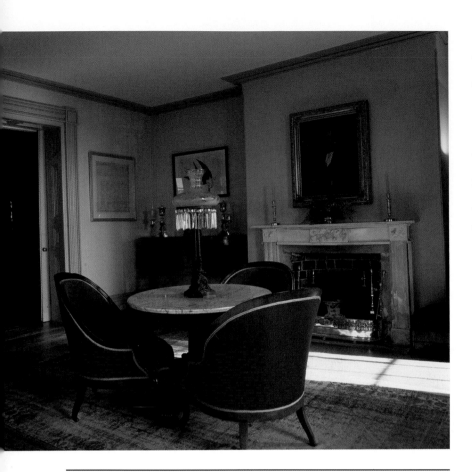

The downstairs parlor doubled as an office and morning room for Charles Alston (that is he in a circa 1858 portrait over the mantel). In the months after the war, General Rufus Saxton operated the Freedmen's Bureau from this room.

She had sat atop a chimney ("The sparks caught my clothes"), but the fire was quickly extinguished. Chesnut survived to keep a voluminous diary that historians cherish for its detail and its author's candor about life in the South during the war.

One of the essential players in the drama also sought to survey the action that unfolded at the mouth of the harbor. According to family history, General Beauregard stopped awhile at the Charles Alston home at 21 East Battery Street, a site that gave him a clear vantage of the harbor. There he found a telescope, through which he gained an even better view. "Beauregard watched the bombardment of Fort Sumter . . . from my uncle Charles' residence," remembered Jacob Motte Alston years later.

Early Saturday afternoon the firing came to an end. With no chance of prevailing, Anderson agreed to terms: In return for surrendering the fort, his men would be permitted to salute the Stars and Stripes as the flag was lowered, after which, along with arms and property, they would depart for a northern port.

The battle won, Beauregard was celebrated—as one versifier had it, "With cannon and musket, with shell and petard, / We salute the North with our Beau-regard." The larger outcome was also clear. In sum, according to Jacob Alston, "[It was] the beginning of a war that was to change the whole aspect."

THE HOUSE AT 21 EAST BATTERY

Late in the colonial era, Charles Towne's builders evolved a vernacular architectural form that suited the city's grid. Just as the New England Cape style was a response to local conditions, the one-room-wide single house, as it was known, proved well adapted to the climate, the narrow lots, and the increasingly urban streetscapes of the prosperous place that, as of 1783, was officially known as Charleston.

Built on long, rectangular footprints, houses like Charles Alston's encountered the world with two faces. An entrance on the narrow gable end overlooked the street, permitting passersby access to shops or offices but screening the domestic realm from the conduct of business. A covered porch that ran the length of a

incoming shot, shells, or mortars. Remarkably, no one was killed during the artillery exchange.

Charlestonians climbed to their rooftops to watch and wonder, settling in with opera glasses in hand. At night, the darkness was relieved by lanterns brought by slaves, who also carried up chairs, tables, and even picnic baskets and beverages. Viewing the night sky during the first hours, Mary Chesnut, the wife of South Carolina senator James Chesnut, wrote, "The regular roar of the cannon . . . who could tell what each volley accomplished of death and destruction."

She continued, "Up on the housetop, I was so weak and weary I sat down on something that looked like a black stool." Suddenly, she heard a man's voice. "Get up, you foolish woman—your dress is on fire."

longer side surveyed a garden and a narrow drive that led to a rear yard with service buildings. At what is today known as the Edmondston-Alston House, these buildings included a freestanding kitchen and a carriage house, the latter with a hayloft and slave quarters on the upper level.

The privileged visitor gained entrance to the living areas of the home via the first-floor piazza, which opened onto a central passage that led to the entertainment rooms of the house, including a dining room on the ground level and a staircase rising to two drawing rooms on the second floor (the bedchambers were located on the third). The rooms on the upper levels captured the prevailing breezes, with piazzas that offered the Alstons—and such guests as General Beauregard—an unobstructed vista near the tip of the peninsula that juts into Charleston Harbor at the confluence of the Cooper and Ashley Rivers.

Originally constructed in 1825 by merchant Charles Edmondston, the house sat on marshland that had been drained and filled after the completion of a permanent seawall in 1819. A prominent rice planter with large plantation holdings in Georgetown, sixty miles north on the Carolina coast, Alston acquired the house in 1838. He added the third-floor piazza, hid the old hip roof behind a parapet, and made some interior changes, giving Edmondston's fine Federal house au courant Greek Revival details. Today, the house looks much as it did in the decade before the war, when the in-town house was home to the Alstons for roughly three months annually. For the rest of the year, the family resided on their plantation in Georgetown, coming to town for the winter social season.

On more than one occasion, the tall and elegant home proved an unsuspecting bystander to the events of the war years. Eight months after Beauregard's visit to 21 East Battery, General Robert E. Lee arrived, on December 11, 1861. A raging fire threatened much of the city, but Lee and his entourage—including two babies and the wives of his aides—found refuge, according to Lee's adjutant, Captain Walter Taylor, "[at] the private residence of Mr. Charles Alston, on the Battery, out of the line of danger & kindly offered for Gen. Lee's use."

Two of Charles Alston's sons, John Julius Pringle Alston and Joseph Pringle Alston, took direct roles in the war, serving in artillery companies. The Union blockade, initiated by Lincoln just days after Fort Sumter's fall, gradually closed down one Southern port after another, and Charleston, one of the last survivors, became a Union target. Several ironclads were among the ships that launched an artillery offensive in 1863, when Emma Pringle Alston wrote to her husband of "heavy cannonading." She told him on July 10 that "dreadful reports" had reached her that their son Julius "was seriously wounded, had lost a leg, was taken prisoner, etc." In fact, the young man sustained only minor injuries as the Confederates fought back the Union offensive. Just three months later, however, Julius would join the ranks of the war dead. Like most of the estimated 720,000 men who died in the war, Julius died of illness rather than battle-inflicted wounds. His survivors would see the city bombarded for more than a year, leaving much of Charleston in ruins.

The standoff at Fort Sumter in the spring of 1861 attracted a notable Southern partisan to Charleston: the Virginian Edmund Ruffin. He was among the most visible and vociferous of the fire-eaters, those Southern men who sought not merely secession but war. Less than a week before General Beauregard issued the order to fire, Ruffin confided in his diary his hopes for "open hostilities." He expected that "they would soon bring Virginia and the other delaying States into the Southern Confederacy." True to his rhetoric, Ruffin would do his part, discharging one of the first cannons fired, and his wish for further secessions soon came true.

Ruffin's lust for battle stood in sharp contrast to Major Anderson's expressed fears. As Anderson wrote to his military superiors in Washington in the days before the fight at Sumter, "God grant that our country may be saved from the horrors of a fratricidal war."

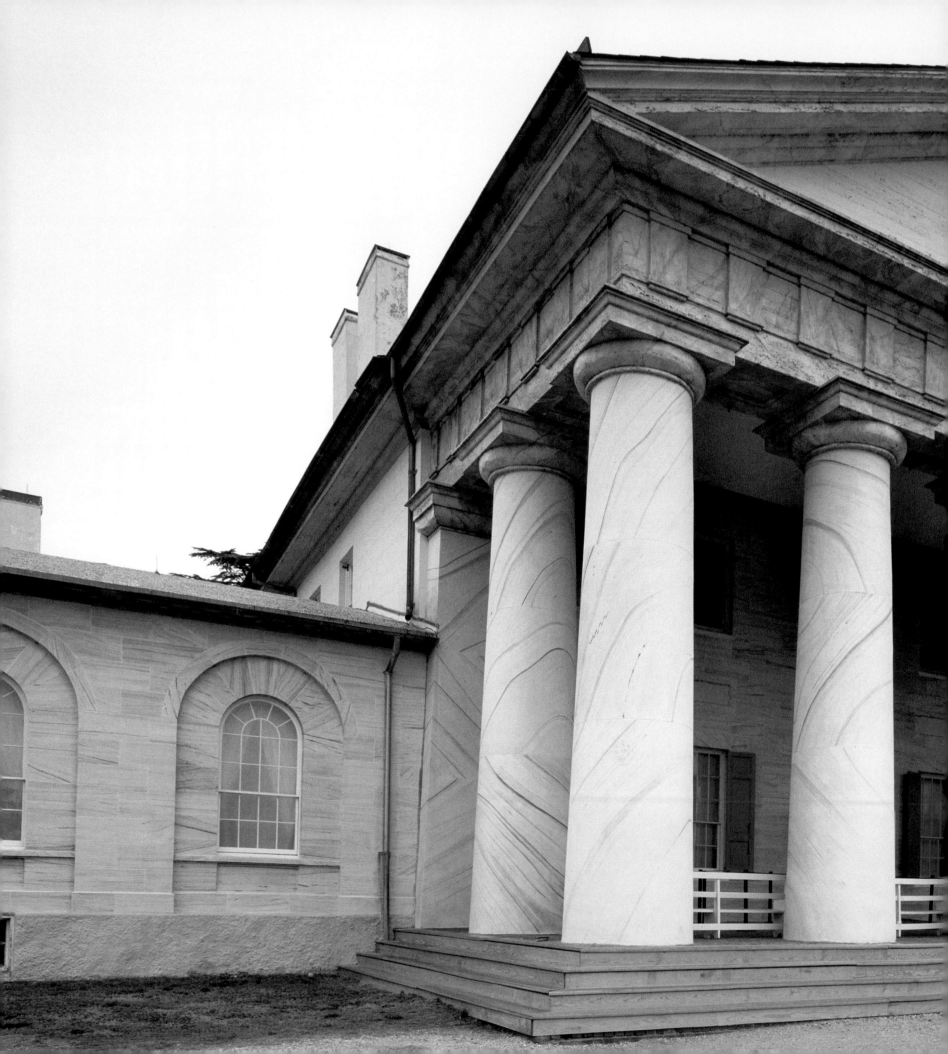

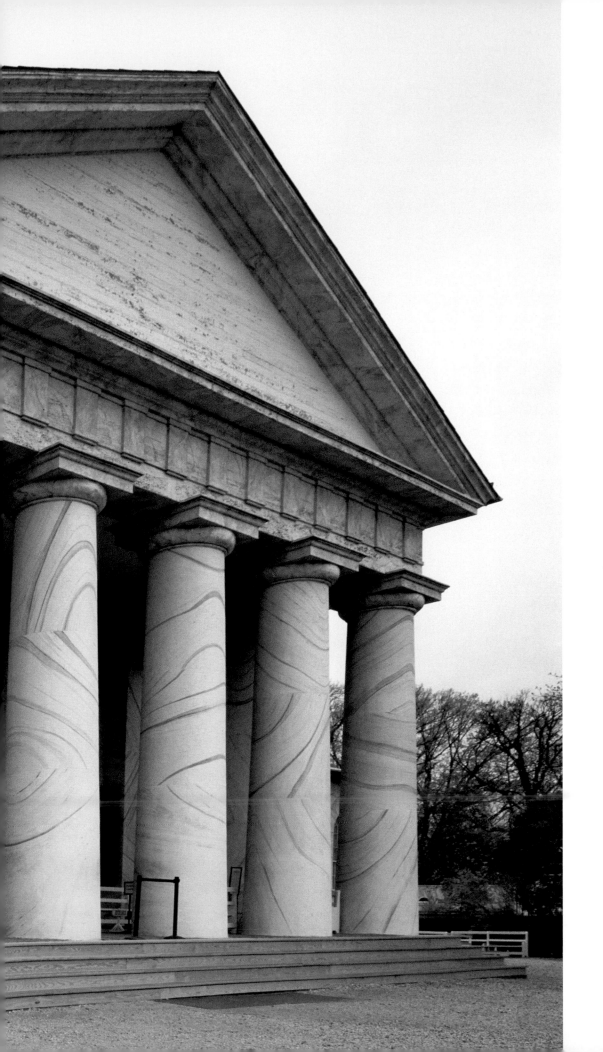

ROBERT E. LEE
AND
ARLINGTON
HOUSE

ARLINGTON, VIRGINIA

"I must say that I am one of those dull creatures
that cannot see the good of secession."

COLONEL ROBERT E. LEE

April 19, 1861

Colonel Lee confronted a damnable dilemma. He did so on Virginia soil, from the hilltop mansion his wife had inherited, with its panoramic view of the Federal City across the Potomac. Just days before the outbreak of the Civil War, standing upon the portico of Arlington House with its colossal columns, he gazed upon the unfinished Capitol dome.

"That beautiful feature of our landscape," Lee remarked to a visitor, "has ceased to charm me as much as formerly. I fear the mischief that is brewing there."

Since graduating from West Point, in 1829, Robert E. Lee (1807–1870) had worn the military uniform of the United States. He served as a chief aide to General Winfield Scott during the Mexican War and, later, as superintendent at West Point. In October 1859, President James Buchanan ordered him to Harper's Ferry, where he commanded the attack to recapture the arsenal, ending John Brown's attempt to foment a slave uprising (see "The Invasion at Harper's Ferry," page 63). But events in the North and South in recent months had riven his allegiances.

Lincoln's election and South Carolina's secession (on November 8, 1860, and December 20, 1860, respectively) elevated the national crisis, which worsened with the withdrawal from the Union of five more states in January 1861. Stationed at Fort Mason in the Indian country of central Texas, Lee wrote to Markie Williams, a younger cousin of both himself and his wife, Mary: "God alone can save us from our folly, selfishness & shortsightedness." He added a terrible—and prescient—prediction. "I can only see that a fearful calamity is upon us, & fear that the country will have to pass through for its sins a fiery ordeal."

After Texas seceded, on February 1, Lee received orders to return to Washington and report to his old friend and mentor General Winfield Scott, commanding general of the Union army. Lee knew not whether the summons meant a promotion or an invitation to rejoin General Scott's staff. But he did understand he likely faced an unwelcome decision.

For his first fifty-four years, Lee felt an absolute allegiance to the country his father had helped found; Henry "Light-Horse Harry" Lee had fought with distinction during the War of Independence, which won him the enduring friendship of General George Washington. Ironically, the younger Lee had begun the year 1861 reading a biography of Washington, a gift from his wife, Mary, who also had strong connections with the founding generation: Mary's father, George Washington Parke Custis, had been raised from infancy by George and Martha Washington. Before leaving Texas, Lee dispatched a letter to Arlington House bemoaning "how [Washington's] spirit would be grieved could he see the wreck of his mighty labors!"

On his arrival at home some weeks later, he did receive an offer of a promotion, but it came in a letter from the secretary of war of the new nation, the Confederate States of America (C.S.A.),

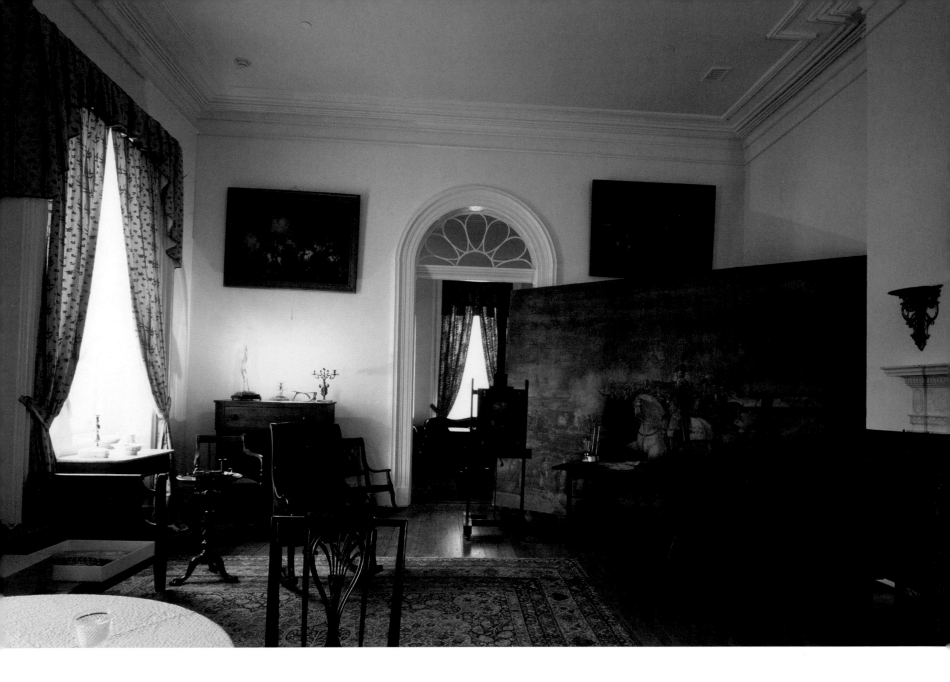

Previous spread: Designed by George Hadfield, a British architect who arrived in America to help supervise the construction of the Capitol, the monumental Arlington House is fronted by an immense portico with twenty-three-foot-tall columns (each is five feet in diameter at the base). The plain, bold proportions of the house helped ensure that even when it was seen from the Potomac or the Federal City on its other side, Arlington's Grecian character would be unmistakable.

Above: The morning room perhaps best commemorates Lee's father-in-law, George Washington Parke Custis. The large canvas represents Custis's attempts to keep alive the spirit of the Chief, his adoptive father, George Washington. The eight-by-twelve painting *The Battle of Monmouth* may have the feel of a children's-book illustration, its workmanship unsophisticated, but the artist did not claim to be making great art. The value of his paintings lay, he explained, in "their truthfulness to history in the delineation of events, incidents and costumes."

who tendered him a commission as brigadier general. Yet this substantial promotion did not tempt Lee. First and foremost a Virginian (he called it his "homeland"), he was acutely aware as he made way east via rail and steamer that the delegates to Virginia's secession convention had debated at length the future of the Commonwealth and then had voted two to one in favor of remaining in the Union. Lee dismissed secession as "nothing but revolution." As he had confided in a friend before leaving Texas, "If Virginia stands by the old Union, so will I."

The April events in Charleston Harbor—the bombardment of Fort Sumter and, on April 14, the Union surrender of the fort—raised the stakes higher still. As Lee readied himself to go

Armed Union soldiers stand guard outside Arlington House in June 1864.
Andrew J. Russell/Library of Congress, Prints and Photographs

to Washington, a new secession vote was scheduled in Richmond, but its outcome was uncertain.

Then, on April 18, the United States made its offer: Lee learned in a closed-door meeting that President Lincoln had authorized an intermediary to inquire whether Lee would accept command of a new Federal army numbering seventy-five thousand or more men. He knew immediately what he would be asked to do, and, as he recalled the conversation, "I declined the offer . . . stating as candidly and courteously as I could, that, though opposed to secession and deprecating war, I could take no part in an invasion of the Southern States."

General Winfield Scott, himself a Virginian, reacted not with anger but with sadness. "You have made the greatest mistake of your life," he told his old friend, "but I feared it would be so." When he left Scott's office, Lee had not yet decided on his future path. He would not oppose his own region, but could he join the C.S.A. and fight the nation he had served for so long?

IN THE HALLS OF HISTORY

On the night Lee learned the delegates had voted for Virginia to become the Confederacy's eighth state, Mary Anna Randolph

Custis Lee, sitting in the parlor, heard her husband pacing upstairs in their bedchamber in Arlington House, pondering the dilemma ("the severest struggle of his life," Mary later said). Neither could know how dearly the decision would cost them. Part of the price would be the loss of her father's house.

The builder of Arlington, George Washington Parke Custis, dubbed himself "the child of Mount Vernon." If he had had his way, Custis, an orator, writer, and agrarian, would have spent his life not atop the two-hundred-foot-tall bluff at Arlington but eight miles downstream at Mount Vernon.

When Martha Washington's only son, Jacky, died of "camp fever" after the Battle of Yorktown, she and her husband took in

Robert E. Lee is said to have proposed to Mary Anna Randolph Custis in the dining room *(foreground)*; they took their vows in the family parlor *(beyond)*. Known for its owners' hospitality, Arlington House was the scene of a party to celebrate George Washington's birthday in February 1861. Numerous future Union and Confederate generals were in attendance, and subsequently, both sides would claim Washington as a guiding spirit.

her six-month-old grandson and her two-year-old granddaughter, Eleanor. Though there was no provision in English or Virginia law for formal adoption, the Washingtons raised the children as their own.

In youth, Wash Custis didn't live up to the general's high expectations, failing in three attempts at college, but in the last year of his life, Washington entrusted the eighteen-year-old Wash with the role of coexecutor of his estate. When Martha died, three years after George, Custis attempted to purchase Mount Vernon from the designated heir, Judge Bushrod Washington. When Washington's eldest nephew refused to part with the place, young Custis moved to the eleven-hundred-acre property that was part of the legacy left to him by his own father.

At first, he called it Mount Washington. He installed his collection of Washington memorabilia in the four-room cottage that stood on the property (some of the contents of Mount Vernon were sold in a series of public and private auctions, and Custis had made so many purchases that he was left owing $4,545, a debt that required years to pay off). After finding some of his cherished mementos damaged by vermin and dampness due to poor storage conditions, Wash resolved to build a proper vessel to preserve and display his Washingtoniana. He dubbed the massive Greek Revival mansion Arlington House, after an earlier Custis plantation.

In 1804, he brought home a wife, Mary Lee "Molly" Fitzhugh. George and Molly resided in the completed north wing, and the rest of the structure, which included the tall main block and a second, symmetrical wing, was completed over the next dozen years. The house features a façade that stretches 140 feet. Though built of brick fired on the property, the walling of the house, parged with hydraulic cement, was scored and painted to create a faux finish that resembled marble and sandstone. Arlington's contents would include Washington's "war tent," still in its original two leather portmanteaus, as well as a mix of family portraits.

As the repository for his "Washington Treasury," Arlington House became an essential stopping place for those wishing to pay their respects to the memory of George Washington. Among Cus-

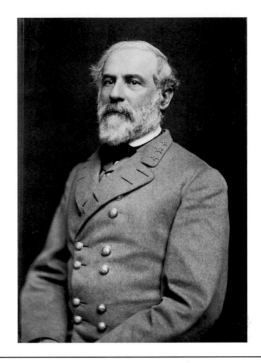

According to Lee's contemporaries, this collodion photograph, taken in 1864, is a good likeness. *Julian B. Vannerson/Library of Congress, Prints and Photographs*

tis's many guests was Gilbert du Motier, better know as Lafayette, who visited while on his American tour in 1824. Custis wrote an account of their discussions in a series of articles called "Conversations with Lafayette," which attracted national attention. His first "Recollection of Washington" followed in May 1826, and for many years thereafter, usually on the occasion of the first president's birthday or on Independence Day, memory pieces were printed in papers from Savannah to Boston.

Soon Custis found another means of honoring Washington. When Wash was just eight years old, his grandfather had underwritten the purchase of painting supplies, buying him watercolors and a paint box (cost: three shillings). Wash's devotion to painting had been less than assiduous, but in 1832, he picked up his brushes once again and produced a series of history paintings featuring the general.

By then, Custis's daughter Mary had married—she became Mrs. Robert Edward Lee in the family parlor at Arlington House on June 30, 1831. Custis would live to witness the births of the

Opposite: The north wing was built first (the house required nearly twenty years to complete), and a winter kitchen installed on the basement level along with a wine cellar that housed wine brought from Mount Vernon.

Above: The Lees decorated this room in 1855—previously, it had been a store-room—purchasing new Renaissance Revival furnishings and fabrics and a marble chimneypiece that Lee helped design. The portrait over the mantel is of the lady of the house, Mary Anna Randolph Custis Lee, as a young woman.

lected writings were published in book form, as *Recollections and Private Memoirs of Washington by His Adopted Son George Washington Parke Custis.* Although George Washington Custis has faded into obscurity, he remains an essential link between the two historic figures that tower over him: his adoptive father and his son in law. Equally, his home, sometimes known as the Custis-Lee Mansion, would become a symbol for the War between the States.

Lees' seven children, but he died in 1857, after which Lee took a leave of absence from the U.S. Army to tend to the plantation and mansion. Meanwhile, Mary Lee saw to it that her father's col-

THE SPOILS OF WAR

After breakfast on April 22, 1861, Robert E. Lee rode away from Arlington House for the last time. He departed for Richmond

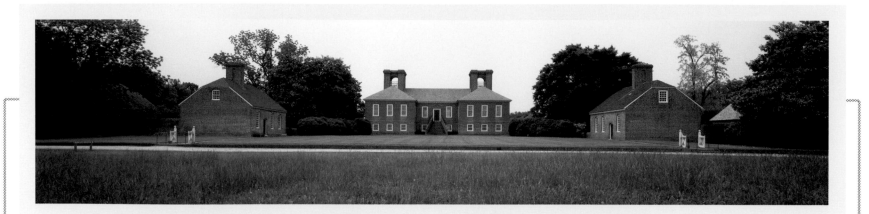

STRATFORD HALL

Unlike his wife, Robert E. Lee failed to inherit the family mansion. However, he was most assuredly to the manor born.

Three generations before Lee's birth in the southeast bedchamber, Stratford Hall's foundation was laid on a 1,443-acre estate overlooking the Potomac. Built to an unusual H-shaped floor plan, the Great House would be home to the only brothers to sign the Declaration of Independence, Richard Henry Lee and Francis Lightfoot Lee.

Having married a granddaughter of builder Thomas Lee, a Lee cousin named Henry occupied Stratford Hall when his wife, Ann, gave birth to their last-born son, Robert Edward Lee, on January 19, 1807. A Revolutionary War veteran and deft horseman, Light-Horse Harry memorably eulogized his friend George Washington as the man who was "First in War, First in Peace, and First in the Hearts of his Countrymen." The father imparted to his son a reverence for the general's memory, but Henry Lee's accumulated debts meant that, after a stay in debtors' prison, he and his family had to leave Stratford to live in more modest circumstances in Alexandria, Virginia. When the boy came of age, his widowed mother lacked the wherewithal to pay for Robert to go to college. The family prevailed upon Secretary of War John Calhoun (see "John C. Calhoun's Fort Hill," page 26) to appoint him to West Point, thereby launching his long and distinguished military career.

The last Lee owner sold Stratford Hall in 1822; after a series of private owners, the Robert E. Lee Memorial Foundation, established in 1929, acquired the property, opening it in 1935 to honor Lee's memory.

Although a boy not yet four on departing Stratford Hall, Lee felt the pull of the place throughout his life. After his family was forced to abandon Arlington House, in 1861, General Lee wrote to his wife on Christmas Day, "In the absence of a home I wish I could purchase Stratford. That is the only place I could go to, now accessible to us, that would inspire me with feelings of pleasure and local love."

dressed in a black suit, a silk hat atop his head. Two days later, he accepted command of Virginia's military forces.

In just under four years, Lee rose to general in chief of the Armies of the Confederacy and became President Jefferson Davis's most trusted military adviser. He won a number of decisive battles, including those at Second Manassas, Fredericksburg, and Chancellorsville. Despite failed invasions of the North that resulted in defeats at Antietam and Gettysburg, he gained enduring international fame as a charismatic leader and military tactician before he finally surrendered to General Ulysses S. Grant at Appomattox (see "Generals Grant and Lee at the Wilmer McLean House," page 172). With the coming of peace, Lee served as president of Washington College in Lexington, Virginia, until his death in 1870, after which the school was renamed Washington and Lee.

Mary Lee left her ancestral home a few weeks after her husband, having sent many of the Washington treasures and family portraits and much of the furniture to inland Virginia for safekeeping. Arlington's strategic overlook of the capital meant that Union troops soon occupied the property. For a time, the house

Opposite, top: The imposing Stratford Hall surrounded by its dependencies. Pictured are the servants' house and kitchen *(left and right, respectively)*, with the roof of smokehouse just visible. The main house consists of a full story in the raised basement (with service rooms, kitchen, and several bedchambers) and the principal living quarters above.

Opposite, left to right:
Over the fireplace mantel in the parlor hangs a portrait of Henry Lee, a canvas attributed to Gilbert Stuart. The mantelpiece dates from a Federal-era renovation that Light-Horse Harry Lee engineered in the last decade of the eighteenth century.

According to family lore, Robert Edward Lee entered the world in this bedchamber and slept in this walnut crib, here hung with mosquito netting that would have been loosely draped around the perimeter once the child was settled into it. The Robert E. Lee Foundation, modeled on the Mount Vernon Ladies' Association, acquired Stratford Hall Plantation and restored the site to venerate the Virginia general.

This Federal-era secretary bookcase at Stratford belonged to the family of Mary Anna Lee.

remained empty, the keys entrusted to slave Selina Gray, who had been Mrs. Lee's personal maid. When cousin Markie arrived to collect her possessions, she reported to Mary, "The poor House looked so desolate."

For a time, General George McClellan and other military officers occupied the house, establishing army headquarters in its generous rooms. Union soldiers felled nearby stands of old-growth oak, elm, and chestnut to build barracks and for firewood; defensive earthworks and access roads soon marred the once pristine landscape. A hospital was constructed on the property, and in 1863, the southern portion of the estate became a freedmen's village for thousands of runaway slaves. (The Custis-Lee family had owned almost two hundred bondsmen.)

In 1864, the property was auctioned for nonpayment of taxes, and the U.S. government acquired the estate. By May, with the interment of both Union and Confederate soldiers, the estate had begun its transformation into a burial ground; in June, the land around the mansion was formally designated Arlington National Cemetery. Legal wrangling with Lee heirs went on for years after the war, finally ending in 1883 with the federal government gaining full ownership. The mansion served as cemetery headquarters until the early twentieth century, when, pursuant to a 1924 act of Congress, restoration of the Custis-Lee Mansion began. In 1972, the National Park Service site was formally redesignated Arlington House, the Robert E. Lee Memorial.

The view from the Arlington House portico differs today from the vista Lee once cherished. The immediate landscape is dominated by a rank and file of uniform gravestones, with larger monuments and other structures dotting the landscape. The more distant view of Washington is defined by the Arlington Memorial Bridge, which opened in 1932 and links the cemetery with the National Mall. Seen from Arlington Heights, the bridge appears to terminate at the Lincoln Memorial, a Grecian temple of white marble. That building's surrounding colonnade of thirty-six fluted columns represents the thirty-six states that were reunited in 1865.

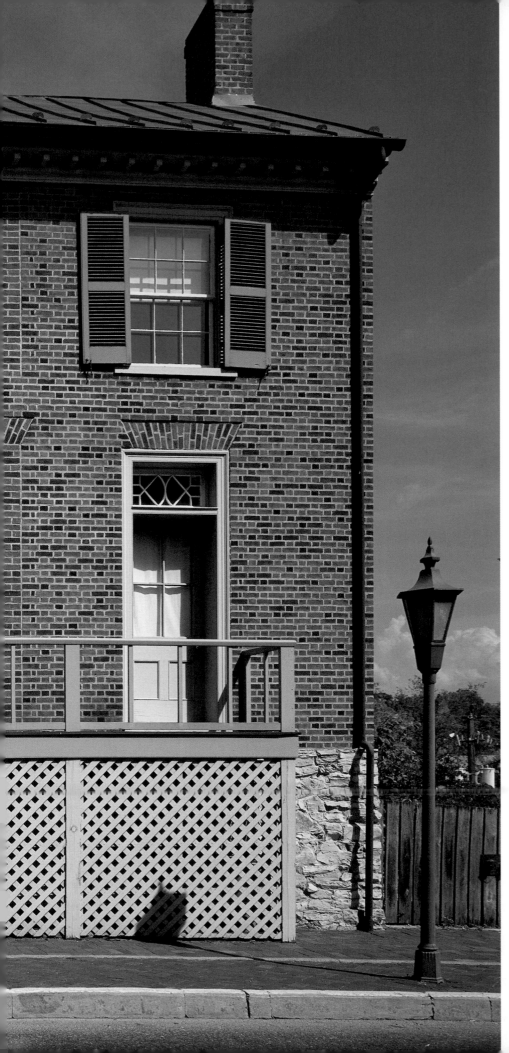

THOMAS J. "STONEWALL" JACKSON HOUSE

LEXINGTON, VIRGINIA

"I have no gift for seeming."

T. J. JACKSON

T he professor's habit had long been to set aside the Sabbath for church duty. He attended services in the morning; in the afternoon, he taught scripture to the enslaved and other Negroes at the Lexington Presbyterian church. He would never entrust a letter to the mails if he thought it might be in transit on a Sunday. When his wife made reference on the day of rest to a secular topic, he would smile and remark, "We will talk about that tomorrow."

All of which made April 21, 1861, a most unusual Sunday.

National events threatened the cherished domestic calm of Thomas and Anna Jackson's life on Washington Street. On April 13, the Confederate flag had been raised over Fort Sumter after Union forces surrendered; two days later, Abraham Lincoln invoked the Militia Act of 1795, calling upon the states, the Commonwealth of Virginia among them, to supply seventy-five thousand men "to execute the laws of the Union, suppress rebellions, repel invasions." The president's demand galvanized Virginia's Secession Convention, and on April 17, after two months of hesitation, they voted, 88 to 55, to join the Confederacy.

Academic studies temporarily ceased at the Virginia Military Institute. Modeled on West Point, VMI had been the second government military school in the nation; with secession, artillery drills and other military instruction became the order of the day, all day, every day, as cadets and teachers alike awaited orders from the state capital at Richmond. When Jackson found the time to return to his two-story brick house just a half mile away, he packed his bag for the inevitable summons.

Marching orders duly arrived by telegram on the Lord's day, and soon after sunrise, a messenger brought word to Major Jackson. He hurried from his home to VMI, where, in the course of the morning, he prepared the school's four companies for their thirty-six-mile march to the rail hub at Staunton. He also arranged for a pastor to offer a prayer to the men before departure. Late in the morning, he returned home and put on his dress uniform with sash, sword, and the shoulder boards of his rank. He knelt in prayer, then stood, embraced and kissed his wife, and left the house, never to return.

As the clock in the barracks tower struck twelve thirty, Major Jackson mounted his horse. A veteran of the Mexican War, in which he had won his rank, he knew a good deal more of what lay ahead than did the 176 fresh-faced young men to whom he issued the order to march. As he had confided to his pastor a few days before, "I have seen enough of it to make me look upon [war] as the sum of all evils."

PROFESSOR, DEACON, AND HUSBAND

Though brevetted a major in the Mexican War, Thomas Jonathan Jackson (1824–1863) had left the peacetime army in 1851 to assume a new role in the quiet college town of Lexington. He joined the

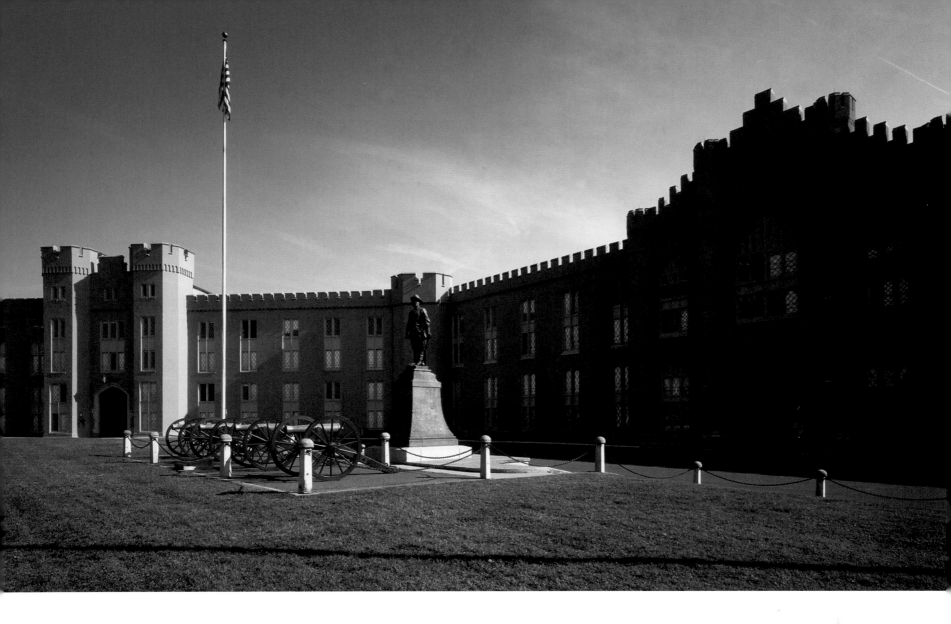

Previous spread: Thomas and Mary Anna Jackson's plain, two-story Federal-style town house, built in 1802. A local doctor purchased the house half a century later, put a stone addition on the rear (doubling the house's depth), and added a separate front entrance to the right of the center door to accommodate patients seeking his care.

Above: Before his marriage, Professor Thomas Jackson occupied a room on the fourth floor of one of the barracks towers at the Virginia Military Institute. The crenellated limestone structure, designed by Alexander Jackson Davis, was the West Point of the South.

VMI faculty as instructor of artillery and professor of natural and experimental philosophy (physics, in today's terms), but, an awkward man in almost all things, he presented a puzzle to his students, colleagues, and neighbors in Lexington.

Jackson possessed no capacity to unbend. Even at social events, according to one student who sought to glimpse the war hero, "he sat perfectly erect, his back touching the back of the chair nowhere; the large hands were spread out, one on each knee, while the large feet [stuck] out at an exact right angle to the leg." In the classroom, the dour Jackson exhibited no sense of humor and delivered his precisely memorized science lectures each morning in a characterless drone. His rigid discipline and single-mindedness won him few admirers among his students, though his afternoon artillery classes would train a generation of cadets, some of whom would be among the Confederacy's best cannoneers.

His ill-at-ease manner stemmed from many causes. Orphaned as a young child (his father died when he was two, his mother five years later), he and his siblings had been farmed out to extended family. At West Point, after he achieved the lowest score on the entrance exam among members of the class of 1846, his utter devotion to his studies left him little known to his fellow plebes, though

On a summer trip north in 1858, the couple bought household goods in New York and Philadelphia, acquiring a piano, three stoves, and other furniture, along with nineteen boxes of roofing tin. Jackson's plain tastes were in evidence; as Anna noted, "Simplicity marked every article." Her husband's stated philosophy: "A place for everything, and everything in its place."

Professor Jackson laboriously prepared his lectures each day, working in what had been the doctor's consulting room. Jackson owned a six-volume collection of Shakespeare's works, from which his wife read to him at night. His eyes were weak, and he made it a policy never to strain them by reading by candlelight.

his reward was a ranking in the top quarter of his graduating class. He was partially deaf in one ear and subject to frequent sore throats; his eyesight was poor, and he suffered from chronic digestive complaints. Within two years of his arrival in Lexington, he married Elinor Junkin, the daughter of a Presbyterian minister and the president of Washington College, which was also located in Lexington. Just fourteen months later, Professor Jackson lost his wife; she died giving birth to their stillborn son.

Religion helped sustain him; his Lexington congregation elected him a deacon, and its minister later remarked that Jackson's faith "not only made him brave, but gave form, order, direction and power to his whole life." He believed in self-improvement, and he annotated the closely read books in his large library with marginal notes. Among his volumes were more than two dozen works

of history, not a few of which were devoted to military campaigns, ranging from Xerxes's and Caesar's to Washington's and Napoleon's. The devout Jackson also owned Bibles in four languages as well as some two dozen other theological works.

A softening of sorts occurred when the bereaved major embarked on a late-summer tour of Europe in 1856, taking in all manner of sights in the course of his sixteen-hour days. He traveled to England, Scotland, Belgium, Germany, Switzerland, Italy, and France, examining few battlefields but studying architecture, paintings, sculpture, and landscapes. On his return home, he resolved to marry again.

Once more he chose the daughter of a college president, this time Mary Anna Morrison, whose father had been president of newly founded Davidson College. Though the marriage brought

another dose of sadness when a daughter born to Anna and Thomas the next year died at less than four weeks of age of a liver ailment, the couple determined to leave their boardinghouse quarters and establish a home of their own.

In 1858 they purchased a house just off Lexington's Main Street for three thousand dollars. The structure required significant repairs, but its quarter-acre property enclosed a deep backyard where Jackson could grow fruits and vegetables. The main floor of the home contained four rooms that opened off a central passage: a comfortable parlor or sitting room, a dining room, bedchamber, and an office with a separate street entrance. A previous resident, a doctor, had used the last as a consulting room, but Jackson made it his study and spent every afternoon there preparing his lectures for the following day, always standing at his made-to-order desk. In the basement was the kitchen, the bedrooms on the top floor.

The home would be the only one Jackson ever owned. As he wrote to an aunt during the short but peaceful years he and Anna resided on Washington Street, "I am living in my own house. Have learned from experience that true comfort is only to be found in a house under your own control."

GENERAL JACKSON

On April 27, 1861, Jackson assumed command of the Confederate force at Harper's Ferry. Commissioned a brigadier general in June, he assembled five Virginia infantry regiments and the Rockbridge Artillery into what would become the storied Stonewall Brigade. The name derived from the nom de guerre their commanding officer gained when Jackson and his troops famously held the line at the Battle of First Manassas (see "Stopped by Stonewall at First Manassas," page 90).

Over the course of twenty-two months, the once obscure Major Jackson, despite his fondness for well-worn uniforms and battered forage caps, was promoted in rapid succession to brigadier, major, and lieutenant general. In spring 1862 he was charged with defending western Virginia. In the Shenandoah Valley, Jackson led his men in a series of feints, countermarches, and sudden

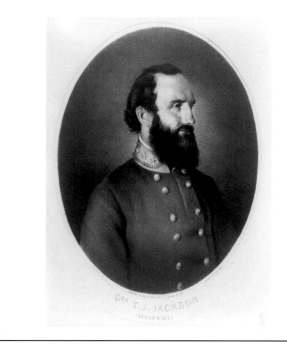

Stephen Vincent Benét once described the great soldier this way: "Stonewall Jackson, wrapped in his beard and his silence." *Library of Congress, Prints and Photographs*

swerves that consistently surprised the Union forces that greatly outnumbered Jackson's. He won early victories at Front Royal and Winchester, then made a daring escape through the pincers of two Union armies, which led to two more victories, at Cross Keys and Port Republic, before he and the Virginia brigade escaped to Central Virginia. A master of misdirection, Jackson expertly read the terrain and employed local intelligence, driving his "foot cavalry," as his infantry became known, almost four hundred miles in five weeks. Old Jack gained not only the adoration of his men, but also worldwide fame—and the fear and respect of the enemy. At the end of 1862, after further battles at Cedar Mountain, Second Manassas, and Antietam, Lee granted Jackson command of half of his Army of Northern Virginia.

Earlier, Anna had joined Thomas in Winchester at his 1861/62 winter quarters. Their second child, Julia Laura Jackson, was born the following November, but the father would not see his daughter until 1863. In April of that year, mother and child visited the Confederate camp south of Fredericksburg, and, as his wife

STOPPED BY STONEWALL AT FIRST MANASSAS

In life, he was known by a variety of names. As a boy, he was Thomas; as a young man, he signed his name T. J. Jackson. He was both Professor Jackson and Major Jackson at the Virginia Military Institute, where he taught for ten years, and he was known as Deacon at his Presbyterian church. Following Virginia's secession from the Union, in 1861, he was elevated to the rank of general in the Confederate army. But in the annals of military history, his name is almost always rendered as Stonewall Jackson, a sobriquet he gained in the Confederate victory at the first great land battle of the Civil War.

The First Battle of Manassas was fought by two untried armies barely twenty-five miles from the Union's capital, near the railroad hub of Manassas Junction and the Potomac tributary Bull Run (thus the other name by which the clash is commonly known, particularly in the North: the Battle of Bull Run). That day the Federals attempted to move on Richmond, and Confederate forces sought to protect their new capital.

Troops on both sides had amassed for days, and minor skirmishes preceded the attack on the morning of July 21, 1861, when a large Union force moved on the left flank of the Confederate line. Firing began before sunrise, and, in the course of the morning, the Union troops drove Confederate forces to retreat to the heights of Henry House Hill. The rebels regrouped, and among the reinforcements that arrived at midday was Brigadier General Thomas Jackson's First Virginia Brigade.

As a professor of artillery, Jackson studied the lay of the land, then chose to post his men on the reverse slope of the hill, thereby providing them protection. A row of pines on the hilltop offered additional cover for his gunners. When his smoothbore cannons were fired from the crest of the hill, Jackson knew, the recoil would propel their carriages a short distance down the low slope at the backside of the hill. There, out of the enemy's view, his men could reload the pieces in relative safety and then push them forward for the next volley. Jackson carefully situated his infantry to protect the artillery.

For several hours, enemy artillery pounded Jackson's position; his eight six-pounders were outnumbered three to one by the more sophisticated rifled cannons in the Union batteries. In midafternoon, Federal troops marched on the battered Confederate line; as one Virginia soldier reported, "The enemy were thick in the field, and the long lines of blue could not be counted."

With the Confederate forces in the ravine at the base of Henry House Hill in trouble, the commanding officer of the third brigade of the Shenandoah, Brigadier General Barnard Bee, galloped to Jackson's position with a warning.

"General," he reported desperately to Jackson, "they are driving us."

Jackson's response was plain but determined. "Sir, we will give them the bayonet."

Bee, who had attended West Point with Jackson, wheeled his horse around and descended the hill. According to a correspondent for the *Charleston Mercury*, whose account of the battle was published four days later, General Bee attempted to rally his brigade. Gesturing toward Jackson with his sword, he exhorted his troops, "Look, men, there is Jackson

remembered, "for nine days, the General and his lady enjoyed as normal a life as military duties and anxieties would permit." The child was baptized, but word soon came that Union forces had launched the spring offensive, and the domestic idyll quickly came to an end.

Three days later, on May 2, 1863, during the Battle of Chancellorsville, shots rang out in the night as Jackson and his staff reconnoitered the terrain. Mistaking Jackson's scouting party for the enemy, a North Carolina regiment fired into the brush in the darkness. Struck three times by friendly fire, Jackson was badly wounded; hours later, his shattered left arm was amputated at the shoulder. Lee and his army prevailed at Chancellorsville as Anna and Julia returned to Jackson's side, but the wounded man died of pneumonia on the Sabbath, May 10, 1863.

In the days before Virginia's secession, Jackson, in typically terse terms, offered an opinion: "Military men make short speeches, and as for myself I am no hand at speaking anyhow. The time for war has not yet come, but . . . when it does come, my advice is to draw the sword and throw away the scabbard."

He followed his own prescription, and his tactics, which employed mobility, a thorough knowledge of topography, and rapid shifts from offense to defense, are still studied by military strategists. But as a man of few words, he left many questions unanswered. One was why, despite his apparent ambivalence toward both slavery and secession, he had proved such a determined warrior for the Confederate cause. Jackson was a reluctant secession-

the growl of the hunted beast . . . and the deeper tones of that wordless rage of the strong man as he leaps to guard the threshold of his home."

By five o'clock, the Union commander, Brigadier General Irvin McDowell, ordered a retreat. Reversing toward Washington, the Union army disintegrated into a chaotic mob. A crowd of civilians, picnicking nearby in order to watch what they had anticipated would be an easy Union victory, clogged the road to the capital. Bridges had been destroyed by artillery fire. In a heavy rain, the beaten Union forces straggled into Washington all through the night. *London Times* correspondent William Howard Russell saw a U.S. Army that "presented such a sight as can only be witnessed in the track of runaways of an utterly demoralized army."

His forces routed at Manassas, Lincoln signed a bill the following day authorizing the enlistment of five hundred thousand men for three years of service. For both sides, the battlefield at Bull Run was a shock: More than eight hundred men died there; three times that number were wounded. The realization took hold that there would be no easy victory for either side. Among the casualties was General Bee, who succumbed to his wounds the following day. His reference to his fellow West Point cadet, thereafter Stonewall Jackson, would long survive him.

The caped and bearded Thomas J. Jackson astride Little Sorrell, by Joseph Pollia. The bronze equestrian sculpture, dedicated in 1940 at the Manassas, Virginia, site of the two Battles of Bull Run, is inscribed THERE STANDS JACKSON LIKE A STONE WALL.

standing like a stone wall! Let us determine to die here, and we will conquer! Follow me!"

In the hours that followed, Jackson's men held their position. When the enemy drew close, Jackson ordered his men to charge forward with their bayonets bared and, as Jackson put it, "yell like furies." That was the enemy's first hearing of what came to be called the rebel yell, a mix, as one Confederate put it, of "shrill horror . . . the exultant shout [of the hunter] . . . the wild laughter of reckless youth that mocks at death . . .

ist; as his widow explained years later, in the lead-up to the war, he "maintained that it was better for the South to fight for her rights *in the Union than out of it*." Like many men of the middling sort in the antebellum South, he owned no great plantation, though he did own slaves (between them, he and Anna owned as many as nine). The first he acquired, Albert, was purchased at the behest of Albert himself, with the understanding that the black man would then buy his own freedom by repaying Jackson's investment in annual installments. Against the will of many in his congregation, Jackson founded a Sunday school for the slaves. "I am very confident," Anna Jackson wrote, "that he would never have fought for the sole object of perpetuating slavery." But Jackson chose his side, and, as happened in so many families, as a consequence, he alienated a sibling. His sister Laura Jackson Arnold, with whom Jack-

son had maintained a cherished relationship since their difficult childhood, was a staunch Unionist; her brother's devotion to the cause of the South left them estranged.

Even in death, his fame survived. Anna Jackson, who never remarried, would become prominent in a postwar organization, the United Daughters of the Confederacy. Known to many as the "Widow of the Confederacy," she represented her late husband at commemorative events; when she died, in 1915, she was buried in Lexington next to Thomas.

The loss of Jackson, age thirty-nine, had been a serious blow to the military fortunes of the Confederacy. Upon learning of the grievous wound Jackson had sustained, Robert E. Lee said sadly, "[General Jackson] has lost his left arm, but I have lost my right arm."

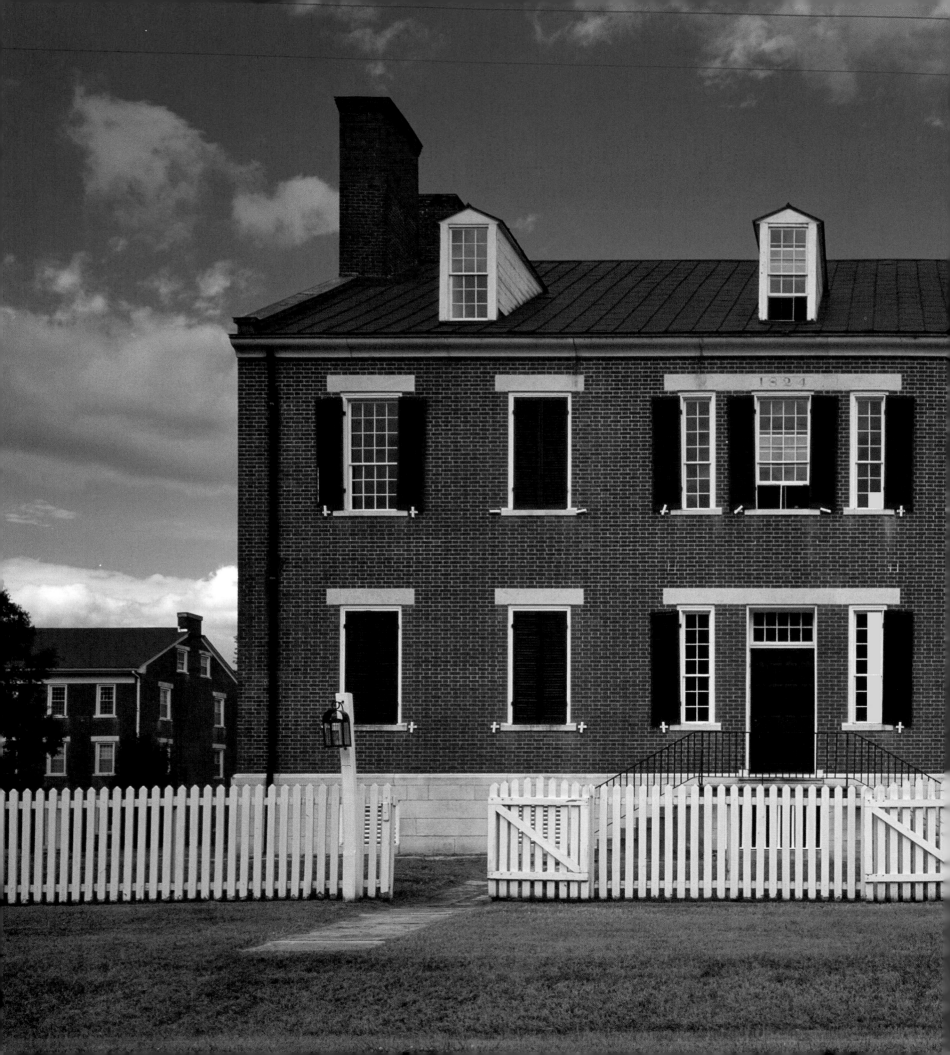

ELDRESS NANCY MOORE AND SOUTH UNION SHAKER VILLAGE

AUBURN, KENTUCKY

"So we had soldiers East of and West of us

and rebels all around."

ELDRESS NANCY E. MOORE

August 29, 1864

The Shakers at South Union occupied the eye of the storm. In the disputed border state of Kentucky, waves of warriors—Confederate cavalry, Union infantry, and guerrillas of uncertain allegiance—visited and revisited the communal settlement near Auburn.

The first recorded military arrival was one Colonel Forest. He rode into South Union on August 15, 1861, together with his cavalry company of eighty-six men with small "secesh flags" flying from the bridles of their horses. Having made camp near the community's millpond, the Confederates enjoyed the supper and breakfast the Shakers prepared for them, along with freshly picked apples and peaches, all at no charge.

Before departing, the colonel called his volunteers into formation in order to address them. If they wished to leave, he advised,

and return to their homes, "now was the time." Six men chose to step aside and, according to a journal kept by Shaker Eldress Nancy Moore, "the Colonel bemoaned them to the last degree. Some of our brethren who heard him, thought they could hardly have borne it. But these poor fellows seemed to have gotten the scales a little off their eyes by that time, and stuck to their good resolution, and left him. I suppose they went home."

For the Shakers, the visit of the cavalry was both a warning and an unwanted intrusion. Their creed was pacifist, and their very definition of themselves and their faith was that they were not of "the World." As Elder Harvey Eads wrote to Lincoln some months later, "There is not money enough in the vaults of the nation . . . to induce *one truly honest Shaker*, to engage in *any* war against his fellow man." When ordered to produce guns in support of the rebellion, the entire community of more than two hundred Believers produced just two, one of which was so outmoded the army rejected it.

Though firmly inclined to support the "Loyal States" (the sect had formally freed all their slaves in 1817), the Believers understood they must not take a side. The war rent Kentucky; in 1861, nearby Bowling Green became capital of Confederate Kentucky. Cannon fire echoed in the distance from Fort Henry and Fort Donelson, and, after both fell to Ulysses Grant's forces in early 1862, the Confederates withdrew from Bowling Green. Union control proved tenuous, and the Shakers endured the comings and goings of soldiers in both blue and gray uniforms on their way to or from

Previous spread: Like all Shaker villages, South Union saw a gradual decline in membership. From a high of perhaps four hundred, the community shrank to the mere handful of brothers and sisters that departed in 1922 after word from the ministry at Mount Lebanon, New York, that the Kentucky community was to close. A railroad man named Oscar Bond bought the property and, over the course of the next few years, reduced what had been a village of some two hundred buildings to today's *nine* survivors. The main Centre Family Dwelling, where roughly a hundred Shakers once resided, is the largest and most impressive structure still standing.

Opposite: Seated at the center of her Shaker family is diminutive Eldress Nancy Moore, her warm countenance framed by a white shawl. Seated on Moore's right is Eldress Betsy Smith. *South Union Shaker Village*

Above: The Centre Family Dwelling is symmetrical, as this image of the second-floor hall suggests. There are matched stairs (west for sisters, east for brethren), pairs of doorways, and separate chambers; even the dining room has his and hers sides. It's a big, impressive building yet a deceptively simple one oriented to the principle of separation of the sexes.

nearby skirmishes or raids ("We were disturbed," Nancy recorded in September 1862, "by the sound of Cavalry horses sweeping thro' our village on the gallop"). Rumors spread that the notorious Confederate raider John Hunt Morgan camped in the neighborhood.

Their first military visitor, believed to have been Colonel Nathan Bedford Forrest, would go on to earn fame in battle (historian Shelby Foote called him one of the two "authentic geniuses" the war had produced; the other was Abraham Lincoln). According to one Union officer, Forrest was "the only Confederate cavalryman of whom Grant stood in much dread."

In peace, the Shakers sought to live apart from society. With the marching of armies across central Kentucky, these peaceful people found themselves drawn unavoidably into the World's war.

A sisters' chamber: While the Shakers lived according to prescribed discipline, they maintained a comfortable and secure lifestyle for their era, as they were well clothed, ate fresh foods often harvested on their own lands, and shared a powerful sense of faith and community. South Union was also a place of calm in war-torn Kentucky; as one grateful lieutenant told a South Union elder, "I shall never forget Shakertown. It is the one green spot in Ky. [that] . . . from Louisville on down to B.[owling] Green was a continual scene of devastation."

ELDRESS NANCY MOORE

The United Society in Christ's Second Appearing came into existence in America when founder Mother Ann Lee, regarded as "the first spiritual Mother in Christ," and eight followers arrived in 1774. The group gained its nickname from the dancing rituals of its worship; the dismissive "Shaking Quakers" evolved into the widely accepted Shakers.

According to Mother Ann, the road to redemption was a rigorous one, starting with the individual's recognition of Adam and

Eve's transgression in Eden as the "root and foundation of human depravity." Each faithful Shaker promised to remain celibate and to live apart from the opposite sex; as there was no progeny, new members came from converts and the orphans the Shakers took in. Equality of the sisters and brethren became a precept of the faith, and Shaker governance consisted of pairs of elders and eldresses, who were charged with spiritual matters, and similar pairings of trustees, who managed practical matters. The Shakers held all property communally, since joining required that members consecrate their worldly goods, lives, and labor to their faith. In Mother Ann's words, the guiding principle was "Put your hands to work and your hearts to God."

The Shakers began to spread their gospel in New England and New York, and in 1806, Shaker missionaries went west and found converts in Ohio, Indiana, and Kentucky. Within a few decades, the Shakers had gathered communities over a wide geographic range, extending from Alfred, Maine, to their southernmost village in South Union. By the time of the Civil War, the head ministry, based at Mount Lebanon, New York, administered to the spiritual lives of some five thousand sisters and brethren at eighteen locations in seven states.

Nancy Elly Moore (1807–1889) had arrived at South Union in November 1811. Though accompanied by her parents, four-year-old Nancy took up residence with the other children in the junior order. As elsewhere, the South Union Shakers organized their village in groups known as families that typically numbered between forty and a hundred persons. At South Union, they included the Church (or Centre), North, West, and East families, and the last had a "Domicil of the Negroes," its elder a former slave named Neptune. In the years that followed her arrival, Sister Nancy rose to a leadership position in the Centre Family, then moved to the lead ministry with the Church family in 1850. She would remain a Shaker until her death, twenty-three days after suffering a stroke at age eighty-two.

The facts cited constitute the little we know of Eldress Nancy's life. With the advent of war, however, she took pen in hand to

A brothers' bedroom: When asked by Rebel soldiers if the Shaker community was "a Union town," one Shaker brother replied, "Some call it so, but we take no sides, we are neutral."

compose a daily diary. "We have a feeling to record," she began in August 1861, "some of the most important items or incidents, concerning this unnatural war, which has brought, and is now bringing so much destruction, distress, and desolation over our once free and happy land."

Her 1,088-day journal described the Shakers' agrarian culture, enumerating such prosaic events as the ripening of berries in the strawberry patch and peaches in the orchard; "a fine ox killed to day in the field with lightening while the storm raged"; the harvesting of rye, wheat, and hay; and the picking of mulberry leaves for the silkworms. Writ into the tranquil cycles of the seasons were gleanings from newspapers, reports of military action elsewhere that offered clues to the progress of the war. Yet the reader encounters in Eldress Nancy's plain prose a sense of the immediate threat posed to South Union's existence by the unending military interruptions.

The State Road, the main east–west passage through central Kentucky, bisected the Shaker village of some two hundred buildings, which included a meetinghouse, dwellings, shops, a tannery,

Elder Harvey Eads's walnut desk may have been the last piece of furniture made at South Union. As with many Shaker-made objects, it was manufactured specifically for its user. Note the lamp rest, mounted on a movable iron arm. Its position on the right side is explained by the fact that Eads was left-handed.

fires and their fodder fed to military horses and mules. The armies confiscated many Shaker horses.

The demands of the war threatened more than Shaker coffers when conscription forced the Shaker brethren to plead for conscientious-objector status. Mount Lebanon Elder Frederick Evans met personally with President Lincoln, and the appeals of Elders John Rankin and Harvey Eads finally prompted a telegram from Secretary of War Edwin Stanton exempting the brethren at South Union "whose conscientious scruples adjure war."

By dint of self-discipline and their deep faith, and despite repeated demands on their resources, the Shakers managed to stay out of the line of fire. As a hired tradesman at South Union remarked in 1864, "Certainly there is a charm throwed over this place, I know that the hand of Providence is stretched out to guard and protect it from harm."

SHAKER ARCHITECTURE

In the Civil War era, the word *Shaker* identified an individual who belonged to the United Society of Believers. Nancy Moore, for example, was a Shaker, a member of the faithful. Today, however, although a few members of the sect still live at the Shaker community at Sabbathday Lake, Maine, the word *Shaker* is most often applied in other ways.

In contemporary usage, *Shaker* has become a label that identifies a style of design. To purveyors of kitchen cabinets, for example, *Shaker* is a term used to describe doors with plain, flat panels. In part, this is the result of the popularity of the sect's widely admired furniture, objects that, ironically, had no particular status in their own time; the purpose-made, unadorned country furniture—tables, chairs, stands, and case pieces—reflected the simple ways of the Shakers themselves. But *Shaker* in its newer sense has entered vernacular English just as the simplicity of Shaker objects has influenced modern artists and international design. No wonder that, in 1989, one Sabbathday Lake sister, Mildred Barker (1897–1990), lamented to a reporter for the *National Geographic*, "I don't want to be remembered as a chair."

a school, mills, barns, and numerous agricultural structures. The region's rail line angled across the Shakers' large holdings of some six thousand acres. In peacetime, the easy access to transportation enabled export of community-produced goods like jellies and preserves, herbs, flat brooms, baskets, and woven items; in war, it meant the constant transit of troops. They came by the dozens, the hundreds, even a thousand or more at a time.

Some days the South Union Shakers baked hundreds of loaves of bread and saw their livestock slaughtered to feed their uninvited, uniformed guests; they served an estimated fifty thousand meals during the war to soldiers camped on their grounds. The menus include fried ham, baked chicken, boiled beef, fresh bread and biscuits, potatoes, corn bread, strawberries, peaches, pies, and coffee. Sometimes the officers paid in dollars, sometimes in Confederate scrip, but often they paid nothing at all. Other costs accrued too, as Shakers watched their fence rails tossed into bon-

The surviving buildings at South Union offer the visitor a chance to witness something of the Shakers' ascetic life in the nineteenth century and learn of the Shaker aesthetic that has come down to us in the twenty-first. Only nine structures survived the closure and sale of the community in 1922; the new owner demolished most of the buildings and ground up Shaker gravestones for agricultural lime. Yet the Shaker structures that still stand bespeak the spirit of the Believers.

Long before Louis Sullivan uttered his oft-quoted and variously interpreted aphorism "Form ever follows function," the Shakers set about constructing eminently practical buildings that embodied the strictures and the spirit of their faith. Separation of the sexes meant a mirrored parallelism in design that involved separate entrances and pairs of staircases. Not by accident, this also produced a bilateral symmetry evident in pleasingly balanced façades and interior elevations.

At a time when architecture in the outside world drew upon Roman and Greek buildings—think of a façade with a column or pilaster on each corner supporting a triangular pediment above, echoing the classical temple form—the Shakers eschewed most ornaments, eliminating the unnecessary, the fancy. In the absence of classical orders (you'll see no capitals or friezes with triglyphs or other carved decorations in Shakerdom), their buildings present as geometry. Despite Shaker religious devotion, the austere buildings lack any iconographic scheme; the designs are plainly patterned and rational.

Wood-frame construction had been the norm in the New England communities, but as Benjamin Seth Youngs, one of the founders of the South Union community, wrote in 1818, "We are much put to it for a little building timber, as it is extremely scarce here … but good building stone of different kinds & the best kind of materials for brick, we have convenient & in plenty." In the two most essential survivors at South Union, the Centre Family Dwelling and the Ministry Shop, the walling material is brick, set off by foundations, window lintels, and even gutters made of limestone. Tall chimneys rise to the heavens, and rows of large win-

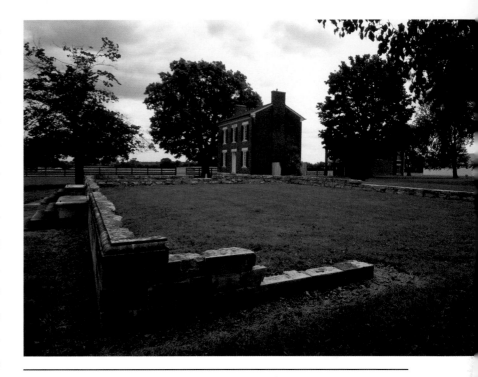

The meetinghouse at South Union was demolished almost a century ago, but the reconstructed foundation indicates its original footprint. The Ministry Shop where Nancy Moore resided, built in 1846, still stands (*rear, center*).

dows brighten the interiors.

Superior craftsmanship reveals itself. Despite keeping their vision on the divine and the hereafter, the Shakers built structures to endure, demonstrating that beauty can be simple. Though monastic, they endowed their spaces with a majesty born of plain surfaces, the play of light, and natural materials.

The untutored architecture at South Union speaks for the Shaker way, as does Eldress Nancy Moore's remarkable diary. The Shakers always sought to live apart from the world, and though that proved difficult to do in a state that Elder Eads described as "baptized in fire & Blood," the Shakers in wartime never ceased improving their peaceable community. As one Union officer observed on seeing a newly laid stone walk at South Union, "We ought to engrave in deep letters which can never be erased, 'Laid in the year of the Rebellion of 1862. While the people of the United States were at war fighting & killing each other the Shakers remained quietly at home improving their Village.'"

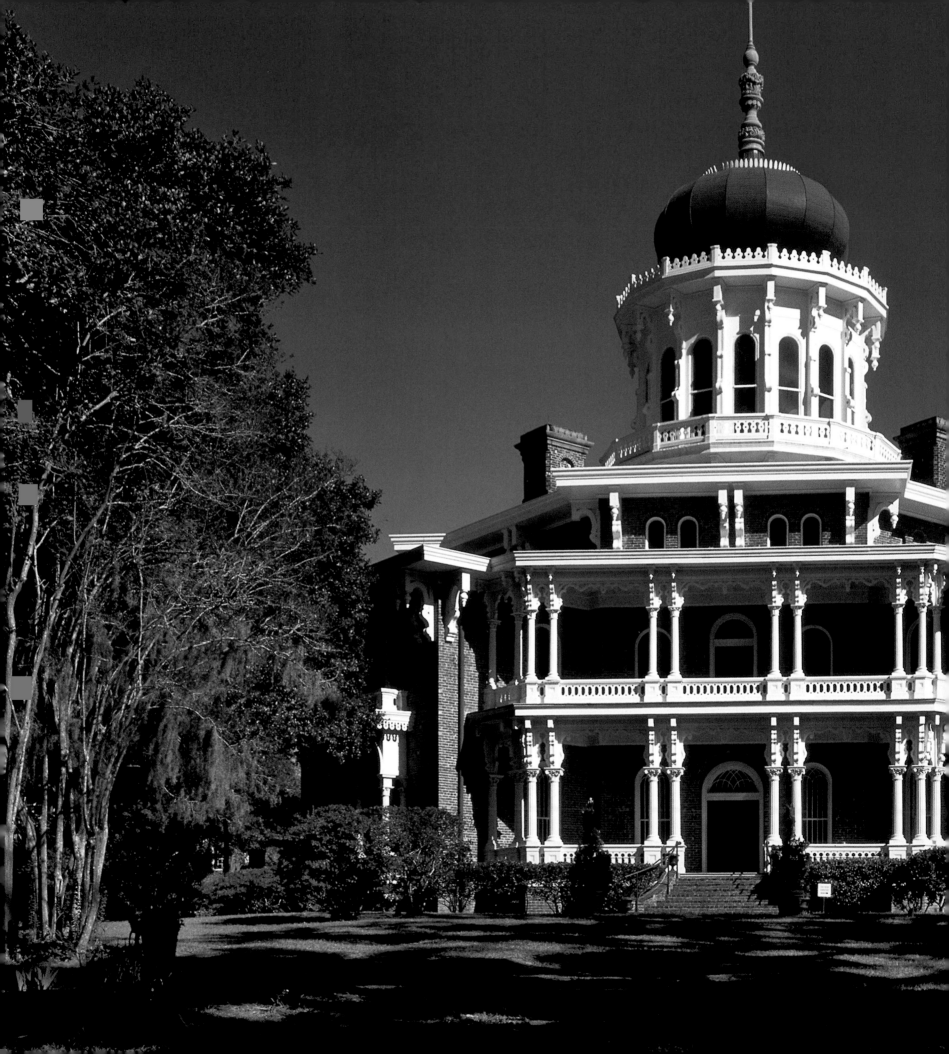

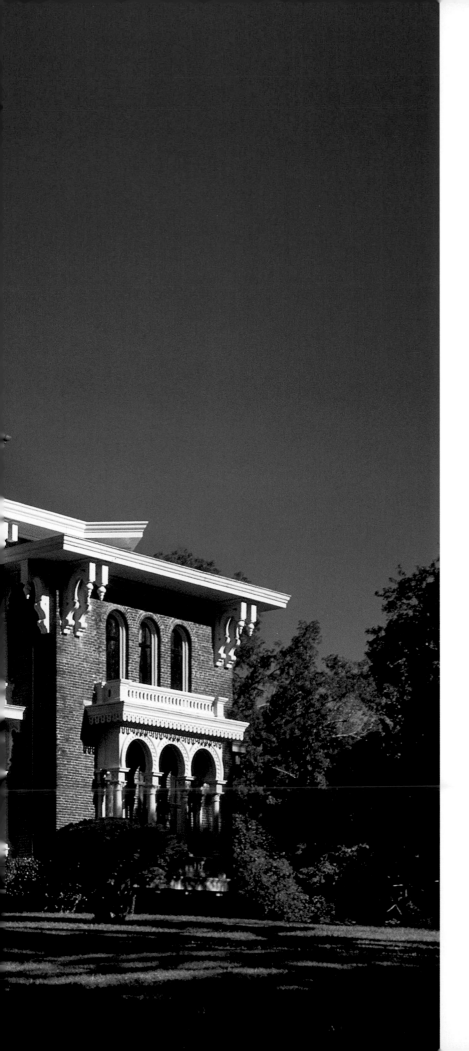

HALLER AND JULIA NUTT AT LONGWOOD

NATCHEZ, MISSISSIPPI

"Natchez is a . . . congregation of wealthy
planters and retired merchants & professional
men, who have built magnificent villas. . . .
Wealth & taste, a most genial climate and kindly
soil have enabled them to adorn these, in
such manner as almost to give the Northerner his
realization of a fairy tale."

GENERAL THOMAS KILBY SMITH

1863

THE END OF AN ERA

Like many an architect, past and present, Samuel Sloan made a promise he could not keep. Despite the complexity of his design and the twelve hundred miles that separated him from the building site, Sloan wrote to his client in March 1860, "I calculate you to move into the house by the 1st of . . . next May."

History intervened, and, a century and a half later, the immense octagonal house that Haller Nutt commissioned remains unfinished. The visitor today sees gaping window frames that punctuate the towering walls of the immense brick edifice. Inside, a bare skeleton presents itself, a pine frame of studs and joists that reaches to the apex of the dome six stories above. At Nutt's Folly, to use the house's derisive nickname, most of the thirty-two rooms in the thirty thousand square feet of living space look just as they did when Sloan's deputy on the building site, a Philadelphian master carpenter named Smith, departed Natchez in September 1861, leaving the house far from finished. Smith headed for Union lines and home.

Ironically, despite the several architectural books Samuel Sloan published and many surviving public and private buildings of his design, Longwood stands as Samuel Sloan's best-remembered work. Its evocative story, emblematic of the fortunes of the cotton barons before the Civil War, elevated Longwood to the status of the quintessential architectural icon of the Civil War South.

THE JEWEL OF THE MISSISSIPPI

The location helped make Natchez inevitable. French settlers established a trading post at the river's edge in 1714; two years later, soldiers of Louis XV constructed Fort Rosalie atop the two-hundred-foot bluff with its panoramic view of the Mississippi River. As the number of inhabitants grew and the acres in tillage radiated out from the settlement, the once passive Natchez Indians began to resist European encroachment on their native lands. After an Indian massacre in which perhaps two hundred French settlers died, the military retaliated, driving the local Native Americans from their lands in 1731.

The British (after the 1763 Treaty of Paris) and the Spanish (in 1779) each took a turn administering the territory, but it would be the Spanish who laid out the town grid, in 1791–1792, for the pre-

Previous page: A widely popular book titled *A Home for All* by Orson Fowler helped make octagons all the rage in the 1850s. Although Haller Nutt's house has been variously termed Victorian eclectic, Oriental, Moslem Revival, and Persian, perhaps the best description would be Italianate crowned with a Moorish onion dome.

Opposite: To visit the unfinished Longwood is to walk into a ghostly drama. The ceilings in the basement level are fourteen feet high, those on the second, twelve. The towering space that was to have been the central rotunda, extending up to the cupola and dome, was six stories tall, and a glazed, sixteen-sided lantern just beneath the dome would flood the place with light enhanced by the multiple mirrors.

Longwood is a very big house indeed, with a circumference of 296 feet and a height (to the top of the twenty-one-foot flagpole and finial) of more than 100 feet. The boxlike contraptions pictured here are skylight wells that permit light to reach the finished rooms in the basement level.

dominantly English-speaking populace, who occupied fewer than a hundred homes on the hilltop. The United States took control of the Natchez district in 1798, when an act of Congress established the Mississippi Territory. The town of Natchez (the name rhymes with *matches*) was formally incorporated in 1803, and Mississippi became the twentieth state to enter the Union in 1817. Yet this listing of dates and political transitions reveals little about how Natchez transformed itself into an ideal place to get rich quick; that was due to a concatenation of other factors.

For much of the eighteenth century, fertile soils and abundant rainfall produced bountiful harvests of wheat, fodder, tobacco, and indigo for Natchez farmers, but as the century drew to a close, a new crop emerged as the sine qua non for the nouveau riche who came

to dominate the town in the years leading up to the Civil War. In 1794, the cotton harvest amounted to fewer than forty thousand pounds; within five years, the rough-and-tumble waterfront district, called Natchez-Under-the-Hill, saw the exportation of three *million* pounds of cotton. The first of Eli Whitney's cotton gins had arrived in the district in 1795, making possible the rapid and efficient separation of vegetable fibers from the seeds in the capsule (or boll) of the cotton. With the inauguration of steamship service in 1811, the raw cotton could reach the market more quickly. The ingredients for sudden prosperity were in place.

For the planters of Natchez, the microeconomic model for attaining affluence ran like this: A modest seventy-five-acre holding would yield perhaps a hundred bales a year, producing, in turn, approximately four hundred pounds of ginned cotton. That represented a handsome profit of several thousand dollars in an average year; in very good years, the sum might be double or triple that. As Natchez bankers provided credit to the planters, the profits could then be reinvested by the planters to acquire more land. Leveraged

Inside Longwood, paint pots and an abandoned workbench remain, left by Yankee craftsmen departing in 1861.

gains meant the hundred-bale-per-year planter could aspire to a higher plateau and, not so many years out, might eventually have holdings that produced a thousand bales per year. That would make him wealthy by any standard.

The worldwide demand for cotton and cotton goods, driven by explosive industrial growth, provided the macroeconomic backdrop. By the time the Union forces surrendered Fort Sumter in April 1861, three-quarters of the cotton sold on world markets came from the American South, and cotton constituted more than half of the nation's exports. Thus, it was no coincidence that, in a mere half century, Natchez went from a frontier town to the home of more millionaires per capita than any other city in the United States.

The agricultural holdings of the city's planters extended upstream into the Mississippi Delta, across the river into Louisiana, and beyond to Arkansas and Texas, but the accumulating wealth made Natchez itself a western outpost for opulence and display. According to one British visitor, the inhabitants were "the most elegant, both in dress, appearance and ease and polish of manners, that I had yet seen in the United States." The planters desired homes that expressed their newfound wealth, which led to a building boom. As the young Frederick Law Olmsted wrote in 1854—he was then a reporter for the *New York Daily Times*—"Within three miles of the town the country is entirely occupied by houses and grounds of a villa character."

In the same way that the dresses of the day relied on unmentionable underpinnings of laces, stays, and crinolines, the cotton industry depended on slavery. Growing, harvesting, ginning, and baling cotton were all labor-intensive, and the work fell to enslaved laborers. A healthy slave could be counted upon to produce seven or eight bales of cotton a year, and "chattel," like land, could be bought on easy credit terms, so planters accumulated slaves in tandem with plantation acres. There was no moral taint to being a

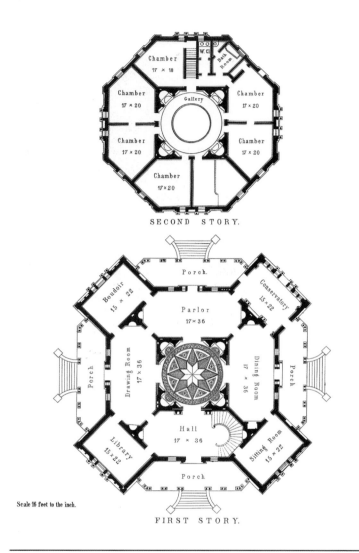

Chamber
17 × 18

W. Cl.

Bath
Room

Chamber
17 × 20

Gallery

Chamber
17 × 20

Chamber
17 × 20

Chamber
17 × 20

Chamber
17 × 20

SECOND STORY.

Porch.

Boudoir
15 × 22

Conservatory
15 × 22

Parlor
17 × 36

Porch

Drawing Room
17 × 36

Dining Room
17 × 36

Porch

Hall
17 × 36

Library
15 × 22

Sitting Room
15 × 22

Porch.

Scale 16 feet to the inch.

FIRST STORY.

In this plate from volume 2 of *The Model Architect*, Sloan's clever geometric design allows for rooms with square and oblique corners as well as a cylindrical rotunda, all within an octagonal footprint.

slaveholder; as one Mississippi advocate for secession put it while Longwood was under construction, "Slavery was ordained by God and sanctioned by humanity."

Haller Nutt occupied a place on the top rung of Natchez society. His wife, Julia, grew up in the town; a graduate of the University of Virginia, Nutt was a "scientific farmer" (he and his planter father both developed varieties of cottonseed well adapted to Natchez's climate). His large holdings included five plantations, three in Louisiana and two in Mississippi, along with eight hundred slaves to work more than forty thousand acres.

Though an opponent of secession and a confirmed Unionist, Haller Nutt, along with his secessionist friends and neighbors, soon found himself enmeshed in a war that would bring the grand days of Natchez to a sudden, shocking halt.

AN ORIENTAL VILLA

In an optimistic moment—it was Christmas Eve 1859—Haller Nutt wrote to Samuel Sloan. The time was nigh, he told the Philadelphia architect, to build his Natchez house, and he needed plans and specifications. Sloan wrote back with a promise to journey to Mississippi within a fortnight. The architect wanted to close the deal on Nutt's lavish and prestigious commission, and their copious correspondence soon produced the necessary construction specifications.

Haller and Julia chose a design they had found years earlier in the pages of Sloan's book *The Model Architect*. Looking to build a grand house in Natchez to complement the cottage at their plantation in Tensas Parish, Louisiana, they wanted Sloan to reconfigure design forty-nine in his 1853 book to accommodate their seven children, who ranged in age from one to eighteen years, with another expected in the new year. Haller had acquired the Natchez property known as Longwood a decade earlier as a gift for Julia.

Their new house on almost ninety acres would be a *villa suburbana*, one of many grand mansions within an easy carriage ride of the town. But theirs would be different, constructed on an eight-sided footprint. The details of their octagonal house would also differ from those of several recently built mansions in Natchez. The Nutts' grand new home would be decorated not by Ionic and Corinthian orders but by Italianate and Moorish elements.

Its scale also distinguished the new house. The plan for the main floor featured four rooms that measured twenty by thirty-four feet, four more measuring eighteen by twenty-four feet, and four large verandas. The most impressive space was the rotunda at the core: twenty-four feet across, the space would soar six stories. Sloan and the Nutts thought large in almost every way, with specifications calling for 115 doors, 125 windows (some of them eleven feet tall), 26 fireplaces, 24 closets, and dozens of gaslight fixtures. The

The dining room may seem grand (the dimensions are eighteen feet by twenty-four), but it is hardly so compared to what was planned. The architect's renderings called for a thirty-two-room house, including a sun parlor on the fifth-level balcony and an observatory on the sixth. Note the fly fan over the dining room table. Called a punkah, this device was powered by a slave who pulled on the rope and made it swing, keeping flies away from the table.

hardware was to be silver-plated. Managing such a place would take manpower; not including the children's tutors and governesses, thirty-two enslaved servants were to wait upon the occupants.

At first, construction proceeded apace. As a crew dismantled an existing home on the property and dug a mammoth new cellar hole, a team of fifteen men and eight boys made the bricks on-site. Guided by four masons that Sloan sent from Philadelphia, the laborers began constructing the twenty-seven-inch-thick walls, but as they did, a shift in American politics was under way elsewhere on the continent. The "Illinois Rail-Splitter," a sworn enemy of extending slavery into new territories and states, ran for president.

That autumn saw the arrival at the building site of millwork from Philadelphia, a shipment that included more than a hundred columns and pilasters, as well as brackets, door frames, and almost two miles of molding. But events elsewhere continued to unfold: a month after Lincoln's November 1860 election, South Carolina seceded from the Union.

The walls at Longwood rose steadily, and the trim was being applied like frosting to a layer cake as Mississippi withdrew from the Union on January 9, 1861. The four Yankee masons worked only until March; with the masonry shell nearly complete but war looming, they left for home. Though master carpenter Smith worked on, along with a tinner from Philadelphia who arrived to apply the roof and complete the building's envelope, the last Yankee workers departed for good in September, leaving behind an empty shell.

Relying on his slaves and local artisans, Nutt managed over that winter to plaster and complete the interior finish on the basement level, after which he and his family moved into the cellar of the grand house. Whatever Nutt's earlier dreams, the remaining, grander stories of Longwood would never be finished.

WAR AND PEACE

Begun in peacetime and marooned by war, Haller Nutt's Longwood—unfinished inside but a grand sight indeed from without—survived the War between the States. The same could not be said for either Nutt's fortune or the man himself.

His terrible timing put him in the crossfire. Though he was both a Southerner and a supporter of the Union cause, the Confederate and U.S. armies each contributed to his financial ruin, as his plantations, warehouses, and other possessions were confiscated or destroyed. Despite a "protection paper" issued by General Grant, Nutt's Louisiana plantations were an almost complete loss (though the house at Winter Quarters survives). With his crops burned and the Union's having taken over the port of New Orleans, he owned nothing he could sell and lacked the means to get goods to market. Haller Nutt, a man of sometimes sickly disposition, contracted pneumonia and died at age forty-eight on June 15, 1864.

After the war ended, Julia Nutt and, later, her sons pursued a reparation claim against the federal government, seeking compensation for property confiscated by Union forces, including livestock, tools, lumber, and brick from the Longwood building site, as well as damages for fields and agricultural buildings burned by soldiers. The case outlived both Julia (1822–1897) and the nineteenth century, but, over time, Haller Nutt's heirs collected compensation

BATTLE OF SHILOH

The two-day battle waged in the vicinity of a tiny log church near the Tennessee-Mississippi border foretold much that was to come in the ensuing thirty-six months of war. The casualty count alone stunned both capitals: The loss of 23,746 men exceeded the combined dead, wounded, and missing in all previous American wars. Shelby Foote, author of the magisterial three-volume *The Civil War*, put it into context: "Shiloh had the same number of casualties as Waterloo. And yet, when it was fought, there were another twenty Waterloos to follow."

Confederate troops under the command of General Albert Sidney Johnston opened the fighting with a dawn attack on April 6, 1862. Looking to prevent the Army of Tennessee from proceeding south to the crucial rail and communications hub at Corinth, Mississippi, Johnston caught General Ulysses Grant and his men by surprise. Initially the Confederates advanced, but their clear advantage faded in a long day of fighting. In the midafternoon, a bullet that may have been fired by one of his own men struck Johnston behind his right knee as he led a charge. A severed artery soon filled his boot with blood; despite the application of a tourniquet, the Confederate general died of blood loss. By nightfall, when the fighting finally ceased in a teeming rain, the outcome wasn't clear, despite the telegram that Pierre Gustave Toutant Beauregard, who had assumed Johnston's command, sent to Jefferson Davis announcing A COMPLETE VICTORY.

Another general joined the fray in the night: Don Carlos Buell arrived with the Army of Ohio. Grant opened day two with an attack, and, again, long hours of fighting ensued. Before Grant's much larger force could overwhelm the Army of Mississippi, Beauregard and his army managed an orderly retreat to Corinth.

The Battle of Shiloh saw the reemergence of Union general William Tecumseh Sherman as an effective commander following a bout of depression (see "General Sherman Occupies the Green-Meldrim House," page 152). Some of the best-known skirmishes of the war also took place at Shiloh, including one at the Peach Orchard, where fallen soldiers lay beneath a shower of blossoms, and another at the Hornets' Nest, a stretch of road lined with impenetrable underbrush where three Union divisions turned back a series of Confederate attacks.

Today, the battleground is the site of the Shiloh National Cemetery, where 3,584 Civil War dead are buried; just two of them fought for the South. The log church around which Sherman's troops encamped and that Beauregard used as his headquarters has been reconstructed, adding a poetic touch. In Hebrew, the word *shiloh* means "the place of peace."

Opposite: The Battle of Shiloh—also known as the Battle of Pittsburg Landing—saw many men fall in the exchange of cannon fire. Ambrose Bierce, a Union soldier from Indiana who would later become a noted writer and editor, remembered the battle twenty years after: "And this was, O so long ago! How they come back to me—dimly and brokenly, but with what a magic spell—those years of youth when I was soldiering! Again I hear the far warble of blown bugles. Again I see the tall, blue smoke of camp-fires ascending from the dim valleys of Wonderland."

payments that came to some two hundred thousand dollars. It was a mere fraction of losses that totaled in the millions.

Submerged in the legalese of Julia Nutt's court filings is testimony to the human loss. "On June 16, 1864, I buried my husband. He had gone to Vicksburg on private and public business; and was much exposed; and taking pneumonia died suddenly. It was not Pneumonia that killed him. The doctor said it was not. It was his troubles. Three million dollars worth of property swept away; the labor of a life time gone; large debts incurred by the War; pressing on him, and his helpless wife, with eight children and two other families looking to him for support. All were reared in the lap of luxury and now utter poverty stood before them. This crushed him and he died."

Three generations of Nutts inhabited Longwood: the widow Julia, her namesake daughter, and, later, three grandsons. The family made the best of the basement quarters until 1968, after which Longwood became a museum and the most visited site in Natchez, a city where showing off great houses became an essential source of local income. Although the site bears a formal designation as a National Historic Landmark, Longwood, a place of personal heartbreak with its share of unquiet ghosts, became something more too: an architectural metaphor of a historic moment when the rules changed.

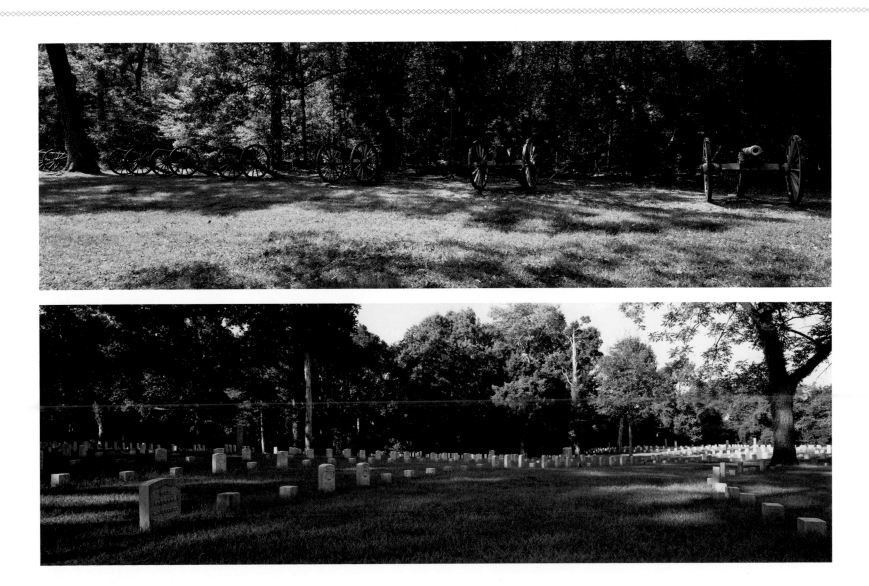

MARY CONRAD WEEKS MOORE AND SHADOWS-ON-THE-TECHE

NEW IBERIA, LOUISIANA

"I never saw a more delightful airy house, my room particularly. I have all the children in it and open the doors and windows every Night."

MARY CONRAD WEEKS TO DAVID WEEKS

June 1834

D espite the infirmities of her advancing age and the presence of the hated Yankees in her tall brick house, Mary Moore refused to leave the home she loved. For thirty years she had watched the waters of Bayou Teche flow past. She wasn't going to permit the Union occupation to change that.

With the surrender in April 1862 of New Orleans to the U.S. Navy, the encroachments of war had expanded in Louisiana. The fall of New Orleans meant more than just the loss of the Confederacy's largest, wealthiest, and most industrialized city. Just as important, the Federals gained control of the lower Mississippi River, the great water that constituted, as Abraham Lincoln expressed it, "the backbone of the Rebellion."

Mary Conrad Weeks Moore (born 1796) liked Lincoln not at all; she may have liked his military representative in New Iberia, General William B. Franklin, even less. He had banished her to the upper floors of her home and established his own headquarters on the ground level of Shadows-on-the-Teche. Federal troops encamped on her property, took over outbuildings, and set up their tents in her gardens. Mrs. Moore and her sister-in-law, Hannah Jane Conrad, retained only the second floor of the house and the attic spaces, which were used by their three house slaves (Louisa,

Previous page: The colossal (two-story) Tuscan columns of parged brick support the Doric frieze, gable roof, and pedimented dormers at Shadows-on-the-Teche. The building materials were local brick made from bayou clay, with wooden structural members of cypress harvested in nearby swamps. The builders were local craftsmen James and Jotham Bedell, jointer and mason.

Left: Painted in her younger days, this portrait of Mary Conrad Weeks Moore by John Beale Bordley was likely done shortly after her second marriage, in 1841. *National Trust for Historic Preservation/Shadows-on-the-Teche*

Opposite: The center door on the gallery opens to perhaps the most important public room on the main level, the formal parlor, with its American Empire furniture, brass astral lamp on the table, and Brussels carpet. Above the pier table (*right*) is an architectural watercolor of Shadows itself.

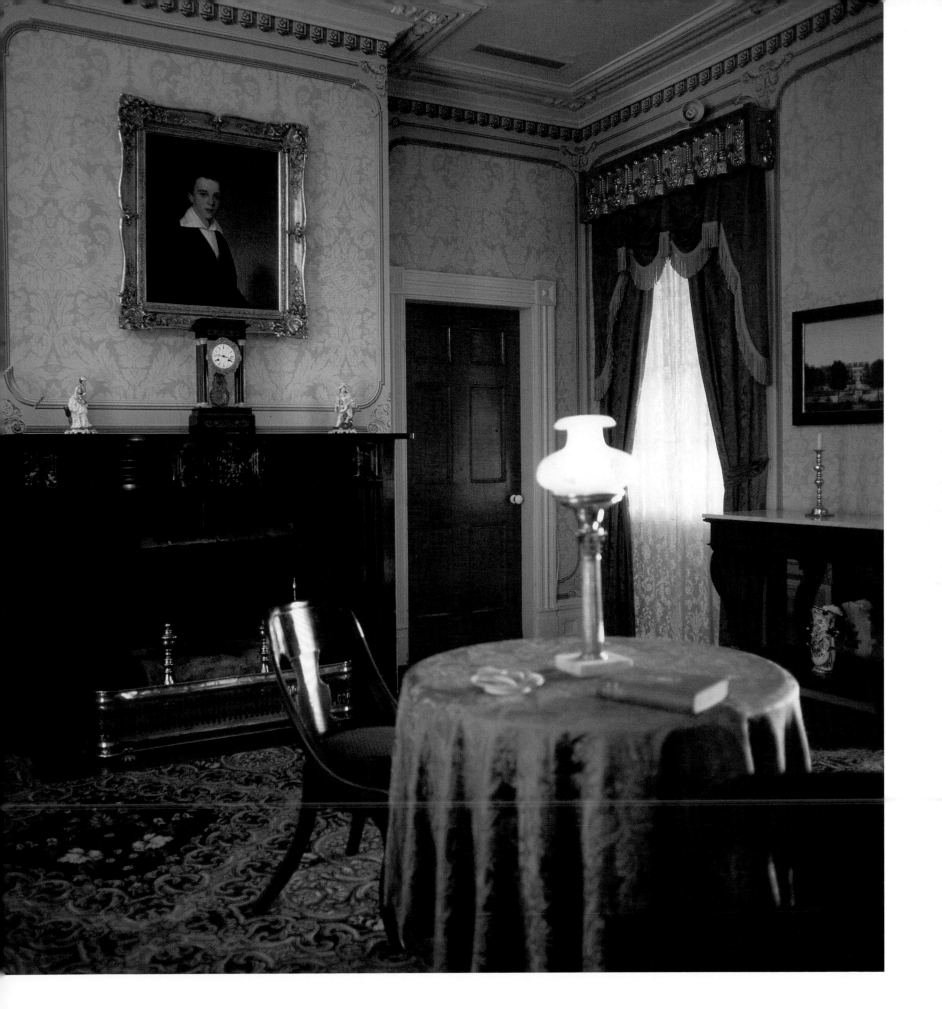

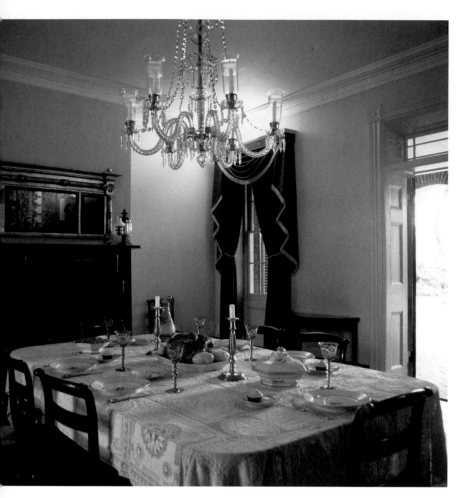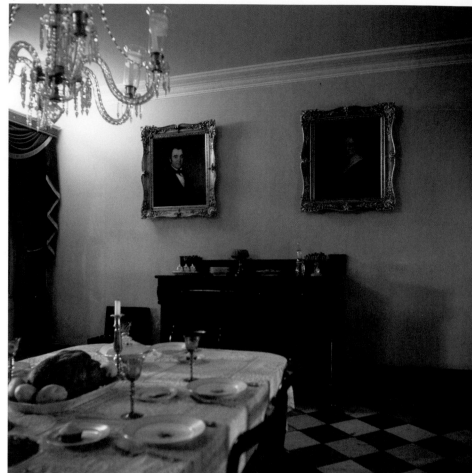

The ground-floor dining room features red twill draperies, consistent with a surviving 1835 invoice, and a gilt overmantel mirror (*at left*). Above the mahogany sideboard (*right*) are pendant portraits of her second husband, Judge John Moore, and Mary (*at right*). In 1846, the fifteen-room manor of some 3,700 square feet was assessed at $10,000, but the home remained in Mary's name, as the couple had signed a contract to ensure her children would inherit the property.

Charity, and Sidney). In the absence of her menfolk, Mary Moore complained, "We are alone having no gentlemen with us."

Mrs. Moore and General Franklin stood in perfect opposition to each other. He had the charge of Iberia Parish as Union forces moved to consolidate the region west of New Orleans, seeking to establish coastal Louisiana as a Union stronghold. In contrast, almost every aspect of Mary's life attested to her Confederate allegiance. In 1861, her husband, Judge John Moore, a former Louisiana congressman, had helped draft the state's Ordinance of Secession.

With the arrival of Union soldiers, he became a refugee, avoiding capture only by fleeing, along with other members of the family and most of their slaves, to destinations in Confederate-held areas of northwest Louisiana and Texas. Mary's grandson David Weeks Magill, a student in Virginia at the outbreak of war, became a lieutenant in an artillery unit stationed at Vicksburg, Mississippi, part of the Confederate force resisting the Union assault.

Mary admitted she felt "abandoned by all," bemoaning to her husband, "I fear I shall never see you again, my heart sickens with despondency, every thing seems so changed, my thoughts are all of gloom." Still, she insisted on staying at the house she and her first husband had built. As mail service was unreliable, she obtained news of her kin only intermittently. In September 1863, however, word did arrive of one family member, Lieutenant Magill. Her grandson, age twenty-one, had been killed in July at Vicksburg.

Although General Franklin occupied her property and, she admitted, conducted himself as a gentleman, Mary Moore would not abandon her principles. Her life with the Yankees might be easier, she was told, if she swore an oath of allegiance to the Union. Her refusal was adamant. She told her sister-in-law, "No[,] Hannah Jane[,] my Husband & children shall never know that mortification."

Her resistance ended, however, on December 29, 1863, in the darkness before dawn. At age sixty-seven, Mary Conrad Weeks Moore died in her sleep at Shadows-on-the-Teche. "The vital spark was extinguished," her son reported, "her body cold and lifeless. The candle had burned out & the book [she had been reading] still in her hand." As Hannah Jane reported to the widower husband, Mary's remains were interred in her garden, since "the graveyards were all open[,] the fencing having been torn down by the Yankees."

Whatever the indignities she suffered, Mary Moore remained on her property in the last months of her life, and that may well have prevented the house from being ransacked, the fate of so many other homes in captured territory. She helped assure that Shadows-on-the-Teche would be an extraordinary survivor of the antebellum era.

THE LOUISIANA SUGAR BOWL

Profits from sugar built Shadows-on-the-Teche. The industry began in Louisiana in 1794 when a New Orleans planter named Étienne de Boré successfully cultivated seed cane, a crop previously grown on Caribbean islands. Having constructed a sugar mill and drying room, he manufactured Louisiana's first granulated sugar the next year, turning a profit in the process.

Following his lead, other coastal plantation owners grew cane on their sea-level lands in the rich, alluvial soils. With levees to protect the watery acreage from floods, slaves for planting and harvesting, and sugar mills to process the sugar, the bayou country of shallow lakes and creeks soon became Louisiana's "sugar bowl."

Mary Moore's first husband, David Weeks (1786–1834), accumulated some two thousand acres on remote Grand Cote Island (now called Weeks Island), where his sugar plantation provided him the wherewithal to raise his family in comfort. Eight children would be born to the couple, and in 1825, David moved his growing family to a 158-acre tract of land he purchased at New Town (today's New Iberia), twenty miles north of the remote island plantation.

Construction on the house known today as Shadows-on-the-Teche began in 1831. At a glance, the Shadows resembles its distant cousins farther north, those symmetrical houses termed *colonials*. Like vernacular Georgian- and Federal-style homes, the Shadows-on-the-Teche façade is symmetrical, stands two stories tall, and welcomes visitors at a center entrance. The columned, two-story porches are decorated with classical details, with Tuscan capitals and a Doric frieze. Upon stepping onto the porch at New Iberia's proudest house, however, a visitor can see the differences emerge.

In an era long before air-conditioning, the hot, humid climate demanded shade; thus the covered porches, called galleries, which protect the brick walls from the direct rays of the sun. The several doorways that open onto each of these porches give a clue as to the floor plan inside, as three entrances per floor look out on what was once the Old Spanish Trail that meanders westward. Contrary to the classic colonial floor plan, the center door does not provide access to a generous hall with a rising staircase; instead, it opens into the most elegant room in the house, the parlor. It is an airy creole floor plan within a neoclassical box.

The Shadows en suite plan incorporates no interior stairs or passageways, as the rooms, arranged enfilade (in a line), flow directly into one another. All the principal rooms open onto either the galleries at the front of the house or an open loggia at the rear. A partially enclosed exterior stairway to the house's other levels is accessed from the loggia, while the main staircase at the front is obscured behind slatted blinds, which also serve to protect the stairs from wind or blowing rain. Though most of the ground level of the house was given over to storage and service areas, the dining room is located there. The parlor, sitting room, and several of the bedchambers are on the main floor, raised high above grade as a stately *piano nobile* (literally, "noble level").

Construction of the Shadows required three years, but David Weeks would never see the completed building. The New Iberian climate was far from healthy—malaria, typhus, dysentery, yellow fever, and cholera took an annual toll on white and black inhabitants alike—but Weeks contracted something else, perhaps consumption (tuberculosis). Seeking treatment in the North, he boarded the steamboat *Lancaster* in May 1834, the month before his wife and six surviving children took up residence at their new house. Mary soon wrote him, "Our old furniture distributed about the rooms looks better than you would think." From the North, David shipped "carpeting enough for four rooms," along with a bookcase and other pieces of furniture. He died on August 25, 1834, in New Haven, Connecticut.

The lush bayou landscape, with its trademark live oaks and Spanish moss dangling from the immense oak limbs, has been described as a "fertile mud paradise." Mary Weeks might not recognize the grounds today; the landscape design was the work of her great-grandson Weeks Hall.

MARY'S HOUSE

For seven years, the widowed Mary managed the Weeks estate, which consisted of the fine house in New Iberia and the sugar plantation at Grand Cote Island. She married Judge Moore in 1841 but kept her property discrete from her second husband's. Partnership contracts, complete with accompanying schedules of slaves, specified her obligations to provide mosquito netting and "have Cabins made for the use of her Slaves at her individual cost." On her instructions, log cabins were constructed at Grand Cote Island.

After they had been tutored at home, her two elder sons went to the University of Virginia. William returned and operated the island plantation. With the coming of the war, the sale of granulated sugar, a major cash crop, become problematic. Sons Alfred and William, attempting to evade the Union blockade, purchased a steamboat to get their sweet cargo to Texas in early 1862. Alfred made it to the Texas coast, only to discover sugar prices had fallen.

With the occupation of southern Louisiana by Federal forces, the men in Mary's life left, and, once again, she assumed management of her estate. Perhaps because she had already survived widowhood and maintained her independence even after taking a new husband, she had a stronger sense than many of her sex did at the time that she needn't rely on men. She was more fortunate than many Southern woman, as several slaves continued to serve her; other Confederate ladies had to assume menial tasks for the first time in their lives in order to survive.

Life at the Shadows in good times represented a gracious and mannered ease, but it was the uglier reality of the sugar plantation on Grand Cote Island that made such a genteel world possible. One Scots visitor described Louisiana sugar plantations as "the most terrifying of all the various hells of the deep South to which blacks from the older slave economies of the tidewater states could be sold."

Mary Weeks Moore may well have been a more benevolent mistress than others in the business of making sugar. In one of her partnership agreements, she established that her slaves were to be "humanely treated" and, further, that those who "may be old and

infirm . . . shall be clothed, fed and receive all necessary medical attendance, at the Expense of the partnership." Yet no evidence survives of her inclination to educate, not to mention emancipate, the roughly two hundred slaves that generated the monies that made the Shadows and her life there comfortable in the decades before the Civil War.

When Mary experienced firsthand the enemy's arrival, she might have said, as one Virginia woman did, "We've seen the elephant at last." Mary Weeks refused to vacate her home for the habitation of a conquering army.

———— ⋈ ————

Like a well-constructed play, the story of Shadows-on-the-Teche consists of two distinct acts. For most of three antebellum decades, Mary Weeks Moore lived the life of a prosperous plantation owner, raising her children in New Iberia. After a lengthy intermission, her great-grandson Williams Weeks Hall inherited the property in 1922, appointed himself conservator in chief of the Shadows, and remained there until his death, in 1958, bequeathing the restored house to the National Trust for Historic Preservation.

Its two principal caretakers left its attics full of family papers, an invaluable cache of some seventeen thousand documents and letters that recount in vivid detail the political, economic, and family events that unfolded at Shadows. Scholars of African American history, the Louisiana sugar bowl, and the Confederacy have found riches in those documents, and visitors have found Shadows itself evocative and moving.

One of Weeks Hall's many famous visitors, writer Henry Miller, expressed the specialness of the house when he described Shadows as being "as organically alive, sensuous, and mellow as a great tree."

The ground level for the Weeks family included double pantries, a dining room, a bedroom, and an office, though room usage varied over time. The second floor included three bedrooms, a sitting room, a parlor, and, once the loggia area was enclosed, a music room. The third floor contained another bedchamber and storage rooms.

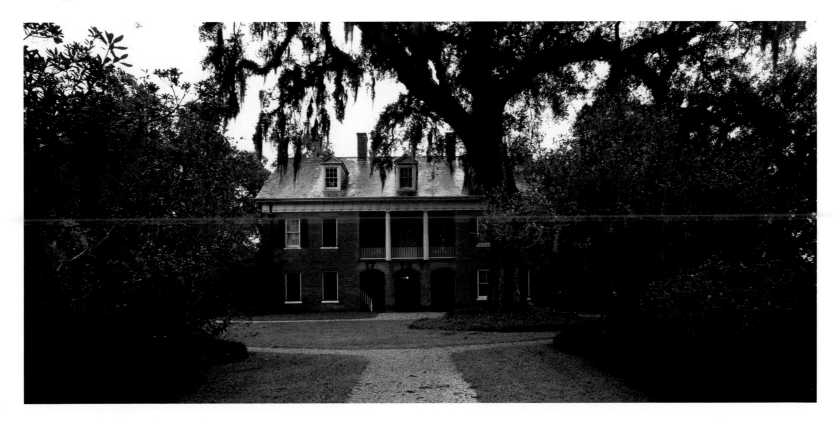

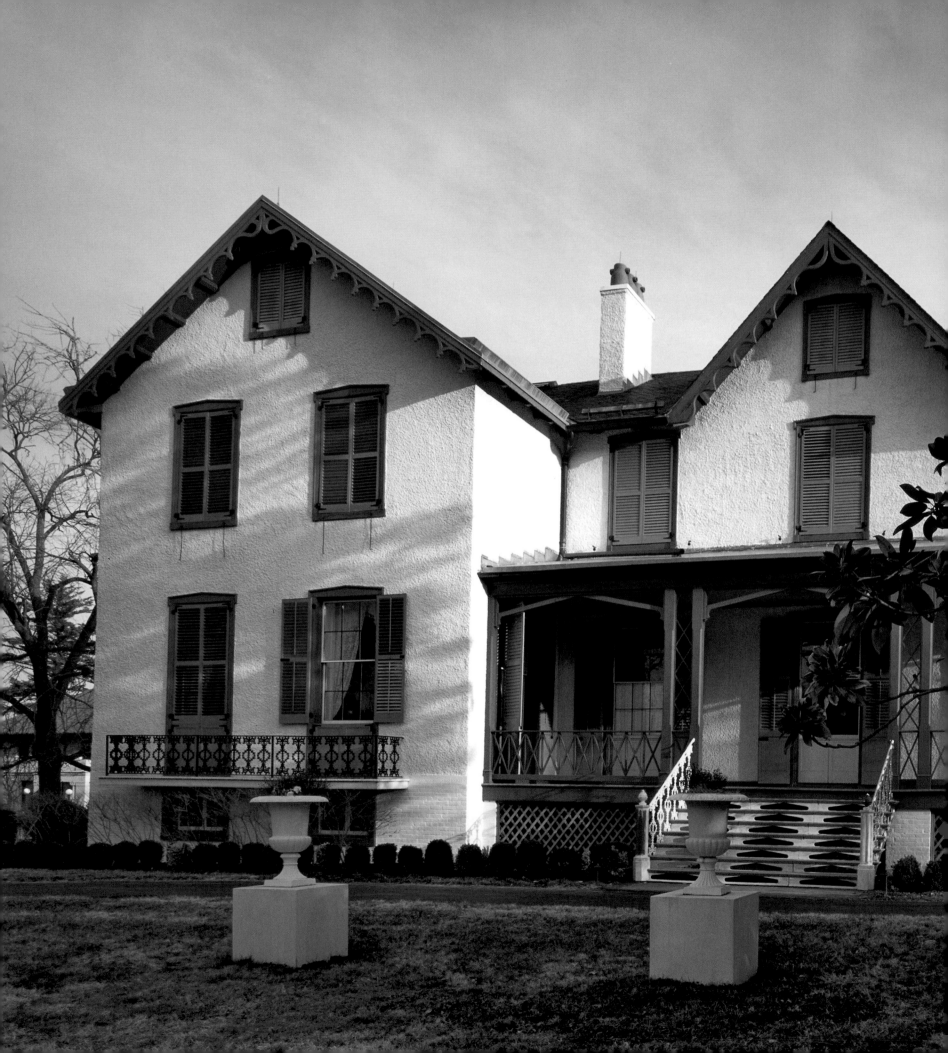

PRESIDENT LINCOLN'S COTTAGE

WASHINGTON, DC

"The president impressed me more favorably than
I had hoped. A frank, sincere, well-meaning
man, with a lawyer's habit of mind, good
clear statement of his fact, . . . but with a sort of
boyish cheerfulness."

RALPH WALDO EMERSON

Journal, February 2, 1862

A VISITOR

T
he Rail-Splitter—a nickname for Abraham Lincoln used admiringly by his political allies and jeeringly by his enemies—possessed an unlikely charisma. On paper, Lincoln, with his political inexperience, western origins, and sketchy academic history, appeared unimpressive. Seen in person, Lincoln was remarkable for his height, but his physiognomy struck folks as distinctly odd; the words offered by British journalist George Borrett were typical. "He was very sallow," Borrett wrote of Lincoln, "very ugly, and awkward, and ungainly." As uncomplimentary as Borrett was, his encounter with President Lincoln permits us a dispassionate view of the man during the Civil War.

A journalist and a fellow of King's College, Cambridge, George Tuthill Borrett came to America to take the tour. He wrote assiduously of what he saw, describing his travels in the strange lands of Canada and the United States, including his stop in wartime Washington. Despite finding comfortable accommodations at the Willard Hotel and discovering the unfinished Capitol to be quite admirable (he thought it "beautifully proportioned"), Borrett dismissed bustling Washington as "nothing more nor less than a gigantic military depôt." A particular desire of his being to meet Lincoln, he prevailed upon a new friend to arrange a visit with the president. A plan was soon in place. The daughter of an undersecretary of the treasury "would take us upon the evening to [Lincoln's] country-seat."

The destination proved to be not a great house of the sort Borrett's aristocratic countrymen inhabited. True, the Lincolns' summer home stood, Borrett reported, "in a sort of park," but he observed it was "guarded by a regiment of troops, encamped picturesquely about the grounds." The principal building on the three-hundred-plus acres of the Soldiers' Home was not a manor house at all but an expansive residence hall with a hundred and fifty beds and a five-story clock tower, an institutional building to accommodate disabled army veterans. The First Family inhabited a secondary structure, escaping the heat and unhealthy summer air of downtown Washington in a cottage on the hilltop property.

Arriving after dark, Borrett and his two companions could see little of the house's exterior, but a servant ushered them into a

Previous page: The woodwork offers the clearest clues to the architectural style at Lincoln's Cottage. Note the "gingerbread" of the porch's flattened arches and the intricately cut bargeboards that line the gables. The Gothic Revival began in England, where houses in the style were typically built of stone; in America, builders more often relied on the new technology of the scroll saw to produce its decorative elements.

Opposite: The view from the library through to the drawing room, where Lincoln and George Borrett most likely conversed.

"neatly furnished drawing room." Though the visitors had no appointment, Lincoln soon appeared, a "long, lanky lath-like fig-ure . . . with hair ruffled, and eyes very sleepy." Despite his embar-rassment at having gotten the nation's chief magistrate out of bed, Borrett expressed shock at observing his host's "feet enveloped in carpet slippers." After handshakes all 'round, Borrett noted, they "were at home at once. All my uneasiness and awe vanished in a moment before the homely greeting of the President, and the genial smile which accompanied it."

A brisk conversation ensued. Lincoln asked what his guest thought of "our great country." He spoke of England's "political aspect and constitution" before discussing in detail "the material points of difference between the governments of the two countries."

In the absence of hard information about the cottage's contents—the Lincolns' temporary occupation meant virtually all their furniture came and went with the seasons—the National Trust for Historic Preservation was left with more questions than answers. As a result, it chose to install only a few representative pieces of furniture in the large house, among them this Lincoln rocker. Such chairs gained the designation after Lincoln's assassination; he had been seated in one at Ford's Theatre.

Borrett thought his commentary "very lucid and intelligent." Lincoln turned the conversation next to poetry. He told his guests that he had been reading Alexander Pope when they arrived, and, from memory, he recited the closing lines of Pope's "Essay on Man."

After an hour, Borrett and his companions rose to go. "Thanking us cordially for coming to see him, he gave us each a hearty grip of the hand—it was much more than a shake—and we withdrew. So ended our visit to the President," Borrett concluded, "a much more pleasant one than I ever had with any other potentate."

The skeptical journalist had been won over and reported as much in his book *Letters from Canada and the United States*, pub-lished in London the following year. "Sit and talk with him for an hour," he challenged his British readers, "and note the instinctive kindliness of his every thought and word, and say if you have ever known a warmer-hearted, nobler spirit."

THE SOLDIERS' HOME

His presidency lasted barely four years. During that time, Abra-ham Lincoln spent some thirteen months in residence at what today is known as President Lincoln's Cottage. From roughly June to November in the years 1862 through 1864, the Lincoln family relocated from the White House (elevation: sixty-two feet above sea level) to the third-highest summit in Washington, seeking refreshing breezes to temper the hot and swampy tidewater cli-mate. They escaped more than the heat, since the nation's capital, swollen by soldiers, could be an unsavory place, with hundreds of houses of prostitution and a murder rate that sometimes topped twenty a month.

Each summer more than a dozen wagons brought from the White House an array of household goods and family belongings ranging from parlor furniture to son Tad's toys. Though more modest than the president's house on Pennsylvania Avenue, the two-and-a-half-story warm-weather domicile, constructed in 1842/43 for banker George Washington Riggs, consisted of thirty-four rooms, including several generous hallways. Nearly a dozen chimneys, their flues topped with terra-cotta pots, sprouted from intersecting

gable roofs. Gingerbread verge boards decorated the overhangs, and a roughcast layer of plaster hid the brick structure beneath.

The nation purchased the property after an act of Congress in 1851 called for the establishment of a "military asylum for the relief and support of invalid and disabled soldiers of the army of the United States." Riggs and the owner of an adjoining property sold their hilltop holdings to the federal government, and the army built the large castellated residence. During his administration, President Buchanan occasionally occupied one of the cottages on the property, as did Secretary of War Edwin M. Stanton and his family during the Civil War.

Lincoln traveled back and forth daily to the White House; sometimes he traveled the three miles with Stanton, Mary, one of his secretaries, or a military escort; sometimes he rode alone. On one such solitary nighttime trip, a sniper's shot rang out, a harbinger of the awful event to come, though the only casualty of that 1864 shooting proved to be Lincoln's eight-dollar silk hat, which sustained a bullet hole through its crown.

The cottage was a place apart for the Lincolns. In 1862, the house offered them distance from their sense of loss, as they mourned the death of eleven-year-old Willie, who had died that February, probably of typhoid. With Robert away at Harvard, Thomas "Tad" Lincoln was alone with his parents, but the likable nine-year-old soon found adult friends among the soldiers on the hilltop. They permitted Tad to drill with them on his pony, dubbing him their unofficial "3rd lieutenant."

Mary and Tad took occasional trips north, to Philadelphia, New York, and Manchester, Vermont. They left Lincoln on his own, but the president found companionship in his soldiers and secretaries. He liked to tell stories, and the youthful John Hay recalled Lincoln penning humorous poems for his amusement. One evening the president read aloud to his secretary from Shakespeare's histories. Hay reported that Lincoln read him "the end of Henry VI and the beginning of Richard III till my heavy eye-lids caught his considerable notice & he sent me to bed." Another time Lincoln is said to have recited his draft of the Emancipation Proclamation—much of which he wrote at the cottage—for Vice President Hannibal Hamlin. Secretary of State Seward and other members of the cabinet visited, as did Lincoln's old friend Senator Orville Browning, various Union generals, and others.

The vista from Lincoln's Cottage took in the Capitol, its new dome still unfinished, and the Washington Monument, then a half-risen spire on which work had ceased almost a decade before. The more immediate view, however, included a cemetery where each day saw the interment of soldiers, the burial of the boys that Mr. Lincoln had sent to war.

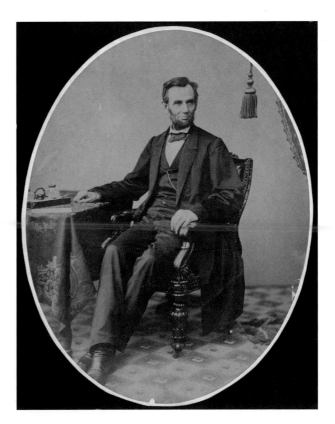

Alexander Gardner recorded Lincoln's image on November 8, 1863, four days after the Lincolns moved back to the White House from the Soldiers' Home. Inevitably, perhaps, posterity came to regard this photograph as the Gettysburg Portrait, since Lincoln delivered his address at the Pennsylvania battlefield less than two weeks later. At the dedication, Lincoln followed the two-hour oration of the day's principal speaker, Edward Everett. The president's approximately three-minute-long speech ended almost as soon as it began; nonetheless, his words have had a resounding echo over the generations. *Alexander Gardner/ Library of Congress, Prints and Photographs*

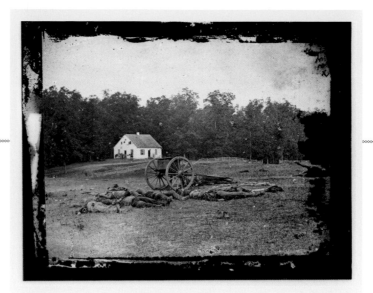

A TURNING POINT AT ANTIETAM

Like six-foot-tall sixth-graders, some historic events cast long shadows on those that surround them. The battle fought at Sharpsburg, Maryland, on September 17, 1862, stands as a case in point.

The resounding Confederate victory at Second Manassas on August 30 emboldened General Robert E. Lee to take the offensive. He marched the 55,000 troops of his Army of Northern Virginia into Union territory in hopes that the citizens of Maryland, a border and slaveholding state, might welcome the Confederates. President Jefferson Davis supported the strategy, believing a victory on Northern soil might sway foreign opinion, winning the C.S.A. recognition in Europe. To put it boldly, they believed their strategy could win the war for the South.

Major General George B. McClellan might have accomplished precisely the opposite in the days before Antietam, when a copy of Lee's invasion plan fell into his hands. Wrapped around three cigars misplaced by a Southern officer, the document detailed Lee's objectives. Though he recognized his chance to "whip 'Bobbie Lee,'" the ever-dilatory McClellan waited too long, permitting Lee to consolidate his forces.

A few days later, Lee's men assumed defensive positions in Sharpsburg along a low ridge with a sunken road at the center of their line. Arriving to repel the invading force, the larger Army of the Potomac (with expected reinforcements, it would number some 80,000 men) made camp on the opposite bank of Antietam Creek.

The battle unfolded that Wednesday with an early-morning engagement in a field of mature corn. Cannoneers on both sides unleashed their fire, transforming the cornfield into "artillery hell," as the combatants on the ground fought hand to hand with bayonets and rifle butts. In the chaos, the thirty-acre stand of tall, browning stalks changed hands more than a dozen times.

By late morning, the focus of the fighting began to shift south to the vicinity of the sunken road, better known today as Bloody Lane. There the carnage continued within sight of a picturesque house of worship, the plain, whitewashed Dunker Church. In the afternoon, the action again moved south, this time to the area around a stone bridge now remembered as Burnside's Bridge, named for a Union general who fought his way across it, Ambrose Burnside.

Neither side won a resounding victory; the Union claimed the day only when Lee withdrew his troops from the field. If the battle was, in strictly military terms, little better than a draw, it succeeded in halting Lee's military momentum—a day later, he retreated into Virginia. The "victory" at Antietam provided President Abraham Lincoln with the excuse he had been looking for: Five days after the Battle of Antietam, he announced the Emancipation Proclamation, the draft of which, at Seward's suggestion, he had pocketed two months before to await a more auspicious moment. His executive order, which would go into effect on January 1, 1863, freed the slaves in ten Confederate states.

The Sharpsburg battle influenced Confederate policy too, as Lee's failure to prevail on Northern soil undercut President Jefferson Davis's hopes for foreign recognition and military aid. Watching from London,

one astute observer of American affairs regarded the unsuccessful Confederate invasion as pivotal in determining the war's outcome. "The short campaign in Maryland," wrote Karl Marx a month later, "has decided the fate of the American Civil War."

For those in the field, the battle at Sharpsburg took a terrifying toll. The two sides sustained some twenty-three thousand casualties; the number of men killed, wounded, and missing made that September day the bloodiest ever in American military history (D-day would see only a quarter as many men fall). One Pennsylvanian at Antietam wrote in his diary, "No tongue can tell, no mind can conceive, no pen portray the horrible sights I witnessed." Clara Barton proved herself at Antietam, tending to the wounded as shells burst overhead (see "Clara Barton House," page 192).

The work of photographer Alexander Gardner meant words weren't required to convey the horrors. The images he recorded two days after the battle were hung that October in New York at Mathew Brady's gallery. On viewing *The Dead of Antietam*, members of the general public could, for the first time, see the wages of war: the mangled corpses, most of them Confederate, piled high (the Union buried their own dead first). The human toll of the battle altered the public's perception of war. As the *New York Times* said of the exhibition, the pictures "[brought] home to us the terrible reality and earnestness of War."

Opposite: When Alexander Gardner's images went on display at Mathew Brady's New York gallery, visitors reportedly used magnifying glasses to view the terrifying but richly detailed images. *Alexander Gardner/Library of Congress, Prints and Photographs*

Below, left to right: Only after a series of charges and a duel with Confederate sharpshooters did Union forces finally take the Burnside Bridge. The bucolic scene today belies the many men on both sides who fell on September 17, 1862.

A German Baptist sect, the Dunkers gained their name from their practice of full-immersion baptism. Their plain churches were constructed without steeples or stained-glass windows. Although worshippers held pacifist principles (believers refused to serve in the army of either side in the Civil War), the Dunker church at Antietam found itself in the line of fire.

Though the Union claimed success at Antietam when Lee and his men retreated, the victory might well have been a more resounding one had McClellan reacted with alacrity when the lost orders fell into his hands.

GETTYSBURG, 1863

In 1863, the pivotal year of the Civil War, events at Gettysburg bookended Lincoln's time at the cottage. He arrived at the hilltop house as Union and Confederate troops massed in middle Pennsylvania. Despite the great cost (more men fell at Gettysburg than at any other Civil War battle), the North prevailed. Union hopes soared in early July with the victory in Pennsylvania and Grant's long-wished-for capture of Vicksburg.

Disappointments and distractions followed. A head injury Mary sustained in a carriage accident unexpectedly worsened, endangering her life. Unprecedented violence erupted in New York in protest of the draft. The Union sustained a bitter loss at Chickamauga, near Chattanooga, Tennessee. By the time Lincoln climbed aboard a train to attend the consecration of a new cemetery in Gettysburg, in mid-November, Union hopes that the war would soon be won had grown dim.

Another man got top billing at Gettysburg that day, and it was Edward Everett, a former president of Harvard and noted speechifier, who delivered a two-hour oration. Still, Lincoln managed in his "Dedicatory Remarks" to acknowledge the status of the war, honor its dead, invoke the nation's founding principles, and redefine the national purpose. Though interrupted five times by applause, he accomplished all of that in less than three minutes, in just eleven declarative sentences.

Lincoln may have worked at his extraordinary little speech, which has come down to us bearing the name the Gettysburg Address, during the six-hour train journey to Pennsylvania the day before the ceremonies. He may have read it over on the morning of the dedication (the ceremonies commenced at noon), but surviving testimony conflicts regarding Lincoln's whereabouts when he wrote the speech. Yet the cadences, the careful qualifications, and the subtleties of his diction suggest that Lincoln, as usual, worked laboriously in choosing and ordering his 275 words. He rarely improvised.

Many of Lincoln's quietest moments during the war, his times of clearest contemplation, occurred at the cottage. During the

Above: Scholars believe that Lincoln worked on the Emancipation Proclamation at the Soldiers' Home. While his desk survives today in the White House (in the more famous Lincoln Bedroom), visitors see this precise reproduction in the chamber he used when in residence at the Soldiers' Home.

Opposite: Youngest son Tad (born 1853) and his father often played checkers. Mary, who lost two sons in their childhood and witnessed her husband's assassination, would also outlive Tad, who died at age eighteen in 1871.

summer of 1863, he spent ten weeks there without Mary and Tad. Though the work of the war consumed him, each evening he was in close proximity to the six-acre burial ground at the Soldiers' Home, where several thousands of Civil War dead were interred beginning in August 1861. Surely as he drafted his dedicatory speech for Gettysburg, the experience of living at the Soldiers' Home influenced his thinking. We know he spent sleepless nights at the cottage, that he pondered the use of "colored troops" and invited Frederick Douglass to tea there. (Douglass would later recall that Lincoln "was the first great man that I talked with in the United States freely, who in no single instance reminded me of the difference between himself and myself, of the difference in

color"; see also "Frederick Douglass's Cedar Hill," page 182.) With Tad and Mary at the Fifth Avenue Hotel in New York or the Equinox House in Manchester, Vermont, Lincoln remained at the cottage, where the deadly realities of the war were never far from his mind.

Still, the Soldiers' Home represented an escape for Lincoln, and not merely during the summer of 1863. As the war finally drew to a close in 1865, just a day before he took his seat for the last time in the president's box at Ford's Theatre, he rode the grounds of his summer retreat. After four years of war, he had led his country out of what his wife called "this hideous nightmare."

GETTYSBURG

Perhaps more than any other battle, the three-day confrontation at Gettysburg lends itself to discussion, disputation, and conjecture. Was his decision to order Pickett's charge the nadir of Lee's generalship? What did Pickett himself say about the crucial assault? (Lee ordered him to destroy his report; apparently, no copy survives.) Why didn't Lee listen to his Old War Horse, Lieutenant General James Longstreet, who later claimed to have counseled against the attack on the center of the Union line on Cemetery Ridge? Given the consensus that the battle was a turning point in the war, *what if* Lee's Army of Northern Virginia had prevailed in Pennsylvania? Questions like this have made Gettysburg—the battle itself, the aftermath, and the military and historic meanings—the most analyzed battle in the history of the United States, if not the world.

The events unfolded over the first three days of July 1863. Prompted in part by a Virginia victory at Chancellorsville a month earlier, Lee took aim at Pennsylvania's capital, Harrisburg; if Lee and his men could reach Philadelphia, the thinking ran, they might shock Lincoln and company into agreeing to peace. The Union army moved to block Lee's northern advance, but when the first shots were fired, on July 1, a larger Confederate force overwhelmed the Union lines north of Gettysburg amid open farmland. By midafternoon, the Federals were beating a hurried retreat through the streets of the town before establishing new positions on Cemetery and Culp's Hills. There they awaited the reinforcements that arrived within hours. On day two, General George Gordon Meade's troops held their lines, for the most part, in the face of heavy Confederate assaults on a number of Union positions, including those remembered today as Little Round Top, the Devil's Den, and the Wheatfield.

Day three would be decisive. The focus of the action was the center of the Union line at Cemetery Ridge. After attempting to soften up his opposition with one of the largest artillery bombardments of the war, Lee ordered more than twelve thousand infantrymen to attack. Stepping off at two o'clock, nine brigades, commanded by Major General George Pickett and two other officers, marched deliberately across open fields. As they covered the thousand-yard distance, shell and solid shot from Union artillery took a toll. Once the oncoming army was within four hundred yards, rifle, musket, and canister fire proved devastating. In less than an hour, the assault ended. The attacking force retreated, having suffered a casualty rate in excess of 50 percent.

An informal truce the next day permitted both armies to bury some eight thousand dead; as they did so, Confederate forces a thousand miles west at Vicksburg, Mississippi, surrendered to Ulysses Grant. While the

total casualty count in Pennsylvania, estimated at fifty-one thousand, made Gettysburg the deadliest battle of the war, the twin losses in the east and west theaters meant the end of Lee's northern offensive and Union control of the Mississippi.

The battlefield at Gettysburg, maintained as a national military park, encircles today's village at Gettysburg (a driving tour of the battle's major sites covers an eighteen-mile loop). The thousands of acres are dotted with monuments and structures that commemorate the 1863 battle and the soldiers that fought there for both the North and the South. It is a verdant, rolling landscape, a place where Lincoln's words seem to linger.

Opposite: At the Gettysburg National Military Park, cannon and ammunition wagons are positioned much as they would have been in the first days of July 1863.

Right: The Gettysburg Battlefield today is dotted with monuments and markers — more than a thousand, in fact — that commemorate states, brigades, individual soldiers, and key sites in the three-day battle.

Below: Monuments and cannons at a snow-covered Gettysburg National Military Park.

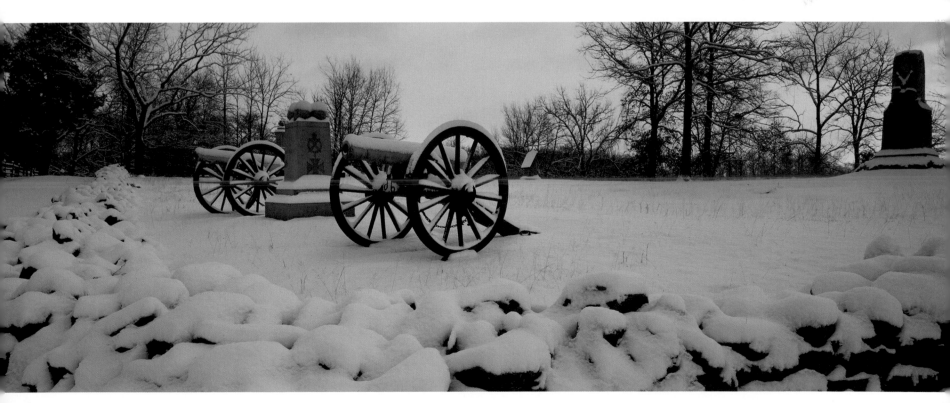

JEFFERSON DAVIS AND THE WHITE HOUSE OF THE CONFEDERACY

RICHMOND, VIRGINIA

"If my opinion is worth anything, you can always say that few people could have done better than Mr. Davis. I knew of none that could have done as well."

GENERAL ROBERT E. LEE

"A SAD CASUALTY"

With war comes death in many guises, but for Jefferson Davis, the first and last president of the Confederacy, the most shocking loss occurred at his home in a most unwarlike circumstance. The date was April 30, 1864.

That morning Davis ate little breakfast before taking the short walk to his nation's executive offices, located in the former U.S. Customs House, not far from the Virginia state capitol. Never a well man (his wife, Varina Howell Davis, once described him as "a nervous dyspeptic by habit"), Davis suffered from headaches, respiratory problems, facial neuralgia (a nerve condition that affected the vision in one eye), and fevers associated with the malaria he had contracted a quarter of a century earlier. Despite feeling poorly that day, however, he went to his desk. He knew he had to deliver a speech in two days at the opening of the Second Confederate Congress. And, of course, he had a war to run.

Varina remained at home, managing the busy household at the Confederate White House. Perhaps the Davises indulged their four young children, whom a friend of Varina's described as "wonderfully clever and precocious children—but [with] unbroken wills." Margaret (known as Polly), age nine, and her three brothers (Jeff Jr., Joe, and Billy, ages seven, five, and three, respectively) kept their Irish nurse, Catherine, well occupied while Varina tended to the social demands placed upon the First Lady of the Confederacy. As if her life were not busy enough, Varina

knew her lying-in rapidly approached; her swelling belly promised the arrival of a little stranger in about two months. Yet that day, Varina, ever worried over her rail-thin husband's fragile health, dutifully carried a picnic basket to his office door, hoping "dear old Banny," as she sometimes addressed her husband, would take some sustenance.

She arrived at one o'clock, but before places could be set for the repast, a household servant burst through the door of Davis's second-floor office. He brought shocking news; together, Jeff and Varina Davis learned not of another military setback but of a terrible fall taken by their middle son, his father's favorite, his "hope and greatest joy in life."

The parents returned in haste to the mansion on the corner of Clay and Twelfth Streets, where they found Joe unconscious but still breathing. No one could say precisely what had happened, but Jeff Jr. had found the boy motionless at the foot of a high piazza. Joe must have tempted gravity, perhaps walking along the balus-

Previous spread: Though today the house sits amid a dense cityscape, the mansion the Davises inhabited once dominated a grassy rise to the east of the Virginia capitol with a sweeping view of the James River. Though the dependencies are gone (kitchen, stable, and slave quarters), the generous columned porch on the house's rear elevation overlooks a formal garden.

Opposite: Contrary to its nickname, the White House of the Confederacy is gray, its main façade just a few feet from Clay Street.

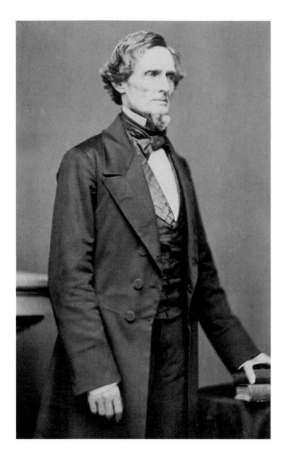

On first meeting Jefferson Davis, his future wife perceived the tension of his character. As she wrote to her mother, "He is the kind of person I should expect to rescue one from a mad dog at any risk, but to insist upon a stoical indifference to the fright afterwards." *Mathew Brady/Library of Congress, Prints and Photographs*

trade before a misstep sent the five-year-old plunging to the brick pavement below, fracturing his skull.

Within an hour of his parents' arrival at his bedside, Joseph Davis died.

Each member of the presidential family grieved in his or her own fashion. Varina's sustained screams echoed around the neighborhood that afternoon. Jeff Jr. knelt by his brother's bedside, racked with tears; he told a family friend attempting to console him, "I have said all the prayers I know how, but God will not wake Joe." As the father watched his son's lifeless body carried up the stairs to be laid out in a bedchamber until his burial the following day, Davis said softly, "Not mine, O Lord, but thine."

At four o'clock a courier brought the president of the Confederacy a dispatch from General Robert E. Lee, who was at the front, but Davis looked uncomprehendingly at the message. Unable to compose an answer, Jefferson, his rigid self-control finally cracking, cried, "I must have this one day with my little son."

Mary Chesnut learned of little Joe's death and went to comfort her friend Varina. In her usual plain terms, Chesnut described what she saw as she climbed the hill toward the Confederate White House that evening. "Every window and door of the house seemed wide open—and the wind blowing the curtains. It was lit up, even in the third story."

She and her husband, Colonel James Chesnut, sat vigil in the drawing room. "I could hear the tramp of Mr. Davis's step as he walked up and down the room above—not another sound," she told her diary. "The whole house as silent as death."

CITIZEN DAVIS

Jefferson Davis (1808–1889) was the other Civil War president born in a Kentucky log cabin. He lived for some months in Louisiana too before his family moved once more, this time to Mississippi, where Jefferson, the youngest of ten children, celebrated his fourth birthday. Of the state to which he would always give his first allegiance, Davis recalled late in life, "There my memories begin."

The young man turned sixteen a month before his father died. Samuel Davis's dual legacy amounted to a history of military service —he fought in the American Revolution—and a commitment to education. A series of academies and then Transylvania University in Lexington, Kentucky, gave Jefferson Davis a solid grounding in Latin, Greek, history, natural philosophy, and French. With the father's death, his eldest son, Joseph, twenty-four years Jefferson's senior, became a surrogate father, and he shortly obtained an appointment to West Point for his brother from Secretary of War John C. Calhoun.

Jefferson Davis's years on the Hudson proved formative. He left West Point in 1828 a brevet second lieutenant with the upright carriage of a soldier, a rigid posture Davis retained into old age.

The state dining room at the White House of the Confederacy served occasionally as the site of military consults between Davis and his generals.

We may see the historical irony in his words, but he departed with the belief that "those who have received their education at West Point, taken as a body, are perhaps more free from purely sectional prejudices, and more national in their feelings than . . . persons to be found elsewhere in the country."

Lieutenant Davis spent the next seven years in the U.S. Army, then, in 1835, after falling in love with Sarah Knox Taylor, daughter of his commanding officer General Zachary Taylor, he resigned his commission. That summer they married, but within weeks both Knox and Jeff fell deathly ill with malaria. The young bride died at age twenty-one, three months after her wedding.

Davis spent much of the next eight years mourning in solitude and establishing his plantation, Brierfield, at Davis Bend; it was part of the large property owned by Joseph Davis, by then a wealthy cotton planter with a successful law practice in Mississippi's most prominent town, Natchez (see "Haller and Julia Nutt at Longwood," page 100). At Joseph's urging, Jefferson Davis rejoined society in 1844. His brother introduced him to eighteen-year-old Varina Howell, and within a year, Jeff married the Natchez belle and took her to Washington, DC, where he had been elected to a seat in Congress.

With the outbreak of war in Mexico, in 1846, he resigned to return to military service, hoping to gain fame on the field of battle; as Colonel Davis, commander of the First Mississippi Regiment, he succeeded. In a fight at Buena Vista, despite taking a musket ball to his right foot, he improvised an inverted V-formation for defending his position. The tactic helped win the day. Though hobbling on crutches, Davis returned home an authentic hero. President Polk offered him a promotion to brigadier general, but Davis once again resigned from military service, this time to accept an appointment as a U.S. senator. He would win the office in his own right in the election of 1848 and then serve the United States for most of the next fourteen years as a senator (1847–1852, 1857–1861) and as President Franklin Pierce's secretary of war (1853–1857).

His time in the capital earned him plaudits from both North and South. The *New York Times* called him "the Cicero of the Senate." He supported John Quincy Adams in the former president's effort to establish the Smithsonian; Davis, a strong proponent of education, went on to serve on its board of regents. As Pierce's secretary of war, his brief included the major renovation of the Capitol (Thomas U. Walter's cast-iron hemisphere would replace Charles Bulfinch's flattened saucer dome) and a reorganization and enlargement of the army. Davis also emerged as an early advocate of the transcontinental railway.

Though firmly in favor of slavery, its expansion to the territories, and even the annexation of Cuba as a slave state, he spoke regularly against secession on the Senate floor. Yet, as a stern believer in states' rights, he felt bound by principle to resign his seat after his state seceded in January 1861. In an affecting resignation speech delivered without rancor, he expressed the hope that, as he and other Southerners "tread in the path of our fathers as we declare independence," they might maintain "peaceable relations" with the people of the North. He acknowledged the risk—"The reverse may bring disaster on every portion of the country"—but he felt honor-bound to resign "from the high and solemn motive of defending and protecting the rights we inherited."

A week later, he departed Washington, a city that he and Varina had come to regard as their home. Soon enough he would occupy an executive mansion in another capital city. This house overlooked not the Potomac but the James River and was located a hundred miles south of the U.S. capital, in Richmond, Virginia, newly established as the capital of the Confederacy.

THE WHITE HOUSE OF THE CONFEDERACY

When the Davis family moved into the gray stucco mansion on August 1, 1861, hopes stood high in the South following the suc-

cesses at Fort Sumter (see page 68) and Bull Run (see "Stopped by Stonewall at First Manassas," page 90). Their new home, acquired by the City of Richmond and rented to the just-born nation, seemed a suitable domicile for the head of government, with its severe façade of tall Doric columns, new technology (gasoliers for illumination), and fashionable rococo furniture.

Originally constructed in 1818 from a design attributed to Robert Mills, one of the nation's first professionally trained architects and later the designer of the Washington Monument in Washington, DC, the house had been renovated in the 1850s by the Crenshaw family, owners of the towering flour mills in town. They added a third story, along with a dramatic curvilinear stair that rose off the oval entry hall. The place impressed even Varina, accustomed though she was to the grand houses of her native Natchez (see Haller and Julia Nutt at Longwood, page 100). "The mansion stands on the brow of a steep and very high hill," she wrote. "[It] is very large, but the rooms are comparatively few, as some of them are over forty feet square." Though she exaggerated the home's dimensions, several spaces were generous indeed, roughly twenty feet by thirty.

The new inhabitants put the house to many uses. Jefferson's brother Joseph, his wife, Eliza, and a mix of young relatives often shared the mansion with the growing Davis family (two children, William and Varina Anne, remembered as Winnie, were born there). Varina frequently welcomed the public for her "evenings," where soldiers on leave danced with Richmond's young women. The Confederate president maintained an office in the house, and maps often papered over the banquet table in the grand dining room, as Davis, accused many times then and since of micromanaging the war, planned battle strategies with Robert E. Lee and other generals. Spirits in the house rose and fell with news from the front, of

battles won and lost, of reports of the dead and wounded.

Varina's help in operating the presidential mansion included Catherine in the nursery; a housekeeper from Baltimore, the widowed Irishwoman Mrs. Mary O'Melia; and a mix of slaves and hired workers. Despite the staff of twenty, there never seemed to be enough hands to run the Confederate nation's first house.

With Richmond threatened off and on throughout the war, Varina came and went, seeking safety out of the range of Union attack, but she left for the last time on March 29, 1865, armed with a pistol her husband had given her. On Sunday, April 2, Jefferson Davis learned that nearby Petersburg had fallen. Advised by Lee to abandon Richmond, he instructed his cabinet that the government would move to Danville, about a hundred and fifty miles away on the North Carolina line. He returned to the Confederate White House that evening, and, after packing some personal items, he "sat on a divan in his study, sad, but calm and dignified," awaiting the carriage that would take him to the train. Two days later, Abraham Lincoln, cheered by the black people who lined his route from the landing, arrived on the doorstep. In Davis's office, he found "the easy chair and sank down into it." He asked for a glass of water, and a member of the household staff—perhaps it was Mrs. O'Melia, perhaps a slave still on duty—brought him one, along with a bottle of whiskey (he is thought not to have tested the latter). Ever hospitable, Mrs. Davis had left orders "to have the house in good condition for the Yankees."

❧

Mention the name Jefferson Davis to students of the Civil War and you will elicit strong feelings—yet he is perhaps the least understood of the conflict's principal players. To this day in the North, he is widely presumed guilty of treason, though he never got a chance to defend himself in court. In the South, he is still revered for his lifelong refusal to disavow the Confederate cause, which most modern historians agree he mischaracterized. Few people occupy the argument's middle ground.

Opposite: Red flocked wallpaper lined the walls of the reception rooms, including the library, pictured here. This room, with its informal air, was used by Davis as a study for quiet discussions and occasionally as a schoolroom for the Davis children. When Abraham Lincoln came to town after the fall of Richmond, he briefly occupied this space.

Like him or hate him, one has to admit that his accomplishments were many. Even setting aside his various labors for the United States before 1861, he helped bring into existence after the secession an army, a navy, a supply system, and many other elements of a nation; in short, a government appeared where there hadn't been one, and he, more than anyone else, made that happen. He fostered a sense of nationalism that kept his underdog nation alive for four years; if his opposite number hadn't been Lincoln, some historians believe, he might even have won. Fire-eater William Yancey wasn't far off when he proclaimed just before Davis took the oath of office as provisional president of the Confederacy, "The man and the hour have met."

Few consider Davis's efficacy in office, however; they damn him on moral grounds. Davis saw no inconsistency in eloquently defending slavery while holding the bedrock political principles of the revolutionary. He believed Lincoln and the Republicans threatened essential constitutional rights; he, along with most Confederates, saw secession as a return to the values held by men like the slaveholder George Washington, who sought independence from the powers that attempted to infringe on his freedoms.

The twenty-first-century mind cannot grant Davis his assumptions; for one, he never varied from his belief that blacks were "poor creatures" and "idle and ungovernable." Yet his opinion differed little from that of the vast majority of U.S. citizens in his time, whether they hailed from the North or South. That he was unrepentant after losing a war is certainly true; equally, he maintained his long-suffering dignity, drawing hatred from the North and admiration in the South, even into his last years. But that's a story better told at his retirement home overlooking the Gulf of Mexico (see "Jefferson Davis's Beauvoir," page 226).

The second-floor nursery at the White House of the Confederacy. The cannon is no mere toy and can be fired; it was cast for Jefferson Davis Jr. at the Tredegar Iron Works (see page 142).

A studio portrait taken during the Civil War era of Varina Howell Davis. *Library of Congress, Prints and Photographs*

THE FIRST LADY OF THE CONFEDERACY

The comparison is tempting: both Varina Howell Davis and Mary Todd Lincoln were born into aristocratic Southern families, buried children during the Civil War, worried over the safety of their husbands (Varina: "His [Jeff's] mails were heavy with warnings of an attempt at assassination"), and struggled with the multiple demands of motherhood, politics, and public life. Like their husbands, the two First Ladies heard criticism from all angles, leaving each with the sense that she lived in a glass house.

From the first days of marriage, Varina helped her politician husband, serving as his amanuensis, taking dictation and editing his speeches. In Washington, Varina proved a valuable political partner as a congressman's and cabinet member's wife, at home in the circles of power of the nation's capital. In Richmond, however, the well-read, intelligent, and sometimes blunt Varina drew criticism in certain quarters; even a dear friend observed she was possessed of "a warm heart and impetuous tongue." Her insistence on maintaining friendships with the spouses of prominent Northern politicians led some in the South to doubt her commitment to the cause, but from the first days in Richmond, she took a pragmatic view of the Confederate undertaking. She wrote her mother that she had made up her mind to "come here & to be happy no matter what danger there was, &

to run with the rest if needs must be."

More than the emotionally fragile Mrs. Lincoln, Varina Davis demonstrated a capacity for dealing with adversity. During her husband's postwar incarceration (see "Jefferson Davis's Beauvoir," page 226), she was his most effective advocate, petitioning Horace Greeley, General Grant, and President Andrew Johnson for help. She sought legal counsel, raised funds, and, a year into her husband's time at Fortress Monroe, received permission for herself and their baby to live with him within the walls of the fort.

The tribulations of those years took a toll on her health, but after her husband's death, Varina moved to New York, taking Winnie, her youngest child, with her. She penned a memoir and wrote articles for the *Sunday World*. Though she and Mrs. Ulysses S. Grant, another New York widow, became fast friends, Varina was ever her husband's staunchest defender.

On her deathbed, having lived a long, eventful life during which she had known high times and hard times, Varina remained in character as she instructed her only surviving child, Maggie, on how she should mourn when Varina was gone. "Don't you wear black," she told her. "It is bad for your health, and will depress your husband."

HISTORIC TREDEGAR IRON WORKS

Established in 1837 on the north shore of the James River, the Tredegar Iron Works, its name derived from the Welsh foundry town from which the original owner Francis B. Deane hailed, became the third-largest iron manufacturer in the United States under the management of its second owner, Joseph Reid Anderson. Tredegar's furnaces and rolling mills initially produced rails for the railroad boom of the antebellum years. The company's output slowly expanded to include locomotives and engine parts for steamships, and in the 1850s, other industries shared the Richmond site, including a stove works and the expansive flour and woolen mills of Crenshaw and Company (Lewis Crenshaw would remodel and reside in the mansion that, after secession, became the White House of the Confederacy; see page 130). The complex would grow to include tenements for housing employees, a company store, and slave quarters.

With the approach of war, the Tredegar works gained new significance as the Confederacy's primary source of cannons. In early 1861, workers raced to mold and manufacture cannons for shipment to Charleston; many of the guns that fired upon Fort Sumter came from Richmond, and on April 15, 1861, the Confederate flag rose at Tredegar, in advance of Virginia's formal secession. The factory was one reason that Richmond was chosen to be the aborning nation's capital.

During the Civil War, the factory produced the iron plate used in the conversion of the USS *Merrimack* to the CSS *Virginia*, the ship that fought the USS *Monitor* to a draw at Hampton Roads, Virginia, in the best-remembered sea battle of the war. The mills produced artillery pieces for Lee and his generals, although, when the war entered its second and third years, the lack of gun iron and a chronic shortage of skilled labor greatly limited the Tredegar output. Even the deployment of much slave labor proved insufficient for the works to come close to meeting demand for munitions in the waning days of the conflict.

While fires set by retreating Confederate soldiers consumed ammunition dumps, warehouses, and much of Richmond in an immense blaze on April 2, 1865, the bulk of Tredegar's buildings survived. Within the year, the mills resumed operation, and the Tredegar company would manufacture ordnance for World War I and World War II before closing in the 1950s. Today just five buildings remain of a complex that once looked like a sea of rooftops and chimney stacks. In the 1861 foundry, the American Civil War Center operates the Historic Tredegar museum, which interprets the war, its causes, and its legacy; another surviving structure, the Pattern Building, serves as a visitor center for the National Park Service and the Richmond National Battlefield Park. These buildings, together with the remarkable documentation that exists tracing the business of the works for more than a century, amount to an invaluable piece of American industrial history.

Opposite: Tredegar was once an industrial village of many buildings, including immense freestanding rolling mills and a dozen or more interconnected foundries, shops, and other mills; its surviving structures are linked by tall walls and other ruins, alternately revealing and obscuring disused mill machinery.

Below: The Pattern Building at the Tredegar manufacturing complex, once used to store wooden casting patterns, survived to help tell the story of Richmond's role in the Civil War.

HORACE GREELEY HOUSE

CHAPPAQUA, NEW YORK

"We are to go through this war to preserve the
inheritance bequeathed us, to save the
Republic—that is what our fathers taught us."

HORACE GREELEY

New York Tribune, July 4, 1864

AN ORACLE OF PEACE?

Horace Greeley wished to broker the peace. Always a man to take the events of the day to heart, the editor of the *New York Tribune* regarded himself as the conscience of the country. His many passions drove him: he was anti-liquor, pro-Union, antislavery, and sometimes pro-war (his "Forward to Richmond" editorials played a role in pressuring the government into battle at Bull Run; see "Stopped by Stonewall at First Manassas," page 90). However, when the war showed no signs of being won after three long years, Greeley thought his readers wanted peace.

When a letter arrived on his desk from Niagara Falls on July 6, 1864, he leaped at the prospect of negotiations. In the strictest confidence, his informant advised Greeley that "two ambassadors of Davis & Co."—representatives, that is, of C.S.A. president Jefferson Davis—awaited on the Canadian side to negotiate with Greeley or, if Greeley could arrange safe passage, to embark on a journey to Washington for talks. Assured that these agents were possessed of "full and complete powers for a peace," Greeley promptly wrote to Abraham Lincoln.

The nation's best-known newspaper editor and the president had met and exchanged letters before. Two years earlier, Lincoln's apparent hesitation to emancipate the slaves prompted Greeley to publish an editorial headlined "The Prayer for Twenty Millions." Wishing to take advantage of the forum the *Tribune* offered, Lincoln had responded in a public letter. "My paramount object in this struggle *is* to save the Union, and is *not* either to save or destroy slavery. If I could save the Union without freeing *any* slave I would do so, and if I could save it by freeing *all* the slaves I would do it. . . . What I do about slavery, and the colored race, I do because I believe it helps to save the Union." Lincoln's cautious sentiments were followed just a few weeks later by a clearer expression of his intent: the issuance of his Emancipation Proclamation. Greeley's paper greeted that document with a *huzzah!* The *Tribune* declared, "God bless Abraham Lincoln."

This time Greeley wrote in secret. "Our bleeding, bankrupt, almost dying country," offered Greeley, "longs for peace—shudders at the prospect of fresh conscriptions, of further wholesale devastations, and of new rivers of human blood." His express wish? "I entreat you to submit overtures for pacification to the Southern insurgents."

Lincoln thought the proposition problematic. He was persuaded that Jefferson Davis would never agree to peace unless Confederate

Previous spread: Horace Greeley bought this house after his wife complained their country home at the time was too isolated; from the porch of this dwelling on King Street, the ailing Mrs. Greeley could watch the life of the village near at hand.

Opposite: Historians debate the phraseology, but Greeley's sentiment—"Go West, young man, go West and grow up with the country"—survives as the best-known directive of a man who advocated ideas as varied as vegetarianism and spiritualism, all of them expressed in the pages of the *Tribune. Library of Congress, Prints and Photographs*

Above: This handsome desk served Greeley during many of the years he was editor of the *Tribune,* which, despite its base in New York, had a national readership.

independence was part of the bargain (an outcome unacceptable to Lincoln) and he doubted the authority of the envoys. Still, the Union president understood that if he flatly rejected the offer to talk, the opinionated Greeley might portray him in the pages of the *Tribune* as an obstacle to peace. So why not, Lincoln decided, "let [Greeley] go up and crack that nut for himself"?

Though at first reluctant, Greeley duly took the train west. Once in Niagara Falls, he learned from the supposed Confederate "commissioners" that they lacked the power to negotiate a peace. Lincoln dispatched his private secretary, John Hay, to join Greeley with a confidential note setting minimum terms, but the negotiations collapsed before they truly began.

In the aftermath, Greeley found himself caught in the crossfire. The rebel agents went public in order to embarrass Lincoln, and in their telling of the story, they cast Greeley as Lincoln's dupe. While the men from the C.S.A. accused Lincoln and the Union of refusing to negotiate for a peace that was "mutually just, honorable, and advantageous to the North and South," the editors of competing papers in New York accused Greeley of "cuddling with traitors," of "bungling" and "meddling" in state affairs.

Yet the circumstances prompted a handwritten note from Lincoln that would frame all subsequent peace discussions. "Any proposition which embraces the restoration of peace, the integrity of the whole Union, and the abandonment of slavery," Lincoln wrote, " . . . will be met by liberal terms on other substantial and collateral points."

Greeley, his anger and embarrassment behind him, rallied to Lincoln's cause later that election season. Though the Niagara peace talks had been a fiasco, Greeley and Lincoln reconciled after the president let it be known that he "regarded [Greeley] as the ablest editor in the United States, if not in the world, and believed that he exerted more influence in the country than any other man."

"GO WEST, YOUNG MAN"

In his youth, Horace Greeley (1811–1872) saw few prospects for himself in Amherst, his native New Hampshire town. A hard-scrabble farmer, his father lost his land to creditors the year his oldest son, known as Hud, turned nine. At age fifteen, seeking his own place in the world, the boy became apprenticed to the editor of the *Northern Spectator*, a Vermont newspaper. When the local weekly closed four years later, the young man set his course for the nation's newspaper capital.

Greeley brought to New York printing skills and an active mind; after a few years of a workaday existence as a printer-in-hand, he went off on his own, publishing the first issue of his sixteen-page weekly journal, the *New-Yorker*, in 1834. The paper gained a reputation for accuracy and its editor earned admiration for his precise grammar and even for his lines of verse. Though Greeley made little money, his careful coverage of political ideas and public events brought him to the attention of two powerful men in Albany, Whig party boss Thurlow Weed and the Whig candidate for New York governor at the time, William H. Seward (see "William Henry Seward House," page 162). After editing two Whig campaign newspapers, the *Jeffersonian* (in 1838) and the *Log Cabin* (in 1840), Greeley, with the help of his friends, launched what would prove to be the project of a lifetime, the *New York Tribune*, in 1841.

Echoing the reform-minded Greeley, the folio sheet aimed to make its city a better place, proclaiming itself "Anti-Slavery, Anti-War, Anti-Rum, Anti-Seduction, Anti-Grogshops." To many, it was known as the "Great Moral Organ."

Greeley's alliances with men like Seward, by then New York's governor, meant inside access, financing, advertising revenues—and a booming circulation. A weekly edition of the paper claimed a broad national readership, and by the early 1850s, the combined circulation of the city and weekly *Tribune* exceeded one hundred thousand; five years later, the number had more than doubled, with readership perhaps triple that. With the aid of skilled writers and editors, including Margaret Fuller, an early literary editor; Charles A. Dana, a longtime managing editor; and Henry Jarvis Raymond, who went on to found the *New York Times*, Horace Greeley's paper became the most powerful newspaper of the era.

FARMER GREELEY

Though the young Horace Greeley became a city man—as he put it, "I shook from my brogans the dust of the potato-patch"—the middle-aged Greeley bought himself seventy-eight acres of land in the hamlet of Chappaqua, an hour's rail ride north of Manhattan.

The mirror and candlesticks on the dining-room mantel belonged to Molly and Horace Greeley and descended through the family of their daughter Gabrielle Greeley Clendenin, as did many other Greeley objects.

In the master bedroom, the washstand pitcher and bowl stand ready for the morning ablutions, a linen press in the background. According to family tradition, Mary Woodburn Greeley used the cradle to rock her son Horace.

His wife, Mary, established some ground rules. She wanted a freshwater spring, a "brawling brook," and evergreen woods. Honoring her wishes, he constructed a "house in the woods" on their country property in 1853.

Mary "Molly" Cheney Greeley led a difficult married life. Five of their seven children died in childhood; the deaths tilted her toward depression and hypochondria. Horace called her Mother, and their relationship grew distant as she descended year by year into what he termed "the saddest mental condition." During the warmer months, she resided in Chappaqua; though he visited on most weekends, he remained in New York during the week; there, as he told a friend, he kept "bachelor's quarters and [got] on very well." When in Chappaqua, he spent much of his time outdoors, working to control the encroaching thickets of alders, cedars, and witch hazel. "The woods," he once wrote, "are *my* special department."

Greeley could claim a professional interest in agriculture—the *Weekly Tribune* devoted many column inches to farming, as its editor sought both to increase the paper's rural circulation and to preach his gospel of fresh air and hard work away from the city. Greeley prided himself on promoting farming innovations, sharing with his readers notions of forest conservation and intensive cultivation. He practiced what he preached, building a great stone-and-concrete barn of the most modern design at a cost of almost six thousand dollars. Years later, he published a small book about his agricultural experiment at Chappaqua, titled *What I Know of Farming* (1871).

In 1864, he purchased another home in Chappaqua, this one nearer the center of the village (the "house in the woods," Molly complained, was damp, its roof leaky). He purchased the place in her name, and, to accommodate her needs in the new house on what is today King Street, he enlarged the compact two-rooms-up, two-rooms-down structure, adding a music room and pantry (on the first floor) and a family parlor and maid's room above. Both husband and wife would come and go from there, he to his work at the *Tribune* and lecture tours, she often on European travels seeking a cure to what ailed her.

Greeley did have good days at his country home. On one occasion during his 1872 run for president, some four hundred of his political friends and campaign volunteers trooped up to Chappaqua. They walked the property and, at Greeley's insistence, tested the water that he advised was "the purest and sweetest water in the world." They dined on lobster salad, ice cream, and lemonade, watched over, according to one among them, by "the vigorous form of the philosopher himself with the broad white hat . . . and gold spectacles glittering in the sun."

THE MAN IN THE WHITE COAT

Greeley cut an entirely original figure in mid-nineteenth-century America. His habitual attire was a long, white linen coat, and he usually carried an umbrella. Though he shaved his cheeks and upper lip, the unkempt whiskers beneath wreathed his chin. When

he traveled, he was known to carry "a yellow bag, labeled with his name and address, in characters which might be read across Lake Erie." His appearance was altogether singular and eccentric.

Often his opinions were the same. As his wildly varying attitudes toward the Civil War president suggest, his temperament tended to the mercurial. Upon first glimpsing Lincoln, he approved, commenting in the columns of the *Tribune* that the "tall specimen of an Illinoisian spoke briefly and happily." But Greeley took Stephen Douglas's side against Lincoln in the 1858 senatorial contest, despite the fact that Lincoln had the endorsement of the Republican Party (which Greeley himself had helped found). By 1860, Lincoln regained favor, and Greeley cosponsored Lincoln's Cooper Union address.

With the war under way, Greeley offered the president regular advice: he demanded in his paper that the U.S. Army march on Richmond, only to fall into a self-described state of "black despair" after the battlefield disaster at First Manassas. He blamed Lincoln, writing to the president, "You are not considered a great man." But Greeley's opinion of Lincoln, a matter complicated by the presence of Secretary of State William Seward, his former business partner and now a sworn enemy, proved as inconstant as the weather of Greeley's native New England. Only when the war was long over did he come full circle, describing Lincoln as "the one providential leader, the indispensable hero of the great drama."

The reformer Greeley was a longtime outspoken opponent of slavery, yet in 1867, he earned himself the enmity of many in the North by personally guaranteeing a large portion of Jefferson Davis's bond. Greeley was no friend of Davis's, but for two years the Mississippian had been imprisoned without trial. In Greeley's opinion, that was a violation of habeas corpus—and just plain wrong. President Johnson added his voice to the chorus critical of Greeley, describing him as "all heart and no head . . . like a whale ashore."

The man who had advised presidents—both in person and from his editorial columns—ran for the chief office of the land himself in 1872. The election season brought nothing but bad news for Greeley: his long invalided wife, Molly, died on October 30; he

In the corner of the music room, which Greeley added to the house, stands a painted plaster statue of Horace Greeley. The object is inscribed *Photosculpture, 1867,* suggesting its sculptor worked from photographs to create the likeness.

lost control of his newspapers; and U. S. Grant, running for a second term, soundly defeated him. In one of his last jottings, Greeley described himself as "truly ruined beyond hope." Within the month, he was dead, on November 29, 1872, the only presidential candidate to die before the electoral college votes had been cast.

He once offered what might have been his own epitaph in describing Benjamin Franklin, to whom he had been compared by no less a man than Lincoln. "I love and revere [Franklin]," wrote Greeley in 1871, "as a journeyman printer, who was frugal and didn't drink; a *parvenu* who rose from want to competence, from obscurity to fame, without losing his head; a statesman who did not crucify mankind with long-winded documents or speeches; a diplomat who did not intrigue; a philosopher who never loved, and an office-holder who didn't steal."

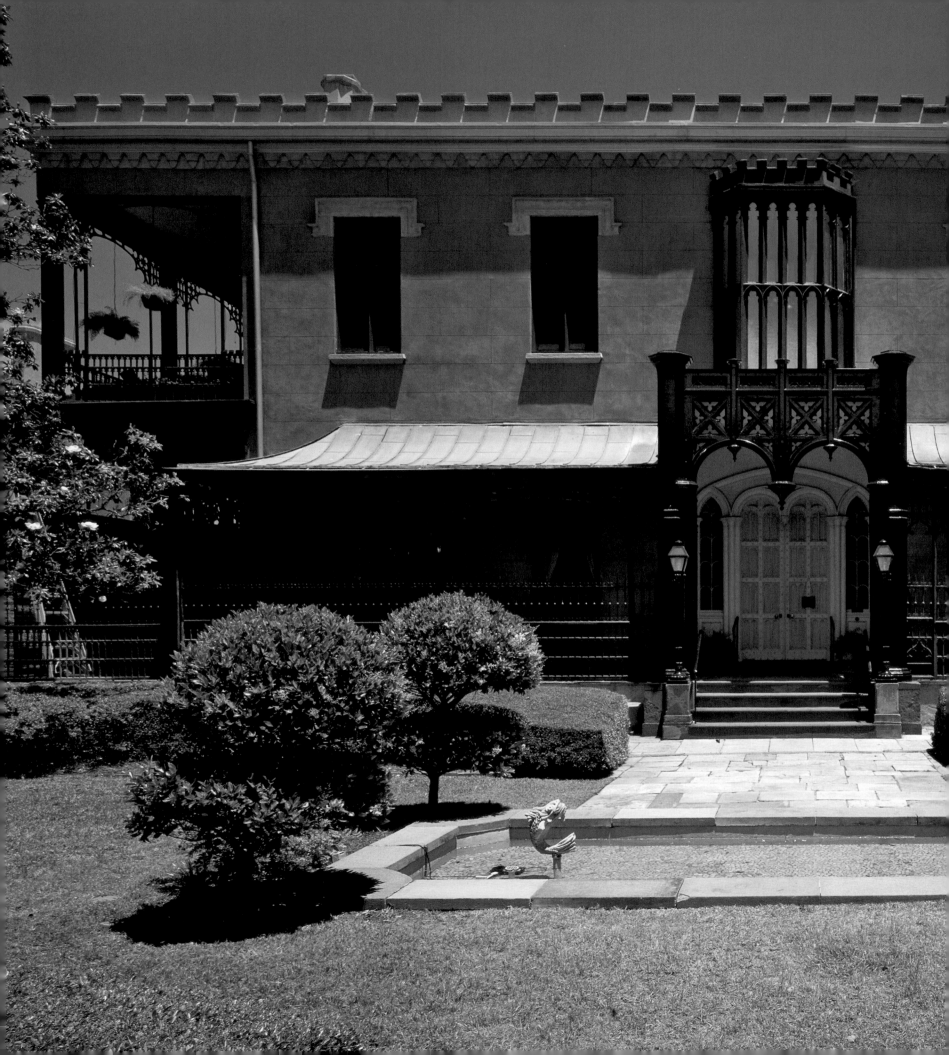

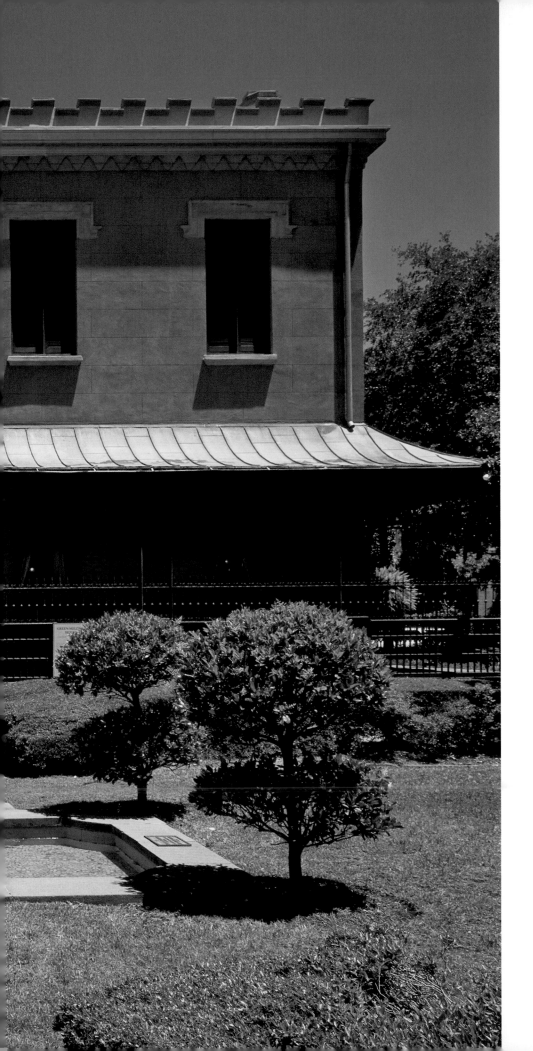

GENERAL SHERMAN OCCUPIES THE GREEN-MELDRIM HOUSE

SAVANNAH, GEORGIA

"Savannah [is] as beautiful as I have ever seen
her. . . . The place is too beautiful to be
occupied by the Yankees—
may Heaven spare [us] this affliction."

GENERAL JEREMIAH F. GILMORE

1862

A CHRISTMAS GIFT TO MR. LINCOLN

With the war in its fourth year, President Abraham Lincoln worried about the 1864 election. He hoped to be aided by notable military victories, having elevated Ulysses S. Grant to commander of all Union troops. He was concerned that his opponent in the presidential race, George B. McClellan, had promised peace negotiations; that seemed a notion many in the war-weary electorate were ready to embrace. The choice between war and peace seemed stark, and Lincoln understood that to prevail that November, he and his allies in the Republican Party needed some very good news from the front.

Although Grant remained stalemated by Robert E. Lee's forces in Virginia, Lincoln finally got the boost he needed in September. After months of uncertainty, word came from Georgia, compliments of General William Tecumseh Sherman, of Atlanta's fall.

After Grant's summons to Washington, the Ohioan had taken command of the military division of the Mississippi. On orders from Grant, Sherman and his men fought their way southeast from Tennessee, and his September 3 telegram delivered news of a great victory: "Atlanta is ours, and fairly won." With that, the electoral momentum shifted, and Lincoln would win a second term (his margin of victory in the electoral college was impressive: he received 212 electoral votes to McClellan's 21).

The ballots had barely been counted, however, when Sherman and his men embarked on another expedition. Though well remembered today as the March to the Sea, the twenty-nine-day trek was shrouded in mystery at the time, with Sherman's destination unknown to all but a few. Some observers thought the target was Pensacola, Florida, or even Mobile, Alabama, but part of Sherman's strategy involved systematically destroying telegraph and rail lines, thereby limiting the flow of news to foe and friend. As Grant observed, his friend Sherman was like a "ground-mole when he disappears under a lawn. . . . [Y]ou are not quite certain where he will come out till you see his head."

Nevertheless, the larger strategy seemed clear: the Union must trap Lee and pincer him between Grant's army on the northern front and Sherman's from the south. The plan called for Sherman's men to turn northward upon reaching the coast, thereafter aided by ferries and naval forces. Before that strategy could be employed, however, Uncle Billy, as his men called him, needed to reach salt water.

Previous page: The centerpiece of the large house (the structure is sixty-four feet across, fifty-six feet deep) is the entrance porch. Its Gothic-style columns and tracery speak of not only the Middle Ages but also the Industrial Revolution, as the porch was fabricated of cast iron. The large bay window above echoes fifteenth-century perpendicular Gothic forms and was probably unique in America at the time. Note the crenellated parapet.

Opposite: The veranda with its view of a private garden. William Howard Russell, correspondent for the *Times* of London, described Charles Green's home in 1861 as "a handsome mansion of rich red sandstone . . . of New York Fifth Avenue character." He was deceived, as it happens, by the stucco applied to the brick walling that gave the place the appearance of ashlar-cut stone.

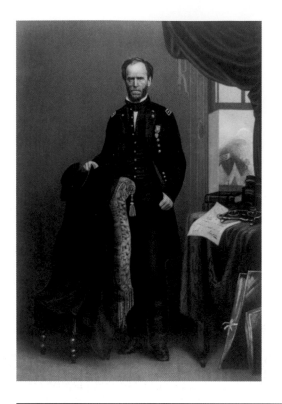

Sherman is said to have rarely stopped talking, but in this engraving, based on a photograph, he seems to be gazing silently and intently at the viewer.
Library of Congress, Prints and Photographs

Sherman's sixty thousand troops began their march from Atlanta on November 15. His four divisions cut a wide swath across Georgia, and at times, a distance of more than fifty miles separated the soldiers on the outermost flanks. The army marched ten miles a day in enemy territory, supplying themselves by "foraging" along the route (Georgians remember it as "plundering").

Sherman understood that success in war consisted of more than winning battles, and permitting his men to help themselves to food and fodder along the route was part of a larger strategy. As he wrote to Grant before departing Atlanta, "If we can march a well appointed Army through [Confederate President Jefferson Davis's] territory, it is a demonstration . . . that we have a power Davis cannot resist. This may not be war, but rather Statesmanship . . . as there are thousands of people . . . in the South who will reason thus—'If the North can march an Army right through the South, it is proof positive that the North can prevail in this contest.'"

Sherman feinted toward Augusta to the north of his route and toward Macon south of it. His army paused to take Milledgeville, the Georgia state capital, but in a march that covered some three hundred miles, there were no major military engagements, with the Union force confronting only disorganized resistance from small bands of Confederate cavalry and militiamen. On reaching the outskirts of Savannah, Sherman's coastal destination, the general demanded the city's surrender, warning the Confederate general in charge, William Hardee, that his forces would "cast heavy and destructive shot [into] the heart of your city." Seventy-two hours later, having cobbled together a floating bridge across rice flats north of the city, Hardee and his men escaped in the night to South Carolina.

Sherman rode into Savannah victorious. On December 22, he wrote to Lincoln, "I beg to present you as a Christmas gift, the city of Savannah, with 150 heavy guns and plenty of ammunition, and also about 25,000 bales of cotton."

THE HOUSE ON MADISON SQUARE

Sherman himself received an unexpected Christmas gift when a man with a British accent visited him at the Pulaski Hotel. Charles Green offered the victorious general accommodations in his house on Bull Street, and, though reluctant "to make use of any private dwelling," Sherman accepted Green's offer. He moved in that very afternoon and on Christmas Day wrote to his wife, Ellen, "I am at this moment in an elegant chamber of the house of a Gentleman named Green . . . my bed Room has a bath & dressing Room attached which looks out of proportion to my poor baggage."

The rumpled general, a man famous for favoring the rough-and-ready life of the military encampment, then took up what would be a five-week residence in one of Savannah's showplaces. Green no doubt had his reasons for making the offer, having spent time in 1861 in a Boston prison after being accused of plotting to provide the Confederacy with munitions shipped from London. As he looked to ingratiate himself with the city's occupiers, he proved an agreeable host with whom Sherman shared many meals.

More than a century earlier, when the city's founder, James Oglethorpe, devised his urban plan for what would become Savannah, he chose a level plat atop a forty-foot bluff overlooking the Savannah River. His 1733 plan called for a city dotted with squares (effectively, small public parks) with designated lots for public buildings (lining the east and west sides of each square), along with forty smaller plots for private residences (to the north and south). The result would be a city of "wards," to use Oglethorpe's term, built on a uniform grid that, by the mid-nineteenth century, had more than quadrupled from Oglethorpe's original plan for six wards.

Savannah's burgeoning prosperity in the antebellum years, based on Sea Island cotton, slave labor, and the invention of the

General Sherman commandeered this second-floor bedroom as his office. Very likely he wrote his "Christmas gift" note to President Lincoln here and, later, met with African American leaders to discuss the understanding memorialized in Special Field Order No. 15 concerning the forty-acres-and-a-mule land grants.

The entrance had no fewer than three pairs of doors; the outer one, here set into the side jambs, was studded in the medieval manner. (Not visible are a set of louvered doors used to enhance air circulation and privacy in hot weather and glass-paneled doors for use on cooler days.) The view is of St. John's Church, which administers the building as a museum and parish house.

cotton gin at the nearby Mulberry Grove plantation, meant that many of its wealthy denizens, such as Mr. Green, had been able to build immense town houses.

Known today as the Green-Meldrim House (*Meldrim* was added later, after a family of that name acquired the home at the turn of the twentieth century), Charles Green's mansion differs from most of Savannah's finest houses. Born in Shropshire, England, Green (1807–1881) arrived in Savannah in 1833. Having clerked in the shipping business in the port at Liverpool, Green amassed in his adopted city a substantial fortune as a cotton broker and ship owner. While many well-to-do Savannahians built grand homes in the popular Greek Revival or Italianate styles, Green, who remained a British citizen, chose Gothic Revival, then all the rage back home.

Completed in 1853, Green's new domicile was distinguished by many medieval details, including windows and doors capped with the characteristic pointed Gothic arch and a parapet of battlement-like crenellations. The large house — its main block encloses some 7,300 square feet behind its fifty-six-foot-wide main façade — was built to the design of master builder John S. Norris. Though a New Yorker, Norris spent a dozen years before the Civil War designing some of Savannah's most admired homes and public buildings.

Norris and his client spent lavishly, as Mr. Green's ships returned from Europe with stone, brick, Minton floor tiles, and Carrara marble mantels. Bay and oriel windows were framed with cast iron. Inside, newfangled gasoliers offered illumination, most dramatically atop the freestanding stair where a saucer dome was lit by ninety-eight gas nozzles. The construction cost totaled a shocking ninety-three thousand dollars.

When General Sherman arrived, not everyone in Savannah welcomed him as Mr. Green did; one correspondent for the *Boston Evening Transcript* reported that "a sullen acquiescence . . . was the only visible emotion on the part of the white inhabitants." The reaction of former slaves, however, was different indeed. "The negros," Sherman wrote to Ellen, "they flock to me old & young . . . and mix up my name with that of Moses." For his part, Sherman issued orders that the slave-auction blocks be dismantled and distributed for firewood.

THE DEMON OF THE LOST CAUSE

William Tecumseh Sherman (1820–1891) occupies a place of paradox in the American memory. In the years just after the Civil War, he was widely criticized by many in the North, including Secretary of War Edwin Stanton, for being too soft on the South (the *New York*

Opposite: Although the north parlor within is grand, the elaborate wood and plasterwork in the hall draw the eye. The door frame is of walnut, stained to resemble mahogany. The arches and cornice are of molded plaster, and the original floor tiles were made at the Minton pottery at Stoke-on-Trent. The fifteen-foot ceilings add to the impression that Mr. Green spared no expense.

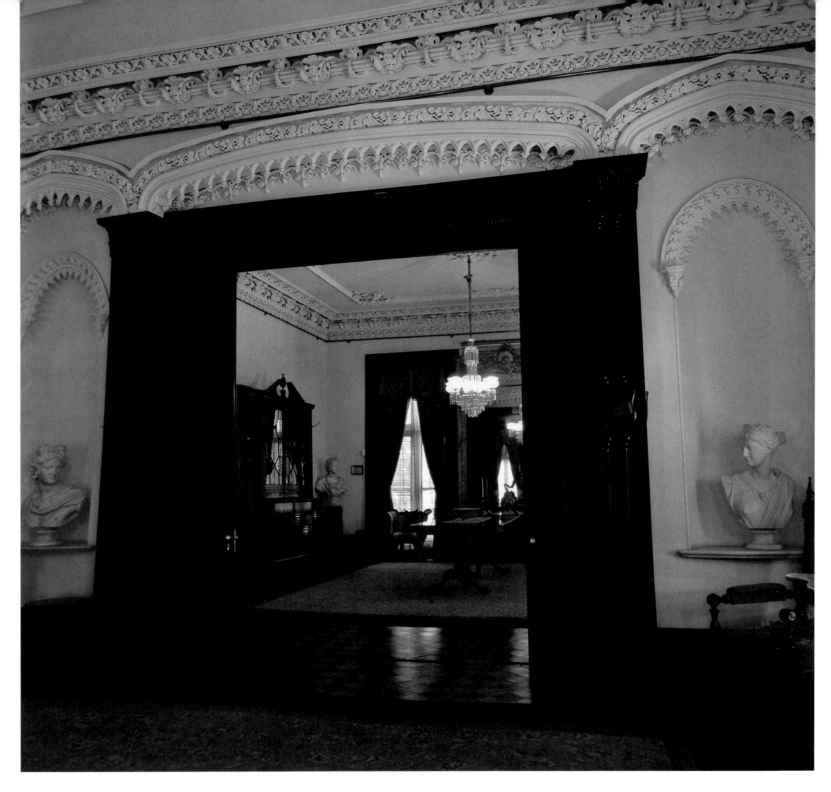

Times, Stanton's surrogate, accused Sherman of "military insubordination" for the lenient terms he offered Confederate general Joseph Johnston on his surrender after Appomattox). However, by the turn of the twentieth century, the dominant Civil War narrative in the South cast Sherman as the Union's chief military villain.

From childhood, Sherman led a life characterized by the unexpected. The sixth of eleven children born to Connecticut Yankees who moved west, the boy started life with the unlikely given name Tecumseh, which honored the charismatic Shawnee chieftain who took the enemy side in the War of 1812. After his father's unexpected death (probably of typhoid fever), the nine-year-old moved to the Lancaster, Ohio, home of Thomas Ewing, a prosperous attorney and soon-to-be U.S. senator. Sherman's years in Ewing's household led to his adoption of a new first name in 1830; his appointment to the U.S. Military Academy in 1836; and his eventual marriage to Ewing's daughter Ellen in 1850.

In the antebellum years, Charles Green entertained often, holding balls and parties. In this room, where William Tecumseh Sherman slept in 1864 and 1865, today's brides and bridesmaids prepare for weddings to be held across the garden at St. John's Church.

After graduating sixth in his class at West Point, Sherman rose to the rank of captain before resigning his commission in 1853. He then worked as a banker and businessman, moving from New Orleans to San Francisco and on to St. Louis and Leavenworth, Kansas. Having achieved no notable successes in the marketplace, he accepted an appointment as superintendent of the Louisiana State Seminary of Learning and Military Academy in 1859. There he excelled, helping to establish the school that later became Louisiana State University. Yet he could do little but watch helplessly as his country threatened to come apart. He decried President Buchanan's inaction, calling him "pusillanimous." He expressed no particular aversion to slavery, but he clearly foresaw the consequences of secession. As he wrote prophetically to a friend on Christmas Eve 1860, "You people of the South don't know what you are doing. This country will be drenched in blood, and God only knows how it will end. . . . War is a terrible thing! You mistake, too, the people of the North. They are a peaceable people but an earnest people, and they will fight. . . . You are rushing into war with one of the most powerful, ingeniously mechanical, and determined people on Earth—right at your doors. You are bound to fail."

After Louisiana seceded, Sherman secured a commission as a colonel in the infantry, but by December 1861, the tall, talkative, red-haired officer was relieved of command. The *Cincinnati Commercial* asserted that he was "insane . . . stark mad," and Sherman himself admitted to his brother in January 1861 that he had contemplated suicide. That spring, however, he overcame his depression to assume command of a division in the Army of Tennessee. In doing so, he launched a professional partnership with another officer whose prewar years had been less than promising.

The generalships of Ulysses Grant and Sherman would prove crucial to the Union's eventual success. Sherman demonstrated a particular genius for maneuvering his forces. His strategies, which involved mobility, deception, and an indirect approach, anticipated the later military thinking practiced by the armored forces of both Great Britain and Germany in World War II.

After the war, Sherman remained in the U.S. Army, retiring in 1884 as general of the army of the United States, having refused overtures to become secretary of war or run for president. He published his memoirs, which were criticized in the North as egotistical. After his death, one Southern historian, writing in the pages of *Confederate Veteran*, asserted that Sherman's "name was but another for murder, theft, fire and the sword."

While there is no consensus view of the torching of Columbia, South Carolina, for which Sherman has been blamed (was it accident, the work of departing Confederates, or arson committed by Sherman's men?), most historians today do agree that Sherman's troops did much less damage in marching across Georgia than has often been claimed. Matters are made no clearer by the fact that Union forces under his command certainly did burn and pillage many properties in South Carolina, although they did so at least in part because of the rank-and-file soldiers' passionate desire to punish the secessionists of the Palmetto State, whom they blamed for starting the war that had taken the lives of so many of their fellow soldiers.

FORTY ACRES AND A MULE

Major General Sherman claimed no abolitionist principles. He resisted the recruitment of black soldiers, writing in 1864, "The negro is in a transition state and is not the equal of the white man." He felt burdened by "contraband," the freedmen who followed his army. As the war ended, he opposed extending the franchise to blacks. Yet in Savannah, on January 16, 1865, he promulgated a radical redistribution of coastal lands in the Sea Islands that granted emancipated slaves acreage abandoned by plantation owners fleeing Union troops.

While Sherman's Special Field Order No. 15 amounted to the fulfillment of an implied promise to former slaves, the policy was the result of pressure exerted by the secretary of war. At Stanton's urging that January, Sherman had convened a meeting with black leaders, treating them with a respect unprecedented in the South (an echo, perhaps, of Lincoln's regard for Frederick Douglass; see "Frederick Douglass's Cedar Hill," page 182). Stanton no doubt guided Sherman's pen as he drafted Special Field Order

No. 15, which granted the heads of black families "not more than forty acres of tillable ground" each, to which they would receive "a possessory title in writing." Many would also receive army mules.

After Lincoln's assassination, President Andrew Johnson aborted the experiment, which, in truth, was entered into by some (including Sherman) at least in part as a cynical answer to concerns about unwanted black soldiers and contraband camp followers; for Sherman, the document was a necessary war measure, not a permanent promise. During the years of Reconstruction, "forty acres and a mule" would be a recurring rallying cry, but one that, having been withdrawn by Johnson, proved a false promise.

Above: An Englishman, William Waud, rendered the image of Mr. Green's mansion occupied by General Sherman's aides in December 1864. *Library of Congress, Prints and Photographs*

Sherman remains an enigmatic figure, his apparent contradictions many. Though the devoted father of eight children, he was never happier than when on the road with his troops. He was an asthmatic with an ever-present cigar. Known for his slovenly dress, Sherman was a man of culture, a passionate theatergoer, a sometime painter, and very much a literary man (he wrote well and read voraciously, favoring the Bible and the works of Shakespeare and Dickens). He feuded with members of the press for decades even as he penned widely published public letters.

Sherman has been called the "first modern general" and the "demon of the lost cause," but whatever you choose to call him, he was surely among the most quotable of men. In addressing the crowd at a veterans' reunion in Ohio in 1880, he uttered a phrase that, though often misquoted, has a fixed place in the American vernacular. "There is many a boy here today who looks on war as all glory," he told the younger members of the crowd, "but, boys, it is all hell."

WILLIAM HENRY SEWARD HOUSE

AUBURN, NEW YORK

"It is an irrepressible conflict between opposing
and enduring forces, and it means that the
United States must and will, sooner or later,
become either entirely a slaveholding nation,
or entirely a free-labor nation."

WILLIAM HENRY SEWARD

October 28, 1858

APRIL 14, 1865

Confined to his bed, the usually voluble secretary of state could barely speak. That morning his doctors had affixed wires to his teeth to stabilize his jaw, dislocated and broken in his fall from a carriage the previous week. His broken arm pained him too, as did contusions of his nose and cheek and the exquisite tenderness of the gout that had just recurred in his right foot.

For all his discomforts, William Henry Seward could take solace in the news from the front. Abraham Lincoln himself had visited a week earlier, just back from Richmond, the former Confederate capital now in Union control. The president, stretched out on one side of the bed, his head resting on his elbow, briefed Seward for half an hour. "I think we are near the end at last," the president told him. Seward could only nod and whisper in response.

That conversation would be their last.

April 14, 1865, may be best remembered for the events at Ford's Theatre, but John Wilkes Booth's coconspirators had also planned to kill two other men of the government at the hour of ten o'clock that evening. The man Booth had assigned to kill Andrew Johnson chose not to shoot the vice president—the would-be assassin spent the night walking the streets of the city, his gun unfired—but at Seward's fine three-story brick mansion overlooking Lafayette Square, a tall, well-dressed man presented himself at the door, and

in the next several minutes, he transformed the house into a place of carnage.

Lewis Powell gained entry by telling the servant who answered the bell that he brought medicine for Seward, along with specific instructions from the doctor as to its administration. Seward's son Frederick, who was also the nation's assistant secretary of state, met the messenger at the second-floor stair landing. The patient was asleep, the younger Seward told Powell. "Give me the medicine and the directions; I will take them to him."

Powell insisted that he needed to see the patient personally, but Frederick refused to let him. The visitor turned as if to depart and descended two or three steps. Then he suddenly whirled, brandishing a bowie knife with one hand and pulling a revolver from his pocket with the other. He pointed the gun at Frederick, but when he pulled the trigger, the weapon misfired. The two men

Previous page: After Judge Miller's death, Seward gradually remodeled the Federal-style house into a grander, more contemporary mansion. He made some changes, then in 1868 he hired architect Edward T. Potter of Schenectady to help transform the place into an Italianate villa. As viewed across Seward's generous garden, the three-story tower to the rear of the house was among Potter's additions.

Opposite: After his retirement from service as secretary of state, the widower Seward spent more time traveling than he did in Auburn. His destinations included many European capitals, and in a fourteen-month journey, he circumnavigated the globe, the first American political figure to do so, returning home in the autumn of 1871.

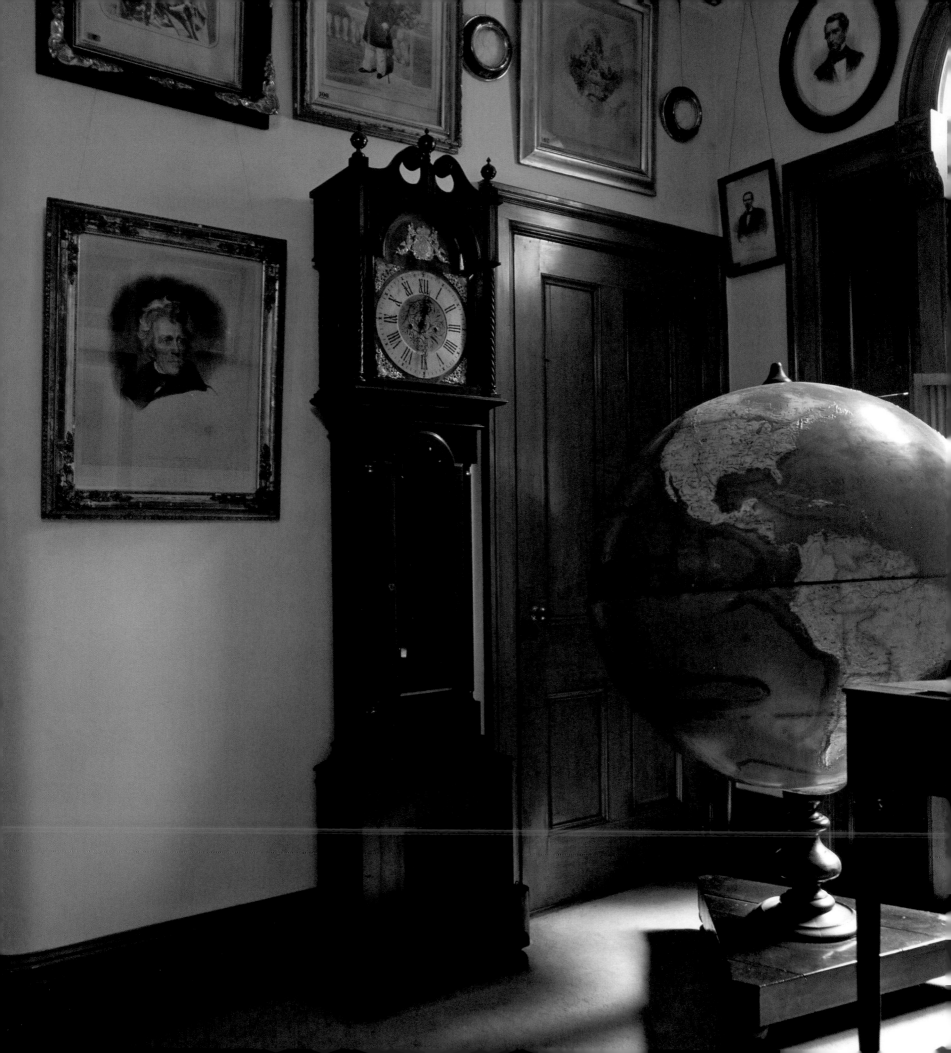

struggled, and the solidly built Powell, wielding the gun like a club, struck Frederick, fracturing his skull. Frederick Seward fell to the floor unconscious.

The assassin made for Secretary of State Seward's bedchamber. Inside, hearing the fracas in the hall, a soldier detailed to perform orderly duties in the household went to the door. He was greeted by a charging Powell, who drove him out of his path, slashing the soldier's forehead with the bowie knife. Seward's daughter Fanny, who had been reading to her now sleeping father, screamed as the attacker plunged the knife repeatedly into Seward's neck and face. Seward tumbled to the floor on the far side of the bed, bleeding profusely. Before Powell could renew the attack, another son, Augustus Seward, and the orderly managed to pull him away, though Powell repeatedly lashed out with his knife before making his escape. He stabbed a State Department messenger on the stairs as he departed.

He left behind five bleeding men. None would die, although initially the doctors believed Frederick might not survive his head wounds. Yet the Seward family would soon suffer a great loss.

A disheveled William Henry Seward, as photographed by Mathew Brady during the Civil War. Historian Henry Adams famously said of Seward that he had "a head like a wise macaw; a beaked nose; shaggy eyebrows; unorderly hair and clothes." *Library of Congress, Prints and Photographs*

Although she had not been attacked, Seward's wife, Frances, hearing the screams of her daughter, emerged from her room to find her sons and husband grievously wounded. As she saw the men recover in the coming weeks, she herself, long subject to depression and such recurrent complaints as headaches, fevers, and neuralgia, fell gravely ill. According to Frederick, "The shock of the assassination . . . prostrated her with a slow fever." She died at age fifty-nine, two months after the attacks.

The recovering William Henry Seward—to Frances, he had been Henry—left Washington with his wife's remains, honoring her dying wish to be among the flowers and birds in the garden of their home, *her* home, in Auburn, New York.

JUDGE MILLER'S SON-IN-LAW

As a groom four decades earlier, William Henry Seward impressed people, though not by his looks. His bride stood several inches taller than he; she was a woman with black eyes and dark hair whom the artist Chester Harding described as "very beautiful." Henry, in contrast, attracted notice for being "light as to hair and eyes" and "big as to nose."

The red-haired suitor had gotten the consent of the bride's father, Judge Elijah Miller. Born in the rural town of Florida, New York, some sixty miles from Manhattan, William Henry Seward (1801–1872) graduated with highest honors from Union College, then read law, gaining admission to the New York Bar. In 1824, he went west to assume a junior partnership with Judge Miller. In the flourishing town of Auburn, hard by the turnpike that linked Albany with newly prosperous western New York, Seward came to view the older man as a friend as well as his partner in law. Just six months after the establishment of the firm of Miller and Seward, the junior man asked for the hand of Miller's daughter in marriage.

Seward wrote to his own father that Frances Adeline Miller met his three requirements for a spouse: she had affection for him; she was possessed of a "strong mind"; and she offered him the promise of financial security. Henry also reported that Frances's father happily regarded him "as a son."

Seward used this cluttered and cramped office space to work on his autobiography, which would be published posthumously, edited by his son Frederick. William Henry Seward died in this room at four o'clock in the afternoon on October 10, 1872.

Seward called the upstairs hall the Diplomatic Gallery; its walls were covered with images of sovereigns and ministers of the mid-nineteenth century, many of whom Seward met on his travels.

The soon-to-be father-in-law did, however, impose one stipulation on the couple's marriage. A widower since Frances's infancy, he required that she remain in residence in Auburn at his home until his death. Seward accepted the terms, as the gracious ten-room house could certainly accommodate a multigenerational family, which at that point included his wife's paternal grandmother and an aunt. In retrospect, however, he seemed to regret the choice, and his terse description of the understanding is telling: "I thus became an inmate of her family."

Surviving correspondence and the accounts of others leave little doubt that Henry and Frances were devoted to each other, their relationship enduring, warm, and affectionate. Yet Henry's other great love regularly drew him away from the house and its four manicured acres. Politics would be the greatest passion of his life.

Just six years into their marriage, Henry won election to New York's state senate. He lived in Albany for the annual four-month legislative session that commenced each December, leaving Frances to celebrate Christmas with their growing family (five of their six children would reach adulthood) and Judge Miller. After serving four years as a senator, he ran for governor; he lost in 1836 but won the 1838 election. Frances consented to live in the governor's mansion, but she soon found the social obligations of being the "Governor's Lady" enervating.

After building his law practice and establishing widespread political connections following his gubernatorial years, Henry went to Washington as a U.S. senator in 1849. One week into his first term, in his maiden speech, he set the tone, declaiming that "there is a higher law than the Constitution." He thereby established himself as an outspoken opponent of the Slavocracy, the coalition of slaveholders who, in the view of an increasingly wary contingent of so-called Conscience Whigs, looked to dominate the national government in order to protect their slaveholding interests.

Despite the fact that the Fugitive Slave Act of 1850 made the action a federal crime, Seward housed runaways when home in Auburn ("the underground railroad works wonderfully," he reported). He sold a plain house to Harriet Tubman, perhaps the best remembered conductor on the U.G.R.R. (see "General Tubman's Home," page 171).

Although he opposed the expansion of slavery into the territories, Seward was not a radical abolitionist. He joined the newly formed Republican Party in 1855 and quickly rose to a leadership role, part of a political wave that would alter the nation's balance of power, leading to a climactic confrontation between those who sought to limit the spread of slavery and those who resisted any limits.

THE HOUSE ON SOUTH STREET

The place Seward promised to call home had been constructed to Judge Miller's specifications in 1816. Built in the Federal style with a side-hall plan and a fan sash over the entry, the brick house cast a long shadow. The raised basement of brownstone and two tall stories of soft red brick housed a well-furnished home that reflected the proper taste and considerable means of its owner.

Twice in Seward's time of occupancy, the house was enlarged. A rear ell and a three-story tower were added in 1848. In 1860, after arson destroyed an earlier wood-frame carriage house, two new, freestanding stone carriage houses were constructed. An 1868 addition to the main house produced the most radical change, as the longtime side hall of the south-facing front became the center hall of a classic, five-bay colonial design, complete with Italianate detailing in the prevailing Victorian taste. Inside, visitors found a new, generously proportioned drawing room and a grand dining room, suitable for the newly retired statesman.

Important visitors knocked at the Sewards' door. Henry Clay came for the night, accompanied by his body slave, in 1839; a torchlight procession brought John Quincy Adams to Seward's doorstep in 1843. But as Seward rose in prominence, his time at home diminished. He returned for the birth of his children but was often in absentia (during the four years of Civil War, he took just nine trips to Auburn for brief visits, while Frances traveled annually to Washington, typically for a month).

When away, he wrote his wife almost daily and, early in his career, consulted her often, reading her his speeches, talking over matters of style and principle. His absences from Auburn, however, resulted in a growing intellectual and emotional distance; she knew he needed to pursue his work, having described him as "the most indefatigable of men." As a result, his wife's house on South Street gradually became Seward's home away from home; his home became the nation's capital.

Ironically, the biggest disappointment of Seward's public life occurred in a quiet moment in the garden at the Auburn house. In May 1860, the delegates gathered in Chicago for the Republican

Though the stairway was added after Seward's death, the California Pioneer Society provided the laurel and manzanita woods used, a gift in honor of his 1850 Senate speech (in which he intoned the epithet *higher law*) and in appreciation of his efforts to have the state admitted to the Union as a free state.

course shifted. In the coming weeks he contemplated retirement, confiding in a longtime political ally, "I am content to quit with the political world, when it proposes to quit with me." But Republican friends persuaded the devoted partisan to hit the road, and he embarked on a five-week campaign tour in support of Lincoln, traveling as far west as Kansas, as far north as Minnesota, and passing through Wisconsin, Ohio, Indiana, and Illinois, where he met with Lincoln. On his return home, he crisscrossed New York, making no small contribution to Lincoln's victory in the November 6 election. The following month he got a new call to duty: Lincoln wrote offering him the position of secretary of state, adding, "It has been my purpose, from the day of the nomination at Chicago, to assign you by your leave, this place in the administration."

For eight years, Seward served Lincoln, then Andrew Johnson, in his appointed role. At first, the veteran Washington politician imagined he would dominate the government of the inexperienced Lincoln; soon enough, Lincoln made it clear that he valued Seward's counsel but would choose his own path, and a solid partnership evolved. Seward gave Lincoln the sage advice to delay the Emancipation Proclamation until after a military victory (which proved to be Antietam), and he came to regard Lincoln as "the best and wisest man" he had ever known.

Though he failed to reach the political summit to which he had earlier aspired, Seward played an important role as secretary of state in helping shape Lincoln's policies during the war and as a powerful presence in the Johnson administration. His résumé includes the acquisition of Alaska (thus its sometime nickname of "Seward's Folly"). Even after his retirement, the widower proved reluctant to remain in Auburn, traveling widely to the Pacific Coast, visiting Alaska and Mexico. On another journey, he circled the globe, with stops in China, India, Egypt, and many European capitals. He spent the last year of his life at his wife's home—Judge Miller had deeded it not to Seward but to Frances and her children—where he died in his small office in October 1872.

Convention. Public opinion seemed to favor Seward as the party's candidate for president, and even an opposition newspaper, the *New York Journal of Commerce,* regarded his nomination as "a settled fact."

He retired to Auburn to await the good news and was relaxing beneath a vine-covered arbor talking with an old friend, the local Universalist minister John Austin, when a telegram arrived. It contained a short but hardly sweet message: *Lincoln nominated third ballot.*

Austin saw his friend's face go pale, flush briefly, then become as "calm as a summer morning." In that moment, Seward's life

GENERAL TUBMAN'S HOME

A diminutive woman named Minty, barely five feet tall, grew up enslaved on a Maryland farm. When she was young, she was struck with a two-pound weight and sustained a head injury. The untreated injury—she was ordered back into the fields to work—left her with an ailment that has been variously diagnosed as epilepsy or narcolepsy, as she periodically lost consciousness. Whatever the other consequences, however, the injury did not prevent her from leading a long and extraordinary life.

Upon her marriage to John Tubman, she assumed the name Harriet. In 1849, she escaped to Philadelphia, aided by a neighboring farmer, who covered her with vegetables in the bed of a wagon. For a time she worked as a maid, but despite the risk of recapture, over a period of years she returned a dozen times or more to Maryland's Eastern Shore to lead others to freedom. No precise documentation exists, but it is estimated that in her work for the Underground Railroad, she freed about seventy-five slaves.

Her exploits as a conductor gained Harriet Tubman (1820–1913) the admiration of Frederick Douglass ("The midnight sky and the silent stars have been the witnesses of your devotion to freedom and of your heroism"; see also "Frederick Douglass's Cedar Hill," page 182). In support of

the cause, she delivered many abolitionist lectures in New York and Massachusetts, sometimes using the pseudonym Harriet Garrison (it was abolitionist William Lloyd Garrison who called her the Moses of her people). John Brown, who dubbed her "General Tubman," tried to enlist her aid in 1858, laying out his plans for a slave uprising; having fallen ill that autumn, she made no journey to Harper's Ferry (see "The Invasion at Harper's Ferry," page 63). During the Civil War, Tubman served as a Union cook and nurse for black soldiers. As a scout and spy, she helped liberate some 750 slaves in South Carolina.

Although the Fugitive Slave Act of 1850 had forced her to settle in Canada, in 1858 she returned to the United States from St. Catharines, Ontario, when Senator William Henry Seward sold her seven acres of land in Auburn, together with a small house, for twelve hundred dollars. When Seward died, she sent flowers to his heirs.

The property would remain hers for the rest of her long life. She founded the Harriet Tubman Home, a residence for aged and infirm African Americans, on an adjacent piece of property she purchased for $1,650. She would spend her last days in the Tubman Home. Today, the site commemorates the life and deeds of General Tubman.

Top: Located in Auburn, New York, less than a mile from the Seward House, Harriet Tubman's domicile commemorates the woman who settled there in the home she obtained through the good offices of William Henry Seward.

Left: Harriet Tubman, photographed about 1860. The original print in the Library of Congress is captioned "nurse, spy and scout." *H. B. Lindsley/Library of Congress, Prints and Photographs*

GENERALS GRANT AND LEE AT THE WILMER MCLEAN HOUSE

APPOMATTOX COURT HOUSE,
VIRGINIA

"I recognize fully that the surrender of
this army is the end of the Confederacy."

ROBERT E. LEE
TO E. P. ALEXANDER

April 9, 1865

STANCHING THE EFFUSION OF BLOOD

L ieutenant General Ulysses Grant couldn't sleep. Despite such remedies as mustard plasters applied to his neck and immersing his feet in hot water, an intense sick headache hung over him like a miasma. The refusal of his opposite number to accept the inevitable helped not at all.

For two nights running, missives had arrived at midnight from General Robert E. Lee. The first had been a response to a short note from Grant dated April 7, 1865, in which the general had written, "The results of the last week must convince you of the hopelessness of further resistance." That being so, he went on, "I . . . regard as my duty to shift from myself the responsibility of any further effusion of blood by asking of you the surrender of . . . the army of Northern Virginia." After four bloody years, he believed the time to end the war was at hand.

In his late-night response to Grant's letter, Lee rejected Grant's assessment that the Confederate army's situation was hopeless. Still, the South's commander did not rule out negotiation altogether. "I reciprocate your desire to avoid the useless effusion of blood," Lee wrote, "& therefore before considering your proposition, ask the terms you will offer on condition of its surrender."

Grant had written back the following morning stating his sole condition: "The men and officers [of the Army of Northern Virginia] surrendered shall be disqualified from taking up arms again against the Government of the United States." The implications were gen-

erous: Lee's soldiers would not be imprisoned, and, once paroled, they could go home to restart their lives.

Yet again, however, after Grant had suffered through another afternoon and evening of migraine pain, Lee's answer was a deflection. Though he affirmed his willingness to continue the conversation about "the restoration of peace," he refused to give up, writing, "I do not think the emergency has arisen to call for the surrender of this Army."

Grant's aide-de-camp, Lieutenant Colonel Horace Porter, recorded Grant's reaction to Lee's second note. "The general shook his head, expressive of his disappointment, and remarked, 'It looks as if Lee still means to fight; I will reply in the morning.'"

The exhausted Grant, in full uniform save for his jacket and boots, lay down on the sofa in the parlor of his farmhouse headquarters. Though he rested his head only some twenty miles from the now-revered surrender site at Appomattox Court House, Grant's attempt to sleep that night would be in vain.

"NOT YET"

The worst week of Robert E. Lee's military life neared an end. The master strategist, a man whose first instinct most often led him to attack, retreated west. Forced to abandon the city of Petersburg on Sunday, April 2, he learned that hours after his departure, Abraham Lincoln had arrived to tour the town, guided by General Grant. On Monday, with the capital of the Confederacy still shrouded

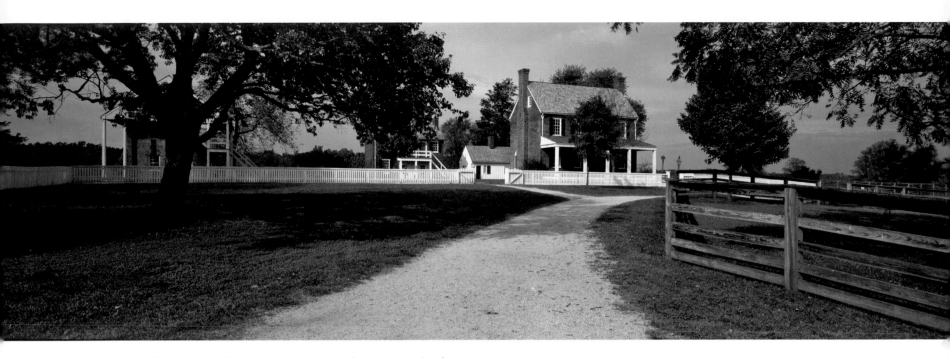

in smoke (fleeing Confederates seeking to destroy supply depots burned more of Richmond than Sherman's army burned of either Atlanta or Columbia), a worshipful mob of freemen on the street engulfed Lincoln on his arrival. These were great gains for the Union, both symbolic and territorial, and painful for Lee to contemplate.

The news got worse. On Thursday, April 6, at a disastrous engagement at Sailor's Creek, Lee lost eight thousand men, most of them taken prisoner by Union troops. Among them was his eldest son, Major General George Washington Custis Lee. As the sun set, Lee watched the retreating mob of Confederate soldiers who had managed to escape.

"My God," he was heard to say, "has this army dissolved?"

His ever-diminishing army now consisted of just two corps, one commanded by Lieutenant General James Longstreet and the other by Major General John B. Gordon. As they marched through the night, the ranks of the proud Army of Northern Virginia grew smaller still; at every crossroad, more and more soldiers, hungry, exhausted, and demoralized, turned to walk toward home. Though on the run and in desperate circumstances, Lee did his best to keep up morale. In responding to the salute of a cavalryman that day, an officer remembered, Lee's face broke into "a calm smile that assured us our confidence was not misplaced."

As bad as things were, Lee remained impassive even to his inner circle. On Friday, after he read Grant's first note recommending surrender, he passed the message wordlessly to General Longstreet, the man he called Old War Horse. As he handed back the note, Longstreet spoke for both men: "Not yet." The hope remained that if the Army of Northern Virginia could outrun Grant, Lee and his men could veer south and consolidate with the Army of Tennessee and other forces under the command of General Joe Johnston.

On Saturday morning, Lee learned that not all of his generals shared his optimism. In need of a respite after a long night in the saddle, Lee lay resting in the shade of a pine tree when General William Pendleton rode up, dismounted, and approached. He apprised his commander of a confab the previous evening at which Pendleton and several officers reached the hard conclusion that, "in their opinion, the struggle had reached a point where further resistance was hopeless."

Previous spread: The oldest surviving structure in the village, the Clover Hill Tavern, built in 1819. Once little more than a stop on the Richmond-Lynchburg stage road, the hamlet previously known as Clover Hill became Appomattox Court House when Appomattox County was established in 1845.

Above: The tavern (*right of center*) pictured with its attendant buildings, including more guest quarters (*left*) and a kitchen to the rear.

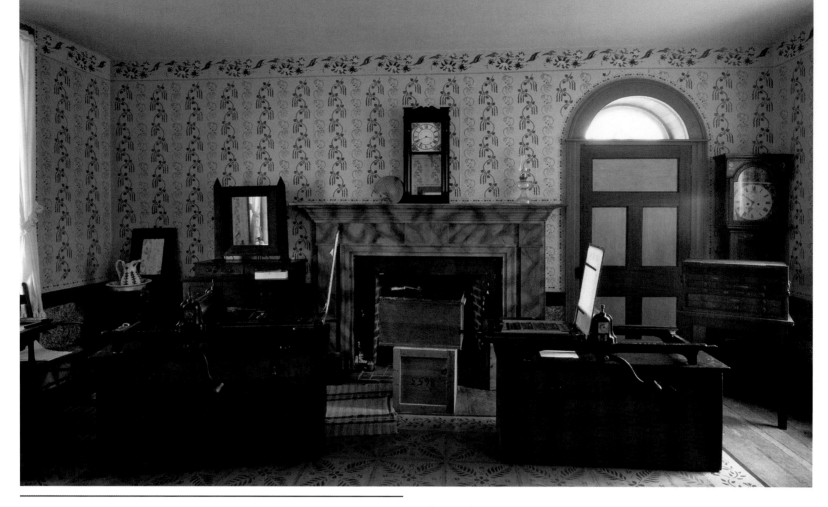

Printers at work in the Clover Hill Tavern produced 28,231 parole passes for issue to former Confederate soldiers. The documents functioned as permits, enabling the defeated army troops to return home.

Still, Lee resisted. The Confederate army lurching toward Appomattox consisted of perhaps thirty thousand effectives, about the same number he had led after the Battle of Antietam three years earlier. He nursed the fragile belief that his troops might break through the Union armies, which, he knew, aimed to surround him. But it was not to be.

PALM SUNDAY

The receipt of Robert E. Lee's next message banished Grant's headache. As he remembered years later, "The instant I saw the contents of the note I was cured."

The evening before, the Federal infantry had outmarched Lee's weary soldiers, and General Philip Sheridan's forces captured Confederate supply trains at nearby Appomattox Station. With the light of day, Lee saw that no good escape route remained and, at last, accepted the need to capitulate. Soon couriers under flags of truce carried a rapid exchange of messages between the camps. The essential words were Lee's: "I now request an interview in accordance with the offer contained in your letter of yesterday." A ceasefire agreed upon, both commanding generals rode toward the tiny village of Appomattox Court House.

Astride his horse Traveler, under a cloudless blue sky, Lee arrived before Grant. Preceding him had been Colonel Charles Marshall, who, seeking a place to hold the negotiations, had inquired of a townsman, Wilmer McLean, where he might find a suitable room. In one of American history's oddest coincidences, McLean, a cotton and sugar broker, proved to be the same man who inhabited the plantation house on the Bull Run battlefield that had been adopted as Confederate headquarters by General P. G. T. Beauregard. In that first Virginia battle, McLean's summer kitchen had been blasted by Union artillery fire, and now, having moved to the town of Appomattox Court House, McLean allowed that his parlor, in the middle of this final Virginia battlefield, might be a suitable site for Lee's surrender.

Lee entered the McLean parlor and assumed a seat. He put

his hat and gauntlets on the marble-topped table before him and waited. After thirty-nine years of duty—at West Point, in the U.S. Army, and, for the last four, in service to the Confederate States of America—he knew his military career was approaching its end. Half an hour later, the man responsible for that walked in the door.

As they shook hands, both Grant and Lee understood the meaning of the moment. A nation divided into two had been at war with itself for four years; hundreds of thousands of soldiers had died in combat, and disease more than doubled the death toll. But this day they would end the bloodshed.

Both men wore full beards, but the resemblance went no further. A man with a courtly air, Lee stood erect; in honor of the occasion, he had donned a fresh dress uniform, with a red silk sash and a ceremonial sword. His shoulders rounded, Grant had ridden in from the field; his garb was a plain soldier's blouse of blue flannel. His trouser legs were stuffed into ordinary boots, and he wore no spurs or sword. As one of his officers described him, "Covered with mud in an old faded uniform, [he] looked like a fly on a shoulder of beef."

"I met you once before, General Lee," Grant began, "while we were serving in Mexico." The man before him had aged noticeably in the intervening two decades. Unlike Grant's still nut-brown hair and beard, Lee's hair had gone to gray. Lee was sixteen years older than his opposite number, whom, Lee admitted, he remembered meeting but did not recognize. During the Mexican War, Grant was a lowly infantry lieutenant, Captain Lee a fast-rising aide on General Winfield Scott's staff.

They talked politely for a time of other matters before Lee brought the conversation around to the terms of surrender. At Lee's request, Grant committed to paper the proposed terms. In fewer than two hundred words, he elaborated only slightly upon his previous proposal. The soldiers of the South would stack their rifles and artillery, then sign parole agreements promising not to take up arms against the government of the United States. The officers would keep their sidearms, horses, and baggage. Lee asked

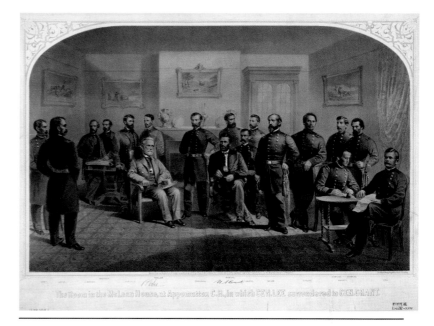

Commissioned by Wilmer McLean as a profit-making venture, this image portrays Lee's aides along with Union generals George Custer, Philip Sheridan, George Meade, and Edward Ord. The lithographers, Major and Knapp, didn't get it quite right, however, as neither Custer nor Meade was on the scene; the wrong man is pictured writing out the terms of surrender (it should have been the Native American colonel Ely Parker); and the only Confederates present were Lee and Marshall. *Library of Congress, Prints and Photographs*

whether the troops might also be permitted to retain their horses. Recognizing that the animals would be essential to spring plowing for many small farmers, Grant agreed.

"This will have the best possible effect upon the men," Lee observed. "It will be very gratifying and will do much toward conciliating our people."

In less than two hours, on Palm Sunday 1865, an understanding was struck. Grant treated his opponent with dignity; his generous terms—he effectively pardoned all those who surrendered —both advanced the cause of reconciliation and honored the promise President Lincoln had made in his second inaugural address barely a month before. "With malice toward none, with charity for all, with firmness in the right as God gives us to see the right," Lincoln had proclaimed, "let us strive . . . to bind up the nation's wounds, to care for him who shall have borne the battle and for his widow and his orphan, to do all which may achieve and cherish a just and lasting peace among ourselves and with all nations."

General Ulysses S. Grant occupied a table and chair closely resembling these when he drafted and signed the terms of surrender (*left*), while Lee waited nearby (*right*).

THE GHOST OF MR. MCLEAN'S HOUSE

The village of Appomattox Court House still consists of just a handful of houses, dependencies, two law offices, a store, the Clover Hill Tavern, a jail, and a courthouse. Once home to fewer than a hundred and fifty residents but now a National Historical Park, it offers tens of thousands of visitors each year a chance to consider the moment in April 1865 when Generals Lee and Grant placed the McLean House indelibly on history's map.

The hauntingly beautiful Central Virginia landscape—the rolling fields, rail fences, tall trees, and peaceful agrarian air—threatens to lull the visitor into forgetting that a violent battle unfolded on all sides in the hours before the generals met. Harkening back to that crucial day in 1865 is made more difficult still by the chorus of voices that have offered discordant accounts of the war's last days. Some versions serve the Lost Cause view of the conflict, in which Southern historians of earlier generations portrayed

Lee as nearly infallible and his troops unfailingly devoted (see "The Lost Cause," page 225). Romanticized after-the-fact recollections exaggerated the comradely behavior of the opposing sides, endowing them with an instant and shared nationalism characterized by Yankee magnanimity and Confederate honor.

In a way, the story of the McLean House stands as a metaphor for the blurring of historic memory. Constructed as a tavern in 1848, the original structure lasted less than fifty years; in 1891, speculators purchased and dismantled it, planning to relocate the site of the signing for permanent display in the nation's capital. The stacked materials never left Appomattox, however, with the wooden elements soon decaying beneath a thicket of honeysuckle and locust bushes. Relic hunters carried off countless bricks. By 1903, according to an aging Civil War general who returned to view the site, the house was "a dismal heap of ruin." Not until the late 1940s did the National Park Service re-create the house on its original foundation, though by then only the drawings and photos made during the dismantling and a few thousand bricks remained to guide the builders. At the dedication ceremony in 1950, Lee's biographer

Douglas Southall Freeman delivered an address to an audience that included Ulysses S. Grant III and Robert E. Lee IV.

Much of the McLean parlor furniture survives, having gained the status of cherished relics. General Sheridan purchased the table at which Grant wrote the terms of surrender, leaving McLean twenty dollars in gold before gifting the table to the wife of Major General George Custer. Another Union general is said to have paid forty dollars for the parlor table at which Lee sat. Although both generals' chairs and Grant's table are in the collection at the Smithsonian, the McLean House today has parlor pieces copied directly from the originals.

Whatever the shifting palette of interpretation and recollection over time, the events over the course of the eight weeks following the meeting at Appomattox Court House included the surrender of the other Confederate armies under Grant's terms (they were Joseph E. Johnston's in North Carolina, Richard Taylor's in Alabama, and Edmund Kirby Smith's in Texas). The tone had been set by Grant and Lee, who shared a common expectation and hope for the future.

Lee had not taken the suggestion of one of his generals that he continue the conflict as a guerrilla war; he rejected the idea, since, as he stated, his men "would become mere bands of marauders," and the result would be "a state of affairs it would take the country years to recover from." Grant put it more simply on the evening of April 9 when he returned to the Union camp and said to his men, "The war is over; the rebels are our countrymen again."

Above: Though the famous American artist Thomas Nast would record the scene later, Londoner Alfred R. Waud stood outside the McLean house at the moment of the surrender. That's Lee in the foreground, with Colonel Charles Marshall trailing. After shaking hands with Grant, Lee departed. *Library of Congress, Prints and Photographs*

Below: A panoramic view of an Appomattox streetscape, with the Meeks' store on the left and the brick courthouse on the right. The original courthouse burned in 1892 but a replica was built in the 1960s.

RECONSTRUCTION AND AFTER

TIMELINE

1865

After twenty-four weeks of incarceration in Union jails, Alexander Stephens is released from the prison at Fort Warren in Boston Harbor. He will later serve in the Forty-Third through Forty-Seventh Congresses.

1866

The second of the three so-called Reconstruction amendments, the Fourteenth Amendment, is approved by Congress. It guarantees that all persons born in the United States will receive the full and equal benefit of all laws.

Black Codes are passed by all-white legislatures in former Confederate States; the Ku Klux Klan is formed in Tennessee.

1868

U. S. Grant is elected president of the United States.

1869

The last of three Reconstruction amendments, the Fifteenth, is passed by the House and Senate on February 25 and 26, respectively. When ratified, it guarantees that the right to vote "shall not be denied or abridged . . . on account of race, color, or previous condition of servitude."

1877

Following Rutherford B. Hayes's inauguration as president, the last Federal troops leave the South, effectively ending Federal control of Reconstruction.

1881

Jefferson Davis's *The Rise and Fall of the Confederate Government* is published to modest sales but admiring reviews in the South.

The first Jim Crow laws are passed in Tennessee, segregating state railroads.

1885

Ulysses S. Grant dies in July; in December the first volume of his *Personal Memoirs* is published and becomes one of the most successful books of the nineteenth century.

Opposite: Jefferson Davis's bedroom at Beauvoir; positioned before a pair of glazed doors, the shaving mirror with its candle arms offered illumination natural and artificial.

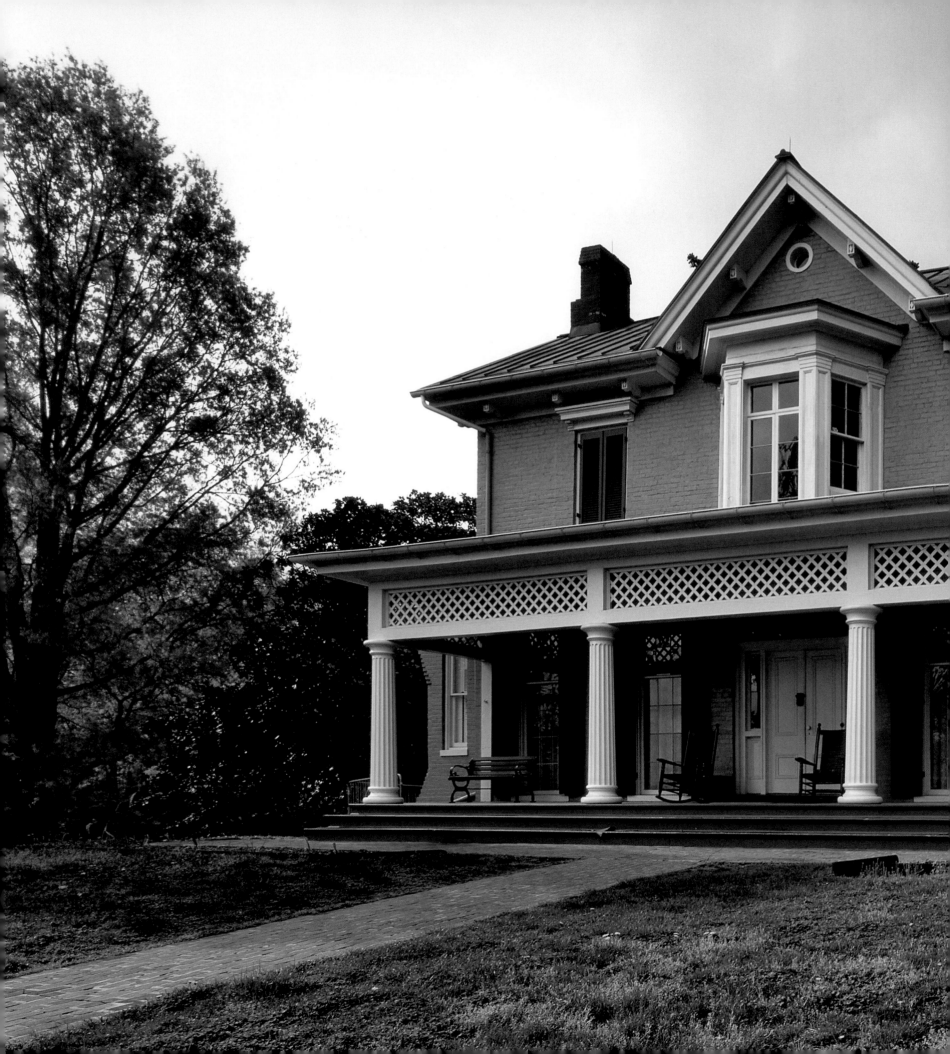

FREDERICK DOUGLASS'S CEDAR HILL

WASHINGTON, DC

"If there is no struggle there is no progress. Those who profess freedom and yet deprecate agitation, are men who want crops without plowing up the ground, they want rain without thunder and lightning. They want the ocean without the awful roar of its many waters."

FREDERICK DOUGLASS

"PERPETUAL UNPAID TOIL"

Freddy learned a life-altering lesson from his master and mistress. Upon discovering his wife knew no better than to educate the young slave, Hugh Auld reprimanded Sophia Auld. To teach the enslaved the rudiments of "the A, B, C," he warned, was unlawful and unwise. "A nigger should know nothing but to obey his master. . . . Learning could *spoil* the best nigger in the world. . . . He would at once become unmanageable, and of no value to his master. As to himself, it could do him no good, but a great deal of harm. It would make him discontented and unhappy."

Mrs. Auld took her husband's directive to heart, and in the half a dozen years that Freddy remained in her household, she did everything in her power to prevent him from learning his letters. But neither Mr. nor Mrs. Auld understood the passion they inadvertently planted in the boy's breast. The warning to his mistress struck the slave child, he recalled later, with the power of a "new and special revelation." The master's "argument which he so warmly urged, against my learning to read, only served to inspire me with a desire and determination to learn."

In the years that followed, Frederick Bailey secretly mastered reading and writing by means of stolen conversations with strangers, borrowed copybooks, and symbols deciphered at the Auld shipyard. As if to fulfill Hugh Auld's prophecy, the boy's aborning literacy meant that meeting some new words, like *abolition* and *abolitionist*, gave him torment. "[Learning] had given me a view of my wretched condition, without the remedy. It opened my eyes to the horrible pit, but to no ladder upon which to get out." From this grew an unbreakable determination to be free.

After doing fieldwork on a Maryland plantation, serving hard time with a slave-breaker, and mastering the caulker's trade in the Baltimore shipyards, the young man, age twenty, disguised himself as a sailor and escaped to the North. Discarding the name of his first master (who may also have been his father), Frederick Augustus Washington Bailey became Frederick Douglass of New Bedford, Massachusetts, where he settled into the life of a freeman.

In August 1841, Douglass recounted the tale of his escape from slavery at an abolitionists' meeting in Nantucket. Despite a halting start, Douglass told a story of unmistakable power. William Lloyd Garrison, one of the leading radicals of the day, proclaimed that

Previous page: The house dates from the late 1850s. Its builder, a real estate speculator named John Van Hook, moved into the rectangular brick structure during the Civil War. Previously known as Van Hook Hill, the property became Cedar Hill with Douglass's arrival. The substantial porch that fronts the house, with fluted columns and a latticework frieze, offered a panoramic view of the city. As one 1892 visitor wrote, "The scene from the veranda . . . is magnificent, away over the city with its dazzling white dome and obelisk."

Opposite: A desk he purchased from the estate of Charles Sumner held a place of honor amid bookshelves in Douglass's study that hold perhaps a thousand volumes. Though Douglass was very much a man of the mind, his daily ritual after breakfast involved taking a several-mile constitutional.

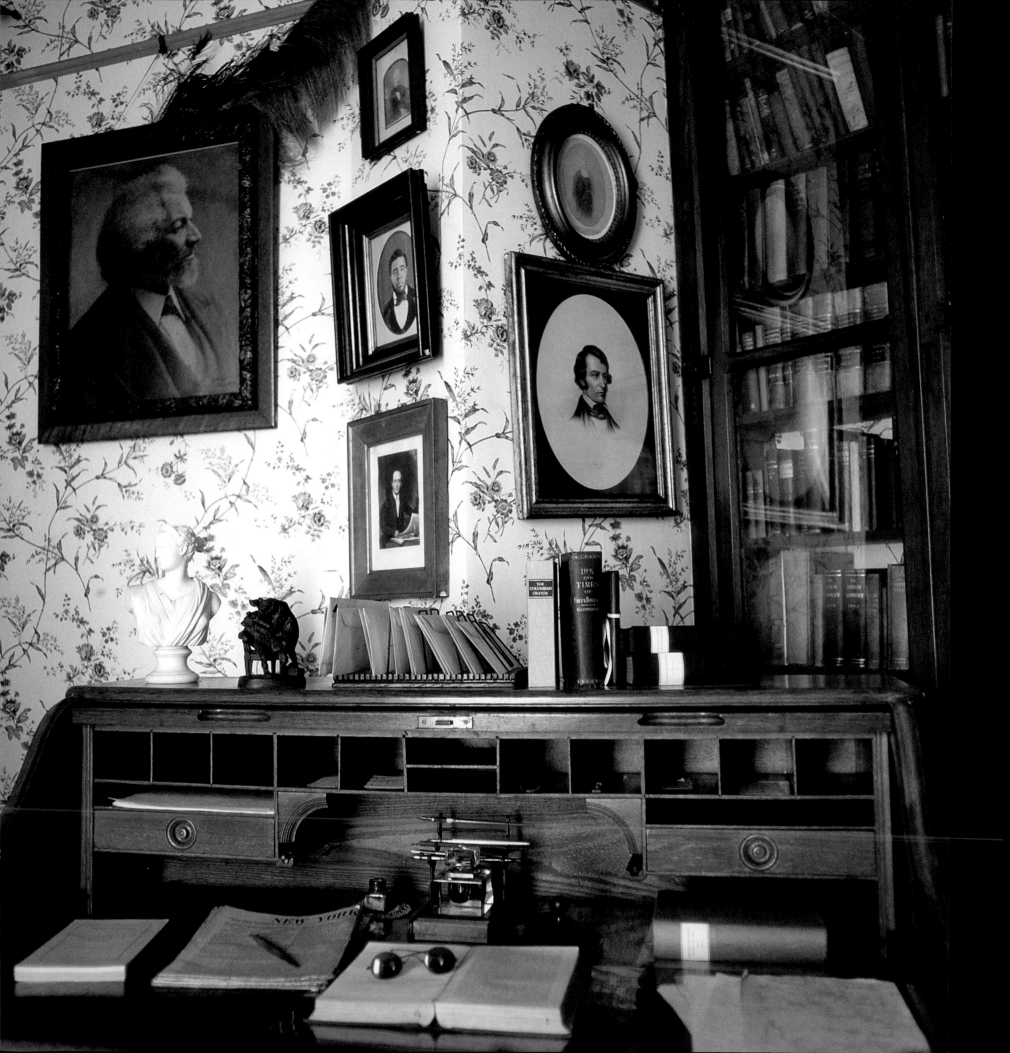

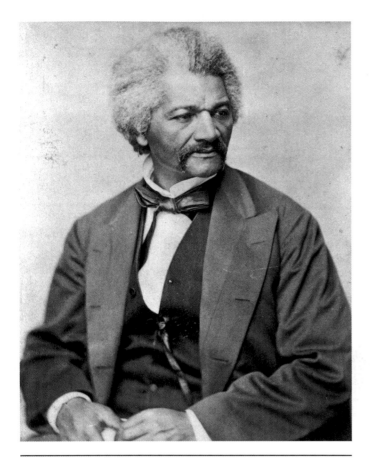

A Civil War–era image of Frederick Douglass. *Library of Congress, Prints and Photographs*

"PATRICK HENRY, of revolutionary fame, never made a speech more eloquent in the cause of liberty." Four years later, Douglass's story, "Written by Himself," appeared in book form as *Narrative of the Life of Frederick Douglass, an American Slave* (1845). It proved widely popular on both sides of the Atlantic, with a dozen English editions (and a French one) coming off the presses in the next few years.

As a slave boy, Frederick had intuited from his master that ignorance was at the heart of "the white man's power to enslave the black man." Without having spent so much as a day in a proper classroom, the adult Douglass nevertheless deployed learning to find, as he put it, "the pathway from slavery to freedom."

THE SAGE OF ANACOSTIA

The original 1854 deed reserved the property "for the use, benefit and enjoyment of white persons only." The document further specified the land could not be "sold, leased or devised to any negro, mulat[to] or person of African bloo[d]." By 1877, however, the rules had changed, with slavery abolished in Washington, DC (in 1862), the Civil War ended, and the Fourteenth Amendment ratified, guaranteeing equal protection to all.

In that span, Frederick Douglass's destiny shifted too, taking him far afield from what his masters might have expected. Douglass (1818?–1895) became a prolific writer, producing autobiographical pieces in addition to his memoir; many editorials in the weekly paper he founded, the *North Star*; essays; and a vast correspondence. He devoted himself to "pleading the cause of my brethren."

Having become a dynamic rhetorician, he delivered countless lectures around the North. The former slave achieved international fame as an antislavery agitator and a confidant of Lincoln. His purchase of the house on the hill in Washington's Anacostia neighborhood for $6,700 in 1877 can only begin to suggest how his status—and that of the American Negro—had changed.

When he first emerged from obscurity, the charismatic Douglass had served as exhibit A for abolitionists. The muscular physique of the six-foot Douglass, his evident intelligence, and his high seriousness impressed white audiences. "In listening to him," one diarist noted, "your whole soul is fired—every nerve strung—every passion inflated—every faculty you possess ready to perform at a moment's bidding." His face framed by a mass of black hair, his gaze intense, Douglass possessed a baritone voice that could boom or whisper, wax angry or eloquent. He rarely used notes and often spoke for two hours and more. To many people who heard him, Frederick Douglass amounted to the evidence they needed—proof, even—to dismiss the prevalent notion that Douglass's race was congenitally inferior.

Douglass spent several years in Massachusetts under Garrison's tutelage, but with the publication of his *Narrative* in 1845—in its pages he named his Maryland master and revealed his own new surname—friends advised him to go abroad for his own safety. He traveled to England and Ireland and, in his twenty-month tour, lectured widely, influencing attitudes toward slavery in par-

ticular and the United States in general. Before he returned home, new British friends raised seven hundred dollars to purchase his freedom from the Auld family.

Shortly after his return to the United States in 1847, he moved to Rochester, New York. Nourished by the Erie Canal, the frontier town had become a city of thirty thousand as well as a stop on the Underground Railroad. Douglas launched the *North Star,* in which he articulated his own notion of abolitionism. Departing from the principles of his mentor Garrison, who sought to use moral suasion to end slavery and rejected the Constitution as a proslavery document, Douglass took another tack. He would undertake to reform the constitutional system. He believed political action could be used to end slavery, consistent "with the noble purposes avowed in [the Constitution's] preamble."

During his Rochester years, Douglass provided food and lodging to escaping slaves on their flight to Canada. But he recognized his stationmaster role on the Underground Railroad was secondary to the likes of Harriet Tubman. As he wrote admiringly to Tubman, "I have had the applause of the crowd while . . . the midnight sky and the silent stars have been the witnesses of your devotion to freedom and your heroism." (See "General Tubman's Home," page 171.)

Harriet Beecher Stowe, then a little-known minister's wife at work on the early chapters of a novel, asked Douglass for guidance concerning life on a cotton plantation (see "Harriet Beecher Stowe House," page 208). Douglass paid attention to other radical movements of the day; he was the only man to support Mrs. Stanton's suffrage resolution in Seneca Falls, New York, in July 1848 ("It is the duty of the women of this country to secure to themselves the sacred right of the elective franchise").

In August 1859, his friend John Brown appealed to him to join the raiding party bound for Harper's Ferry. "Come with me, Douglass!" Brown begged. "When I strike the bees will begin to swarm and I shall want you to help hive them." Douglass refused but, upon hearing of Brown's capture in West Virginia that October, he fled to Canada, afraid that their correspondence might come to light and

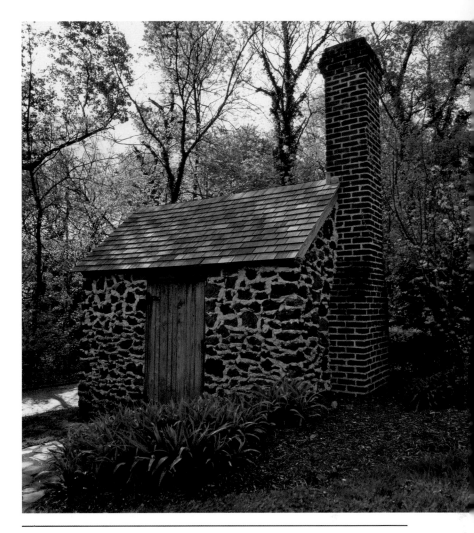

Douglass called this little fieldstone building in his backyard the Growlery. Though small and windowless, the Growlery functioned as a sort of freestanding den for Douglass, a place where he retired to think and write.

implicate him in the plan. Douglass moved to England, where he spent five months.

The country he returned to soon was at war, and during the conflict he worried at what he initially saw as Lincoln's "doubting, hesitating and vacillating policy . . . in regard to the real difficulty—slavery." His attitude toward Lincoln softened with the Emancipation Proclamation (its issuance, Douglass exulted, was to be celebrated as "a day for poetry and song"), and the two men met three times.

In 1863 Douglass asked for a meeting, at which he lobbied for the rights of black soldiers; a year later Lincoln invited him back

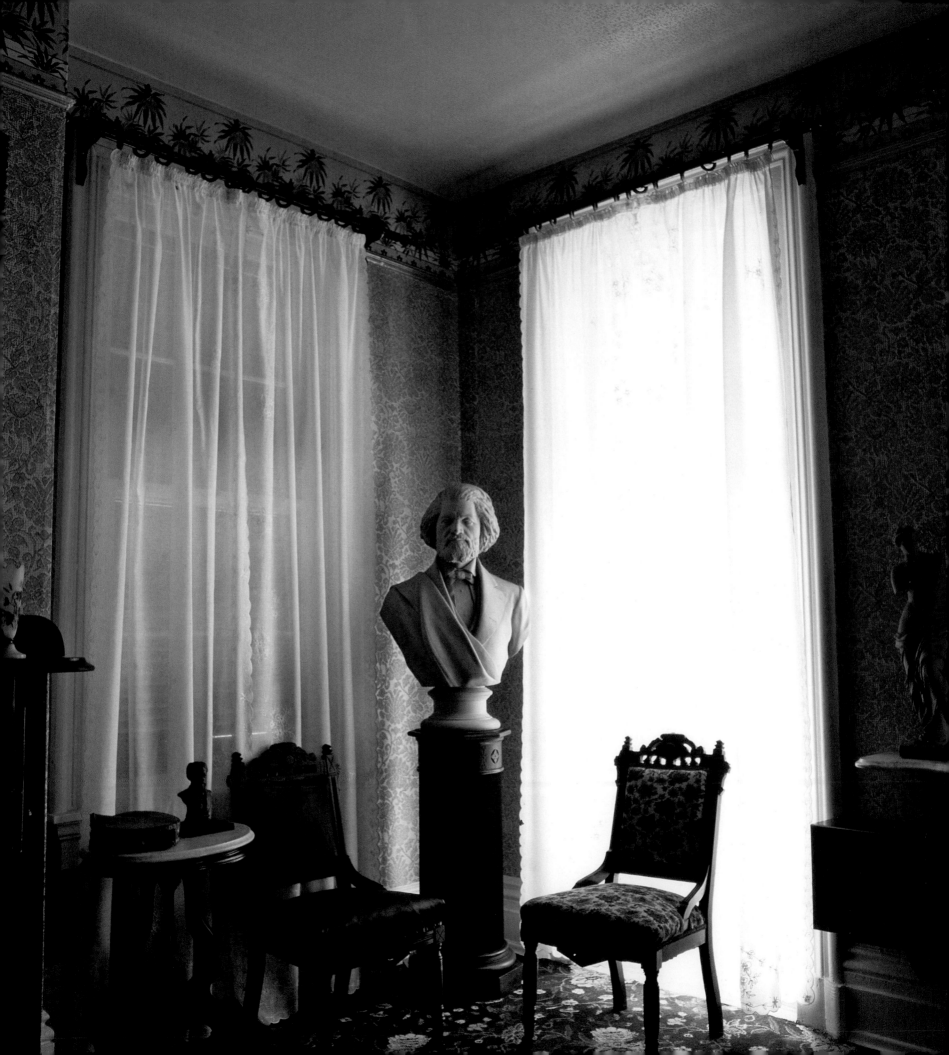

to the White House to talk of ways that word of the Emancipation Proclamation could be more widely distributed in the South. Lincoln treated Douglass with respect; when a secretary announced that the governor of Connecticut had arrived to meet with the president, Lincoln carried on the conversation with Douglass for another hour. "Tell Governor Buckingham to wait," Lincoln instructed his aide, "I wish to have a long talk with my friend Douglass."

On the occasion of Lincoln's second inauguration, Douglass ventured to the White House for what would be their last meeting. For a black man to attend the reception that followed the speech was extraordinary, but when guards tried to prevent his entry, he insisted a message be taken to Lincoln. Moments later, the portals opened.

"I saw you in the crowd today," Lincoln said in greeting, "listening to my inaugural address; how did you like it?"

"Mr. Lincoln," replied Douglass, "I must not detain you with my poor opinion, when there are thousands waiting to shake hands with you."

"No, no," Lincoln responded. "You must stop a little, Douglass; there is no man in the country whose opinion I value more than yours. I want to know what you think of it."

"Mr. Lincoln, that was a sacred effort."

Six weeks later a derringer bullet to the head took Lincoln's life at Ford's Theatre.

ACT III

One late-century visitor described Douglass's house as "a moderate sized mansion on an elevation surrounded by full-grown trees." With the wood-frame ell that Douglass added to the rear of the original brick home, the house consisted of twenty rooms; though a coal-fired furnace heated the house, seven fireplaces served the major spaces. A carriage house and other outbuildings also stood

Opposite: Douglass himself still inhabits the house, in the form of many likenesses: in addition to this bust in the west parlor, there are two-dimensional images, including a crayon sketch, an oil portrait, and numerous photographs.

on the fifteen-acre property, and Douglass employed three servants to wait upon his family (on moving-in day, he had twelve grandchildren). A man of means, with holdings and directorships in banks, insurance, and manufacturing, he still delivered a dozen or more lectures a year, at fees that had risen to $150 plus expenses. His net worth probably exceeded $100,000.

As in Douglass's years of residence at Cedar Hill, everything about the place today offers a retrospective view of his life. In his days there, Douglass held the status of elder statesman, occupying a place unprecedented for a black man in Washington society. He had sought votes for several presidential candidates, including Ulysses S. Grant. Rewarded by Rutherford B. Hayes with the appointment as marshal of the District of Columbia, Douglass became recorder of deeds in James Garfield's administration and Benjamin Harrison's minister to Haiti. President Grover Cleveland invited Douglass to White House receptions.

Yet Cedar Hill more often recalls earlier moments in his career. On its walls hang portraits of the abolitionists with whom he collaborated, including William Lloyd Garrison, Wendell Phillips, and Gerrit Smith. There is the totemic cane of Lincoln's that his widow sent to Douglass after the assassination. Images of John Brown, Susan B. Anthony, and Elizabeth Cady Stanton recall his days as a self-described "agitator."

The changes he saw after the Civil War didn't always please him. He recognized that Lincoln's successor, Andrew Johnson, was no ally of the black man; in their one meeting, Johnson told Douglass that he still favored emigration for the blacks, a notion that Lincoln had considered and then rejected as impractical. Douglass condemned the Supreme Court decision that declared the Civil Rights Act of 1875 unconstitutional; he watched with outrage when the withdrawal of the U.S. army from the South in 1877 led to the disenfranchisement of blacks and the rise of Jim Crow intimidation and segregation.

As a public man, one still called upon to speak even his last years, Douglass reminded his listeners that he viewed emancipation as the Civil War's central issue. "I shall never forget the dif-

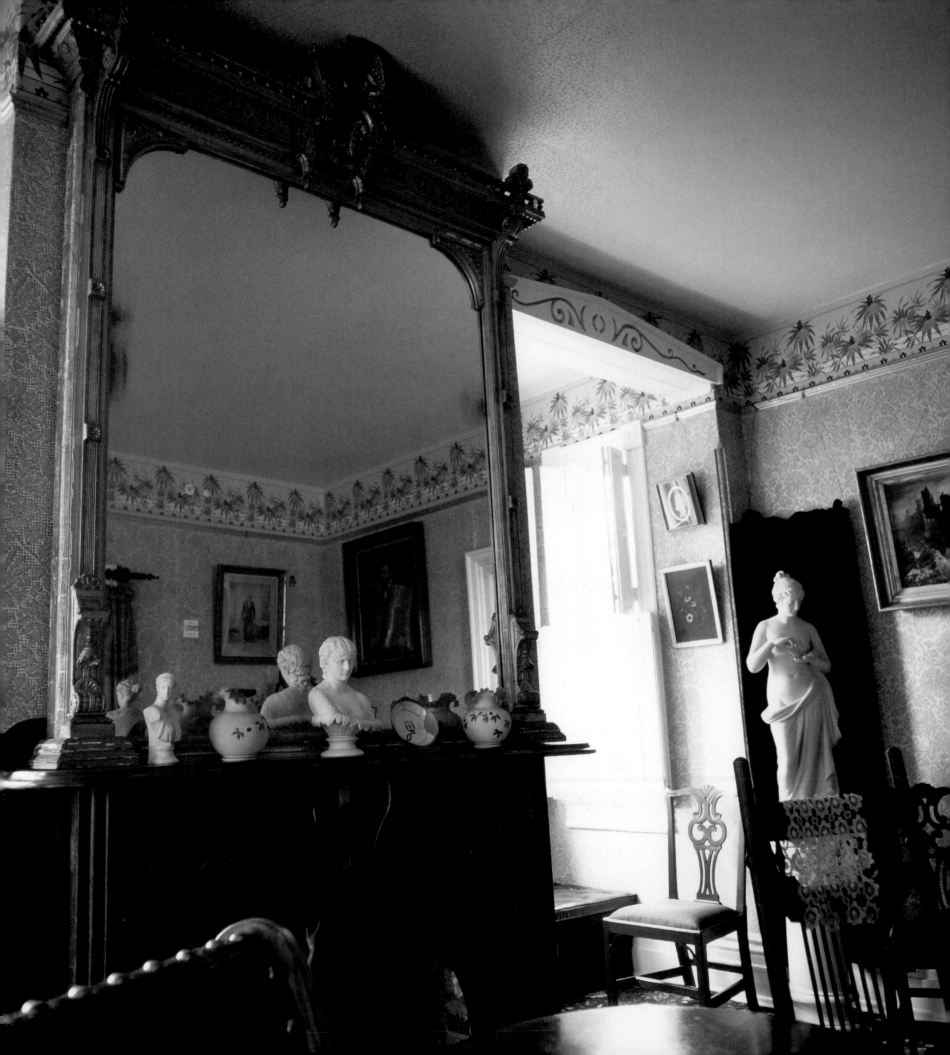

ference between those who fought for liberty and those who fought for slavery; between those who fought to save the republic and those who fought to destroy it."

At Cedar Hill, another framed image begs the visitor's attention, and the logic of its presence bears consideration. Suspended over the sofa is a hand-tinted print of a scene from Shakespeare's *Othello*, portraying the title character in intimate conversation with Desdemona. Douglass read Shakespeare; a student of the theater, he memorized speeches and took pleasure in declaiming them at the Uniontown Shakespeare club. He also knew well that the pretext for racist violence in the South in the decades after the Civil War was often the accusation that a black man had raped a white woman. "The crime to which the Negro is now said to be generally and specially addicted," wrote Douglass in 1892, a time when lynching was at its height, "is one of which he has been heretofore, seldom accused or supposed to be guilty."

The image also echoes Douglass's own circumstances: His first wife, Anna Murray Douglass, had been a free woman of color; seventeen months after her death, he married his former secretary at the recorder's office. Helen Pitts was white, and disapproval of their interracial marriage was widespread among blacks, whites, and even Douglass's children. Yet the marriage proved a happy one, as the couple traveled widely (to Europe and Haiti) and shared a vibrant intellectual life (Helen was a graduate of Mount Holyoke Female Seminary; Anna had been unlettered).

As for Douglass, he thought the brouhaha about skin color absurd. He was the most famous, most admired, and most influential spokesman for his people in the country, perhaps the world. He had become respectable, so why the objections to his marriage? After all, he observed, his first wife "was the color of my mother, and the second, the color of my father."

Skin color mattered little to Douglass. "[My] fundamental and everlasting objection to slavery," he once wrote, "is not that it sinks a Negro to the condition of brute, but that it sinks a *man* to that condition."

Opposite: Douglass became a famous man, one who achieved worldly success over the course of his life, attested to by his house and the furnishings in this stylish parlor. At the time of his birth, however, no one recorded the event; the scholarly best-guess date is the year 1818, and Douglass himself chose February as his month of birth.

Above: When he died, an inventory listed Douglass's worldly goods. The most valuable items were his books ($200), his manuscripts ($100), and his piano ($250). He also played the violin; among his favorite pieces to perform was "The Star Spangled Banner."

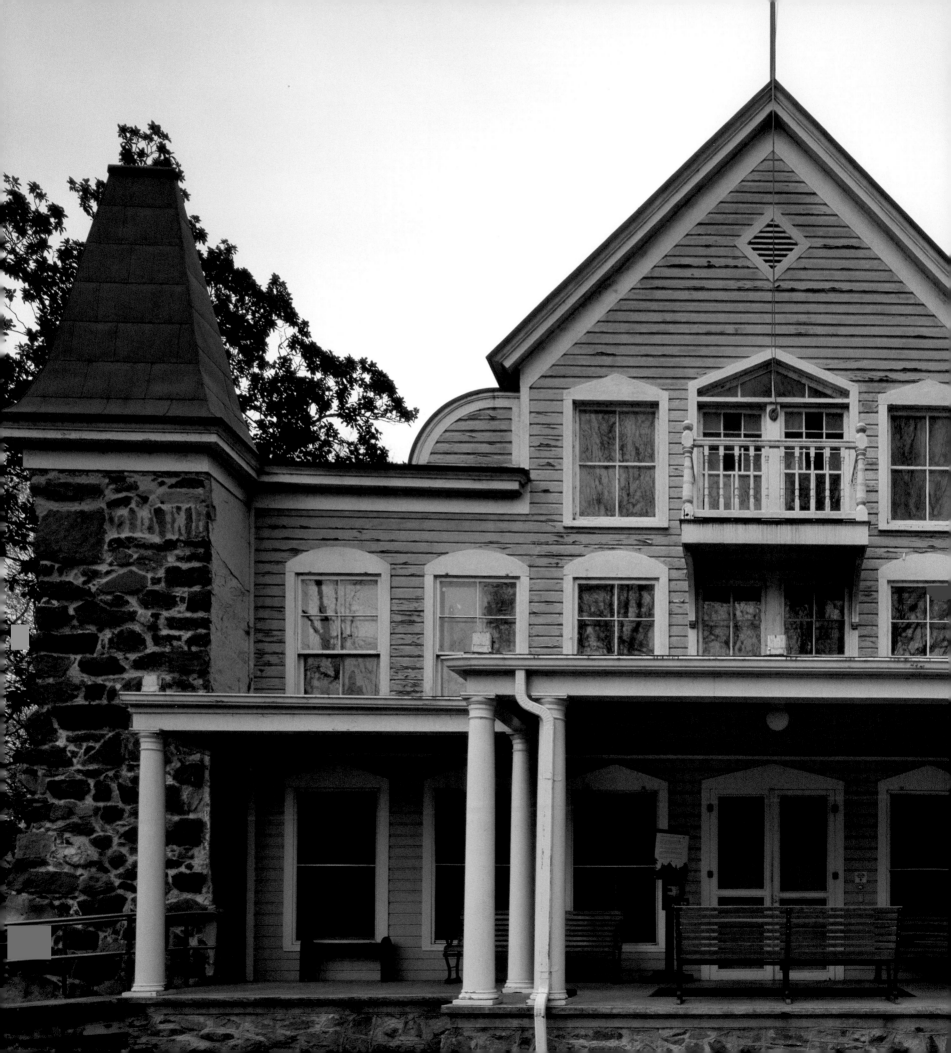

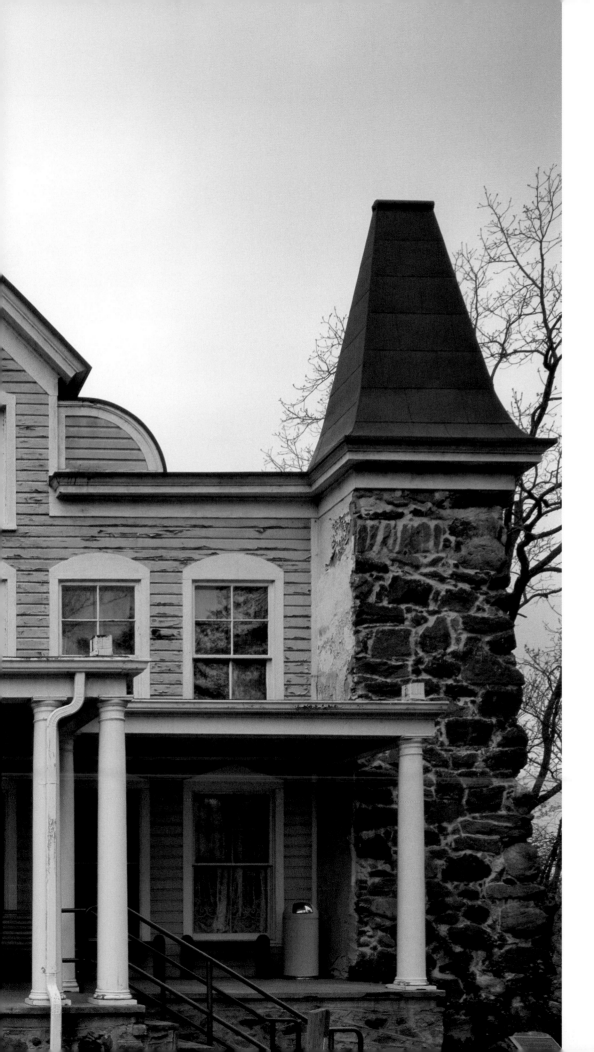

CLARA BARTON HOUSE

GLEN ECHO, MARYLAND

"The *women* who went to the field; and pray
What did they go for? Just to be in the way!—

They'd not know the difference betwixt
work and play,
What did they know about *war* anyway?"

CLARA BARTON

"The Women Who Went to the Field," 1892

"FOLLOW THE CANNON"

In September 1862, Clara Barton finally made her way to the front. Men of the military had told her that women would "skedaddle and create a panic" at the first sight of a gun. One general thought Barton herself an "unreasonable, meddlesome body." The forty-year-old Barton, understanding that a shortfall of medical care took a terrible toll, remained undeterred.

She had witnessed the cost firsthand, as the wounded from the Second Battle of Manassas on August 30 arrived in Washington. A full *ten days* had been required to treat the injured and remove them from the field of battle, and Barton vowed to "bridge that chasm and succor the wounded until the medical aid" could catch up. The wounded simply could not wait.

Over the course of the previous year, she had accumulated medical supplies, soliciting individuals and organizations in her native Massachusetts and in New Jersey, where she had taught school. In an advertisement in the *Worcester Spy*, she exhorted, "The cause is holy; do not neglect an opportunity to aid it." She won the support of Bay State senator Henry Wilson, and, by the time she found a quartermaster willing to listen, she had filled three warehouses with hospital stores and foodstuffs. Months of meetings gained her access to the field at the Battle of Cedar Mountain, but the firing had stopped when she arrived. The suffering she saw

only heightened her urge to "follow the cannon," to be there when the wounded fell.

Her chance arrived with a secret message delivered by hand. Although she would live another half a century, Barton would never name the man who revealed the intelligence that Robert E. Lee's Army of Northern Virginia marched on Maryland. With the help of a teamster assigned by the sympathetic quartermaster, Barton and her assistant packed an army wagon with bandages, dressings, medicinal alcohol, and food. Churchgoers in the capital that Sunday morning saw the wagon, pulled by six mules, heading northwest. The teamster held the reins, but a small woman wearing a bonnet rode beside him.

Following the National Road, the wagon passed another recent battlefield, where Barton reported seeing bodies of the dead, "a mingled mass of stiffened, blackened men." Determined to advance her place in General McClellan's interminable supply line, she

Previous page: Despite its three-story height and the pair of steeple-roofed turrets, Miss Barton's clapboard house is nearly hidden today in a grove of trees.

Opposite: A central atrium extends two stories up, with clerestory windows at the perimeter of its lantern roof. Originally there were thirty rooms in the three-story structure, some of which Barton converted to offices and closets. In the process, she added a mix of elements, including ceilings of muslin, an unlikely but inexpensive material she had on hand. The original muslin survives on the first floor.

195

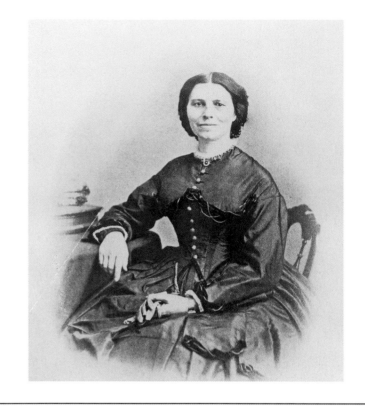

A notably timid child, Clara Barton would become a highly visible public person, lecturing widely and meeting many presidents in her long life. This photograph dates from circa 1865. *Mathew Brady/Library of Congress, Prints and Photographs*

awakened her driver at one o'clock on the morning of Tuesday, September 16. After a quick breakfast in the darkness, they took to the road, passing some ten miles of parked supply vehicles. By dawn, they caught up with the horse-drawn artillery.

In the early hours of September 17, the Battle of Antietam began when the Confederate artillery opened fire, and seventy-five Union field pieces hurled shells and solid shot in return. Despite the deafening roar, Barton made her way toward the line of battle. She came across an impromptu dressing station in an old barn and stopped. From the nearby farmhouse, Dr. James Dunn emerged; Barton had assisted the Pennsylvania surgeon a few weeks before, after the Battle of Cedar Mountain. He showed her the four makeshift operating tables. "We have nothing but our instruments," he told her, "and the little chloroform we brought in our pockets." In the absence of proper bandages, they were using green corn leaves to dress fresh wounds, and the linen in Barton's

wagon was soon put to good use. "Never before had linen looked so white," she remembered.

The fight raged for hours (see "A Turning Point at Antietam," page 124). With the line of battle so close, shells burst overhead at the Samuel Poffenberger farm, and stray bullets scarred the second floor of the house, a tall, gable-roofed structure with walling of honey-colored local limestone. Far from "skedaddling," Barton ignored the "savage continual fire" and administered chloroform as surgeons worked, distributed food, and stanched wounds, and, at the insistence of one soldier, she excised a bullet from his cheek using her pocketknife ("I do not suppose a surgeon would have pronounced it a scientific operation," she allowed). Once, as she bent to hold a cup of water to the lips of a wounded soldier, she felt her sleeve twitch; the man quivered, then slumped. A bullet had passed through the crook of her arm, tearing a hole in her sleeve before ripping into the man's chest.

The end of the day found Barton's face blackened by gunpowder, her skirt hems pinned about her waist, her hair jumbled. When Dr. Dunn bemoaned the lack of light to continue his surgeries, she summoned lanterns from her wagon. No wonder, then, that Dunn would write to his wife, "In my feeble estimation, General McClellan, with all his laurels, sinks into insignificance beside the true heroine of the age, *the angel of the battlefield.*"

THE TIMID TOMBOY

Clarissa Harlowe Barton was the baby of the family, the fifth of five children. Born in North Oxford, Massachusetts, she learned of military matters from her aging "soldier father," as she habitually called him. A veteran of the Indian wars in the Michigan Territory, Captain Stephen Barton taught his daughter a respect for the military. "I never addressed a colonel as captain, got my cavalry on foot or mounted my infantry," she once said. A natural tomboy, she became an accomplished horsewoman who was also skilled with tools, good at tying knots, and proficient at a range of household and farm duties. More than once, she remarked proudly that she had never learned to dance.

A plain girl with a broad forehead, Barton stood barely five feet tall, but she demonstrated a strong work ethic at an early age. An intensely shy girl, she first found her calling at age twelve when her brother David fell from the rafters during a barn raising. For nearly two years she worked as his caregiver, tending to his needs, which included the regular administration of leeches. When he finally recovered (the cessation of the leech treatment may well have been curative), Clara felt both relieved and bereft. "Life seemed very strange and idle to me," she recalled in her memoir *The Story of My Childhood* (1907).

Worried at her timidity, her family consulted L. N. Fowler, a phrenologist famed for his skills at reading the bumps on the human skull to identify traits and temperament. Although phrenology has long since been dismissed as quackery, Fowler's insight into Clara seems to have been surprisingly prescient. "She will never assert for herself—she will suffer wrong first—but for others she will be perfectly fearless."

At Fowler's recommendation, the eighteen-year-old Barton went to work as an educator, first teaching at a school near her childhood home and then founding a school to teach the children of mill-workers at one of her brother's factories. After a decade of teaching, she herself assumed the status of student at the Clinton Liberal Institute in Clinton, New York. She next moved to Bordentown, New Jersey, where she established the town's first free public school. The venture proved successful but, when a man was chosen over her to administer the school she had founded, Barton resigned.

She moved to Washington, finding work as a recording clerk in the U.S. Patent Office, one of a handful of women on the federal payroll. Her labors there, however, ended with the change of administrations; when President James Buchanan took office, her position was eliminated. She went back to Massachusetts and resided there for more than two years; she even considered resuming her teaching, but, at the suggestion of friends, she returned to the Federal City. After Abraham Lincoln's election, the climate in Washington changed, and with the advent of war, Barton later wrote, she felt "the patriot blood of my father . . . warm in my veins."

During the Civil War years, Clara Barton brought the skills of a nurse and a quartermaster to the battlefield. She was entirely undaunted by the danger and the horrors, and she helped with the wounded at the December 1862 Battle of Fredericksburg; in South Carolina as the bombardment of Charleston began (there she also tutored slaves to prepare them for freedom); and at battles at Fort Wagner in South Carolina and the Wilderness and Spotsylvania Court House in Virginia.

A month before the war ended, she won Lincoln's support in establishing the Office of Correspondence with the Friends of the Missing Men of the United States Army, launching an organized effort to determine the whereabouts of missing-in-action soldiers. Her work at the notorious Confederate prison Andersonville led to an appearance before Congress in 1866. Her testimony at the Capitol would be followed by hundreds of lectures about her Civil War experience in the ensuing months. She often appeared with Frederick Douglass and Ralph Waldo Emerson (see pages 182 and 10).

An obscure government clerk at the time of Fort Sumter's bombardment, Clara Barton earned national fame for her bravery. To the general public, she became the Soldier's Friend, the Heroine of Andersonville, and the Florence Nightingale of America.

THE AMERICAN RED CROSS

Barton's commitment to her cause took a toll on her health. Standing at the speaker's platform in Portland, Maine, in December 1868, she suddenly lost her voice. The following year, she traveled to Europe on the advice of her physician. Seeking a break from her American labors, she visited Scotland, London, and Corsica, but a stop in Switzerland prompted a renewed focus on men wounded in war.

In Geneva, she learned of a new movement to establish a series of national societies whose volunteers would provide relief assistance on the battlefield. Two years earlier, the International Conference of National Aid Societies for the Nursing of the War Wounded had convened in Geneva. Various national societies were being founded around Europe, unified by both common

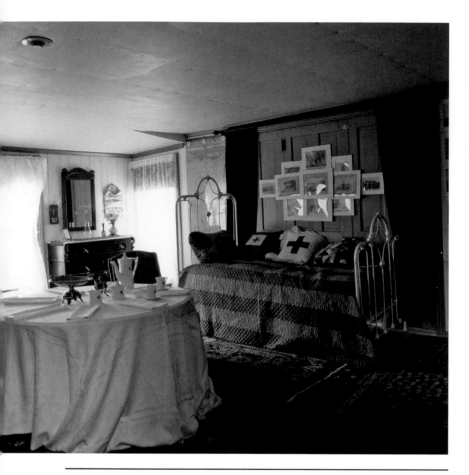

Clara Barton's upstairs sitting room, complete with tea table and daybed, in the big barn of a house, warehouse, and office that she occupied at the end of her life. The Clara Barton National Historic Site, established 1974, was the first National Park Service site to honor the accomplishments of an American woman.

principles and a symbol to be worn by medical personnel in the field: a white armband bearing a red cross.

The Red Cross House in Glen Echo, Maryland, survives today, an architectural reminder of Barton's postwar labors. After her European sojourn, during which she did relief work in Paris and Strasbourg to aid the wounded of the Franco-Prussian War, she returned to the United States. She worked to establish an American branch of the organization that, in 1876, adopted the name the International Committee of the Red Cross. When the American Association of the Red Cross was established in 1881, Barton served as its first president.

The mission of the organization broadened beyond the battle-field. The first major disaster effort undertaken by the American Red Cross unfolded in 1889 at Johnstown, Pennsylvania, after a flood caused by a dam failure killed twenty-two hundred people. Barton and her fledgling organization not only brought doctors to the scene but built apartment houses for the displaced survivors. With the relief effort completed, some of the remaining lumber was shipped to Maryland, where in 1891 it was used to construct a rambling variation of the apartment and storehouse structures used at Johnstown. The large wood-frame building would be home base for the Red Cross for two decades; it would also be Barton's office and domicile until her death, in 1912.

The structure is eccentric, a cross between a boardinghouse, storage facility, office, and home. But the character of its primary occupant also defied easy classification. A highly independent woman of remarkable energies, Clara Barton, having found her vocation on the battlefield, invested her life in saving lives in the most challenging of circumstances.

In communal fashion, Barton's great oak desk shared a clerical space with volunteers and their typewriters.

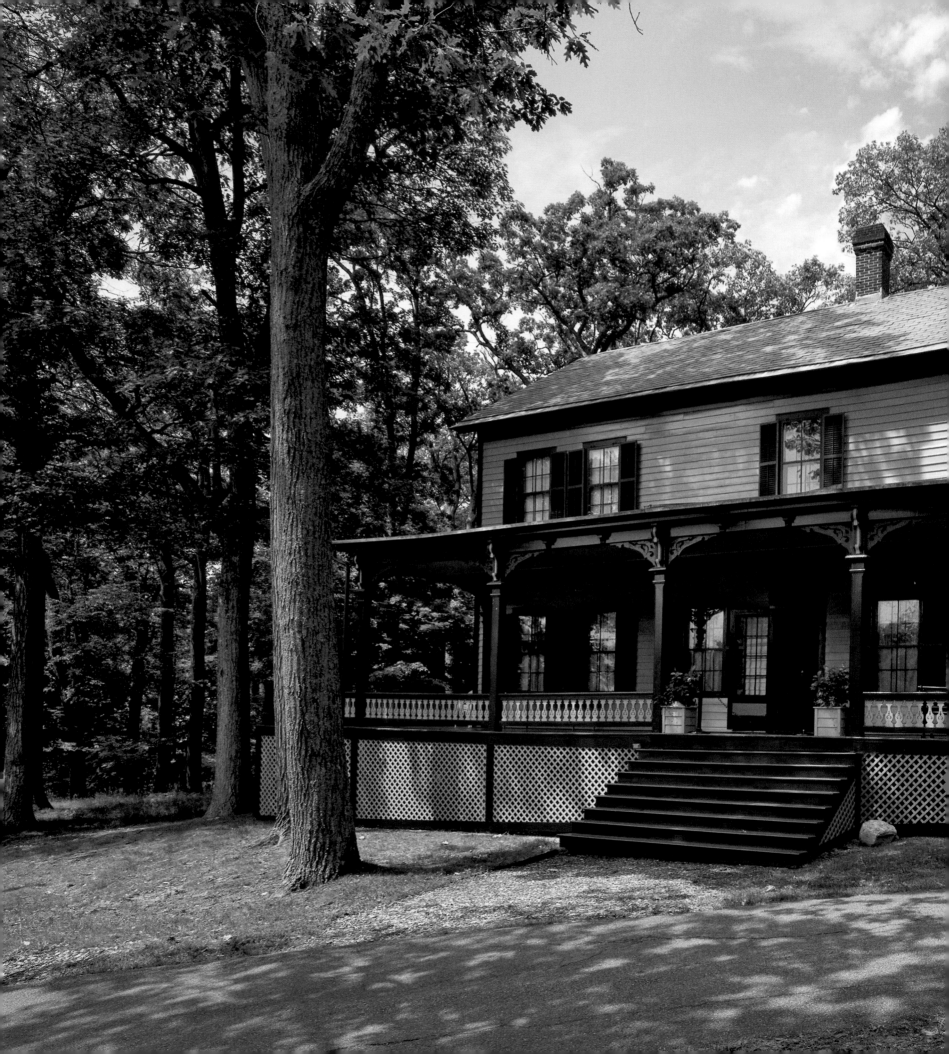

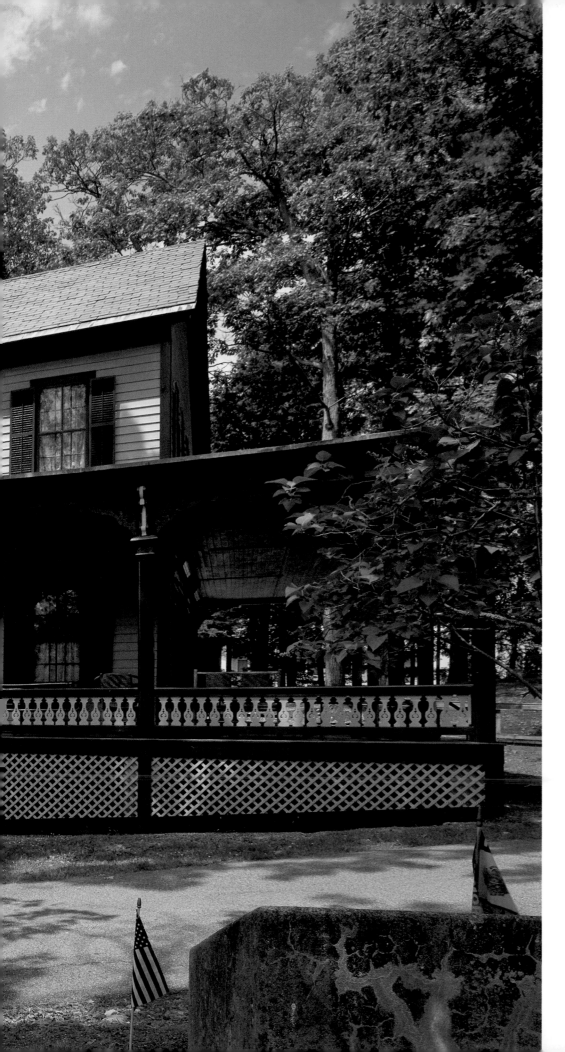

ULYSSES S. GRANT COTTAGE

WILTON, NEW YORK

"I pray to God that [my life] may be spared to complete the necessary work on my book."

ULYSSES S. GRANT
TO JULIA DENT GRANT

July 8, 1885

"I AM A VERB"

When the door of the house opened just after eight o'clock, a white-bearded figure emerged. Despite the warmth of the day (the mercury in Manhattan rose to nearly one hundred degrees that afternoon), he wore a long coat, neck scarf, and top hat. His ashen appearance surprised no one among the small crowd of well-wishers standing before his house at 3 East Sixty-Sixth Street. Ulysses S. Grant, the general who won the Civil War, the man who served two terms as the nation's eighteenth president, and the best-known American in the world, was, as a *New York Times* headline bluntly proclaimed several months earlier, SINKING INTO THE GRAVE.

With the aid of "the faithful Harrison [Terrell]," his African American valet and a former slave, Grant climbed into a carriage for the short ride to Grand Central Station. He boarded his friend Mr. Vanderbilt's personal railcar with his wife, Julia Dent Grant, son Colonel Frederick Grant, and several other relatives. The party also included friends and numerous members of the press riding in a second passenger car. Soon in motion, the Grant Train steamed northward toward a cottage atop the southernmost peak in the Adirondack Mountains.

Barely a year before, the general and Julia had been enjoying a comfortable and carefree retirement. A founding partner of the private banking firm of Grant and Ward, their son Ulysses S. Grant Jr. (known as Buck) had brought unexpected prosperity to the family, with Ferdinand Ward delivering astonishing profits to his underwriters, one of whom was General Grant. Then, on May 6, 1884, Grant and Ward suddenly suspended operations. Accused of running what today is termed a Ponzi scheme, Ward admitted his guilt ("I had to rob Peter to pay Paul," he explained). Ward faced a prison sentence while the former president was confronted with utter financial ruin and, if not for the kindness of friends, the prospect of homelessness.

Grant dozed on the train journey, though Julia woke him to view the gray stone buildings of the United States Military Academy on the opposite bank of the Hudson River. There, decades earlier, an Ohio boy named Hiram Ulysses Grant had gained not only a commission on his graduation, in 1843, but, due to a mistake in his nomination papers, the name by which he would be known as an adult. Grant's subsequent military career took him from West Point to the Mexican War and then on to duty in California, after which, in 1854, he resigned from the U.S. Army, deeply

Previous page: The restored Grant cottage looks today much as it did in 1885 when the *New York World* described it as "a modest-looking two-story frame building, decked out in a new coat of old gold paint with neat brown trimmings."

Opposite: The pain in his throat meant that, as Grant himself put it, he "talked a good deal with my pencil." On July 5, the patient wrote to Dr. Douglas—who may well have been standing before him here, in the cottage's parlor—of his progress on the book. "The work to be done is mostly after it gets back in gallies."

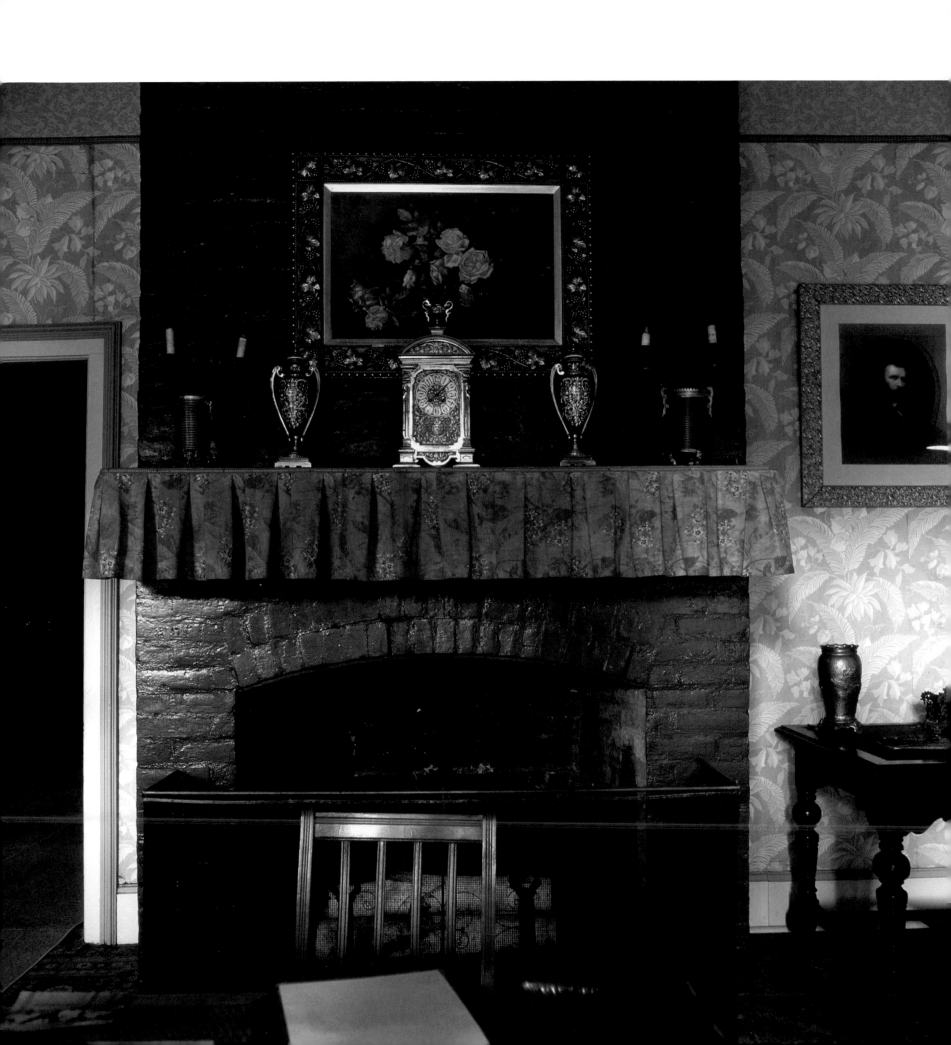

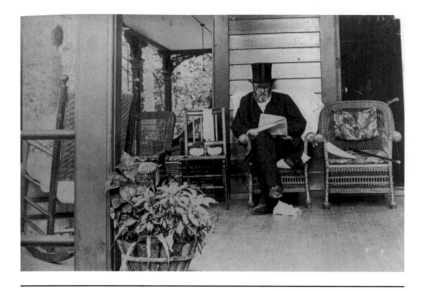

John G. Gilman recorded this image a few days before Grant's death. On the back of the original print at the Library of Congress is the penned notation, *Waiting for "Taps."* Library of Congress, Prints and Photographs

depressed. Along with Julia (they married in 1848), he endured hard years as a farmer outside St. Louis, a career that ended with the loss of Hardscrabble, the log house he built (it was "so crude and homely," remembered his wife, "I did not like it at all"). Grant's prospects as a merchant and clerk in Galena, Illinois, were looking little better when the firing of the guns of Sumter in Charleston Harbor in April 1861 changed everything.

When the Grant Train reached Saratoga, New York, in the early afternoon of June 16, 1885, the entourage shifted to a much smaller conveyance, a narrow-gauge train on the Mount McGregor Lake George Railroad. Though an honor guard stood nearby, ready for inspection, the exhausted Grant managed only a nod and a gesture of salute with his cane. After a delay occasioned by the difficulty in shifting two upholstered easy chairs onto the smaller train—Grant briefly reemerged to supervise—the last leg of the journey began.

Since the spring, the bulky invalid chairs had served as Grant's sleeping accommodation; because periodic choking episodes threatened his life, he slept sitting upright, his feet stretched from one chair to the other. A malignancy, first apparent the previous summer, gripped him by the throat. At a time when few people dared

to utter the word *cancer*, Grant's own physician, John H. Douglas, avoided the term, calling Grant's condition "serious epithelial trouble." The general could eat little, sipping just milk, egg, and beef tea. As his condition deteriorated, he relied upon cocaine rinses to dull the pain during the day and morphine to help him sleep at night. With the coming of summer, Grant had resolved to leave New York City for a place, in the words of Dr. Douglas, that was "above the vapors, . . . among the pines, [where] the pure air is especially grateful to patients suffering as General Grant is suffering."

The growth swelling the general's tongue and throat became the best-reported case of cancer in the nineteenth century, but Grant himself chose to write another part of his story. Faced with the prospect of leaving his widow destitute, Grant agreed to record his military memories. After the failure of Grant and Ward, *Century Magazine* offered him five hundred dollars each for four articles devoted to individual battles. He set to work, and as his writing skills became apparent, talk of a book arose, reaching fruition when Grant's friend Samuel L. Clemens advanced him ten thousand dollars with the promise that Grant would receive 70 percent of the net profits. A year of work had produced a fat manuscript of almost 275,000 words, but as he read galley proofs of volume one and raced to complete the second, Grant worried over the "likelyhood of omissions."

The final ten miles of the day's journey tested Grant's stamina. The straining locomotive rattled up a steep slope, pitching from side to side, filling the passenger compartments with thick, black coal smoke. On reaching the Mount McGregor platform, Grant attempted to walk the short distance to the cottage, but, finding his reserves exhausted, he permitted two Union veterans to carry him, seated in a rattan chair, the last few yards. Aided by his cane, he climbed the steps to the porch under his own power.

Ulys, as his wife called him, would spend the last thirty-eight days of his life in the pleasant cottage with the wraparound porch and overhanging pines, surrounded by his family, visited by friends and admirers, and tended by his doctor, who sometimes slept on a cot in Grant's room. He would spend many hours each day revising

and supplementing the pages of his *Personal Memoirs.*

The general died on the morning of July 23, 1885; his legacy consisted of two things he had done superlatively well. First, he had anchored the Union effort to win the Civil War; second, he had written an opus about the events of that war, investing his last, best energies in completing it. "I think I am a verb, instead of a personal pronoun," he confided in Dr. Douglas in a penciled note near the end. "A verb is anything that signifies to be; to do; or to suffer. I signify all three."

Published posthumously in December 1885 and February 1886, the two-volume *Personal Memoirs of Ulysses S. Grant* more than restored his family's fortune. The sale of some 320,000 copies produced a windfall of $450,000 for the widow Grant.

A WRITING MAN

Grant's opposite number, Robert E. Lee, left the telling of the tale to others. Innumerable veterans would make their contributions to the Civil War literature, among them Lee's Old War Horse, James Longstreet; his aide-de-camp Charles Marshall; and the vocal proponent of the Lost Cause view of the war, Jubal Early. Union men, too, including William Tecumseh Sherman, Philip Sheridan, and Joshua Chamberlain, wrote lengthy recollections. Yet none of the other books gained the status of Grant's *Personal Memoirs.*

Grant wrote the way he lived. An unpretentious man with an admitted distaste for such niceties as dress uniforms, he offered his readers a straightforward narrative based on his own recollections. He supplemented his text with correspondence and other documents he had at hand (during the editing process at Mount McGregor, a small room in the cottage converted to an office was the site of fact-checking by Fred Grant, who consulted voluminous war records, maps, and charts). Grant recounted the events of the war in the order they occurred, offering along the way his analysis of military strategy. He invested few pages in battles and events in which he had not been engaged but described Lincoln, Secretary of War Edwin Stanton, and other Washington figures, as well as the military men.

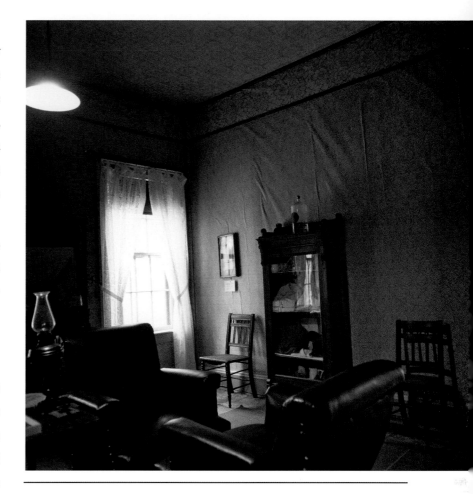

The general settled into a bedroom on the first floor; Julia and the rest of their family moved into the six bedrooms upstairs. This room, where Grant slept upright in one of this pair of chairs, doubled as the author's office.

Grant opened his book with a summary of his early life, then told of the Mexican conflict (1846–1848). He found his storytelling stride with his days in 1861 as colonel of the Twenty-First Illinois Volunteer Infantry. With the western war unfolding along the Mississippi River, Grant had risen rapidly to general, winning hard-fought victories at Fort Donelson and Shiloh in 1862 and at Vicksburg and Chattanooga the following year. In 1864, Abraham Lincoln commissioned him lieutenant general, commander of all Union armies, and Grant detailed in his book the wins and losses that culminated with Lee's surrender at Appomattox (see "Generals Grant and Lee at the Wilmer McLean House," page 172). Of his presidency (1869–1877) he wrote almost nothing. He left the politics to the politicians.

Grant's deathbed scene played out here in the parlor. He drew his last breath on July 23, 1885.

By the time Grant occupied the yellow cottage with the deep red trim, he commanded the writing of his book as he had his army. He began the process with a collaborator, the self-described literary man Adam Badeau. After months of work, however, when Badeau condescendingly suggested that Grant's book was "the simple story of a great general" and required Badeau's participation to carry it from "dictation" to completion, Grant parted ways with his former adjutant. "I do not want a book bearing my name to go before the world which I did not write to such an extent as to be fully entitled to the credit of authorship."

He would write the book his way, Grant promised, since, "for the last twenty-four years[,] I have been very much employed in writing. As a soldier I wrote my own orders, plans of battle, instructions and reports. They were not edited, nor was assistance rendered. As president, I wrote every official document, I believe, usual for presidents to write."

He went on. "The public has become accustomed to my style of writing. They know that it is not even an attempt to imitate either a literary or classical style; that it is just what it is and nothing else."

In the finished book, the voice is unselfconsciously Grant's, the paragraphs peppered with first-person pronouns. The prose is lean, the verbs active. The writing lacks apparent artifice but is more than workmanlike; one can imagine Grant's methodical mind unburdening itself to a stenographer in the straightforward manner of one accustomed to recording thoughts and experiences

in an ordered fashion. Neither a novelist nor an angry man, Grant in the pages of his *Personal Memoirs* left the upbraiding and bragging to others, telling his story with clarity and simplicity. Despite the *Personal* in his title, Grant, for the most part, took a just-the-facts approach to the story of the war.

During the weeks at Mount McGregor, Grant worked at an improvised lap desk, adding a new chapter to the second volume and writing a preface for the first. He reviewed proof sheets of book one and revised his account of the last year of the war. Mark Twain arrived for a three-day visit and spent many hours editing with Fred. Though Grant could speak only in a pained whisper, he grew adept in his last weeks at what he called "pencil-talking." In one note to Twain in early July, he confided, "If I could have two weeks of strength I could improve it very much."

The author brought his own unmistakable perspective to his autobiography; Grant's unabashed belief in the morality of the Union cause emerges boldly in the thesis sentence of the conclusion that he wrote at Mount McGregor: "The cause of the great War of the Rebellion against the United States will have to be attributed to slavery." Although generations of historians of the South would find fault with this fundamental assumption, for many Southern sympathizers, such as English critic Matthew Arnold, who regarded Robert E. Lee as "the hero of the American Civil War," Grant nevertheless came across as "a man of sterling good sense as well as of the firmest resolution; a man, withal, humane, simple, modest . . . [and] never boastful."

In his last days, Grant received visitors at Mount McGregor. As a platoon of the press hovered, old friends arrived to pay their respects. One was Simon Bolivar Buckner, a fellow cadet from West Point days who, as a C.S.A. general, surrendered to Grant at Fort Donelson. The emotion of the old soldiers' parting was such that neither man could manage more than a single word of farewell. "Grant," said the former C.S.A. general, taking his friend's hands in his. "Buckner," croaked Grant.

With the book's posthumous publication, Grant's heirs, as well as his publisher friend Samuel Clemens, benefited from both

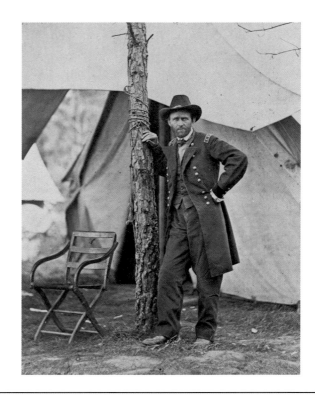

No stickler for military discipline for its own sake, Grant leans casually against a tree at his headquarters in Cold Harbor, Virginia, in June 1864. *Library of Congress, Prints and Photographs*

widespread admiration for Grant and the public's sense that the book was something of a memorial to the general whose death-watch had consumed the nation's attention just months earlier. *Personal Memoirs* immediately gained a place on the bookshelves of firm Unionists and has not been out of print since.

Characterizations of Grant himself vary. Some remember him fondly as the magnanimous victor at Appomattox who announced to his men, "The war is over; the rebels are our countrymen again." Others seek to dismiss him as the man responsible for much military butchery. Whatever his role in life, in dying he reinvented himself as a literary man, producing a remarkable book that he himself, in typical understatement, termed "truthful history." After comparing it to Thoreau's *Walden* and Whitman's *Leaves of Grass*, twentieth-century literary critic Edmund Wilson went even further; he described *Personal Memoirs of Ulysses S. Grant* as "a unique expression of the national character."

HARRIET BEECHER STOWE HOUSE

HARTFORD, CONNECTICUT

"I sat up last night until long after one o'clock
reading and finishing *Uncle Tom's Cabin.*
I *could not* leave it any more than I could have
left a dying child. . . . I thought I was a thorough-
going abolitionist before, but your book has
awakened so strong a feeling of indignation
and of compassion that I never seem to have
had any feeling on this subject until now."

GEORGIANA MAY TO HARRIET BEECHER STOWE

1852

FATHER ABRAHAM

L
incoln may or may not have uttered the famous witticism attributed to him on the occasion of the well-documented visit by Harriet Beecher Stowe (1811–1896) to the White House on December 2, 1862. We have no direct testimony from either party to confirm Lincoln's exact words.

That said, Stowe's son Charles Edward reported that, upon her arrival for tea on that damp and chilly day, the president rose awkwardly from his chair before the fire. According to Charles (who wasn't there but apparently heard his mother's version of events), the president looked upon his guest "with a humorous twinkle in his eye." We're told that Abraham Lincoln then remarked, "So you're the little woman who wrote the book that made this great war."

Regardless of whether the words are apocryphal or accurately rendered, they do possess an inherent truth. A decade earlier, the "little woman" that Lincoln met—Stowe stood less than five feet tall and weighed fewer than a hundred pounds—wrote a book that changed the national conversation. Begun as a serial in the June 5, 1851, issue of the weekly *National Era,* her novel *Uncle Tom's Cabin; or, Life Among the Lowly* gained immediate and unprecedented success. Published in two volumes in 1852 even before the serial had run its course, the first American edition sold three hundred thousand copies that year alone. Stage adaptations took the

tale still further, offering a new window onto slavery. By the time Mrs. Stowe came to Washington, some two million copies were in print in the United States and several times that worldwide.

In recounting the ordeals of Uncle Tom, Eliza, and other characters seeking to escape bondage, Stowe succeeded in endowing them with a humanity previously unrecognized by many in either the North or the South. In short, her compelling melodrama forced millions of Americans to grapple with the uncomfortable concept that slaves were people, not property.

Her journey to Washington in the late fall of 1862 had two purposes. She wished to visit with one of her sons; she worried that Fred, a Union army lieutenant stationed in the capital, might be indulging his known tendency for whiskey. On the larger stage, however, she wanted to satisfy herself that Mr. Lincoln's Emancipation Proclamation, published on September 23 but not yet in full force and effect, was "a reality & a substance not a fizzle out."

Both mother and the daughter who accompanied her found "Father Abraham," as Stowe called him, most entertaining (twenty-

Previous page: Mrs. Stowe's painted brick house, just one-third the size of Samuel Clemens's next door, featured Gothic Revival trim. The gray-on-gray color scheme dates from 1882. "We have a pretty yard in front," Mrs. Stowe wrote of the place, "and space for a little flower garden in the back."

Opposite: Restored consistent with Beecher and Stowe's book *The American Woman's Home* (a book she coauthored with her sister Catharine), the kitchen features a great cast-iron cookstove.

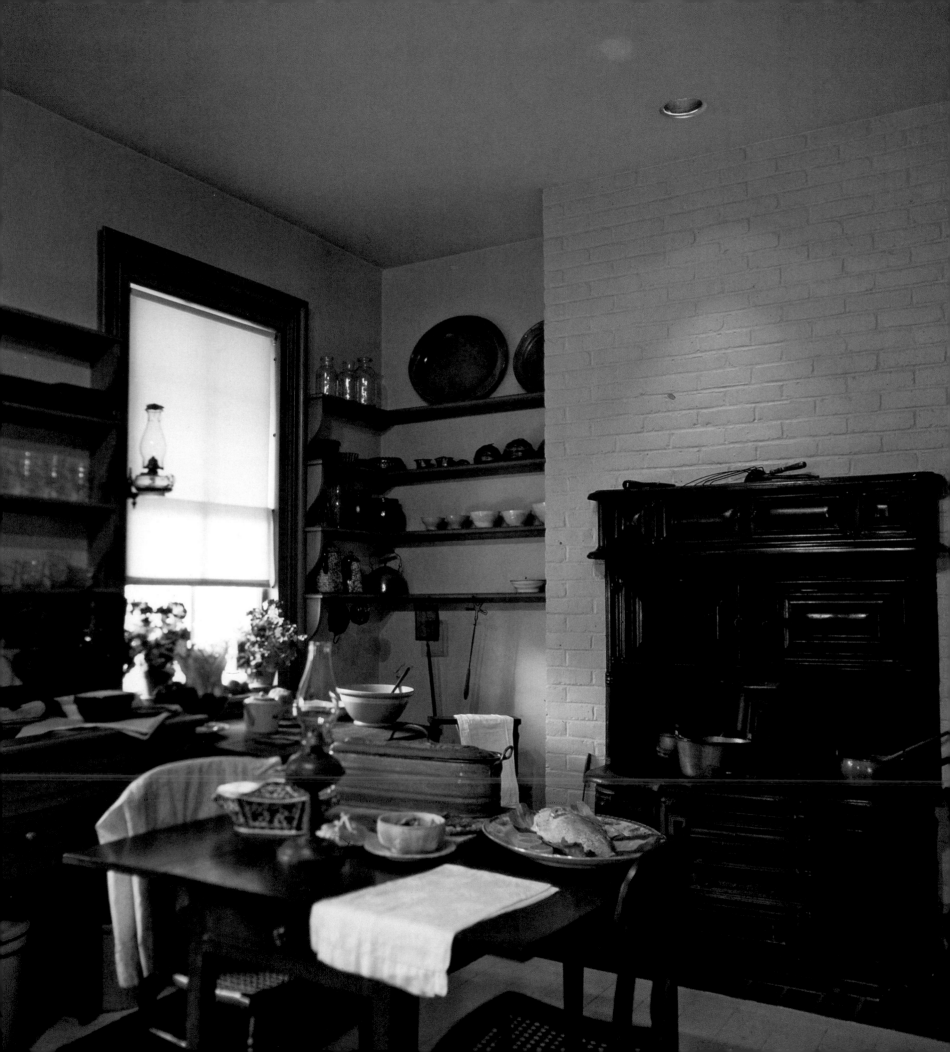

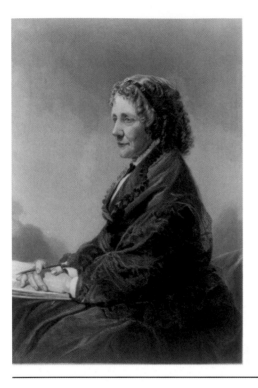

This circa 1872 engraving, based on a painting executed by Alonzo Chappel, portrays Mrs. Stowe at the time she moved to Forest Street. *Johnson, Fry & Co., Engravers/Library of Congress Prints and Photographs*

six-year-old Hatty wrote home to her sister, "It was a very droll time that we had at the White house"). Her mother's letter to her husband at the time offers less about the White House visit than about a Thanksgiving Day meal she shared with fugitive slaves, whose call-and-response rendition of "Go Down Moses" she found "strange and moving." Even so, Lincoln clearly satisfied her concerns with respect to the Emancipation Proclamation. Mrs. Stowe soon dispatched a long letter for publication in which she reaffirmed the nation's opposition to slavery and its dedication to emancipating its four million slaves.

"We have striven in the cause," she wrote, "even unto death."

A NOT-SO-LOWLY LIFE

One of the most notable clergymen of his time, Lyman Beecher fathered eleven children. All seven of his sons would become men of the cloth, including Henry Ward Beecher, who, as a lecturer and Congregationalist minister in Brooklyn, New York, gained international fame as a social reformer concerned with slavery, women's suffrage, and temperance. But it would be Lyman's sixth child, his daughter Harriet, whom the father termed a "great genius." When his daughter was seven, Lyman Beecher confided in a relative, "I would give a hundred dollars if she was a boy and Henry a girl—she is as odd—as she is intelligent & studious."

Born in Litchfield, Connecticut, Harriet Beecher was five when she lost her mother to consumption, but she fared well in educational terms in the years that followed. Few schools of the day recognized girls as the intellectual equal of boys, but she attended two that did. At age eight, she enrolled at the Litchfield Female Academy, just down the street from the Beecher parsonage, and at thirteen, at the Hartford Female Seminary. Though she received instruction in the "ornamental" subjects women traditionally learned (dancing, embroidery, painting), Harriet Beecher also gained an academic education that differed little from her brothers' schooling, including as it did classical languages, logic, history, the natural sciences, rhetoric, and mathematics. Harriet remained at the Hartford Female Seminary, which her sister Catharine had founded, until 1832, rising from student to teacher. Religion played an important role at the school and in Harriet's adolescent life; her father described her at age fifteen as "full of elevated & ardent Christian experience & practical zeal."

At twenty-one, she moved with her father, stepmother, and a number of other family members to Cincinnati. Lyman Beecher became president of Lane Theological Seminary, but Harriet worked at launching her career as a writer. In the months after she arrived in Ohio, her first book was published, a school text titled *Primary Geography for Children*. For a time, she taught at a new school her sister founded. In 1836, she married a recently widowed Lane professor, Calvin Stowe (his wife had been a friend of Harriet's), and nine months later, she gave birth to twin daughters.

In her eighteen years in Ohio—in 1850 Calvin would accept a professorship at his alma mater, Bowdoin College, and move the family to Maine—she gave birth to six children. She observed the explosive growth of Cincinnati, where the population expanded

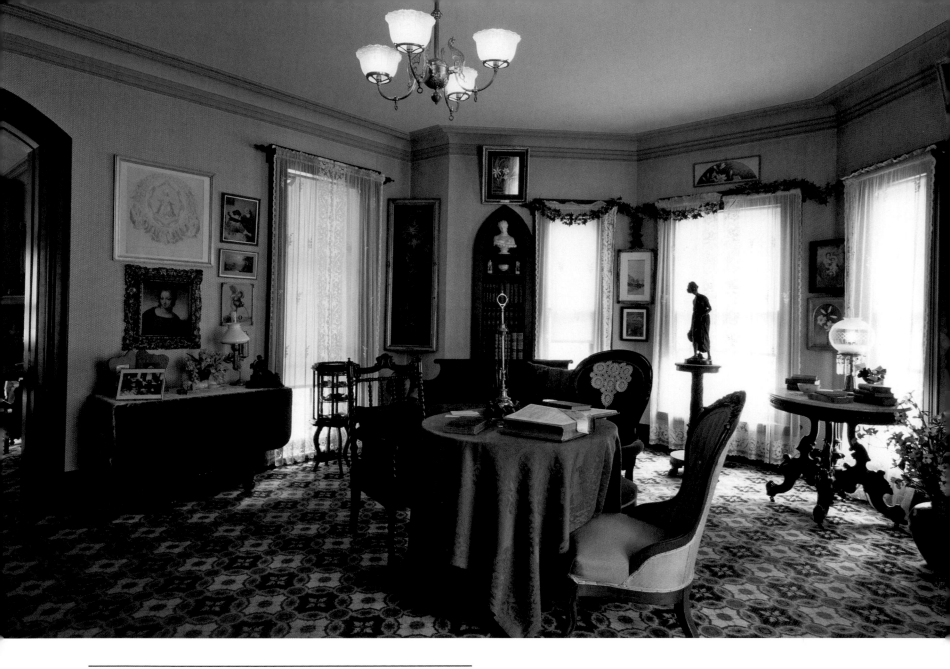

The bright front parlor, illuminated by a broad bay window, features many Stowe family artifacts, including family heirlooms, contemporary Victorian-era furniture, and a tourist copy of a Raphael *Madonna*. The "little woman" who played such a role in the years leading up to the Civil War was laid out in this room after her death in 1896.

more than tenfold between 1830 and 1850. She came to know a place different in character from the New England of her childhood. Nearly half the port city's inhabitants were immigrants; the speech of the place was flavored with German and Irish accents. With the slave state of Kentucky just across the Ohio River, the diverse peoples Harriet Stowe encountered included fugitive slaves who spoke the dialect of the plantation South.

She continued writing as she raised her children, occasionally publishing sketches and stories in small-circulation newspapers and religious journals, but she was inspired to embark on a larger work of fiction by the Fugitive Slave Act. One of five bills that constituted the Compromise of 1850, the legislation required citizens "to aid and assist in the prompt and efficient execution" of the law. The distasteful practice of recapturing escaped slaves suddenly assumed an immediate reality to many in the North (some called the legislation the "Kidnapping Act"). The law stunned the conscience of many people, especially those, like the Stowes, who had been known to harbor fugitives. Her first year in Maine, she wrote several pieces, including a parable called "The Freeman's Dream," which appeared in the pages of the *National Era*. The editor encouraged her to keep writing, and on March 9, 1851,

The majority of the objects at the Harriet Beecher Stowe home belonged to the family, like the spool writing table and many of the objects assembled in this still-life.

Mrs. Stowe herself painted some of the cottage-style furniture in the home, including this marble-top commode in the master bath.

Stowe wrote to him that she was at work on "a series of sketches which give the lights and shadows of the 'patriarchal institution.'"

The panoramic antislavery story that emerged consisted of more than forty sketches, which then assumed another form as the forty-five chapters in *Uncle Tom's Cabin.* The book recounts the successful escape of the slave Eliza, her son Harry held to her bosom, eluding slave catchers in Kentucky by leaping onto an ice floe that carries her across the Ohio River. Uncle Tom meets a Christ-like end at the hand of Simon Legree, a vicious Louisiana plantation owner who beats the slave to death even as Tom forgives him. The cast of characters also includes a saintly young woman, Eva, the daughter of slave owners; the slave Cassy, who, having seen two of her children sold away, killed her third child; and the mischievous Topsy.

Some of the book's emotional power reflects Stowe's own experience. The loss of a son to cholera in 1849 remained with her, and, in a brief autobiographical note written shortly after the publication of *Uncle Tom's Cabin,* she recalled the effect on her of the death of her eighteen-month-old toddler. "It was at *his* dying bed

& at *his* grave, that I learnt what a poor slave mother may feel when her child is torn away from her. . . . I felt I could never be consoled for it, unless it should appear that this crushing of my own heart might enable me to work out some great good to others."

While many in the South expressed outrage, dismissing the book as a misrepresentation of plantation culture and values, Stowe had done her homework. Her time in Ohio and her ear for colloquial speech produced dialogue with a verisimilitude that won the admiration of readers. She had visited a Kentucky plantation during her Ohio years; one of her brothers, having lived in Louisiana, briefed her on the brutalities of slavery as practiced in the Deep South. She knew the abolitionist literature well, including Theodore Weld's *American Slavery As It Is* (1839). Her portrait of slave life, though played for sentiment, rang all too true.

NOOK FARM

With the end of the war, Harriet Beecher Stowe chose to write about domestic affairs. As she told her friend James Fields, by

then the editor of the *Atlantic*, "It is not wise that all our literature should run in a rut . . . red with our blood—I feel the need of a little gentle household merriment & talk of common things." In columns that appeared under such titles as "House and Home Papers" and "The Chimney-Corner," she wrote of carpets and cooking, of servants and home decoration. She brought an unusual perspective, as her income, rather than her husband's, had long paid the family expenses.

By the time the Stowes moved to Forest Street in Hartford, Connecticut, in 1873, to the home restored today as the Harriet Beecher Stowe House, Calvin had been ten years retired from the pulpit and Harriet was nearing the end of her writing career. For the last twenty-three years of her life, aside from lecture tours and several winters spent in Florida—for some years, the Stowes owned a home there, pioneering the trend of wintering in the South—she resided in Hartford's Nook Farm neighborhood. She knew the acreage near the Park River well, having built Oakholm, another house in the Nook Farm neighborhood, a decade before. A large dwelling with eight gables, it loomed too large and was too expensive to heat, and the Stowes had sold Oakholm in 1870 (the entry hall alone had a footprint of twenty-four by forty-eight feet). The smaller home Stowe purchased on Forest Street for fifteen thousand dollars better suited the aging couple and the two unmarried daughters, Eliza and Hatty, who lived with them. Son Charles, who resided nearby and preached at the Windsor Avenue Church, checked in on his parents daily. "Mr Stowe and I lie on opposite sofas and doze," Stowe wrote to an old friend in 1880, "& occasionally [we] compare notes like two old superannuated carriage horses." They employed two African American servants to help operate the household, and Mrs. Stowe made the house her own, adding a portico to the façade, a trellis on the rear, and small porches on the sides.

Samuel Clemens built a fine brick mansion adjacent to the Stowes' home; as an author, Clemens regarded Stowe as something of a mentor, and they sometimes dined together. Her sisters Mary and Isabella also lived in the Nook Farm neighborhood.

After her Civil War era heyday, Harriet Beecher Stowe spent her last decades quietly. She published more than thirty books in her lifetime, including another antislavery novel, *Dred* (1856), but none had the impact of *Uncle Tom's Cabin*. If her writings didn't make her as rich as they should have (in the absence of international copyright law, foreign editions yielded few royalties), her books made her a celebrity at home and abroad. *Uncle Tom's Cabin*, a writerly mix of the romantic, the realistic, and the preachy, packed a powerful punch, reducing many readers to tears. Another book of hers was *A Key to Uncle Tom's Cabin* (1853), a detailed response to the many critics of the novel, particularly those in the South, who accused her of distorting the master-slave relationship.

Over the next century, Uncle Tom would be seen by millions of Americans on the stage. Wildly varied "Tom Shows," some of which parted radically from the intents and content of Mrs. Stowe's text, included *Mickey's Mellerdrammer*, an early Walt Disney animated short (1933), and the play-within-a-play in the 1951 Rodgers and Hammerstein stage musical *The King and I*. The book would fall out of popular favor in the later twentieth century, in part due to black Americans' discomfort with Uncle Tom's passivity (Henry Louis Gates put it well: "The term 'Uncle Tom' became synonymous with self-loathing"). The novel's contrived plot and didacticism probably didn't help, but a larger factor in the eclipse of *Uncle Tom's Cabin* was the broad acceptance of Margaret Mitchell's more benign view of plantation life as portrayed in *Gone with the Wind*.

With the turn of a new century, Mrs. Stowe's book shows signs of gaining a new currency. New scholarly editions have reached a wider readership, leading to a renewed interest in Tom, Eliza, and Topsy. Literary critics discuss how Stowe's central character compares to Jean Valjean in Victor Hugo's *Les Misérables;* some historians now argue that *Uncle Tom's Cabin* inspired leaders of the nonviolent, Christianity-infused civil rights movement. With the public's renewed willingness to talk more frankly about race, the book that helped start the Civil War has a place, once again, in the American conversation.

ALEXANDER H. STEPHENS'S LIBERTY HALL

CRAWFORDVILLE, GEORGIA

"[He] carried more brains and more soul for the
least flesh of any man God Almighty ever made."

ROBERT TOOMBS

HAMPTON ROADS, 1865

Aleck and Abe greeted each other like the old congressional colleagues they were. Their friendship dated from the Thirtieth Congress. In 1848, Lincoln, a freshman representative, had written home to William Herndon, his law partner in Illinois, observing that "a little, slim pale-faced consumptive man . . . just concluded the very best speech of an hour's length I have ever heard. My old, withered dry eyes are full of tears yet." The man from Georgia also cherished their shared service in the Capitol, remembering "I was as intimate with him as with any other man." But many years had passed.

When they met again in February 1865, C.S.A vice president Alexander Hamilton Stephens came aboard the steamer *River Queen* in the waters of Hampton Roads. As the little man unwound the shawls that protected him from the February chill, the U.S. president quickly stepped in to assist Stephens with his wool greatcoat. Towering over Stephens, Lincoln remarked with a smile, "Never have I seen so small a nubbin come out of so much husk." They shook hands.

Although they would talk cordially of the old days in the four-hour meeting that ensued, the passage of time had transformed the two thirty-something Whigs into political and military adversaries. Neither man arrived with high hopes of agreement for "the restoration of peace," though that was the stated purpose. Lincoln's companion, Secretary of State Seward (see "William Henry Seward House," page 162), and Stephens's co-commissioners, John A. Campbell, assistant secretary of war, and Robert M.T. Hunter, president of the C.S.A. senate, were dubious too. But all were willing to try to end the long and bloody war, now well into its fourth year.

Their talk addressed the possibility of an armistice, but Lincoln remained firm that none was possible until the armies of the South disbanded and all states acknowledged Federal authority. Stephens knew that Confederate president Jefferson Davis would settle for nothing less than Confederate independence.

On the slavery question, Lincoln spoke generously of restitu-

Previous spread: He called the place Liberty Hall, Stephens explained, "because I do as I please here and expect my guests to do the same." In his time, the Liberty Hall grounds included peach and apple orchards, fig, pear, and pomegranate trees, as well as gardens that produced vegetables and showy roses. A stand of Catawba vines produced enough grapes to yield five hundred gallons of wine annually.

Opposite: Alexander H. Stephens as photographed during his service as vice president of the Confederate States of America. *Library of Congress, Prints and Photographs*

Above: After a heavy gate fell upon Stephens's fragile form, mangling a hip, he employed what he called roller chairs to move about Liberty Hall. Note this room, the men's parlor, contains a bust of Stephens.

tion for lost "property" and said he would never have "interfered" with it had he "not been compelled by necessity to do it, to maintain the Union." But, Lincoln added, "Whatever may have been the views of your people before the war, they must be convinced now, that Slavery is doomed." The two sides differed there too.

Despite the evident goodwill of both men, Lincoln and Stephens's exchange uncovered only one tiny piece of common ground. As they parted, Lincoln promised to secure the release of Stephens's nephew Lieutenant John A. Stephens, who'd been held for sixteen months in an Ohio prison.

Lincoln steamed back to Washington, and the blue and gray armies fought on. Returning to Richmond, Stephens briefed Davis, who hardly needed to be told the outcome of the talks. Then Alexander Stephens departed once more, this time for his home, Liberty Hall. He left the doomed capital of the Confederacy with no plan of returning. Events, expected and not, at Appomattox and at Ford's Theatre soon altered what Stephens had hoped would be his "perfect retirement" in Crawfordville, Georgia.

LITTLE ALECK

Alexander Stephens (1812–1883) lived up to his nickname, as the gaunt little Georgian never carried more than about a hundred pounds on his five-foot, seven-inch frame. As a child, he faced difficult circumstances, with the death of his mother when he was a babe-in-arms, and of his father's and stepmother's at fourteen. Despite such auspices and his poor health (he suffered from what appears to have been rheumatoid arthritis, curvature of the spine, migraine headaches, dyspepsia, and various other ailments), Stephens shouldered his way into the picture at many of the major moments of his time.

Early on, family and friends recognized the young man's intellectual gifts. Relieved of farm chores at fifteen, he adopted the surname of the kindly master at a local academy, Hamilton, as his middle name. He went on to studies at the State University at Athens (later, the University of Georgia). After a brief career as a teacher, Stephens shifted to the study of law in Crawfordville,

where he boarded with a distant relative, a minister whose estate, in 1845, the by-then-prosperous Stephens would purchase. He renamed the house Liberty Hall.

At age twenty-one, he cast his first ballot. He later recalled weighing the issue of tariffs, then a matter of great moment and, time would reveal, also a harbinger of things to come, since the controversy raised the dual specters of nullification and secession. Stephens voted against the nullifiers then, but just three years later, he remembered, "I was elected to the Legislature as a States Rights man."

Elected to the U.S. Congress in 1843 (he would serve sixteen sessions), he quickly won the trust of such varied powers in the Capitol as Henry Clay, Daniel Webster, and John Calhoun (see "John C. Calhoun's Fort Hill," page 26). He possessed a precise legal mind, as well as a gift for parliamentary procedure. As the House point man, he and longtime ally Senator Stephen Douglas enabled passage of the multiple bills known as the Compromise of 1850; later, his clever use of an obscure parliamentary rule led to the enactment of the 1854 Kansas-Nebraska Act. At the time, he regarded the 1854 legislation as his greatest political victory, and although his reading of that circumstance was dead wrong (the outbreak of violence remembered as "Bleeding Kansas" resulted), Stephens would prove a better prognosticator after the issuance of the Emancipation Proclamation. Perhaps alone among the South's leaders, he understood that Lincoln's decision to free the slaves in the seceded states meant the end to any chance of an early close to the war.

A pragmatic politician, Stephens's prewar political journey took him to the camps of the Jackson Democrats, the Whigs (as a "Young Indian" in support of presidential candidate Zachary Taylor), and the Democrats of Stephen Douglas. Then, in 1859, he walked away from political office. He campaigned for Douglas the following year in Georgia, but he felt certain that Lincoln would prevail at the polls in November. As he explained to a friend, "The Republican nominee will be elected. Then South Carolina will secede. For me, I should be content to let her have her way. . . . But the

Gulf States will follow her. . . . After that the Border States will hesitate, and their hesitation will encourage the North to make war upon us." His words proved prescient, and his next political position would be as Jefferson Davis's vice president.

LIBERTY HALL

As a sometime real estate lawyer, Alexander Stephens might have described life at Liberty Hall during the spring of 1865 with the term *in abeyance*. Reports arrived of last battles lost. His nephew John returned home, prompting a family reunion that brought half brother Linton, to whom Stephens was deeply devoted, to Crawfordville (Alexander Stephens would never marry). But word of Lincoln's assassination and the attempt on Seward's life reached

Visitors in Stephens's lifetime remembered the running bond pattern of a painted floor cloth in a sparsely furnished center passage.

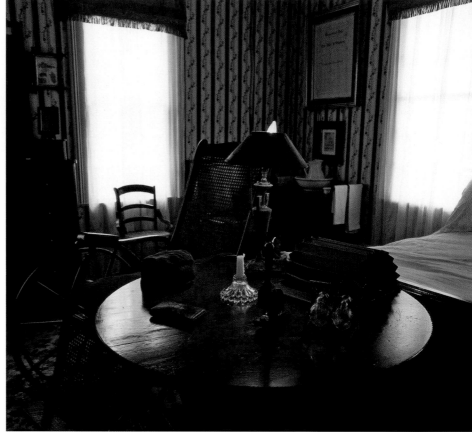

Stephens added rooms to the rear of Liberty Hall, separated from the main structure by a covered way. His library contained some 6,500 volumes, largely law and history, and it was here he tutored his law clerks.

Stephens's house possesses a certain grandeur, but his fellow Georgians called him the "Great Commoner." Note the smoking cap, pocketbook, and inkwells on the parlor table, all of which belonged to Stephens.

Crawfordville too. With many in Washington certain of a link between the Booth conspirators and Jefferson Davis's government, Vice President Stephens awaited the inevitable.

He sat quietly in his parlor, playing a game of casino, when one of his slaves brought word of the arrival of the Yankees. Soon the heavy tread of boots sounded on the broad porch that fronted Liberty Hall. The exchange was very civilized: Captain Saint of the Fourth Iowa Cavalry produced orders for the arrest of Alexander Hamilton Stephens, then permitted his cooperative prisoner to pack a carpetbag with clothing. A quarter hour later, a procession left for the rail station, with the rail-thin detainee surrounded by a phalanx of guards.

Stephens spent most of his imprisonment on Georges Island, Massachusetts. During his incarceration, he recorded his thoughts in long form, a journal published after his death as *Recollections of Alexander H. Stephens: His Diary Kept When a Prisoner at Fort Warren, Boston Harbour 1865* (Doubleday, Page, 1910). While he reported on the bedbugs with which he shared his bed and his "low, underground, damp room," Stephens's thoughts in his prison cell often transported him to Liberty Hall.

He pined for "my dear home." He mused, "How do the yard, the grove, the lot, and all things about Liberty Hall, appear to those who are there today?" He recollected an unending series of visitors, among them his aged friend Quinea O'Neal, one of Stephens's law tutors, who resided off and on at Liberty Hall, dying there at age

ninety (his grave demeanor was recalled by the name given his bed-chamber: the Parson's Room). Stephens's home was well known for its hospitality. Dinner at Liberty Hall, it was said, was timed to align with the arrival of the train at Crawfordville station.

He made friends of his jailers, one of whom treated him with such courtesy that Stephens confided in his diary, "I hope yet to have the pleasure of entertaining him with such hospitality as I can command at Liberty Hall." As Davis refused to do (see "Jefferson Davis's Beauvoir," page 226), Stephens wrote to President Andrew Johnson seeking a pardon. His diary closed with his much-wished-for return to Liberty Hall, twenty-four weeks to the day after his arrest. There his former slaves Harry and Eliza awaited him. "The children all cried for joy," the freed Stephens reported, "[Eliza's] eyes, too, were full."

MR. VICE PRESIDENT

Alexander Stephens embodied the sense of conflict that so many in the South felt as war approached. As a delegate to the Georgia Secession Convention, he spoke for union in November 1860. "Our present government is the best in the world," he said of the constitutional democracy he had long served. "My judgment is against secession."

Word of that speech reached the ears of, among others, the president-elect of the Union, who wrote asking for a copy. Stephens obliged Lincoln, observing in the letter dispatched to Springfield, "The country is in great peril, and no man ever had heavier or greater responsibilities resting upon him than you have in the present momentous crisis." In his reply—marked *For your eye only*—Lincoln agreed ("I fully appreciate the present peril") but offered assurances that his administration would not interfere with the South's slaves. Lincoln added, "You think slavery right and ought to be extended; while we think it is wrong and ought to be restricted. That, I suppose, is the rub. It certainly is the only substantial difference between us."

A compromise choice as vice president because of his opposition to secession, Stephens played a notable role in the creation of

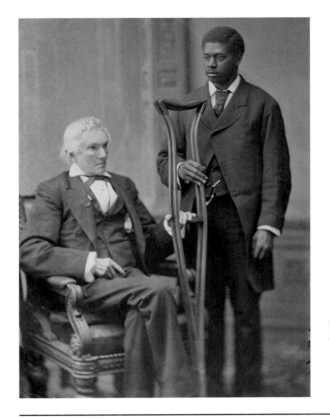

A postwar image of Stephens with a manservant believed to be the former slave Harry. *Library of Congress, Prints and Photographs*

the Confederacy's permanent constitution, but his time of influence effectively ended there, and Stephens would spend more war years at Liberty Hall than in Richmond. At times his support for Jefferson Davis appeared halfhearted, as he criticized the president's policies on conscription, the suspension of habeas corpus, and even military strategy. Perhaps more than anyone else in the Confederacy, Stephens looked to negotiate an end to the war, not only in February 1865 but earlier, at a proposed 1863 peace conference and during an exchange with General William Tecumseh Sherman after the latter took Atlanta in 1864.

Yet Stephens's most quoted words concerned neither peace nor constitutional doctrines. On completing the Constitution in Montgomery, Alabama, he addressed his fellow Georgians on his way to Liberty Hall. At an enthusiastic rally in Savannah on March 21, 1861, he spoke at length, but one passage stood out then, as now, as if in boldface. The government of the abolitionist North,

One of Alexander Stephens's lifelong political allies and dearest friends, Robert Toombs, who served as the Confederacy's first secretary of state, was a frequent guest at Liberty Hall. This was his designated room and the bed he slept in, with Gothic-style red-velvet hangings.

he asserted, was based upon equality of the races. In contrast, Stephens told his eager audience, "Our new government is founded upon exactly the opposite idea; its foundations are laid, its cornerstone rests upon the great truth, that the negro is not equal to the white man; that slavery—subordination to the superior race—is his natural and normal condition."

In the coming days, years, and even decades, Jefferson Davis, Stephens, and a multitude of others would backtrack from what came to be called Stephens's "cornerstone speech," and his words,

taken out of the larger context of a reasoned speech about the political realities of the moment, were used to rally people to the cause in the North. Try as they later would to downplay the matter of slavery, however, Stephens and the other defenders of the Old South understood that the bondage of the black man, in an economic and social sense, remained central to the state-versus-national-sovereignty debate.

His postwar years followed the pattern of many rehabilitated Confederates. His fellow Georgians were quick to elect him their senator, but, given his former allegiance to the Confederacy, he was not allowed to assume a seat in the U.S. Senate. For some years he devoted himself to writing, and his two-volume *A Constitutional View of the Late War Between the States* (National, 1868, 1870) met with surprisingly strong national sales. When permitted to return to Washington in 1873, he served in the House until his resignation in November 1883, when his fellow Georgians bestowed upon him a final honor, the governorship of Georgia. He died just four months into his term.

Like Robert E. Lee, Alexander Stephens in 1860 possessed a deep love of his country—that is, the United States of America—and believed in its prospects and, most of all, in its Constitution. Both men had long served the nation (as an army officer and a congressman, respectively), but with the secession of their states against their own wishes in 1861, both felt honor-bound to follow them.

Stephens repeatedly demonstrated a great sympathy for the poor, weak, and unfortunate. As an orphan, he had received the aid of others to gain an education, and he would help many lads pursue schooling. Numerous young men read law under his tutelage in the Liberty Hall library. A prosperous man (in 1860, his estate was estimated to be worth $53,000, of which about a third was the valuation of his thirty-four slaves), he gave substantial sums away (as much as $2,000 at a time). During the war, wounded soldiers found accommodations in his home; after the war, one room, named for its transient inhabitants, came to be known as the Tramps' Room. By all accounts, he won the loyalty of his own slaves, many of whom chose to remain at Liberty Hall after emancipation.

THE LOST CAUSE

The capacity of any individual for recollecting the past is, at best, imperfect and incomplete; similarly, cultural memory inevitably accumulates mythic overlays that, while not necessarily false, may be selective or colored by the predispositions of those who assemble them. The principal one of the Civil War era, at the very core of which both Alexander Stephens and Jefferson Davis stand, is the Lost Cause view of the conflict.

Even before Davis emerged from Fortress Monroe, the widely known editor of the *Richmond Examiner* Edward A. Pollard published a book titled The *Lost Cause*. Pollard's 750-page tome, its frontispiece an engraving of Jefferson Davis, bore the subtitle *A New Southern History of the War of the Confederates*. It offered a justification for fighting the disastrous war that, in the four years that followed Jefferson Davis's orders to fire upon Fort Sumter, saw Southern wealth decrease by 60 percent.

According to Pollard and the many subsequent writers who shared his view, the antebellum South possessed a superior culture of grace and gentility that, when faced with Northern aggression, had no choice but to defend itself; thus, righteous secessionists responded by enlisting an army of brave men to fight for their freedom. Much later, Davis himself grappled with this tension in his massive, two-volume *The Rise and Fall of Confederate Government*, a book that, tellingly, first bore the working title *Our Cause*.

By the early twentieth century, the Lost Cause view of the Civil War permeated many U.S. history textbooks, but more recently, a growing number of revisionist historians from both the North and the South have cast doubt upon crucial aspects of the Lost Cause interpretation. Among the long-held assumptions now disputed: that the South's soldiery was superior to the North's; that the Confederate army wasn't beaten but overwhelmed; that Robert E. Lee was "god-like" and Thomas J. "Stonewall" Jackson a true Christian martyr; and that Ulysses S. Grant was a butcher.

The central disagreement, however, concerns slavery and the Lost Cause view that it was not the principal cause for going to war. In light of recent scholarship, that claim no longer seems tenable. At the outset of the war, the state secessionist conventions talked openly about slavery; the delegates in Texas, for example, cited as a cause for war the embrace by Lincoln's "great sectional party" of "the debasing doctrine of the equality of all men, irrespective of race and color—a doctrine at war with nature, in opposition to the experience of mankind, and in violation of the plainest revelations of Divine Law." Davis himself, shortly after becoming president of the Confederacy, cited the reasons for war and included among them "a persistent and organized system of hostile measures against the rights of owners of slaves" on the part of the Northern majority in Congress. For Davis, the slaves were "peaceful and contented laborers."

The postwar Lost Cause view sought to elide slavery as a basis for the war; Davis and others insisted the cause was states' rights. In the North, many labor under a not dissimilar misconception that Lincoln and others embarked on a crusade to free the slaves. In fact, the move to emancipate a race of men whom Lincoln, like virtually every white American of his age, regarded as unworthy of equal rights evolved over time but was not an initial motivation for fighting the war.

Perhaps more than any other single figure, Jefferson Davis continues to represent the powerful polarities that, a century and a half after the Civil War, still elicit ingrained, visceral reactions, not a few of which, in both the North and the South, stand on erroneous ideas. The story of the war, from perspectives Northern and Southern, is a minefield of contradictory attitudes, a mix of myths and symbols and simplifications.

Yet Stephens could not remove the racial blinders that narrowed his vision. He never accepted the Fourteenth and Fifteenth Amendments, which granted citizenship and the franchise to people of African descent. He held to his principles with grim certainty, sitting in the House wrapped, no matter what the weather, in a cloak and layers of clothing (a reporter of the time described him, seated on the aisle, as a "queer-looking bundle"). As the critic Edmund Wilson observed, "It was as if he had shrunk to pure principle, abstract, incandescent, indestructible."

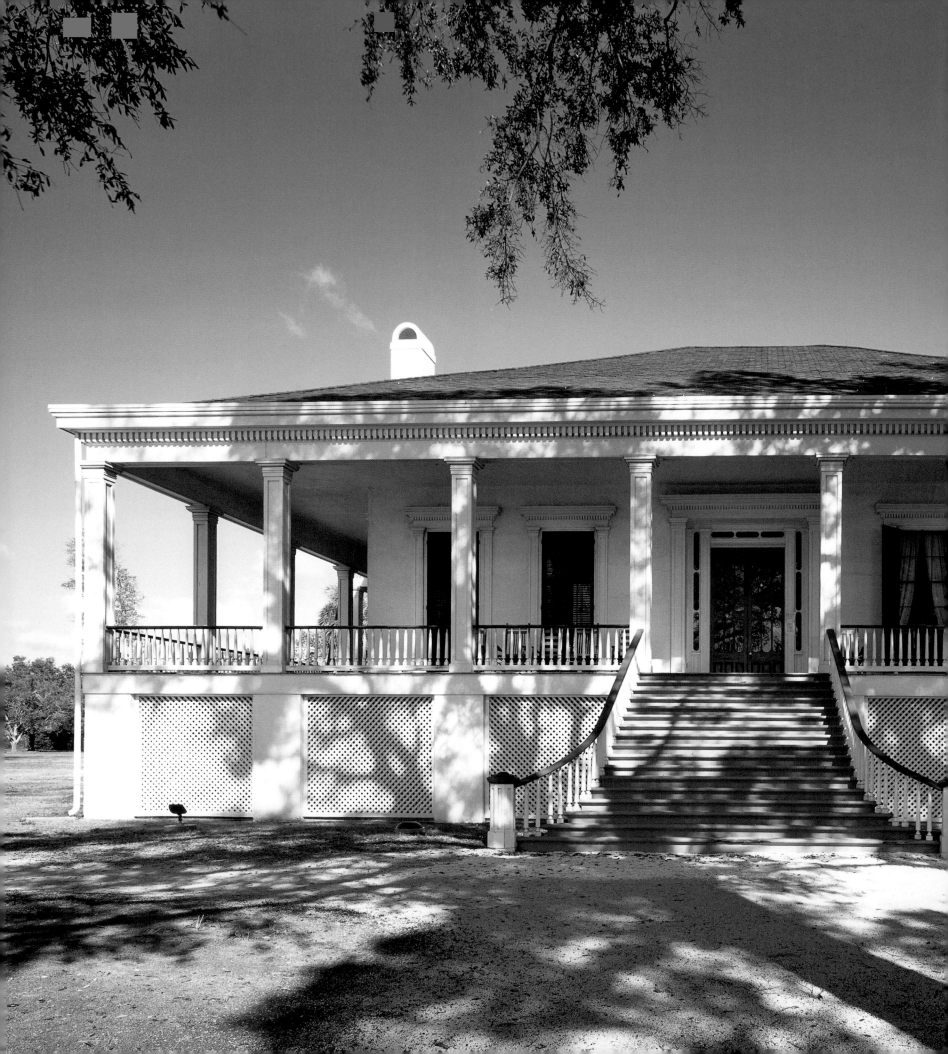

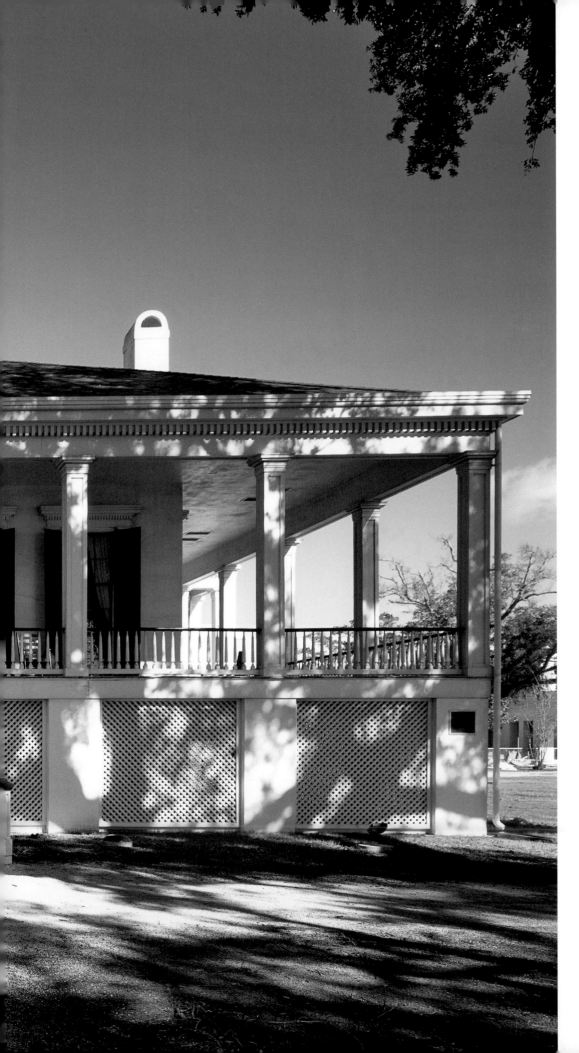

JEFFERSON DAVIS'S BEAUVOIR

BILOXI, MISSISSIPPI

"The air is soft. In winter especially the sea breeze is invigorating. The oranges are shining golden on the trees, and our pine knot fires soar in the chimneys . . . In their light I try to bury unhappiness."

JEFFERSON DAVIS

1879

"WEARY OF WANDERING"

J efferson Davis's postwar tribulations resembled the trials of Job. After Lee's surrender at Appomattox, Davis fled south, but Union soldiers arrested the president of the defeated Confederate States of America in Georgia. The grand house in Richmond he occupied as chief executive (see "Jefferson Davis and the White House of the Confederacy," page 130) faded into memory as Davis, incarcerated at Fortress Monroe in Hampton, Virginia, shared a cell with armed guards. A light burned all night, and the single, barred window looked out upon a moat.

For a time, his legs were in shackles—and many in the North wanted a noose around his neck for his presumed role in Lincoln's murder. Although the evidence against him as a coconspirator proved to be pure fabrication, a full year passed before Davis's captors eased conditions. By then, his vision, hearing, and memory had deteriorated, and his chronic facial neuralgia worsened. Regarded as the war's arch villain, Davis, in military custody, would remain in the Union equivalent of the Tower of London for 720 days.

Yet the status of political prisoner suited the resolute Mississippian. Before Davis's release on bail, the bulk of which was posted by three Northern stalwarts (*New York Tribune* editor Horace Greeley, abolitionist Gerrit Smith, and financier Cornelius Vanderbilt), Lincoln's successor, President Andrew Johnson, let it be known that an application for a pardon would be looked upon favorably. But the prisoner wanted no shortcut to freedom. As he explained later to one of his attorneys, "When closely confined at Fortress Monroe, I was solicited to add my name to . . . a petition for my pardon. . . . Confident of the justice of our cause, and the rectitude of my own conduct, I declined to sign the petition and remained subject to inexcusable privations and tortures." Jefferson Davis sought not a get-out-of-jail-free card but exoneration. According to his reading of the Constitution, he had done nothing wrong.

After his release, Davis joined his family in Canada for a time, but he soon returned to the United States, seeking to restore his fortune and clear himself of the charge of treason. He failed on both counts, his trial delayed and his Mississippi plantation, Brierfield, south of Vicksburg, confiscated (once, Davis had been among the state's richest citizens). He traveled to England in 1868,

Previous page: Historical accounts have it that the front porch (or gallery, as the space was called) was a well-used living area. One visitor, writing in the *Atlanta Constitution* in 1879, reported finding a "gentleman" seated there, at "a large table, covered with papers. . . . There was the first and last President of the Confederate States of America."

Opposite: A New Orleans *Picayune* reporter visiting Biloxi found Varina and Jeff Davis in what she called their "cool, sweet drawing room." She described the aging Davis, with a clock, piano, portraits, and cut flowers in vases around him, as "tall and thin and shrunken, with silver white hair and beard, distinguished and remarkable in his appearance."

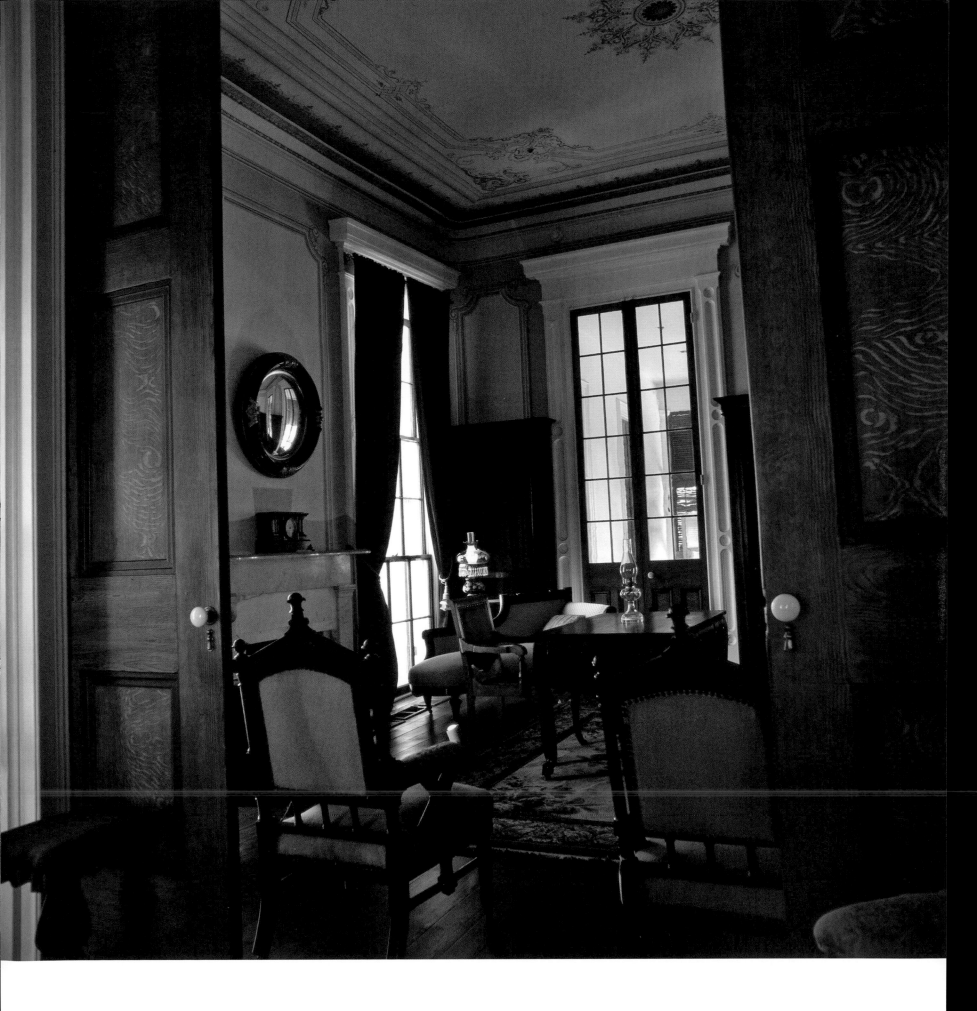

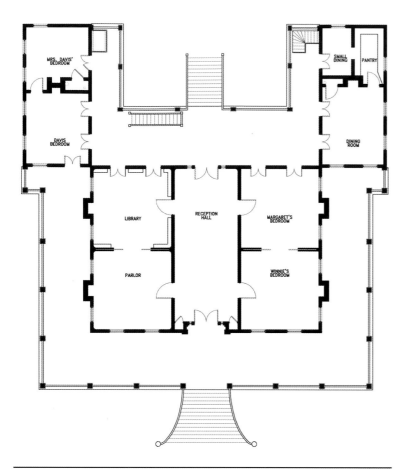

Beauvoir's unusual floor plan—every room has at least one door that opens onto one of the galleries—proved perfectly suited to its climate. The design incorporated a double drawing room at center, a space used as a sitting room on sultry days to take advantage of the cooling breezes off the Gulf waters. *Albert & Associates Architects/Hattiesburg, MS*

then on to France and Scotland. He returned in 1869 to run the Carolina Life Insurance Company in Memphis, but the venture soon failed.

The passage of more years brought few consolations. He mourned the death of Joseph Davis, the elder brother who had raised him, and lengthy legal wrangling ensued when Jefferson was forced to pursue his title to plantation property in the courts. He invested in an ill-fated venture to manufacture an ice-making machine, and a mix of other business opportunities either failed or never materialized. Often parted from his wife—his health and Varina's remained precarious—he decided a decade after the Civil War to resort to what seemed like his last option.

He would write the history of "the Southern struggle." Earlier, after his two years of incarceration, he had begun the task only to find recollecting the days of the war too upsetting (he explained to Varina, "I cannot speak of my dead so soon"). By 1876, however, his postwar frustrations and failures persuaded him the time had come to write his memoirs, and he set out to find a place to "get books and papers together for the work always in contemplation."

"A REFUGE WITHOUT ENCUMBRANCES"

Senator and Mrs. Jefferson Davis had purchased three acres of land in Mississippi City twenty years earlier, hoping one day to retire to the seaside there. Still attracted by the "moaning of the winds among the pines and the rolling waves of the Gulf," the former president now returned to inspect his holdings, hoping the property might become his writing place. But the challenge of clearing the overgrown lot and building a house seemed a daunting prospect.

Despite his sense that "the world goes wrong to me," Davis's ill fortune finally changed for the better when his path crossed that of an old acquaintance. Learning of his presence nearby, Sarah Anne Ellis Dorsey invited Davis to visit her home, Beauvoir, near Biloxi. When he told her just before Christmas 1876 that he had accepted a proposal from New York publisher D. Appleton and Company to write his reminiscences, she immediately embraced the project as if it were her own. She offered him use of a small pavilion, one of two cottages that flanked the large and elegant main house on the Beauvoir property. In February 1877, Davis took up residence, along with his body servant, a devoted former slave named Robert Brown. Davis insisted upon contributing fifty dollars a month for room and board.

Built on a square footprint with a pyramidal roof, the cottage amounted to little more than a belvedere with galleries on four sides. At Mrs. Dorsey's orders, a carpenter adapted the original design to Davis's needs, enclosing the length of the east porch, then partitioning the space into a ten-by-sixteen bedchamber for Davis and a smaller, ten-foot-square dressing room, which would double as Brown's quarters. The main room became a study for the

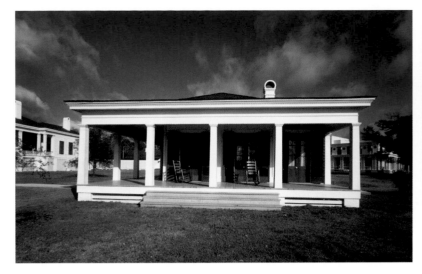

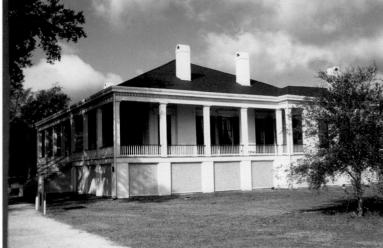

During the Davis occupancy, two smaller cottages flanked the façade of the main house to the east and west. Hurricane Katrina destroyed the pavilions, but both, including the Library Cottage (*above*) where Jefferson Davis wrote his history, have been reconstructed.

This view suggests why houses such as Beauvoir have been termed *raised cottages*. The Doric capitals on the porch and the simple frieze identify Beauvoir's style as vernacular Greek Revival, but the enclosing porches are characteristic of Louisiana and lower Mississippi plantation architecture, well adapted to the near-tropical climate.

literary work, with bookshelves that Davis himself built and a desk, chairs, and other furniture he ordered shipped from Memphis.

A schoolmate of Varina's many years before and long acquainted with the Davis family, the well-educated and well-traveled Sarah Anne Ellis Dorsey was an author in her own right, having published four pseudonymous romantic novels as well as a biography of Louisiana's wartime governor Henry Watkins Allen. She wrote of what she knew—life in the South during and after the Civil War—and remained proud indeed of her Confederate connections. The invitation to work at Beauvoir was fortuitous for the peripatetic ex-president of the Confederacy, and for Mrs. Dorsey, the presence of the man she regarded as "the noblest man she had ever met on earth" offered a glorious opportunity to demonstrate her allegiance to what she called the "Confederate Cross." At the end of February 1877, work on the book commenced, with Davis dictating copy to Mrs. Dorsey, who had volunteered to act as his amanuensis.

An inexperienced writer, Davis required the help of not only Mrs. Dorsey but several other collaborators hired by Appleton. Varina Davis, in England recovering from a nervous condition (a

"misplaced malaise," one doctor termed it), expressed outrage from afar at her husband's presence in the home of the widowed Sarah. Though her relationship with Jefferson likely remained quite proper, Sarah usurped Varina's place as Jefferson's secretary, and he described Sarah in his letters to his distant wife as "kind and constantly attentive" (so concerned was Dorsey with her boarder's comforts that she sent to Cuba for his favorite cigars). Even after her return to the United States, Varina adamantly refused invitations to Beauvoir. "I do not desire ever to see her house," she wrote Jefferson. "Nothing would pain me like living in that kind of community." Eventually, as work on the book progressed without her, Varina relented, setting aside her high Victorian mores and arriving in July 1877.

Three years were required to complete the book, published as *The Rise and Fall of the Confederate Government* (1881). During that time, further sadness struck: Varina and Jefferson's fourth and last surviving son, Jefferson Jr., succumbed to yellow fever. Mrs. Dorsey fell ill too. Prior to her death, on July 4, 1879, with Jefferson at her bedside in New Orleans, she amended her will. Though she had

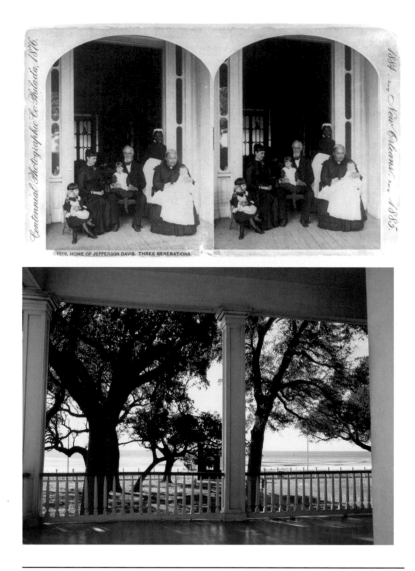

Top: Three generations of the Davis family, circa 1884, pictured at Beauvoir. *Library of Congress, Prints and Photographs*

Bottom: Once the view of the Gulf of Mexico was unbroken; today, though cars pass between the home and the shore, there remains a sense of the seascape vista that gave the house its name.

already agreed to sell him Beauvoir (for $5,500), she deeded the property and her entire estate "to my most honored and esteemed friend Jefferson Davis."

"OH MY, WHAT A BEAUTIFUL VIEW!"

Originally known as Orange Grove, the six hundred acres Jefferson Davis inherited encompassed a forest of long-leaf pine, a scup-

pernong vineyard, and a large grove of orange trees that perfumed the air. The property gained the name Beauvoir when Mrs. Dorsey, first gazing upon the saltwater sea through the screen of live oaks, magnolias, and cedars from the front gallery, stated the obvious— "Oh my, what a beautiful view!"—and decided on the spot to rename the estate.

Before the war, James Brown, a planter from Madison County, Mississippi, had built the main house, completing it, along with the flanking cottages, about 1853. With windows and doors trimmed out with Greek Revival–style pilasters, the large main house sat atop brick piers, which elevated the living quarters some nine feet above the grade, offering protection from the risk of surging sea-waters and permitting cooling breezes to pass beneath. Deep porches enveloped the south-facing façade and the east and west sides. Though Brown's slaves milled cypress and pine on the prop-erty to build the house, Beauvoir was never a working plantation (the soil was too poor). Antebellum Biloxi had become a resort for well-to-do planters and New Orleans merchants.

A flag stop on the Louisville and Nashville Railroad a few hundred yards away made travel to New Orleans and Mobile, Alabama, an easy matter, and visitors, welcome and unwelcome, arrived at Beauvoir Station during the Davis's years in residence; among them were newspaper magnate Joseph Pulitzer, John Quincy Adams's grandson Charles Francis, and even Oscar Wilde. Though the playwright expressed admiration for Davis and the Confederate cause (he equated the South's "struggle for auton-omy" with his wish "to see the Irish people free"), Davis went to bed early the evening Oscar Wilde visited and later remarked of his guest, "I did not like the man." By contrast, Davis often wel-comed former Confederate general Jubal Early, who shared both Davis's regard of the Confederacy as a virtuous cause and his dis-like for former comrades—"harmonizers," they called them—who reconciled too easily with their former enemies.

Davis spent the last dozen years of his life at Beauvoir. No longer on the brink of penury, Varina offered tea to their distin-guished company, pouring from a silver tea service into Sèvres

porcelain cups. Visitors could take a turn around a generous back garden full of flower borders and elaborate rose beds, with a kitchen garden and fruit trees nearby. Jefferson and Varina's daughter Maggie and her husband arrived periodically from their home in Colorado; Jefferson Davis proved a doting grandparent. His youngest daughter, Winnie, returned from school abroad. Her looks favored her father, and she shared his musical gifts (he often sang; she played the piano). As her father's eyesight failed, Winnie read nightly to him from the pages of Cervantes, Sir Walter Scott, Shakespeare, and the Book of Job. In his last years, he would observe of Beauvoir, "Life here is so uneventful that there is nothing to write about." But the chief work of his Beauvoir years had already been printed and bound.

———◆———

The 1,561 pages of *The Rise and Fall of the Confederate Government* amounts to a long-form justification of secession (volume 1) and a recounting of the events of the war (volume 2). Davis devoted a hundred pages to one legal premise in particular; in effect, he presented the case he never got to argue in court.

Predictably, critical reaction to the treatise divided along regional lines, with few notices in the North and high praise in the South (a "noble and triumphant defense of the Confederate cause," offered the *Southern Historical Society Papers*). Unlike Ulysses S. Grant, whose *Personal Memoirs* appeared four years later (see "Ulysses S. Grant Cottage," page 200), Davis lacked a gift for narrative. Grant's book became one of the great bestsellers of the nineteenth century, but Davis's sold fewer than twenty thousand copies in his lifetime and netted its author little profit. Nevertheless, the book raised his status, and, in his last years, immense crowds turned out to celebrate him at events commemorating the Confederacy in Alabama, Mississippi, Georgia, and Kentucky. After his death, on December 11, 1889, an estimated two hundred thousand attended his funeral in New Orleans, among them deputations from every Southern state.

A tall four-poster bed in one of the high-ceilinged bedchambers at Beauvoir, its covering a crazy quilt, a patchwork of many colorful and random fabrics.

Just as Beauvoir offered Jefferson Davis the tranquillity to put on paper the brief history of the nation he attempted to found, the place today offers a suitable setting to contemplate the chasm that lies between Davis's admirers and those who continue to see him as the enemy. Consider the Jefferson Davis Presidential Library, a bold and columned multiuse building that stands a short distance from Beauvoir. Recently constructed after several previous buildings were obliterated by Hurricane Katrina, it contains a gift shop, offices, galleries, and other facilities.

For those who view Davis as the Civil War's central antihero, the library is a peculiar trope; Davis never won election to the presidency of the United States, their argument goes, so he is hardly

Despite the depredations of Hurricane Katrina and a subsequent restoration, the well-furnished Beauvoir maintains the character of the home that Jefferson Davis knew.

That romantic and innocent-seeming epithet can convey a great deal about those who employ it; the Lost Cause has long been the litmus that distinguishes the Davis friend from foe. To the Yankee partisan, the mingling of flavors include racism and treasonous secession; to those with a taste for the South's antebellum days, the Lost Cause evokes gentility, righteousness, valor, and an ease based on a contented servant class. Therein lies a historiographical tension that still engages scholars (see "The Lost Cause," page 225).

In March 1888, Jefferson spoke to an audience of young men in nearby Mississippi City. "I feel no regret that I stand before you this afternoon a man without a country," offered Davis, "for my ambition lies buried in the grave of the Confederacy. The past is dead," he continued, "let it bury its dead." If his opening was characteristically defiant, what followed was surprisingly conciliatory. "Let me beseech you to lay aside all rancor," he exhorted, "all bitter sectional feeling and to make your places in the ranks of . . . a reunited country."

Davis's short speech, delivered in his eightieth year, was among his last public utterances. As such, perhaps it can be read as the parting words of a man scarred by life's events, not least the early death of his first wife. He had been a devoted public servant (initially to the United States, later the Confederacy), a unionist before becoming a secessionist, a president and a prisoner, simultaneously an outcast and a hero. Despite the vagaries of his turbulent life, however, he remained unrepentant, regarding himself as a principled constitutionalist, little given to self-doubt.

Davis died the following year. His descendants would wait many years for his moment of reconciliation with the nation he had both served and fought. Nine decades later, in an act sponsored by Mississippi senator Trent Lott and signed by President Jimmy Carter, Congress posthumously restored to Jefferson Davis full rights of U.S. citizenship.

entitled to the honor of a presidential library. Further, he headed a government that never won the recognition of any foreign nation, much less that of the United States.

On the other side of the divide stands the Sons of Confederate Veterans, Mississippi Division, the organization that owns and operates the Jefferson Davis Home and Presidential Library as a shrine. Consistent with the deed by which the Sons acquired the house from Varina Davis in 1903, they maintain the property as "a perpetual memorial sacred to the memory of Jefferson Davis, the only president of the Confederate States of America, and sacred to the memory of his family and 'the Lost Cause.'"

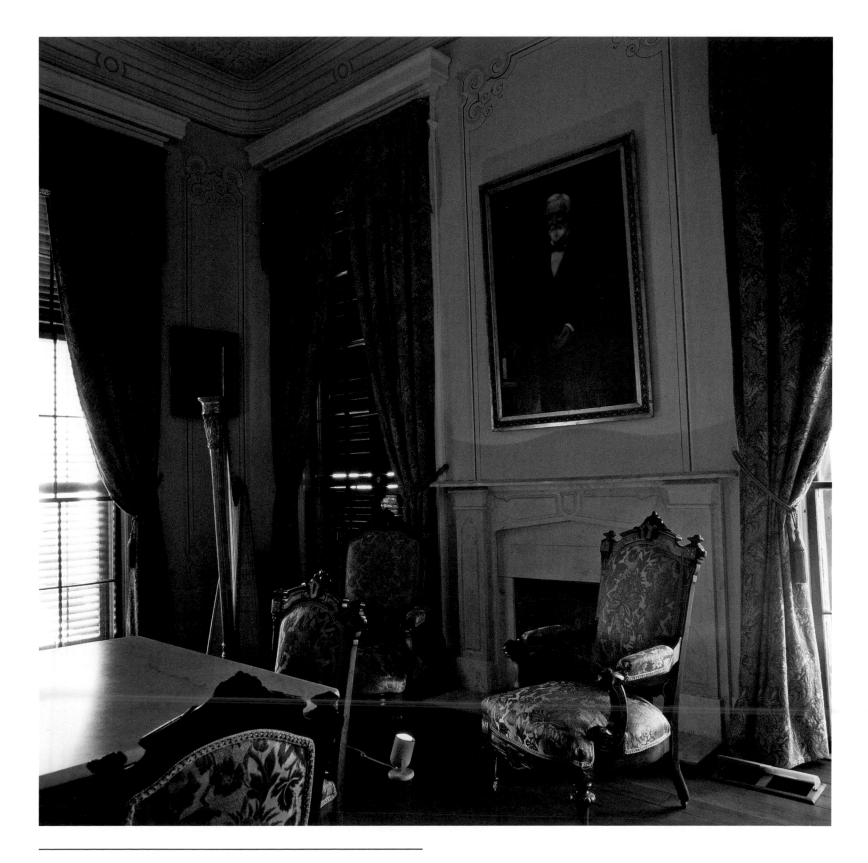

Several of Beauvoir's six fireplaces have marble mantelpieces; this one is
topped by a portrait of Davis.

ACKNOWLEDGMENTS

As the long list of names below suggests, many people guided us in our research and photography. Yet even before commencing the work of making the book, we drew upon a network of imaginative and well-informed advisers, each of whom pointed us in unexpected directions (some of them years ago, some in quite different contexts). Our thanks, then, to Susan Anderson, Bruce Boucher, Susan Buck, Patrick Clarke, Edward Douglas, Charles Duell, Jerry Grant, Pam Green, Emily Howie, Fiske Kimball, Sharon Koomler, Erin Kuykendall, Martha Lawrence, David Mattern, Travis McDonald, John I. Mesick, Ron Miller, Richard Moe, Grant Quertermous, Sherri Scott, Thomas Gordon Smith, Coxey Toogood, Diana Toole—and other helpful friends we've no doubt forgotten.

As for the business of publishing, our thanks first to Michael Sand, our editor at Little, Brown, for his belief in this book; his willingness to offer his guidance as we took an inchoate idea and made it a book; and his close and thoughtful reading of the text. Other Little, Brown colleagues played key roles in bringing this book to the press, among them Garrett McGrath, who tended to countless editorial details; production editor Ben Allen, who oversaw the complex process of preparing the book for press; Tracy Roe, who brought a vast knowledge of grammar and good sense to the task of copyediting the manuscript; and Jean Wilcox, whose clear-eyed design sense permits the photographs to speak for themselves. Our thanks, as well, to publicist Fiona Brown for her good efforts in making our book visible amid a cluttered marketplace. Our deep and abiding appreciation to Gail Hochman—friend, agent, and wise counselor. Many friends and acquaintances have aided and abetted our research; among them were Dominick Abel and Kathleen Moloney; Bob Beatty; Sion Boney; Don Carpentier; Thurston Clarke; Jim and Jan Day; Trish Hatler; Darrell and Angela Scott; David and Julia Rubel; and Wayne Walker.

My happy association with Sawyer Library at Williams College has been essential to my research; my thanks, then, to Rebecca Ohm, Lori Dubois, Jodi Psoter, and their colleagues. I've asked pestering questions and found valuable materials at many libraries, including those at the New-York Historical Society Library, the Sterling and Francine Clark Art Institute, the University of Virginia Alderman Library, and the Chatham (New York) Public Library. I have regularly drawn upon the collective resources of both the Mid-Hudson Library System and C/W MARS, the central and western Massachusetts library system. My library of last resort, one that rarely fails me even when all the others have, is the New York Public Library.

I wish to acknowledge the most essential sources—the caretakers at the historic sites featured in this book. Our thanks, then, in the order that we visit them in these pages, to the custodians of the Ralph Waldo Emerson Memorial House, including house director Marie Gordinier and Emerson descendant Bay Bancroft; Jane Williamson at Rokeby; William D. Hiott Sr. at Fort Hill, John Calhoun's plantation home located on the campus of today's Clemson University; and Lashé Mullins at White Hall.

We extend our appreciation to Charles Duell, M. Tracey Todd, and Virginia Mizel at the Edmondston-Alston house in Charleston. At the Lincoln Home in Springfield, Illinois, we were aided by David Wachtveitl, John Popolis, Rodney Naylor, and Susan Haake; by Patrick Clarke at James Buchanan's Wheatland; Brendan Mills at the John Brown Farm and Gravesite; Dennis Frye at Harpers Ferry National Historic Site; Kimberly Robinson at Arlington House, the Robert E. Lee Memorial; Michael Anne Lynn at the Stonewall Jackson House; Judith S. Hynson and Gretchen Goodell Pendleton at Stratford Hall; and Tommy Hines at South Union Shaker Village.

For guidance, past and present, concerning the unfinished Longwood in Natchez, Mississippi, our thanks to Mary Warren Miller and Ronald W. Miller, Historic Natchez Foundation, and the Pilgrimage Garden Club; appreciation, as well, to Patricia L. Kahle at Shadows-on-the-Teche; Erin Carlson Mast at President Lincoln's Cottage at the Soldiers' Home; Cathy Wright, curator, and Sam Craghead, public relations specialist, at the White House of the Confederacy; and Gray Williams and Betsy Towl at the Horace Greeley House.

In Savannah, we are grateful to Jane Pressly, Tracey Inglesby, Kay Gunkel, and Ann M. Tatum, for the introduction to their beautiful city in general and the Green-Meldrim House in particular, which is adjacent to (and the property of) St. John's Church. Invaluable to this venture were Andrew Roblee and Billye Chabot at the Seward House Historic Museum; Christine Carter at the Harriet Tubman Home; Patrick Schroeder, Joe Williams, and Ernie Price at Appomattox Court House National Historical Park; Ka'mal McClarin at Frederick Douglass National Historic Site; Kimberly Robinson and Kevin Patti at the Clara Barton National Historic Site; Timothy Welch, Cindy Finger, Dave Hubbard, and, in particular, Steve Trimm at the Ulysses S. Grant Cottage; Elizabeth Giard Burgess at the Harriet Beecher Stowe Center; Raven S. Palmer and Andre McLendon at Liberty Hall/A. H. Stephens Historic Park; and Bertram Hayes-Davis at Beauvoir.

FOR FURTHER READING

Civil War literature is not only vast but also remarkably dynamic, as quantitative historians are now employing demographic and topographic data to explain the diaspora of slavery and the impact of the war. New archival research colors what we thought we knew; similarly, a new generation of biographers revisits subjects long dead yet ready for reinterpretation.

The work of scholars like C. Vann Woodward, James M. McPherson, Gary Gallagher, Charles B. Dew, William C. Davis, and the invaluable William Lee Miller, to name just a few, offer orientation to the academic study of the time. One inspiration for this book was Shelby Foote, with whom photographer Roger Straus and I spent a day shortly before Foote died (Foote appeared in our *Writers of the American South*). As a true narrative historian, Foote offered a different (that is to say, nonacademic) means of approaching this subject, but many other historians also inhabit the ranks of the Civil War storytellers, among them Douglas Southall Freeman, Tony Horwitz, Fergus M. Bordewich, and Doris Kearns Goodwin.

I owe an incalculable debt to hundreds of the players—officers and enlisted men, politicians, wives, and others—who, though not writers by trade, penned their own memoirs, letters, and journals. Their words helped immeasurably in offering shading and color to the sites and personalities visited.

The notes that follow (organized alphabetically by the names of the sites) offer only a selective sampling of the sources drawn upon in preparing this book. Consider them as starting points; I hope they offer you both enjoyable hours of reading and further inspiration to pursue whatever detours appeal to you.

ANTIETAM NATIONAL BATTLEFIELD

Most larger works on the Civil War recount the events of the Maryland campaign, but of those volumes focused more narrowly, I would recommend in particular James M. McPherson's *Crossroads of Freedom* (Oxford, 2002) and the essays by various authors in *The Antietam Campaign*, edited by Garry W. Gallagher (North Carolina, 1999). See also the battlefield's website, http://www.nps.gov/anti/index.htm.

APPOMATTOX COURT HOUSE NATIONAL HISTORICAL PARK

Few episodes among the many well-documented events of the Civil War have been recounted more often than the days at Appomattox. Grant offered his version in his *Personal Memoirs* (Webster, 1885–86); Lee's devoted biographer Douglas Southall Freeman presents his view in *Robert E. Lee* (volume 4, Scribner's, 1935). Several participants offered minor variations, including Charles Marshall in his *Lee's Aide-de-Camp* (Little, Brown, 1927), Horace Porter in *Campaigning with Grant* (Century, 1897), and James Longstreet in his *From Manassas to Appomattox* (Lippincott, 1895). Among much recent scholarship, Chris M. Calkins in *The Appomattox Campaign* (Combined Books, 1997) offers an authoritative look at the battle, and William Marvel's *Lee's Last Retreat* (North Carolina, 2002) is a valuable corrective to some of the more problematic accounts. The single best source for the history of the McLean House is Frank P. Cauble's *Biography of Wilmer McLean* (Howard, 1987, second ed.). See also the National Park Service website at http://www.nps.gov/apco/index.htm.

ARLINGTON HOUSE

Douglas Southall Freeman's admiring four-volume *R. E. Lee* (Scribner's, 1934–35) remains the most comprehensive biography. Among the books that take a somewhat more contemporary view of the man are *The Making of Robert E. Lee* by Michael Fellman (Random House, 2000) and Gary Gallagher's *Lee the Soldier* (Nebraska, 1996). The writer that Lee himself was is very much in evidence in *The Wartime Papers of R. E. Lee* (Little, Brown, 1961) and, in a more personal way, *"To Markie": The Letters of Robert E. Lee to Martha Custis Williams* (Harvard, 1934). Mary and Robert's daughter Agnes kept a journal, published as *Growing Up in the 1850s*, edited by Mary Custis Lee deButts (North Carolina, 1988), that touches on life at Arlington. For the history of Arlington House, the most comprehensive source, though a book not so easy to find, is *Old Arlington* by Murray H. Nelligan (National Park Service, 1953). Briefer examinations of the house and its contents include *Arlington House*, Handbook 133 (National Park Service, 1985), and *Museum Collections: Arlington House, The Robert E. Lee Memorial* (Eastern National, 2008). See also the National Park Service website at http://www.nps.gov/arho/index.htm.

BEAUVOIR

Jefferson Davis: Private Letters, 1823–1889, edited by Hudson Strode (Harcourt, Brace, and World, 1966), is an invaluable source for the communications, many of which were transatlantic, between husband, wife, and children as Jefferson Davis settled in at Beauvoir. Though it is often heavy going, the principal work of Davis's Beauvoir years, *The Rise and Fall of the Confederate Government* (Appleton, 1881), is widely available in libraries. *Chronicles of Beauvoir: The Last Home of Jefferson Davis,* edited by Richard F. Flowers (Otter Bay Books, 2009), recounts the story of Davis's retirement home and his years there. For notes on the principal biographies and Davis's papers, see also the bibliographic notes below of the White House of the Confederacy. See also the Jefferson Davis Home and Presidential Library website, www.beauvoir.org.

Of the many books that address the Lost Cause, three stand out: Charles B. Dew's *Apostles of Disunion* (Virginia, 2001), James M. McPherson's *This Mighty Scourge* (Oxford, 2009), and *The Myth of the Lost Cause and Civil War History,* edited by Gary W. Gallagher and Alan T. Nolan (Indiana, 2000).

CASSIUS CLAY HOUSE / WHITE HALL STATE HISTORIC SITE

Cassius Clay published two autobiographical works in his lifetime: *The Writing of Cassius Marcellus Clay, Including Speeches and Addresses* (Harper and Brothers, 1848), edited by the redoubtable editor of the *New York Tribune* (see "Horace Greeley House," page 144), and *The Life of Cassius Marcellus Clay: Memoirs, Writings, and Speeches* (J. Fletcher Brennan, 1886). Both H. Edward Richardson's *Cassius Marcellus Clay: Firebrand of Freedom* (Kentucky, 1976) and *Lion of White Hall* by David L. Smiley (Wisconsin, 1962) offer readable looks at the life. The most authoritative source on White Hall is architectural historian Clay Lancaster's *Antebellum Architecture of Kentucky* (Kentucky, 1991). The White Hall website contains useful introductory materials on Green and Cassius Clay as well as on their home in both its earlier and later incarnations; see http://parks.ky.gov/parks/historicsites/white-hall/default.aspx.

CEDAR HILL / FREDERICK DOUGLASS NATIONAL HISTORIC SITE

Narrative of the Life of Frederick Douglass, an American Slave (1845) remains an essential antislavery document. Despite their age, the two best biographies remain Philip S. Foner's *Frederick Douglass* (Citadel, 1964) and Benjamin Quarles's *Frederick Douglass* (Associated Publishers,

1948). The four volumes of *The Life and Writing of Frederick Douglass,* edited by Philip S. Foner (published 1950–55) traces Douglass's long career from his early days, through the Civil War, to his death in 1895, in his speeches, magazine essays, correspondence, and other writings. David W. Blight's *Frederick Douglass' Civil War* (LSU Press, 1989) offers a most interesting analysis of Douglass's defining role in his era. See also the Cedar Hill website at http://www.nps.gov/frdo/.

CLARA BARTON NATIONAL HISTORIC SITE

The most authoritative biography is Elizabeth Brown Pryor's *Clara Barton: Professional Angel* (Pennsylvania, 1987); Ishbel Ross's *Angel of the Battlefield* (Harper, 1956) merits mention too. In his *A Woman of Valor* (Free Press, 1994), Stephen B. Oates passionately recounts the events of Barton's Civil War exploits. Barton's own 1907 memoir, *The Story of My Childhood* (Arno, 1980), offers a personal view of her upbringing. When considering the Clara Barton National Historic Site, the three-volume historic structure report prepared by the National Park Service offers copious detail about the house and property. The National Park Service website has a number of useful Barton documents; see http://www.nps.gov/clba/historyculture/documents.htm.

EDMONDSTON-ALSTON HOUSE

The basic biography of the Confederacy's first brigadier remains *P. G. T. Beauregard: Napoleon in Grey* by T. Harry Williams (Louisiana, 1954). Maury Klein's *Days of Defiance: Sumter, Secession, and the Coming of the Civil War* (Knopf, 1997) and *Allegiance: Fort Sumter, Charleston, and the Beginning of the Civil War* by David Detzer (Harcourt, 2001) both recount the story of Sumter's bombardment; W. A. Swanberg's *First Blood* (Scribner's, 1957) covers the same ground in a stylish and elegiac manner. Many primary sources survive, not least Mary Chesnut's oft-cited diary (edited by C. Vann Woodward, Yale, 1981); Edmund Ruffin's "The First Shot at Sumter," *William and Mary Quarterly* 20, no. 2 (October 1911): 69–101; and "Eye Witness to Fort Sumter: The Letters of Private John Thompson," *South Carolina Historical Magazine* 85, no. 4 (October 1984): 271–79. For access to unpublished Alston correspondence, I am indebted to M. Tracey Todd at the Middleton Place Foundation. See also Edmondston-Alston website: http://www.edmondstonalston.com/history.html. Architectural sources on Charleston include Kenneth Severens's *Charleston: Antebellum Architecture and Civic Destiny* (Tennessee, 1988) and *The Buildings of Charleston: A Guide to the City's Architecture* (South Carolina, 1977).

FORT HILL

Margaret Coit's biography *John C. Calhoun, American Portrait* (Houghton Mifflin, 1950) offers the most atmospheric look at the man; in his more recent *John C. Calhoun* (Norton, 1993), Irving H. Bartlett takes fewer interpretive liberties, though his book lacks the warmth of Mrs. Coit's portrait. In shorter form, the several chapters devoted to Calhoun in Merrill Peterson's *The Great Triumvirate: Webster, Clay, and Calhoun* (Oxford, 1987) offers perhaps the best summary of the politician's life. For Calhoun's political thought, a good overview is to be found in James H. Read's *Majority Rule versus Consensus* (Kansas, 2009), and Redelia Brisbane's *Albert Brisbane: A Mental Biography* (Arena, 1893) offers a most revealing account of Brisbane's dialogues with Calhoun. Calhoun's papers have been variously published, but, as its title suggests, *The Essential Calhoun*, edited by Clyde N. Wilson, presents a selection (Transaction Publishers, 1992, 2000). In reconstructing life at Fort Hill, I found two family-related sources useful: *A Rebel Came Home: The Diary and Letters of Floride Clemson, 1863–1866*, edited by Charles M. McGee Jr. and Ernest M. Lander Jr. (South Carolina, 1961, 1989), and *The Calhoun Family and Thomas Green Clemson: The Decline of a Southern Patriarchy*, by Ernest McPherson Lander Jr. (South Carolina, 1983). In reconstructing Calhoun's visit to Brady's studio, I drew upon Roy Meredith's *Mr. Lincoln's Camera Man: Mathew B. Brady* (Scribner's, 1946) as well as Coit's account. A variety of materials are also available at the Fort Hill website, www.clemson.edu/fort-hill.

THE GREEN-MELDRIM HOUSE

Sources for William Tecumseh Sherman's own words include his *Memoirs of General W. T. Sherman* (Library of America, 1990) and *Sherman's Civil War: Selected Correspondence of William T. Sherman, 1860–1865*, edited by Brooks D. Simpson and Jean V. Berlin (North Carolina, 1999). Useful architectural references include Frederick Doveton Nichols, *The Early Architecture of Georgia* (North Carolina, 1957), which features fine architectural photographs by Frances Benjamin Johnston; and the online recording of the home at the Historic American Building Survey at the Library of Congress (see memory.loc.gov). We await an authoritative biography of this complex man, but several books do take revealing, if glancing, looks at Sherman and his legacy. One is Stanley Weintraub's *General Sherman's Christmas, Savannah, 1864* (Smithsonian, 2009); another is a detailed historiographical look at Sherman's reputation, *Demon of the Lost Cause*, by Wesley Moody (Missouri, 2011). See also the St. John's Church website, http://www.stjohnssav.org/green-meldrim-house/.

HARRIET BEECHER STOWE HOUSE

Joan D. Hedrick's *Harriet Beecher Stowe: A Life* (Oxford, 1994) is the standard biography; Hedrick's *The Oxford Harriet Beecher Stowe Reader* (Oxford, 1999) contains, among other Stowe writings, a sampling of her correspondence, the full text of *Uncle Tom's Cabin*, and a selection of her shorter writings. Mrs. Stowe's friend Annie Fields left us her *Life and Letters of Harriet Beecher Stowe* (Houghton Mifflin, 1897) and son George Edward Stowe his *Life of Harriet Beecher Stowe* (Houghton Mifflin, 1891). Given transcription oddities, both of the latter are best read in conjunction with more recent scholarly works. *The Annotated Uncle Tom's Cabin*, edited by Henry Louis Gates Jr. and Hollis Robbins (Norton, 2007), is useful not merely for its textual notations but for Gates's quite personal view of the book's evolving place in American culture. I am also indebted to James McPherson for his thoughts regarding late-twentieth-century interpretations of the character of Uncle Tom. The Harriet Beecher Stowe Center administers the author's final residence, home to a rich archive and offering a mix of lectures and other events. See http://www.harrietbeecherstowecenter.org.

HORACE GREELEY HOUSE

Greeley's national role was such that he makes cameo appearances in books about all the major figures of the period, but the best biography of Greeley remains Glyndon G. Van Deusen's *Horace Greeley: Nineteenth-Century Crusader* (Pennsylvania, 1953). Robert C. Williams's more recent *Horace Greeley: Champion of American Freedom* (NYU, 2006) is also useful, as is William Harlan Hale's earlier biography *Horace Greeley: Voice of the People* (Harper and Brothers, 1950), particularly on family matters. Greeley's *Recollections of a Busy Life* (J. B. Ford, 1868) offers a personal view of the life in the man's own words. As for the Greeley house, a detailed description circa 1873 appears in *Story of a Summer* by Greeley's niece Cecilia Cleveland (New Castle Historical Society, 1874, 2006). See also the historical website www.newcastle.org/.

JOHN BROWN FARM AND GRAVESITE AND HARPERS FERRY NATIONAL HISTORICAL PARK

The complex and still controversial John Brown has drawn the constant attention of historians and writers for more than a century and a half. Among the most valuable of the recent books are an examination of Brown's religious life, *"Fire from the Midst of You,"* by Louis A. DeCaro Jr. (New York University Press, 2002); the best and most current biography, Davis S. Reynolds's *John Brown, Abolitionist* (Knopf, 2005); and Tony

Horwitz's dramatic rendering of the events at Harper's Ferry, *Midnight Rising* (Holt, 2011).

Useful compilations of Brown's own words include *John Brown: The Making of a Revolutionary*, edited by Louis Ruchames (Grosset and Dunlap, 1969); and *The Life and Letters of John Brown*, edited by F. B. Sanborn (Roberts Brothers, 1891). A late-nineteenth-century source is Richard J. Hinton's *John Brown and His Men* (Funk and Wagnalls, 1894), which includes among its appendices a first-person account by Richard A. Dana of an 1849 encounter with Brown at North Elba. For other information concerning the Brown homestead, see http://nysparks.com/historic-sites/29/details.aspx; concerning Harpers Ferry National Historic park, visit http://www.nps.gov/hafe/index.htm.

LIBERTY HALL / A. H. STEPHENS HISTORIC PARK

Alexander Stephens left us copious writings, including what's been called the "ablest defense of the Southern position ever made," *A Constitutional View of the Late War Between the States,* (2 volumes; National, 1868, 1870). Of greater interest to the modern reader is his moving diary of his incarceration at Fort Warren, *Recollections of Alexander H. Stephens,* edited by Myrta Lockette Avary (Doubleday, Page, 1910). An early authorized biography appeared shortly after the end of the war, *Alexander H. Stephens in Public and Private* by Henry Cleveland (National, 1866); the quite readable (though unsourced) *Little Aleck: A Life of Alexander H. Stephens* by E. Ramsay Richardson (Bobbs-Merrill) appeared in 1932. Thomas E. Schott's *Alexander H. Stephens of Georgia: A Biography* (LSU, 1988) is a sound, traditional biography; in *The Union That Shaped the Confederacy* (Kansas, 2001), William C. Davis takes a polemical approach to the roles Stephens and his enduring friend Robert Toombs played in opposing Jefferson Davis's government from within. Edmund Wilson's essay "Alexander H. Stephens," published in *Patriotic Gore: Studies in the Literature of the American Civil War* (Oxford, 1962), offers a considered reading of Stephens's postbellum writings.

LINCOLN HOME

The Lincoln shelf groans; of the forty-odd volumes that I consulted (they amount to a small fraction of the works on Lincoln), limitations of space allow the mention of only a few. In musing upon the literary Lincoln, I found much clear thinking in Fred Kaplan's *Lincoln: The Biography of a Writer* (Harper, 2008). David Herbert Donald's *Lincoln* (1995) remains a superior one-volume look at the life of the man. The much-admired *Team of Rivals* (a portion of which was the basis for the recent film *Lin-*

coln), by Doris Kearns Goodwin (Simon and Schuster, 2005), offers a compendious look at not only Lincoln but the politicians who orbited his presidency. The monograph *Seventeen Years at Eighth and Jackson* by Thomas J. Dyba (1982) provides a detailed (though imperfectly documented) look at life in the Lincolns' Springfield home. Many books have been published on Mary; my favorite remains Jean H. Baker's *Mary Todd Lincoln* (Norton, 1987). For other Lincoln references, see Lincoln Cottage, below. The National Park Service website also contains numerous images and useful text regarding the Lincoln Home; see http://www.nps.gov/liho/index.htm.

LONGWOOD

The Building of Longwood, edited by Ina May Ogletree McAdams (Natchez Garden Club, 1972), contains correspondence, documents, and legal papers linked with the house's construction and subsequent history. *The Heritage of Longwood* by art historian William L. Whitwell (Mississippi, 1975) offers perhaps the most detailed account of the house and its history. I also drew upon Nutt family documents found at the Mississippi Department of Archives and History. The drawings of "An Oriental Villa" that inspired the commission were first published in *The Model Architect*, volume 2, by Samuel Sloan (1853). For a larger view of antebellum Natchez, see *Natchez: The Houses and History of the Jews of the Mississippi* (Rizzoli, 2003), text by Hugh Howard, photographs by Roger Straus III. For more on architect Samuel Sloan, consult *Samuel Sloan: Architect of Philadelphia, 1815–1884,* by Harold N. Cooledge (Pennsylvania, 1986). See also the Pilgrimage Garden Club website at http://www.stantonhall.com/longwood.htm.

PRESIDENT LINCOLN'S COTTAGE AT THE SOLDIERS' HOME

The most essential resource is Matthew Pinsker's *Lincoln's Sanctuary: Abraham Lincoln and the Soldiers' Home* (Oxford, 2003), commissioned by the National Trust for Historic Preservation in connection with the cottage's restoration. George Tuthill Borrett's account of his 1864 visit to the United States appeared in his *Letters from Canada and the United States* (London, 1865); the visit to President Lincoln's Cottage is recounted on pages 249–56. Garry Wills offers a close reading of the great speech and its immediate and historic context in *Lincoln at Gettysburg: The Words that Remade America* (Simon and Schuster, 1992), while a more detailed look at Lincoln's character and thinking is to be found in William Lee

Miller's superb volumes on the sixteenth president, *Lincoln's Virtues: An Ethical Biography* and *President Lincoln: The Duty of a Statesman* (Knopf, 2002 and 2008). Firsthand recollections of the cottage appear in *Inside Lincoln's White House: The Complete Civil War Diary of John Hay*, edited by Michael Burlingame and John R. Turner Ettlinger (Southern Illinois, 1996). For other Lincoln references, see Lincoln Home, above; the Lincoln Cottage website also contains numerous images and useful text; see http://www.lincolncottage.org/.

RALPH WALDO EMERSON MEMORIAL HOUSE

Of the numerous Emerson biographies, two good ones are *Ralph Waldo Emerson: Days of Encounter* by John McAleer (Little, Brown, 1984) and *The Life of Ralph Waldo Emerson* by Ralph L. Rusk (Scribner's, 1949). Robert D. Richardson Jr.'s *Emerson: The Mind on Fire* (California, 1995) examines the man's writings. Emerson's own copious essays and other compositions have been collected in various editions, including the twelve-volume *Works* (AMS Press, 1979). *The Letters of Ellen Tucker Emerson*, edited by Edith E. W. Gregg (2 vols., Kent State, 1982) offer a daughter's-eye view of Waldo and his Bush; also of interest is son Edward Waldo Emerson's *Emerson in Concord: A Memoir* (Houghton Mifflin, 1888).

ROKEBY MUSEUM

The Robinsons of Rokeby are most fortunate to have historian and writer Jane Williamson as the keeper of their family history at Rokeby; the story as told in these pages of Rowland the younger and the elder is largely based upon her research. Among writings on Rokeby is her essay "Telling It Like It Was at Rokeby," which appears in the collection *Passages to Freedom: The Underground Railroad in History and Memory*, edited by David W. Blight (Smithsonian Books, 2004). Despite its historical opacity, Rowland E. Robinson's *Out of Bondage and Other Stories* (Charles E. Tuttle, 1936; originally published 1904) offers valuable clues to Rokeby. Wilbur H. Siebert's *The Underground Railroad from Slavery to Freedom* (Macmillan, 1898) was a seminal work in its time, though it must be read through the truer lens that Larry Gara used in *The Liberty Line: The Legend of the Underground Railroad* (University of Kentucky Press, 1961), in which he revised the romanticized view of the U.G.R.R. *Bound for Canaan* by Fergus M. Bordewich (New York: Amistad, 2005) is a sound and highly readable introduction to the larger story of the Underground Railroad. The 1880s memoir *His Promised Land* by John P. Parker was only recently rediscovered in the archives at Duke University (W. W. Norton, 1998). See also http://www.rokeby.org.

SEWARD HOUSE HISTORIC MUSEUM

Seward's copious *Autobiography* (3 vols., edited by Frederick W. Seward; Derby and Miller, 1891) contains many letters and much commentary from favorite son Frederick, making it an invaluable Seward resource. The most recent biography, Walter Stahr's *Seward: Lincoln's Indispensable Man* (Simon and Schuster, 2012), has a valued place on the shelf, along with the standard *William Henry Seward* by Glyndon G. Van Deusen (Oxford, 1967). Two more general books on the era, David Herbert Donald's *We Are Lincoln Men* (Simon and Schuster, 2003) and Doris Kearns Goodwin's *Team of Rivals* (Simon and Schuster, 2005), provide a larger context for Seward during Lincoln's presidency. Patricia C. Johnson offers valuable insight into Frances Seward in her essay "'I Could Not Be Well or Happy at Home . . . When Called to the Councils of My Country': Politics and the Seward Family" (*University of Rochester Library Bulletin* 31, no. 1 [Autumn 1978]). See also the Seward House website, www.sewardhouse.org.

SHADOWS-ON-THE-TECHE

The primary source material for the story of Shadows resides at Louisiana State University, where more than ten thousand items concerning nineteenth-century life at the house were put on deposit by great-grandson Williams Weeks Hall. Containing generations of documents concerning sugar cultivation and, thus, sugar slavery, they have been an important resource for such studies as Roderick A. McDonald's *The Economy and Material Culture of Slaves* (LSU, 1993). Though she did not write of Mary Moore in particular, Drew Gilpin Faust's now classic *Mothers of Invention: Women of the Slaveholding South in the American Civil War* (North Carolina, 1996) characterizes many women caught by the vicious circumstances of war, just as Mary was. The National Trust for Historic Preservation's current guidebook is *"Fine Things Are Without Value": Inside the Shadows* (National Trust, undated). See also the website for Shadows-on-the-Teche, http://shadowsontheteche.wordpress.com.

SOUTH UNION SHAKER VILLAGE

The most essential source is *The Journal of Eldress Nancy Moore*, edited by Mary Julia Neal (Parthenon Press, 1963), a day-to-day recording of life during the Civil War at South Union. Another primary source is *A Shaker Journal, 1861–1864* (Briar Hill Press, 1999). Concerning the South Union community in particular, the basic reference remains *By Their Fruits: The Story of Shakerism in South Union, Kentucky*, by Julia Neal (North Carolina, 1947). For a comprehensive look at the sect, see Stephen J.

Stein's *The Shaker Experience in America* (Yale, 1992). The website for the South Union Shaker Village is http://www.shakermuseum.com.

STONEWALL JACKSON HOUSE

Stonewall Jackson's widow, Mary Anna Jackson, wrote a late-in-life recollection of her husband in which she recalled their lives together; it has been variously published as *Life and Letters of General Thomas J. Jackson* and, with some added materials, *Memoirs of Stonewall Jackson* (Prentice Press, 1894). The best biography is the thorough and well-documented *Stonewall Jackson: The Man, the Soldier, the Legend,* by James I. Robertson Jr. (Macmillan, 1997). Extensive Jackson material at VMI's Preston Library is available on its website, including many images and Jackson papers; see http://www.vmi.edu/Archives/Jackson/Stonewall_Jackson_Home/.

ULYSSES S. GRANT COTTAGE

Several books recount Grant's last days, including *The Captain Departs,* by Thomas M. Pitkin (Southern Illinois, 1973), and Mark Perry's *Grant and Twain* (Random House, 2004). Essential primary sources include the *Personal Memoirs* of both the general (Webster, 1885, 1886) and Julia Dent Grant (the latter, curiously, remained unpublished until 1975, when it was brought out by G. P. Putnam's Sons). Joan Waugh's *U.S. Grant: American Hero, American Myth* (North Carolina, 2009) takes an illuminating look at the mnemonic variables that have caused Grant's reputation to rise and fall. While the best comprehensive biography remains William S. McFeeley's *Grant* (Norton, 1981), the brief *Ulysses S. Grant,* by Josiah Bunting III (Times Books, 2004), offers a highly readable introduction to the man. The website for the Grant Cottage is http://www.grantcottage.org/.

WHEATLAND

The essential source regarding Buchanan's home is *The Story of Wheatland* by Philip Shriver Klein (Buchanan Foundation, 2003, originally published in 1936). Klein's *President James Buchanan* (Penn State, 1962) remains the standard biography. Jean H. Baker's *James Buchanan* (Times Books, 2004) offers a short-form look at the man, while the rather dated but compendious two-volume *Life* by George Ticknor Curtis (Harper, 1883) gives a flavor of the time. See also www.lancasterhistory.org/.

WHITE HOUSE OF THE CONFEDERACY

Davis's own words fill the pages of two multivolume collections. *The Papers of Jefferson Davis,* edited by Lynda L. Crist et al., is a new edition nearing completion, with thirteen of a projected fifteen volumes in print (Louisiana, 1971–2012); *Jefferson Davis, Constitutionalist: His Letters, Papers and Speeches,* edited by Dunbar Rowland (Mississippi Department of Archives and History, 1923) is an earlier, less comprehensive edition in ten volumes. Hudson Strode's three-volume *Jefferson Davis: American Patriot, Confederate President,* and *Tragic Hero* (Harcourt, Brace and World, 1955, 1959, 1964) remains the most compendious—and among the most admiring—of the Davis biographies. *Jefferson Davis, American,* by William J. Cooper Jr. (Knopf, 2000) is perhaps the closest to a fair-minded view of the man. For other bibliographic notes, see also Beauvoir, above.

The basic book on Historic Tredegar's history remains Charles Dew's *Ironmaker to the Confederacy: Joseph R. Anderson and the Tredegar Iron Works* (Yale, 1966).

Varina Howell Davis proved irresistible to several biographers, including the reliable Ishbel Ross (*First Lady of the South,* Harpers, 1958), Ruth Painter Randall in her gently fictionalized account *I Varina* (Little, Brown, 1962), and, most recently, Joan Cashin, in her *First Lady of the Confederacy* (Harvard, 2006).

VISITOR INFORMATION

AMERICAN CIVIL WAR CENTER AT HISTORIC TREDEGAR

Owner/Administrator: American Civil War Center at Historic Tredegar

Address: 500 Tredegar Street, Richmond, Virginia 23219

Web Address: http://www.tredegar.org

Phone: (804) 780-1865

Calendar: Open daily except Thanksgiving, Christmas, and New Year's Day

ANDREW JOHNSON NATIONAL HISTORIC SITE

Occupant: Andrew Johnson (1808–1875)

Owner/Administrator: National Park Service, U.S. Department of the Interior

Address: 101 North College Street, Greenville, TN 37743

Web Address: http://www.nps.gov/anjo/

Phone: (423) 638-3551

Calendar: Open daily except Thanksgiving, Christmas, and New Year's Day

ANTIETAM NATIONAL BATTLEFIELD

Owner/Administrator: National Park Service, U.S. Department of the Interior

Address: 5831 Dunker Church Road, Sharpsburg, MD 21782

Web Address: http://www.nps.gov/anti/index.htm

Phone: (301) 432-5124

Calendar: Open daily except Thanksgiving, Christmas, and New Year's Day

APPOMATTOX COURT HOUSE NATIONAL HISTORICAL PARK

Occupants: Robert E. Lee (1802–1870) and Ulysses S. Grant (1822–1885)

Owner/Administrator: National Park Service, U.S. Department of the Interior

Address: Highway 24, PO Box 218, Appomattox, VA 24522

Web Address: http://www.nps.gov/apco/index.htm

Phone: (434) 352-8987

Calendar: Open daily except for Thanksgiving, Christmas Day, New Year's Day, Martin Luther King Day, and Presidents' Day

ARLINGTON HOUSE

Occupant: Robert E. Lee (1807–1870)

Owner/Administrator: National Park Service, U.S. Department of the Interior

Address: 321 Sherman Drive, Fort Myer, VA 22211

Web Address: http://www.nps.gov/arho/index.htm

Phone: (703) 235-1530

Calendar: Open daily

BEAUVOIR

Occupant: Jefferson Davis (1808–1889)

Owner/Administrator: Sons of Confederate Veterans, Mississippi Division

Address: 2244 Beach Boulevard, Biloxi, MS 39538

Web Address: http://www.beauvoir.org

Phone: (228) 388-4400

Calendar: Open daily

BOONE HALL

Owner/Administrator: Boone Hall Plantation

Address: 1235 Long Point Road, Mount Pleasant, SC 29464

Web Address: http://boonehallplantation.com

Phone: (843) 884-4371

Calendar: Open daily except Thanksgiving and Christmas Day

CEDAR HILL / FREDERICK DOUGLASS NATIONAL HISTORIC SITE

Occupant: Frederick Douglass (1818?–1895)

Owner/Administrator: National Park Service, U.S. Department of the Interior

Address: 1411 W Street SE, Washington, DC 20020

Web Address: http://www.nps.gov/frdo/

Phone: (202) 426-5961

Calendar: Open daily

CLARA BARTON NATIONAL HISTORIC SITE

Occupant: Clara Barton (1821–1912)

Owner/Administrator: National Park Service, U.S. Department of the Interior

Address: 5801 Oxford Road, Glen Echo, MD 20812

Web Address: http://www.nps.gov/clba/index.htm

Phone: (301) 320-1411

Calendar: Open daily except for Martin Luther King Day, Presidents' Day Thanksgiving, Christmas, and New Year's Day

EDMONDSTON-ALSTON HOUSE

Owner/Administrator: Middleton Place Foundation

Address: 21 East Battery, Charleston, SC 29401

Web Address: http://www.edmondstonalston.com/history.html

Phone: (843) 722-7171

Calendar: Open daily

FORT HILL

Occupant: John C. Calhoun (1782–1850)

Owner/Administrator: Clemson University

Address: 101 Fort Hill Street, Clemson University, Clemson, SC 29634

Web Address: www.clemson.edu/fort-hill

Phone: (864) 656-3311

Calendar: Open daily

THE GREEN-MELDRIM HOUSE

Occupant: General William Tecumseh Sherman (1820–1891)

Owner/Administrator: St. John's Church

Address: 14 West Macon Street/Madison Square, Savannah, GA 31401

Web Address: www.stjohnssav.org

Phone: (912) 233-3845

Calendar: Open Tuesday, Thursday, Friday, and Saturday; closed the weeks of Thanksgiving, Christmas to New Year's, and Easter

HARPERS FERRY NATIONAL HISTORICAL PARK

Owner/Administrator: National Park Service, U.S. Department of the Interior

Address: 171 Shoreline Drive, Harpers Ferry, WV 25425

Web Address: http://www.nps.gov/hafe/index.htm

Phone: (304) 535-6224

Calendar: Open daily except Thanksgiving, Christmas, and New Year's Day

HARRIET BEECHER STOWE HOUSE

Occupant: Harriet Beecher Stowe (1811–1896)

Owner/Administrator: Harriet Beecher Stowe Center

Address: 77 Forest Street, Hartford, CT 06105

Web Address: http://www.harrietbeecherstowecenter.org

Phone: (860) 522-9258

Calendar: Open daily except New Year's Day, Easter, July 4, Thanksgiving, Christmas Eve, Christmas Day, and Tuesdays from January through March

HARRIET TUBMAN HOME

Occupant: Harriet Tubman (1820–1913)

Owner/Administrator: Harriet Tubman Home, Inc.

Address: 180 South Street, Auburn, NY 13021

Web Address: http://harriethouse.org

Phone: (315) 252-2081

Calendar: Open Tuesday through Saturday

HORACE GREELEY HOUSE

Occupant: Horace Greeley (1811–1872)

Owner/Administrator: New Castle Historical Society

Address: 100 King Street, Chappaqua, NY 10514

Web Address: /www.newcastlehs.org/

Phone: (914) 238-4666

Calendar: Open Tuesday, Wednesday, Thursday, and Saturday 1:00 to 4:00 p.m.

JOHN BROWN FARM STATE HISTORIC SITE

Owner/Administrator: New York State Office of Parks, Recreation and Historic Preservation

Address: 115 John Brown Road, Lake Placid, NY 12946

Web Address: http://nysparks.com/historic-sites/29/details.aspx

Phone: (518) 523-3900

Calendar: Open daily May through October except Tuesdays

LIBERTY HALL / A. H. STEPHENS HISTORIC PARK

Occupant: Alexander Hamilton Stephens (1812–1883)

Owner/Administrator: Georgia Department of Natural Resources/State Parks and Historic Sites

Address: A. H. Stephens Historic Park, 456 Alexander Street NW, Crawfordville, GA 30631

Web Address: http://www.gastateparks.org/info/ahsteph/

Phone: (706) 456-2602

Calendar: Open Friday, Saturday, and Sunday

LINCOLN HOME

Occupant: Abraham Lincoln (1809–1865)

Owner/Administrator: National Park Service, U.S. Department of the Interior

Address: 426 South Seventh Street, Springfield, IL 62701

Web Address: http://www.nps.gov/liho/

Phone: (217) 391-3226

Tours: Open daily except Thanksgiving, Christmas, and New Year's Day

LONGWOOD

Occupants: Haller Nutt (1816–1864) and Julia Augusta Williams Nutt (1822–1897)

Owner/Administrator: Pilgrimage Garden Club

Address: 140 Lower Woodville Road, Natchez, MS 39120

Web Address: http://stantonhall.com/longwood.htm

Phone: (601) 445-5151

Calendar: Open daily 9:00 a.m. to 4:30 p.m.

OLD STATE CAPITOL

Owner/Administrator: State of Illinois/Illinois Historic Preservation Agency

Address: 1 Old State Capitol Plaza, Springfield, IL 62701

Web Address: http://www.illinoishistory.gov/hs/old_capitol.htm

Phone: (217) 785-7960

Calendar: Closed New Year's Day, Martin Luther King Day, Presidents' Day, Labor Day, Veterans Day, Thanksgiving Day, and Christmas Day

PRESIDENT LINCOLN'S COTTAGE
AT THE SOLDIERS' HOME

Occupant: Abraham Lincoln (1809–1865)

Owner/Administrator: Armed Forces Retirement Home/National Trust for Historic Preservation

Address: Eagle Gate, intersection of Rock Creek Church Road and Upshur Street NW, Washington, DC 20011

Web Address: http://www.lincolncottage.org/

Phone: (202) 829-0436

Tours: Open daily except Thanksgiving, Christmas, and New Year's Day

RALPH WALDO EMERSON MEMORIAL HOUSE

Occupant: Ralph Waldo Emerson (1803–1882)

Owner/Administrator: R. W. Emerson Memorial Association

Address: 28 Cambridge Turnpike at Lexington Road, Concord, MA 01742

Phone: (978) 369-2236

Calendar: Open April through October, Thursdays to Sunday

ROKEBY MUSEUM

Occupant: Rowland Thomas Robinson (1796–1879)

Owner/Administrator: Rokeby Museum

Address: 4334 Route 7, Ferrisburgh, VT 05456

Web Address: http://www.rokeby.org/home.html

Phone: (802) 877-3406

Calendar: Open daily May through October

SEWARD HOUSE HISTORIC MUSEUM

Occupant: William H. Seward (1801–1872)

Owner/Administrator: Seward House Museum

Address: 33 South Street, Auburn, NY 13021

Web Address: www.sewardhouse.org

Phone: (315) 252-1283

Calendar: Open Tuesday through Sunday in the summer months; closed in January and Sundays in the spring and fall

SHADOWS-ON-THE-TECHE

Occupant: Mary Clara Conrad Weeks Moore (1796–1863)

Owner/Administrator: National Trust for Historic Preservation

Address: 317 E. Main St., New Iberia, LA 70560

Web Address: http://shadowsontheteche.wordpress.com

Phone: (337) 369-6446

Calendar: Open Monday through Saturday, closed Sundays, July Fourth, Thanksgiving, Christmas Eve and Christmas Day, and New Year's Day

SHILOH NATIONAL MILITARY PARK

Owner/Administrator: National Park Service, U.S. Department of the Interior

Address: Shiloh Battlefield Visitor Center, Highway 22 North, Shiloh, TN 38376

Web Address: http://www.nps.gov/shil/index.htm

Phone: (731) 689-5696

Calendar: Open daily except Christmas Day

SOUTH UNION SHAKER VILLAGE

Occupant: Eldress Nancy E. Moore (1807–1889)

Owner/Administrator: South Union Shaker Village

Address: 396 South Union Road, Auburn, KY 42206

Web address: http://www.shakermuseum.com

Phone: (270) 542-4167

Calendar: Open Tuesday through Sunday except Christmas Day, Christmas Eve, New Year's Eve, and New Year's Day

STONEWALL JACKSON HOUSE

Occupant: Thomas J. Jackson (1824–1863)

Owner/Administrator: Virginia Military Institute

Address: 8 East Washington Street, Lexington, VA 24450

Web Address: www.stonewalljackson.org

Phone: (540) 464-7704

STRATFORD HALL

Occupant: Robert E. Lee (1807–1870)

Owner/Administrator: Robert E. Lee Memorial Association

Address: 483 Great House Road, Stratford, VA 22558

Web Address: http://www.stratfordhall.org/

Phone: (804) 493-8038

Hours: Daily, 9:30 a.m. to 4:00 p.m.

ULYSSES S. GRANT COTTAGE

Occupant: Ulysses S. Grant (1822–1885)

Owner/Administrator: New York State Department of Parks/Friends of the Ulysses S. Grant Cottage

Address: Mount McGregor, Wilton, NY 12831

Web Address: http://grantcottage.org/

Phone: (518) 584-4353

Tours: Memorial Day through Labor Day, Wednesday through Sunday; Labor Day to Columbus Day, Saturdays and Sundays

ULYSSES S. GRANT HOME STATE HISTORIC SITE

Occupant: Ulysses S. Grant (1822–1885)

Owner/Administrator: State of Illinois/Illinois Historic Preservation Agency

Address: 500 Bouthillier Street Galena, IL 61036

Web Address: http://www.granthome.com/

Phone: (815) 777-3310

Tours: Open Wednesday through Sunday except Martin Luther King Jr. Day, Presidents' Day, Veterans Day, Election Day, Thanksgiving, Christmas, and New Year's Day

ULYSSES S. GRANT NATIONAL HISTORIC SITE

President: Ulysses S. Grant (1822–1885)

Owner/Administrator: National Park Service, U.S. Department of the Interior

Address: 7400 Grant Road, St. Louis, MO 63123

Web Address: http://www.nps.gov/ulsg

Phone: (314) 842-1867

Tours: Open daily except Thanksgiving, Christmas, and New Year's Day

WHEATLAND — HOME OF JAMES BUCHANAN

Occupant: James Buchanan (1791–1868)

Owner/Administrator: LancasterHistory.org

Address: 230 North President Avenue, Lancaster, PA 17603

Web Address: http://www.lancasterhistory.org/

Phone: (717) 392-4633

Tours: Open Monday through Saturday, April through October

WHITE HALL STATE HISTORIC SITE

Occupant: Cassius Marcellus Clay (1810–1903)

Owner/Administrator: Kentucky Department of Parks

Address: 500 White Hall Shrine Road, Richmond, KY 40475

Web address: http://parks.ky.gov/parks/historicsites/white-hall/default.aspx

Phone: (859) 623-9178

Calendar: Open Wednesday through Saturday, April through October

WHITE HOUSE OF THE CONFEDERACY

Occupant: Jefferson Davis (1808–1889)

Owner/Administrator: The Museum of the Confederacy

Address: 1201 East Clay Street, Richmond, VA 23219

Web Address: http://www.moc.org

Phone: (855) 649-1861

Calendar: Open daily except Thanksgiving, Christmas Day, and New Year's Day

INDEX

Page numbers in italic type refer to illustrations.

ABOUT THE AUTHOR

HUGH HOWARD is the author of *Houses of the Presidents* and many other books on architecture, art, and American history, including *Houses of the Founding Fathers; Mr. and Mrs. Madison's War: America's First Couple and the Second War of Independence; The Painter's Chair: George Washington and the Making of American Art; Dr. Kimball and Mr. Jefferson: Rediscovering the Founding Fathers of American Architecture;* and a memoir, *House-Dreams*. He lives in East Chatham, New York; visit his website at www.HughHoward.com.

ABOUT THE PHOTOGRAPHER

ROGER STRAUS III spent thirty years in book publishing before deciding to devote himself full-time to photography. His work has been featured in several books, including *Houses of the Presidents; America's Great Railroad Stations; Houses of the Founding Fathers; U.S. 1: America's Original Main Street; Mississippi Currents; Modernism Reborn;* and *Wright for Wright*. His photographs have also appeared in newspapers and magazines such as the *Washington Post* and *Architectural Digest*. He lives in North Salem, New York.

Little, Brown and Company
Hachette Book Group
1290 Avenue of the Americas, New York, NY 10019
littlebrown.com

First Edition: November 2014

Little, Brown and Company is a division of Hachette Book Group, Inc. The Little, Brown name and logo are trademarks of Hachette Book Group, Inc.

The publisher is not responsible for websites (or their content) that are not owned by the publisher.

The Hachette Speakers Bureau provides a wide range of authors for speaking events. To find out more, go to hachettespeakersbureau.com or call (866) 376-6591.

ISBN 978-0-316-22798-8
LCCN 2014934463

10 9 8 7 6 5 4 3 2 1

SC
Designed by Wilcox Design
Printed in China

The images that open this book, appear on its title page, and face the epigraph were taken, respectively, at the Seward House Historic Museum, Appomattox Court House National Historic Park, and Frederick Douglass's Cedar Hill.

The houses illustrated on the front jacket are Longwood in Natchez, Mississippi (*top*), and (*right to left across the bottom*) the John Brown Farm in Lake Placid, New York; the Clover Hill Tavern at Appomattox Court House, Virginia; the Abraham Lincoln Home in Springfield, Illinois; the William Henry Seward House in Auburn, New York; Frederick Douglass's Cedar Hill in Washington, D.C.; and the Dunker church on the Antietam Battlefield in Sharpsburg, Maryland. The photograph on the back jacket was taken in the morning room at Arlington House in Arlington, Virginia.